THE ECONOMY

OF

PRESTIGE

THE ECONOMY

OF

PRESTIGE

Prizes, Awards, and

the Circulation of

Cultural Value

JAMES F. ENGLISH

HARVARD UNIVERSITY PRESS
Cambridge, Massachusetts
London, England
2005

Library of Congress Cataloging-in-Publication Data
English, James F., 1958–
The economy of prestige : prizes, awards, and the
circulation of cultural value / James F. English.
p. cm.
Includes bibliographical references and index.
ISBN 0-674-01884-2
1. Awards—Economic aspects. 2. Literary prizes—Economic aspects.
3. Art—Awards—Economic aspects. 4. Culture—Economic aspects.
5. Intellecual life—Economic aspects. 6. Popular culture—Economic aspects.
7. Cultural industries—Economic aspects.
8. Value. 9. Prestige. I. Title.
AS935.E54 2005
001.4′4—dc22 2005050273

For Eileen

Acknowledgments

Having sat through a good many awards banquets, I am aware that once people start thanking supporters and contributors they often find it difficult to stop. The list of acknowledgments is the tedious ballast of every prize ceremony, dragging the very hero of the show—the gifted individual, the consecrated genius—down toward the level of mundane social practice, where nobody, or everybody, deserves the credit. Too much acknowledgment can ruin the whole noble ceremony of exchange, subjecting it to an overly scrupulous accounting and laying bare the messy truth of cultural debts and gifts: the fact that they are unending, coterminous with society itself. Even in the arena where a two-minute time limit on acceptance speeches is strictly enforced, things can reach the point where, as Billy Crystal said toward the end of Peter Jackson's sweep of the 2004 Academy Awards, "the entire population of New Zealand has been thanked."

Happily, the genre of acknowledgment operates differently in the pages of a scholarly monograph. Even so, in the course of writing this book, I have profited from the contributions of far more people than I can reasonably take space here to name. Many dozens of conversations with students, conference and colloquium participants, nonacademic friends, family members, and others have helped to shape my thinking about prizes and awards in ways that elude any exact specification but whose importance I fully appreciate.

Of my more concretely listable debts, I will begin with those at the University of Pennsylvania, where I owe particular thanks to the Research Foundation for funding travel and other expenses associated with research trips to Rome, London, Los Angeles, and elsewhere. The reference staff at Van Pelt Library, in particular Bob Walther, offered guidance on many questions of central importance to the project. My research assistants, Dottie Burns, John Crowther, Nelly Kalckzuk, Elizabeth Lutz, and Kate Sattelle, helped me to assemble and sift through an enormous database of articles and press releases, and to compile and collate lists of winners, judges, and so forth. My colleagues at Penn helped me by providing contacts in the awards industry, accounts of their own involvement with prizes, criticisms of the work in progress, and advice about publication; in particular I owe thanks to Charles Bernstein, Stuart Curran, Bob Perelman, Jean-Michel Rabaté, Wendy Steiner, and David Wallace. Gregory Flaxman, Aaron Levy, and Matt Hart and Damien Keane arranged for me to present portions of the work to wonderfully attentive and helpful local audiences. And John Richetti has my thanks for his unstinting support.

Beyond Penn, my debts, like prizes themselves, have become too numerous to tabulate. But for their especially helpful contributions I must thank Giovanni Alberti of the Venice Biennale Foreign Press Office; Kim Becker and Caroline Bock of the Independent Spirit Awards; Chuck Bresloff of Recognition Products International; Virginia Button of the Tate Gallery and the Turner Prize; Jamie Chapman of the Arts for the Parks Program; Paulette Coetzee of the International Museum of African Music; Kaylee Coxall of BPI and the BRITs; Bruce Davis of the Academy of Motion Picture Arts and Sciences; Doreen Dean of the BAFTA Awards; Inga Dupont of the Pierpont Morgan Library; Annika Ekdahl of the Nobel Founda-

tion; Cheryl Freedman of the Crime Writers of Canada; Mark Frost of the Medallic Art Company; Martyn Goff of the Booker Prize; Carl Harms of the Actors Equity Foundation and the Paul Robeson Award; Dottie Irving of Coleman Getty; Andrew Jaffe of the Clio Awards; Nicholas Kazan of the Screenwriters Guild; Emilie Kilgore of the Susan Smith Blackburn Prize; Kristine Krueger of the AMPAS legal department; Hossein Mahini of the International Exile Film Festival; David Marks of Third Ear Music and the Hidden Years Music Archive Project; Marcella Meharg and Janet Salter of the Julie Harris Playwright Competition of the Beverly Hills Theater Guild; Alistair Niven of the British Arts Council; Russell Pritchard of the Book Trust; Peter Raymond of Orange PLC and the Orange Prize; Jane Ruddell of the Tate Gallery; Adriana Scalise of the Venice Biennale Photo Library; Jeffrey "Nobel Jeff" Schramek; Rick Spector of Stairway to the Stars; Terri Sultan of the Corcoran Biennial Exhibition and the Blaffer Gallery; Cathy Thornton of the Village Voice and the OBIE Awards; Larry Tise of the International Congress of Distinguished Awards; Sonia Vaillancourt of the Independent Feature Project and the Gotham Awards; Sandra Vince of the Book Trust; John Wilson of the Golden Raspberry Award Foundation. My thanks, as well, to the many prize administrators who responded to my mailed or faxed requests for brochures and other materials connected with their programs.

For help with specific questions of cultural history, I owe thanks to Max Cavitch, Leon Jackson, Lawrence Levine, Alvaro Ribeiro, Erik Simpson, Richard Todd, and Susan Wood. Chris Bongie, Michele Frank, Simon Kovesi, Jean Pickering, Karen Pinkus, Craig Smith, and Claire Squires all arranged for me to present my ideas to interested audiences, in addition to offering their own feedback and criticism.

Jim Impoco, then at *U.S. News and World Report,* craftily facili-
tated my access to various award banquets and events and was an
invaluable resource to me during my six months of research in Los
Angeles. Walter Lippincott, Lisa New, Robert Ray, and Susan Stew-
art offered generous advice and assistance when it was time for me
to seek out a publisher. Lindsay Waters has been the perfect editor
for this book, and a most stimulating interlocutor on all manner of
contemporary cultural topics. The anonymous readers for Harvard
University Press did me the great service of detailing their reserva-
tions about the project as well as their support for it, thus providing
direction and impetus for a final revision of the manuscript. Maria
Ascher, senior editor at the Press, made a great many repairs, cor-
rections, and improvements to the manuscript before launching it
into production. Martha Mayou prepared a first-rate index.

My father, James English, read the manuscript as it neared com-
pletion and gave me the response I needed at that stage from a well-
read nonspecialist. I'm grateful to him also for accompanying me to
the First International Conference on the Literary Prize in Oxford
in the fall of 2003, helping to make that an especially enjoyable
event. My son Jimmy was a wonderfully assiduous double-napper
during the year of leave when I began writing this book; by the time
of the leave year during which I completed it, neither he nor his
younger brother, John, were much good for napping, but both had
learned how to read the "Go Away" doormat outside my garage-
study. My wife, Eileen Reeves, has little interest in prizes but end-
less patience for my obsession with them; I dedicate this book to
her. As for the errors of fact, infelicities of style, and failures of criti-
cal acumen that may be found in its pages, there is of course no one
to acknowledge but myself.

Contents

IV. The Global Economy of Cultural Prestige

Illustrations

THE ECONOMY

OF

PRESTIGE

Prizes and the Study of Culture

I don't know what this means. I don't think it means anything.

> —Eddie Vedder of Pearl Jam, receiving the 1996 Grammy Award for Best Hard Rock Performance

This is a book about prizes in literature and the arts, the stunning rise of which over the past hundred years is one of the great untold stories of modern cultural life. It is also a book about the collective ambivalence or uncertainty in which these prizes are embedded, and which perhaps accounts more than anything else for our failure to come to terms with their ascendancy. The custom of awarding prizes, medals, or trophies to artists—selecting outstanding individuals from various fields of cultural endeavor and presenting them with special tokens of esteem—is both an utterly familiar and unexceptional practice and a profoundly strange and alienating one. It is familiar inasmuch as it has a long history, dating back at least to the Greek drama and arts competitions in the sixth century B.C., to the

classical and medieval competitions in architecture, and to the musical-composition prizes, university essay prizes, and other sorts of cultural awards which were well established by the early Renaissance. The practice becomes more common with the rise of royal and national academies and then of professional associations and learned societies from the seventeenth to nineteenth centuries, has expanded ever more rapidly since the turn of the twentieth century, and presents itself to us today as perhaps the most ubiquitous feature of cultural life, touching every corner of the cultural universe, from classical music to tattoo art, hair styling, and food photography. Yet it remains a strange practice inasmuch as we continue to be discomfited by what seems an equation of the artist with the boxer or discus-thrower, by a conception of art as a contest or competition from which there must emerge a definite winner, and by the seeming incommensurability of gold-plated medals or crystal statuettes, mounted certificates or outsized checks, with the rare achievements of artistic genius that these objects are supposed to honor and reflect. Art and sport may be essentially identical facets of human life, as Johan Huizinga argued half a century ago in *Homo Ludens*,[1] and as is perhaps assumed by contemporary accountants when they enter an exhibition of post-Impressionist paintings and an international track meet on the same "arts and sports" line of marketing costs in a corporate expense ledger. But much in the modern ideology of art militates against such a view, insisting that "the whole emphasis on winners and losers is false and out of place" in the context of culture.[2] Indeed, to most observers, cultural prizes represent an external imposition on the world of art rather than an expression of its own energies. The rise of prizes over the past century, and especially their feverish proliferation in recent decades, is widely seen as one of the more glaring symptoms of a con-

sumer society run rampant, a society that can conceive of artistic achievement only in terms of stardom and success, and that is fast replacing a rich and varied cultural world with a shallow and homogeneous McCulture based on the model of network TV. Prizes, from this vantage point, are not a celebration but a contamination of the most precious aspects of art.

The tension between this familiarity and this strangeness—between the ever more complete and intimate way that prizes have come to occupy the fields of our cultural activity, and their continued capacity to provoke our feelings of alienation or repulsion—is a complex one, which this book will explore in a number of different ways. It involves fundamentally the question of art's relationships to money, to politics, to the social and the temporal. It involves questions of power, of what constitutes specifically cultural power, how this form of power is situated in relation to other forms, and how its particular logic and mode of operation have changed over the course of the modern period. It involves questions of cultural status or prestige. How is such prestige produced, and where does it reside? (In people? In things? In relationships between people and things?) What rules govern its circulation? It involves, indeed, questions about the very nature of our individual and collective investments in art—questions of recognition and illusion, belief and make-belief, desire and refusal.

In short, this book has a more ambitious scope than might at first be apparent. Seemingly focused on a manageable, even rather minor object of study—the cultural prize in its contemporary form—the book in fact addresses itself broadly to the economic dimensions of culture, to the rules or logics of exchange in the market for what has come to be called "cultural capital." In the wild proliferation of prizes since about 1900, this book sees a key to transforma-

tions in the cultural field as a whole. And in the specific workings
of prizes—their elaborate machineries of nomination and election,
presentation and acceptance, sponsorship, publicity, and scandal—
it finds evidence of the new arrangements and relationships that
have come to characterize that field.

For the purpose of exploring these matters, I have adopted a set
of economic terms whose appropriateness and explanatory power
regarding questions of art have been much disputed. Certainly,
money plays a role in the world of art and literature—in sponsor-
ship, marketing, philanthropy, and so forth. Prizes obviously are
bound up in varying degree with the business end of art, with the
actual funding of cultural production and the traffic in cultural
products, and no one would question the legitimacy of inquiring
into their economic motivations and effects in this restricted sense.
But such inquiry represents just one facet of my study, which is also
concerned with the specifically *cultural* economics of prizes and
awards—with what may be called the economics of cultural pres-
tige. This other economics, which is woven together with, and can-
not be understood apart from, the money economy, is not itself
based on money. It involves such terms as "capital," "investment,"
"endowment," "return," "circulation," "accumulation," "mar-
ket," and so forth, and it assumes certain basic continuities be-
tween economic behavior (that is, interested or advantage-seeking
exchange) and the behavior proper to artists, critics, intellectuals,
and other important players on the fields of culture. But it does not
assume the primacy of the money economy; it is a matter not of re-
ducing culture to economics, artistic motivations to money-lust, but
of enlarging the notion of economics to include systems of non-
monetary, cultural, and symbolic transaction—what Goethe called
"the market . . . of general intellectual commerce."[3] The project, as

Pierre Bourdieu has said, must be "to extend economic calculation to *all* the goods, material and symbolic, without distinction, that present themselves as *rare* and worthy of being sought after in a particular formation—which may be 'fair words' or smiles, handshakes or shrugs, compliments or attention, challenges or insults, honour or honours, powers or pleasures, gossip or scientific information, distinction or distinctions, etc."[4]

Cultural prizes seem particularly well suited to such an approach —one that attends to two sorts of economy and their changing relationship without succumbing to a reductive *economism*. To begin with, there is at the very core of the prize a crucial ambiguity or duplicity. On the one hand, we tend to think of a prize—including the trophy or medal, the honor it signifies, and whatever cash award accompanies it—as a sort of gift. The presenting and receiving of a prize is not, after all, simply a purchase or a payment, not an event perfectly continuous with commerce, not an *economic* transaction in the narrow sense of the term. It involves both the awarders and the recipients in a highly ritualized theater of gestures and countergestures which, however reciprocal in some of its aspects, can be readily distinguished from the drama of marketplace exchange. While one can maneuver for a prize in various ways, for example, one cannot generally bargain or haggle for one. One cannot demand a bigger prize for one's artistic efforts as one might demand a higher price for them (or at any rate, doing so explicitly is likely, as we shall see later on, to provoke hostility or embarrassment). Nor can the donor or presenter of the prize insist openly on any economic recompense or return; such arrangements exist (for example, with painting prizes in which the winning artists are obliged to sell their paintings through the awarding institution), but they fatally compromise the prize as prize, deflating its prestige and removing it

to the sphere of contractual marketing agreements. Indeed, from the standpoint of economics, prizes can appear lopsided and disequilibrious in any number of ways, with impoverished artists accepting low-value awards while refusing more lavish ones, distinguished awards carrying less cash value than insignificant ones, relatively low-income academics presenting six-figure "fellowship awards" to multimillionaire artists, freelance critics performing mountains of unrecompensed labor for richly endowed foundations—not to mention the profound and seemingly unaccountable investments of emotion that serious artists and intellectuals, though not themselves personally involved, are capable of making in an award competition. In thus escaping or exceeding the terms of exchange, the prize would seem, from the vantage of any strictly economic or "exchangist" approach, to raise the problem which Jacques Derrida describes as that of a "residue . . . [or] remainder that no one knows what to do with": the problem of the gift as such.[5] Those who, following Georges Bataille, have set out to disrupt and displace economic thinking about cultural practices might count the (authentic) prize, as they count (authentic) art itself, as an instance of "sheer expenditure" which can never be reduced to a "balancing of accounts."[6]

Yet on the other hand, "prize" has its etymological roots precisely in money and in exchange. The word is traced to the Latin *pretium:* "price," "money"; akin to the Sanskrit *prati:* "against," "in return." As Huizinga points out, "*pretium* arose originally in the sphere of exchange and valuation, and presupposed a countervalue."[7] Both the discourse internal to prizes—the discussions that take place among judges and administrators—and the external commentary about them are fairly dominated by rhetorics of calculation, invoking fine points of balance, fairness, obligation, and

debt. And of all the rituals and practices of culture, none is more frequently attacked for its compromising convergence with the dynamic of the marketplace than is the prize, which seems constantly to oscillate between a genuinely cultural event (whose participants have only the interests of art at stake) and a sordid display of competitiveness and greed (whose participants are brazenly pursuing their professional and financial self-interests). When Nicolas Cage, accepting the Academy Award for Best Actor in 1996, thanked the academy "for helping me blur the line between art and commerce," he pointed not just to the fact that the Oscars have become a huge marketing lever for promoters and a major source of revenue for Disney's ABC subsidiary, but to the deeper equivocality of all such prizes, which serve simultaneously as a means of recognizing an ostensibly higher, uniquely aesthetic form of value and as an arena in which such value often appears subject to the most businesslike system of production and exchange.

I have tried in this book to find an angle of approach to prizes that captures this fundamentally equivocal nature. The cultural phenomenon of the prize cannot be understood strictly in terms of calculation and dealmaking: generosity, celebration, love, play, community, are as real a part of the cultural prize as are marketing strategy and self-promotion. For reasons that I will discuss in detail, a strictly cynical or mocking attitude, which economistic exposés of the awards scene tend to induce, is inadequate. But so is the mystified, essentially religious attitude toward culture that would shield artistic practices and artistic value from the kind of scrutiny that deploys economic conceptualizations in a broader sense. We need an analysis that takes the prize seriously on its own best terms, recognizing the high ideals and good faith of many of its participants, while also recognizing that those ideals and that faith are

themselves part of a social system of competitive transaction and exchange which prizes serve and by means of which all cultural value is produced.

The equivocality that necessitates this double-edged approach characterizes what Bourdieu calls the "double reality" of all *symbolic* capital. Bourdieu has been for several decades the most influential and controversial figure in the sociology of culture. By the time of his death in 2001, he had produced more than forty volumes of ethnographic inquiry, theoretical explication, cultural history, and political polemic aimed at advancing a general economic model of cultural practices.[8] To be sure, this model leaves out or greatly underappreciates certain dimensions of art and literature; like all models, it is reductive in ways that strike some readers as unacceptable.[9] I myself, by training a literary critic, am by no means fully in accord with Bourdieu's system of thought (particularly as regards his way of understanding specific literary texts, such as those of Flaubert, Woolf, or Faulkner). One aim of this book is to contest some central aspects of Bourdieu's grand narrative of art's commercialization, as well as the essentially modernist map of cultural fields on which that narrative depends and the strategies of putative resistance to which it gives rise. But the work of Bourdieu and his school, as well as the more general attempt over the past two decades to rethink the relationships among culture, economics, and sociology,[10] form an important theoretical background for this book. No other strain of contemporary scholarship has gone further in exploring the kinds of questions that a study of cultural prizes needs to address: questions about the various interests at stake for the institutional and individual agents of culture, the games and mechanisms and stratagems by means of which these interests assert themselves, and the ultimate role such cultural assertions of interest play in maintaining or altering the social distribu-

tion of power, which is to say the relative positions of different social groups or classes.

The most basic concepts that I have drawn from this literature are those of *capital* and *field,* where "capital" is not merely understood in its narrow economic sense (or even in the somewhat broader meaning embraced by economists who, following Gary Becker, speak of "human capital"), but rather is used to designate anything that registers as an asset, and can be put profitably to work, in one or another domain of human endeavor. Thus, a Harvard philosophy degree or a demonstrable mastery of Sanskrit may be counted as capital in the academic world—as "educational capital" on the "educational field" (itself a zone or portion of the "cultural field" as a whole). These same assets, however, may be relatively worthless on other fields, such as those of military or commercial activity, which produce and circulate their own specific forms of capital according to their own terms of valuation and exchange. Every field (by virtue of its recognition *as* a field) is possessed of its own forms of capital, its own rules of negotiation and transaction, its own boundaries and constraints, above all its own unique stakes, and none may be simply reduced to any of the others. (The cinematic field, to offer a quick example, may not be regarded as simply an outgrowth or product of the field of commerce, with stardom in the film world being *nothing more than* a euphemism for marketability.) Yet every field may be understood as part of a general economy of practices, a broad social logic that involves interested participants, with their varying mixtures or portfolios of capital, in the struggle over various collectively defined stakes, and above all in the struggle for power to produce value, which means power to confer value on that which does not intrinsically possess it.

The key assumption of this book, however, the point on which a

great deal of what I have to say about prizes revolves, is that every form of "capital" everywhere exists not only in relation to one particular field, but in varying relations to all other fields and all other types of capital. There is no question of perfect autonomy or segregation of the various sorts of capital, such that one might occupy a zone or margin of "pure" culture where money or politics or journalistic celebrity or social connections or ethnic or gender advantage mean nothing, or such that one might acquire economic capital that is free of all implication in the social, symbolic, or political economies. It is rather a matter of differing rates of exchange and principles of negotiation, both of these being among the most important stakes in the whole economy of practices. A "pure" form of capital, which would have to be perfectly nonfungible across fields, is neither possible nor desirable. Every type of capital everywhere is "impure" because it is at least partly fungible, and every holder of capital is continually putting his or her capital to work in an effort to defend or modify the ratios of that impurity.

This, indeed, is the root explanation for the simply tremendous growth of cultural prizes, which have been expanding in number and in economic value much faster than the cultural economy in general, even while the cultural economy has outstripped the economy as a whole. Prizes have issued from societies and associations of artists, from academic coteries and committees, even from individual artists and critics, as rapidly as they have from corporate sponsors and wealthy philanthropists, and this is largely owing to the fact that they are the single best instrument for negotiating transactions between cultural and economic, cultural and social, or cultural and political capital—which is to say that they are our most effective institutional agents of *capital intraconversion*. By means of prizes, not only are particular symbolic fortunes "cashed

in" (the Nobel laureate's out-of-print titles suddenly appearing in attractive new boxed-set editions and translated into every major language) or particular economic fortunes culturally "laundered" (Nobel's profits from the manufacture of deadly explosives converted into a mantle of supreme literary achievement; Pritzker's profits from the mass construction of blandly similar Hyatt hotels converted into a symbol of architectural originality and genius), but the very barriers and rates of exchange, in terms of which all such transactions must take place, are continually contested and adjusted. The administrators, judges, sponsors, artists, and others involved in a prize are thus themselves to be understood as agents of intraconversion; each of them represents not one particular, pure form of capital, but a particular set of quite complex interests regarding the rules and opportunities for capital intraconversion. The game they are playing is not to be reduced to a field of battle on which the forces of genuine art defend with the weapons of pure symbolic capital a small (and probably shrinking) strip of "independent" terrain against the imperial forces of commerce (or of "political correctness" and so on), the one force engaging the other along a single borderline, across which attempts are continually made to insinuate false art, like a Trojan horse, onto the terrain of the genuine. This all-too-familiar scenario obscures far more than it reveals about prizes and about cultural life in general. We should think, rather, of a game that is being played at every point or position on the field, the entire field of cultural production a full-contact marketplace or zone of intraconversion on which the (economic) instruments and practices of engagement keep getting more various and more complex.

My approach therefore involves a methodological reorientation, away from the kind of sweeping narratives of art and money to

which phenomena like prizes have normally been subjected (mainly narratives of commodification in which artists, or at least artistic autonomy, may be counted among the historical victims of capitalism; but also, more rarely, narratives of popular liberation, via the marketplace, from the tyranny of elitist coteries and gatekeepers).[11] My approach, while it retains the sociologist's ambition to reveal something of the larger sociohistorical scheme in which prizes exist, maintains a tight focus on the prize as an instrument of cultural exchange, and aims to come to terms with the complex kinds of transaction that it facilitates—transactions in which art and money are by no means the only stakes nor artists, capitalists, and consumers the only significant players. Most contemporary cultural criticism, it seems to me, suffers either from an overvaluation of the particular or from an overreliance on the general. On the one hand, we have various forms of close reading, in which one work or a small handful of individual works of art are meant to yield up a wealth of knowledge and insight through the sheer genius of the artist and/or ingenuity of the critic. On the other hand, we have various attempts to survey and pronounce upon the circumstances and trajectories of cultural life as a whole, based on general theories of cultural production and consumption and broad assessments of national or global trends. What's left out is the whole middle-zone of cultural space, a space crowded not just with artists and consumers but with bureaucrats, functionaries, patrons, and administrators of culture, vigorously producing and deploying such instruments as the best-of list, the film festival, the artists' convention, the book club, the piano competition. Scholars have barely begun to study these sorts of instruments in any detail, to construct their histories, gather ethnographic data from their participants, come to an understanding of their specific logics or rules and of the

different ways they are being played and played with. In our time, prizes have become by far the most widespread and powerful of all such instruments. But there are many other candidates for the sort of analysis I am undertaking here, especially in the areas of arts sponsorship, journalism, and higher education.

To explore and explain these ever more ubiquitous devices of cultural practice is one of the key tasks facing those of us who wish to understand the new conditions under which we are performing our various cultural labors. It is not only a sociological as opposed to a narrowly interpretative or grand-theoretical task, but also necessarily a reflexive one, requiring scholars to pay systematic attention to the symbolic and material bases of their own habitual dispositions. Including, for many of us, our habitual postures of condescension both toward these specific cultural phenomena and toward the sociological approach to culture in general—an approach which, inasmuch as it fails to reckon with the unique qualities of individual works of art, can seem embarrassingly crude from the standpoints of critical expertise and aesthetic refinement.

With its focus on cultural prizes and on the rules, strategies, and players that are involved in them, this book aims, therefore, to suggest a general reorientation of cultural study toward what has too often been set aside as the mere machinery of cultural production, the strictly functional middle space between acts of inspired artistic creation on the one hand and acts of brilliantly discerning consumption on the other—acts that lend themselves much more readily to the kind of quasi-religious orientation that even today dominates the fields of literary and art criticism. Even sociology has rarely been willing to focus its investigations narrowly or inventively enough into the busy marketplace of cultural practices, and has offered us far more extensive analyses of the university or the

museum than of the book club or the hall of fame, far more com-
plete ethnographies of the artist, the critic, the consumer, than of
the cultural functionary or bureaucrat. Such figures as the manager
of the major arts endowment, the vice president of the local film
club, the chief administrator of a poet's-birthplace museum, are
practically invisible within the prevailing optics of cultural study.
And unless we begin to examine some of these neglected agents and
instruments of cultural exchange, whose rapid rise is one of the
most striking features of cultural life in our time, we cannot hope to
discern reliably the ways in which the "games of culture" have
changed since the nineteenth century. My study of the cultural prize
will not yield a neat fable of postmodern cultural apocalypse—of
hypercommercialism, say, or hypercredentialism—or a reassuring
comedy about the democratization of taste. But it can, I hope, pro-
vide us with a clearer recognition of the nature of the struggles as
well as the opportunities that define our immediate cultural future.

1. The Age
of Awards

Prize Frenzy

Everybody has won, and all must have prizes.
—The Dodo, in Lewis Carroll, *Alice's
Adventures in Wonderland*

Why has no historian attempted a history of the modern cultural prize? Perhaps the most obvious reason is simply the daunting ubiquity, the unrelenting proliferation of prizes across all the many fields of culture, from poetry writing to pornographic filmmaking. Who can possibly keep up or keep track? The sense that the cultural universe has become supersaturated with prizes, that there are more cultural awards than our collective cultural achievements can possibly justify, is the great and recurring theme of prize punditry. In literary circles, it has become a sort of running joke: Gore Vidal says that the United States has "more prizes than writers"; Peter Porter, the Australian poet, says there are so many prizes in his country that "there is hardly any writer in Sydney who has not won one"; a

British writer jokes about attending a "great literary function" in Bloomsbury where he turned out to be "one of only two fiction writers present never to have won a literary award."[1] To make matters worse, the other prizeless author was managing to go undetected by laying claim to an award of his own invention—something called the "Pemberton-Frost Memorial Prize"—thus leaving the author of the piece in a perfect comic inversion of the normal prize scenario: a single loser emerging from a congested field of winners. The whole literary awards scene, as many commentators have pointed out, has come to resemble the "Caucus-race" of *Alice's Adventures in Wonderland,* where the Dodo announces that "*everybody* has won, and all must have prizes."[2]

This is not a specifically literary circumstance, of course, but a general feature of contemporary cultural life. In Hollywood, people still quote an old line from Woody Allen's *Annie Hall:* "Awards! That's all they do is give out awards, I can't believe it. 'Greatest Fascist Dictator: Adolf Hitler.'" Allen's joke is dredged up, too, by journalists confronted with the staggering rise in the number of prizes in their own field, where, as one writer put it, "fascist dictators are about the only crowd left out" of the prize sweepstakes.[3] Everywhere, we find the same complaint: "So many awards," observes a columnist reviewing a spate of new music awards shows, "so little excellence."[4] Through a process which in itself warrants some close attention, prizes spawn other prizes—and this process appears today to have reached the point of a kind of cultural frenzy, scarcely a day passing without the announcement of yet another newly founded prize, be it a more ambitious big-ticket superprize (the $200,000 Dorothy and Lillian Gish Prize; the $200,000 Lannan Lifetime Achievement Award; the £100,000 IMPAC Dublin Literary Award; the $100,000 Polar Music Prize); a more local

or surgical microprize (the Mary Diamond Butts Award for a "fiber artist" under the age of forty who resides in Ontario and whose work "is executed by means of threaded needle"; the Friends of American Writers Award for the best work of young-people's fiction by an author of no more than three books who resides in Arkansas, Illinois, Indiana, Iowa, Kansas, Michigan, Minnesota, Missouri, North Dakota, Nebraska, Ohio, South Dakota, or Wisconsin); or a more outrageous mock-prize or antiprize (the Videomatic Hall of Shame Awards; the Golden Raspberry Foundation's Joe Eszterhas Award for Worst Screenplay; and so on).

Of course, other things have proliferated besides prizes. Populations have grown: fourfold in the United States since 1900, nearly fivefold in the rest of the world. Economies have expanded even more rapidly, growing by a factor of perhaps fifteen or twenty worldwide, with a concomitant explosion in all sorts of goods and services. The pieces of this economy that might be lumped together as "cultural"—production and sales of books, theater tickets, musical instruments, art supplies, and so on—have grown even more rapidly than the rest. (Expenditure on books, for example, rose in the United States from .11 percent of GDP in 1929 to about .15 percent in 1950, .18 percent in 1970, and .38 percent in 2000. Since 1982, the number of books sold has risen twice as fast as the population growth, with total expenditures on books rising five times as fast as GDP. If Americans were still devoting the same proportion of their incomes to book purchases as they did in 1929, book sales would be less than $10 billion a year instead of their actual level of $36 billion.)[5] But this expansion of cultural activity in general can explain only a fraction of the growth in cultural prizes. Yes, many more books, plays, TV shows are made and sold today than forty years ago; there are more works competing for prizes than there

used to be, and more money involved in the production and distribution of those works. But the number of book prizes, drama prizes, and TV prizes has risen along a distinct and much steeper curve. (See Appendix A for two illustrations of this general tendency.)

Just indexing all these prizes is a daunting task. In recent years Gale's standard reference work *Awards, Honors, and Prizes* has swelled to two phonebook-sized volumes and more than two thousand pages. Priced at nearly $700 for the set, this index has been adding new prizes at the rate of about one every six hours, though certainly missing many more than it registers.[6] So many stories about prizes pile into the electronic news database of Lexis/Nexis that in the mid-1990s the service opened a file library devoted exclusively to stories about the major arts and entertainment awards, all of which were by then mounting their own websites as well. The International Congress of Distinguished Awards, which was founded in 1994 in a futile but symptomatic effort to control and regulate this chaotic scene, counts more than a hundred "distinguished" prizes carrying cash awards greater than $100,000. The ICDA has selected these especially honorable honors from a pool of more than 26,000 contenders, within which cultural prizes constitute the second-largest category, after awards in the sciences.[7]

If no one can quite keep track of the whole gamut of prizes, everyone keeps track of his or her own winnings. Today's cultural workers—writers, painters, architects, historians, filmmakers, musicians, actors, dancers, academics, journalists, magicians, sculptors, animators, photographers, comedians, advertisers, opera singers, fashion designers, television producers, and so on—carry paper trophy cases with them wherever they go, their prizes and awards set prominently on display in every interview, publicity feature, *Who's Who* listing, grant application, promotion file, or dust-jacket

blurb of their professional lives, right down to that final and obligatory exhibition on the obituary page. An article in the *New York Times* about Stanley Kunitz's 1995 National Book Award for poetry begins by informing us that Kunitz's "first collection, *Selected Poems, 1928–1958,* won a Pulitzer Prize in 1959. The Bollingen Prize followed, as did the Brandeis Medal of Achievement, the Lenore Marshall Prize, the Walt Whitman Citation of Merit and a National Medal of Art."[8] When Tadeo Ando won the 1995 Pritzker Prize, a typical news report began by excusing itself from giving a list of the architect's past awards ("too lengthy to be included here") but then proceeded to offer a brief history of his career which in fact amounted to a chronology of prizes: the Architecture Institute of Japan prize in 1980, the Japanese Cultural Design Prize in 1983, the Isoya Yoshida Award and Mainichi Art Prize in 1986, and the Carlsberg Architecture Prize in 1992. It is almost as though winning a prize is the only truly newsworthy thing a cultural worker can do, the one thing that really counts in a lifetime of more or less nonassessable, indescribable, or at least unreportable cultural accomplishments. In this context it is the prize, above all else, that defines the artist: it was an "Academy Award–Winning Actress" who died last night at age eighty-six, or a "Pulitzer Prize–Winning Author." Even the business pages rely on this uniquely contemporary form of cultural biography. When Arts and Entertainment Television in 1995 appointed a new vice president for on-air promotions, the business press dutifully noted that the man had "garnered three Emmy Awards, two Broadcast Design Awards (BDA), and several top awards at the New York International Film Festival, Chicago International Film Festival, MOBIUS International, Telly and Addy awards . . . [and was] currently nominated for a record fifteen BDA awards."[9]

These reflexive recitations, which you can find examples of in

your morning paper on just about any day, no doubt contribute to the widespread feeling that there are too many prizes, that the cultural prize has become a debased coin. At the same time, however, they reflect a sustained willingness, even an intensified obligation, on the part of journalists and others to accept the purported equivalency between cultural prizes and cultural value, to accept the medals and trophies as a legitimate measure—perhaps the only legitimate measure—of a person's cultural worth. The proliferation of prizes has not reduced but has heightened the concern with their careful tracking and tabulation; one never *stops counting,* even when, as with Michael Jackson, the number of awards received surpasses 200. According to the conventional wisdom, prizes are caught in what must eventually prove a fatal inflationary spiral; yet they continue to serve as the most bankable, fungible assets in the cultural economy.

But once we recognize that the symbolic value of prizes somehow survives all the carping and joking and public deprecation of them—that these prizes really *are* worth something, even to us, whatever we may think we think of them—we raise the question of how to make the kinds of calculations that then seem to be called for. With so many prizes in play, how does one begin to add them up, to make an accounting of them? Which is the more valuable prize, an American Music Award, an MTV Music Award, a Soul Train Award, a Grammy, a Pioneer, a Pulitzer, a Mercury, or a Polar? How many local Emmys does it take to equal one national Emmy? What ratio of value obtains between the "creative" Oscars, such as those for writing or directing, and the "technical" Oscars, such as the sound or lighting awards? Are the latter, being less "political" and judged on more narrowly professional criteria, in fact the more legitimate honors, or are they a trivial sideshow? What

about Addys and Clios and Cannes and Mobius awards for advertising? Do these even count as "cultural" prizes at all? Can we say that a Clio for producing an especially "creative" thirty-second TV ad is culturally worthless, while an Emmy for, say, "achievement" in hairstyling (there are two such awards) carries positive value? Does it matter if the advertisement is a public-service spot rather than a corporate product commercial, or if it has been written or directed by an artist who has achieved recognition outside of advertising (as with the much-celebrated ads for Nike by Spike Lee and, more recently, Spike Jonze)? What about the ESPY (sports network) awards for Most Dramatic Individual Performance, or Best Showstopper?[10] Can we reliably distinguish sports trophies from cultural prizes in fields such as dance, which employ a similarly competitive format and make equally strenuous use of the body? Are professional wrestlers (and there is a long history of wrestling prizes) athletic performers or dramatic ones? What about bodybuilders, who are judged on aesthetic rather than athletic criteria, and for whom prizes have been awarded at least since the late nineteenth century?

These questions are meant to be somewhat frivolous. But they suggest the serious difficulties we face in trying to provide a historical survey or summary of a vast and *relational* field, a field that offers no commanding point of vantage and no stable boundaries. To undertake this project responsibly requires a high degree of self-consciousness about our own investments, about the particular position from which we habitually measure and compare cultural assets, and about the advantages that accrue to us as a result of occupying that position. Such a project, a "reflexive sociology" of the economy of cultural prestige, diverges sharply from the existing commentary on prizes and awards, a body of discussion that is

voluminous but, as a source of critical insight, mostly negligible. Thousands of articles about prizes appear every year in the major newspapers and magazines, and this journalistic literature is what we have in lieu of any real scholarship. Much of this, moreover, falls well outside the category of reportage or news, consisting rather of deprecating brief-mention paragraphs, catty bits of gossip, or strongly opinionated, and often rather acerbic, byline feature pieces. It constitutes a kind of commentary—often generated by people who have themselves served as judges or contenders for the very sort of prizes they discuss—which is all too happily embedded in the system it seeks to describe and critique. Much of it, indeed, is simply part of the extra-institutional apparatus of this or that particular prize, part of the prize's undeclared and perhaps unwitting publicity machinery, even and especially when its posture is a scandalized or condescending one. And the same can be said of the many "insider" accounts or memoirs of individuals connected with particular awards institutions. Far from providing an adequate account of their object, these forms of commentary, like bestselling exposés of Hollywood or Sunday-morning Beltway talkshows about the politics of media, are mere symptoms in diagnostic guise.

No doubt the same could be said of any study of cultural prizes, including this one; no commentator can altogether avoid participating in the very economy of prestige, the very system of valuing and devaluing, esteeming and disesteeming, that he or she undertakes to examine. My point, though, is not to make exaggerated claims for my own methodology (or, more generally, for the possibility of securing the sociological truth of cultural phenomena by reflecting more systematically on our own relationship to them), but simply to stress the peculiar resistance prizes seem to have mounted against any real scrutiny of their functions and effects. What one finds be-

neath the lively surface of the journalistic and quasi-scholarly litera-
ture is endless, tame repetition of the same debates. On the one
hand, cultural prizes are said to reward excellence; to bring public-
ity to "serious" or "quality" art (thereby encouraging the presum-
ably philistine public to consume higher-grade cultural products);
to assist struggling or little-known artists (thus providing a patron-
age system for the post-patronage era); and to create a forum for
displays of pride, solidarity, and celebration on the part of various
cultural communities. On the other hand, it is said that they system-
atically neglect excellence and reward mediocrity; turn a serious
artistic calling into a degrading horse race or marketing gimmick;
focus unneeded attention on artists whose reputations and profes-
sional livelihoods are already solidly established; and provide a
closed, elitist forum where cultural insiders engage in influence ped-
dling and mutual back-scratching.

For reasons that I will be exploring in Part III of this book, the
latter of these sets of opinions is far more frequently expressed than
the former. The tones of satire and condescension have become so
standard a feature of prize journalism that to eschew such tones is
to appear dull-witted or naïve. I will be arguing, though, that the
more crippling naïveté rests with the masters of condescension,
who have failed to consider their own position in the larger system.
Modern cultural prizes cannot fulfill their social functions unless
authoritative people—people whose cultural authority is secured in
part through these very prizes—are thundering against them. The
vast literature of mockery and derision with respect to prizes must,
in my view, be seen as an integral part of the prize frenzy itself, and
not as in any way advancing an extrinsic critique. The reader of this
book should not expect, therefore, a return to the familiar (and
largely predecided) "choices" that shape the lion's share of prize

commentary. My aim in this first part and in the volume as a whole is not to decide whether cultural prizes are a treasure or an embarrassment, whether they are conferred upon deserving or undeserving artists and works, whether they serve to elevate or to degrade the people's taste and the artist's calling. It is, rather, to begin an analysis of the whole system of symbolic give and take, of coercion and negotiation, competition and alliance, mutual disdain and mutual esteem, into which prizes are extended, and which encompasses not just the selection processes and honorific ceremonies, but many less central practices, and in particular the surrounding journalistic discourse—all the hype and antihype itself.

Though I will begin with a general overview of the cultural-prize phenomenon, my approach is far from encyclopedic; it offers no systematic typology, no exhaustive historical survey, no attempt at a complete analytic description. It displays glaring biases, reflecting the limitations of my own expertise, toward examples drawn from the field of literature and from British or American contexts. Nevertheless, it represents what I propose as a superior optic to anything currently available in the literature on prizes. From the vantage assumed here, prizes are not a threat or contamination with respect to a field of properly cultural practice on which they have no legitimate place. The prize *is* cultural practice in its quintessential contemporary form. The primary function it can be seen to serve—that of facilitating cultural "market transactions," enabling the various individual and institutional agents of culture, with their different assets and interests and dispositions, to engage one another in a collective project of value production—is the project of cultural practice as such. If we are more comfortable calling this project the production of beauty or of art, we should nevertheless recognize that it is a process that cannot take place without a whole series of

complex transactions involving more than simply artists and their work. Cultural value cannot emerge in the absence of social debts and obligations, of the (very unequally distributed) credit or respect that certain individuals are granted by others; its production is always a social process. Neither can it emerge in a political vacuum, the participants uncolored by and indifferent to prevailing hierarchies of class, race, gender, or nation; its production is always politicized. And neither can it emerge in perfect independence of or opposition to the economic marketplace itself; its production is always implicated, in multiple ways, in the money economy. The complex transactions that prizes facilitate between artistic, social, political, economic, and other forms of capital are not, at bottom, different from other transactions, elsewhere on the fields of culture, by means of which "art" is produced—that is, made recognizable as art. My object in this study, therefore, beginning with an overview of the rise and rapid proliferation of prizes over the course of the past century, is not to demonize them as the enemy of culture but, on the contrary, to grant their essential continuity with other kinds of cultural practice, and thus to learn from them how better, or more reflexively, to understand our own cultural lives—our tastes, our dispositions, our investments, and our illusions.

Precursors of the Modern Cultural Prize

> *The whole system of prize-giving . . . belongs to an uncritical epoch; it is the act of a people who, having learned the alphabet, refuse to learn how to spell.*
> —Ezra Pound, quoted in *Literary Digest*, January 14, 1928

The modern ascendancy of cultural prizes may conveniently be said to have started in 1901 with the Nobel Prize for Literature, perhaps the oldest prize that strikes us as fully contemporary, as being less a historical artifact than a part of our own moment. Announced in more than a hundred newspapers worldwide,[1] the Nobel seized the collective imagination with sufficient force to impose with unprecedented intensity the curious logic of proliferation that has raised prizes from a rather incidental form of cultural activity a hundred years ago to an undeniably central form today. Within just three years of the first Nobel ceremony in Stockholm, both the Goncourt and Femina literary prizes had been founded in France, and Joseph Pulitzer had declared his intention to launch, in emulation of Alfred

Nobel, a series of annual literature and journalism prizes in America.[2] Other fields of culture, which would not normally have been much influenced by the announcement of a new literary prize (and some of which, such as music composition and architecture, were by the late nineteenth century already well organized around competition systems with elaborated rules and protocols for the judges and substantial cash prizes for the winners), began before long to show signs of Nobel envy. A process had been set in place which would assure that by the end of the century every field, every subfield of culture would feel the need to have its own "Nobel": there would be "Nobel Prizes for Art," as Japan's Praemium Imperiale Prizes call themselves, "Nobels" of the broadcasting and cable industries, as the Peabody Awards like to fancy themselves, a "Nobel Prize of Music," as the Royal Swedish Academy of Music's Polar Prize is invariably referred to, and so on. Even in the field of literature, there would be Nobels from other countries besides Sweden: Oklahoma's Neustadt International Prize for Literature, for example, claims that it is "often" referred to as the "American Nobel." And for every would-be Nobel, there would eventually be dozens, hundreds, even thousands of ever more minutely differentiated variations on the theme of the Best, not to mention the many mock-prizes and antiprizes that play on the theme of the Worst—the Golden Raspberry Awards, the Bad Writing Medal, the Ig-Nobel Prizes.

But while the Nobel marks the dawning of a new and particularly frantic epoch in the history of cultural prizes, we should be careful not to overstate the rupture between this modern period and what preceded it. Cultural prizes themselves have existed for at least two and a half millennia; modern forms, such as those awarded by universities and royal academies from the seventeenth century onward,

have always displayed a tendency to proliferate through imitation and differentiation. What occurred with the explosion of prizes in the twentieth century is quite remarkable, and involved considerable innovation on the part of sponsors and administrators, but in their most basic contours these developments are consistent with long-standing cultural practices.

Prizes for artists date back at least to the later sixth century B.C.E., when annual festivals combining music, poetry, and drama spread throughout the cities of east central Greece (the ancient district of Attica). These festal gatherings were routinely organized in the form of contests or competitions, with poets, playwrights, dramatic troupes, or musical performers competing against one another for prizes awarded by juries, whose selection was governed by sometimes astonishingly elaborate protocols. There were contests in choral singing, in poetic composition and recitation, in harp playing, flute playing, trumpet playing, and other arts. (Contests in architectural design, precursors of the "competition system" which would increasingly structure the field of architecture from the late medieval through the modern period, also existed in classical times, perhaps predating the great festivals. But they were never part of the festivals, nor were they associated with prizes per se. Even today, providing the winning design for a proposed building is not the same as garnering a prize such as the Pritzker or the Sterling.)[3]

Of all the classical culture-festivals, the most famous were the dramatic competitions in Athens, the greatest of the Attic cities. These drama contests formed the central activity of the Athenians' annual festivals in honor of the god Dionysus, and their religious character lent a specially heightened stature to the participating artists. The poets whose plays were performed, the choral directors who organized the productions, and the actors and singers who

formed the dramatic troupes—especially, of course, those con-
nected with the prize-winning plays—were accorded the respect
due "ministers of religion, . . . sacred and inviolable."[4] They en-
joyed this virtually sacred status even while they were enlisted in
what amounted to a kind of public-relations enterprise sponsored
by the Athenian Council (which offered tax breaks to the private
patrons, or *choregos,* who provided the financial backing) and
aimed at attracting and impressing tourists. And in order to earn
the special and lofty position that festivals opened up to them, art-
ists had to endure the stressful and potentially humiliating role of
competitors before a panel of judges—judges who, moreover, in the
festivals' immediate aftermath, were routinely accused of having
been bribed or otherwise improperly influenced, or of simply being
incapable of distinguishing great art from mediocre.

The fundamental ambivalence here—whereby artists are at once
consecrated, elevated to almost godlike status ("consecrations" be-
ing Bourdieu's favored term for cultural honors or awards), and
desecrated, brought rudely down to earth by entanglement in a sys-
tem of hard-nosed financial calculation, national or municipal self-
promotion, and partisan, often petty politics—persists in cultural
prizes to this day, and, as I indicated in my introduction, a major
purpose of the present study will be to explore this convergence of
the sacred with the profane, or the symbolic with the material, in
the modern and contemporary awards scene. In tracing briefly the
prehistory of the modern cultural prize, however, I would like to
stress another ambivalence in the classical prizes which persists into
the present day: that between a festal and a bureaucratic orienta-
tion toward culture, between the *celebration* and the *administration*
of cultural work.

The classical association of prizes with the staging of massive

citywide festivals, culture parties on a grand scale, has endured throughout their subsequent history. Indeed, it appears that prizes have often served as little more than an excuse or a convenient structuring device for such occasions. In his still-valuable study of Athenian stage practices, the nineteenth-century historian A. E. Haigh observed that the tens of thousands of tourists from other cities and districts who flocked to Athens for the annual Dionysian drama competitions were true gluttons for cultural novelty and excitement, "able to sit day after day, from morning to evening, listening to tragedy and comedy, without any feeling of satiety," and thrilled by the opportunities for "direct . . . contact" between author and audience that the festival made possible.[5] The festivals, which in later centuries became increasingly infamous as sexual orgies, were, to begin with, orgies of cultural consumption. Such orgies are still common enough today. One thinks of the hectic eight-films-a-day pace of moviegoers at Cannes or Toronto, the excited "spottings" of major directors and other cultural celebrities—and of course the invariable structuring of such contemporary film festivals around a slate of prizes, the whole festival culminating in the announcement of a Grand Prize winner, a "palme d'or," whose victory is immediately subjected to strenuous carping and complaint. (French journalists at Cannes sometimes react with hooting and booing in the pressroom.)[6] Other fairly straightforward modern analogs to the Greek festivals and arts competitions come to mind, as well: not only theater festivals, such as that of Edinburgh Festival Fringe, but competitions in classical musical performance, such as the fifteen-day Van Cliburn International Piano Competition in Fort Worth, and the major fairs or exhibitions of art, such as the Venice Biennale, all of which bring large, international crowds into the host cities and demand considerable stamina on the part of their

audiences. The Welsh Eisteddfod, an annual festival that comprises competitions in drama, poetry, music, and dance and that is said to date back to 1176, is perhaps an even closer fit with the classical model.[7]

Even where a prize is not in any official way linked to a festival, it often tends to serve as the focus of festal energy, with almost as much importance attaching to pre- and post-awards parties as to the awards presentation itself. In the case of the Academy Awards, the entire Los Angeles area is hopping with various kinds of peripheral celebration and parasitic events—special film series at theaters, special menus in restaurants, special theme nights at dance clubs, secondary and mock-Oscar awards shows, auto-dealership contests to guess the Oscar winners, and on and on—for more than a week before the awards show, and even for some days afterward. On the day of the show it is only a slight exaggeration to say that the whole life of that major city revolves around the Oscars.

Viewing the scene more broadly, we can see the festal emphasis on spectacular excitement, and in particular on mass spectacles of *competition*, persisting today even in prizes that involve no actual live performance or exhibition of the works being judged, but that bring a group of shortlisted contenders into public assembly for the announcement of a single winner: a practice once associated exclusively with televised "entertainment" awards such as the Oscars, Emmys, BAFTAs, and Grammys, but since the late 1970s increasingly typical of prizes in literature and the other "legitimate" arts. In fact, as we will see, one of the primary factors driving the proliferation of prizes in the latter half of the twentieth century has been their unique power to manufacture televisable cultural events out of thin air, drawing cultural celebrities into their orbit with seemingly irresistible force and thereby guaranteeing a certain mass audience.

Even the essentially fraudulent awards that are *nothing but* devices to manufacture inexpensive TV specials—the raft of unknown and often unrepeated awards which are given to whichever celebrities will agree to show up and receive them (and hence to present their saleable faces intermittently to the camera for two hours)—even these dismal cable-TV affairs are apparently capable of drawing a profitably robust viewership. Yet prizes in the more solitary, less telegenic arts, such as literature or sculpture, are bound up in this same economy of spectacle. What besides a prize could focus television coverage on an "unreadable" novel and its author the way the Booker Prize did on James Kelman's *How Late It Was, How Late* in 1994? What, besides the singular feat of winning, on the same day, the Turner Prize for best work of art and the K Foundation Award for worst work of art, could have made an international TV celebrity of British sculptor Rachel Whiteread?

Even in America, where the awards banquets for prizes in literature, painting, and sculpture have yet to find their way onto television, there is a clear sense of convergence. The 1999 National Book Awards ceremony was emceed by TV and film star Steve Martin, who presented the National Book Foundation's 50th-Anniversary Gold Medal to one of the giants of daytime television, Oprah Winfrey. Winfrey was honored for the staggering success of the TV Book Club format her producers had conceived a few years earlier, a device which by the end of 1999 had resulted in Oprah's monthly "picks" making the bestseller lists twenty-eight times in a row and Oprah herself being called the most powerful literary tastemaker in the nation's history.[8] This ostensible "literary" prize for Oprah, presented to a TV star by a TV star, marked a convergence from two directions. On the one hand, her book club itself came near to being a new kind of book prize. Though selection was done monthly

rather than annually, and though it was not a competitive spectacle, since no shortlist was announced and only the selected novelist was invited to the studio, the Oprah Book Club show was designed to hold some of the excitement and suspense of a typical prize ceremony, at least among publishers, booksellers, and literary people. The producers took great pains to assure that absolute secrecy was maintained as to which lucky novel was about to sell an extra million copies—even to the point of having the Library of Congress issue a special ISBN number by means of which booksellers could place advance orders for Oprah's Pick without knowing what title they were ordering. On the other hand, if Winfrey's producers reinvigorated daytime television by appropriating certain elements of the book prize, the administrators of the National Book Foundation likewise tried to reinvigorate the book prize by appropriating certain elements of TV. Having already adopted, back in 1986, the Oscars-style format where the nominees are announced in advance and then subjected to maximum stress and indignity as the announcement is made, the NBF has been looking for further ways to achieve strategic proximities to television. Far from shunning the Oprah Club as a pseudo-prize and a threatening encroachment, the foundation saw it as an opportunity to bolster the televisual appeal of its own prize, to bring some festive glitz and excitement, some big-time celebrity, to a legitimate literary award—an award which, in its first iteration of the new century, would actually be won for the first time by an Oprah Pick (albeit a resistant one), Jonathan Franzen's novel *The Corrections*.

This festive and often spectacular element in the cultural prize has had to coexist, however uneasily, with an element of bureaucratic control and administrative rigor. Already in classical times, despite the exuberantly festal context in which prizewinners were

selected, the selection process itself was very carefully and soberly constrained, particularly when it came to selecting those who would do the selecting. Haigh describes the judging system for the dramatic competitions of the so-called Great Dionysia in the fifth century. Also known as the City Dionysia, since they were held within the walls of the City of Athens (at the Acropolis), these festivals were subject to the authority of the Athenian Council, but council members were not themselves eligible to serve as judges. Rather, representatives from each of the ten Attic tribes brought forward to the council a slate of nominees (conforming to certain general rules of eligibility) from their particular tribe. The name of each nominee was put on a slip of paper, which was then put into an urn corresponding to the nominating tribe. The ten urns were kept under lock and key until the eve of the festival, at which point, in a ceremony attended by all the nominees, one name was drawn from each urn. These ten men, the "preliminary judges," were then required to judge all the plays and submit their ranked lists to the council at the end of the festival. Even this was not the end of the process, however. Once again, an urn was brought out. The ten judges' sheets were placed in the urn, and just five withdrawn at random, these five becoming public documents and serving as the basis for awarding the prize, while the other five were destroyed unseen. In this elaborate series of contrivances, designed to convey the most perfect appearance of autonomy and impartiality, one sees the threat of scandal which still lurks at the door of every auditorium or banquet hall where prizes are awarded, and which continues to foster curious rituals of selection and secrecy: the somber-looking representatives from Pinkerton or Pricewaterhouse Coopers standing in the wings with their specially sealed envelopes. In fact, as I will discuss further on, this threat of scandal is constitutive of the

cultural prize, and such contrivances as urns, blindfolds, and wax seals serve less to allay that threat than to hold it, as is necessary, in the public view.

With their complex protocols of judge selection, the Athenian holders of state office both maintained control over the prize process and used that control seemingly to neutralize their own biases, thus positioning the prize as an official state event, a political event, which was somehow innocent of politics.[9] In this regard, the ancient prizes were at least as bureaucratic as they were Dionysian. And indeed, prizes have always been of fundamental importance to the *institutional* machinery of cultural legitimacy and authority. While arts festivals and competitions form an important line of precursors to the modern cultural prize, marking out one vector of its efficacy, an equally important genealogy can be traced from the later Renaissance and the Enlightenment, when the great national academies of art and literature, followed by the professional societies of architecture and other aspiring "trades," began to bring cultural workers and their products under tighter supervision and discipline. The most important of these were the French academies of literature and of art, founded in 1635 and 1648, respectively. They were not the earliest instances; the latter—officially, the Académie Royale de Peinture et de Sculpture—was explicitly modeled on the Accademia di San Luca, whose founding in Rome predates it by more than half a century and which was itself modeled on the Accademia del Disegno in Florence, founded by Cosimo I and Giorgio Vasari in 1565. But the particular success of the academies in France led to their widespread emulation and hastened the process by which the production of art and of artistic value was brought under the control of national bureaucracies.

The powerful men who ran these academies (Cardinal de Riche-

lieu, Charles Le Brun, Sir Joshua Reynolds, and so on) had, of
course, their particular ideologies and aesthetic agendas, and the
institutions came to represent certain orthodoxies. The Académie
Royale de Peinture, for example, is usually thought of as enforcing
a classical aesthetic on the Continent, and the Royal Academy of
Arts in London is understood to have promoted this continental
classicism, somewhat belatedly, in Britain. But as historians have
long recognized, the more significant agenda of the Académies
Françaises, and of academies generally, was that of academicism as
such. These institutions were machines for securing and extending
their own authority, for ensuring that whatever hierarchies of value
obtained on the fields of national culture referred back to the acade-
mies themselves, either directly or indirectly. An artist's importance
could be measured only in terms of his or her relationship to the
academy and its standards of training and achievement. If the artist
was not an academic painter, either by training or by outlook, then
his or her art could not have any real value. Its worthlessness was
not a matter of dispute; such dispute always signals value rather
than its lack, since access to the arena of critical discussion—which
is premised on access to certain patrons or certain sites of exhibi-
tion—is already a rare achievement. The task of the academies,
quite apart from their particular missions of aesthetic conservatism
or reform (which were ultimately negotiable and indeed, in the last
instance, perfectly arbitrary), was that which faces all agents of
cultural production, whether individual or institutional: to make
themselves definitive authorities or certifiers of value across as large
a portion of the cultural field as possible. In founding the French
Academy in 1635, Richelieu intended to establish a veritable "su-
preme court of literature,"[10] which would make and enforce the
rules of the national literary game, not only rewarding those who

succeeded on the academy's terms, but meting out judgments against those who infringed or transgressed its laws. And indeed, just two years after its founding, the academy issued the first such reprimand, its notoriously critical *sentiments* concerning the violation of Aristotelian unities in Pierre Corneille's drama *Le Cid*. It was on the basis of this official aesthetic judgment that Richelieu was able to suppress public performances of the play.[11]

Given this fundamental orientation toward the task of *judgment* —the upholding of cultural standards by means of reward and rebuke—the academies were naturally disposed toward prizes and awards. In fact, one could say that the very founding of an academy amounted to the creation of a cultural award inasmuch as election to the company of members was itself understood to be highly honorific—and membership numbers were strategically limited (to forty, in the case of the French Academy) so as to intensify this honorific status. But virtually all the academies took it upon themselves as well to begin sponsoring prizes or medals of various kinds practically from their inception. In early 1769, Sir Joshua Reynolds delivered the first of his discourses on art at the opening ceremony of the British Royal Academy; by the end of that year he was delivering his second discourse, on the occasion of the distribution of prizes. Some academies were directly born out of an ambition to administer prizes, to control the flow of patronage. Charles Le Brun, who had been instrumental in founding the Académie Royale in Paris, helped to establish the Académie de France in Rome soon afterward, so that the former might have a place to send the winners of its prizes—to be called the Grands Prix de Rome—for further study in classical technique. These prizes, which the Académie Royale and its Roman offshoot began administering in 1666, quickly became the most coveted consecrations in the European art

world. Capitalizing on this success, they were expanded in 1720 to include architecture prizes, and again in the early nineteenth century to include prizes in music and engraving. By this point, both academies had been reconfigured in the aftermath of the French Revolution, with the Académie Royale somewhat democratized and renamed the Ecole Nationale Supérieure des Beaux-Arts, and the academy in Rome granted greater autonomy and relocated to the Villa Medici. But the point is that for Le Brun, the academies and the prizes were of a piece, part of a single cultural initiative, and he helped to assure that the Grands Prix were from the outset part of a closed institutional loop, judged by the Académie Royale's members and awarded to its students so that they could receive further academic credentials from its satellite institution.

In modern parlance, the Grands Prix de Rome are academic fellowships or scholarships rather than prizes—more like the Rhodes Scholarships than the Turner Prize or the Praemium Imperiale—and this distinction goes some way toward accounting for the relative diminishment of their prestige since the later nineteenth century, when, led by the Impressionists, the fields of painting and sculpture began to detach themselves from specifically academic contexts—though not, of course, from other controlling institutions, such as museums, galleries, and journals. (Even in the literary field, strictly academic awards, such as those awarded to "prize poems" on a set subject at Oxford and Cambridge from the eighteenth century onward, carry only a small fraction of their once-substantial symbolic importance.[12] When Oscar Wilde won Oxford's Newdigate Prize for his poem "Ravenna" in 1878, the achievement significantly enlarged his public reputation. Today, even undergraduates at Oxford are unlikely to have heard of the prize.) Nevertheless, the Grands Prix are typical of the way the official and

bureaucratic dimensions of prizes, their conscious deployment as instruments of institutional monopolization, which had been evident though relatively obscured in the classical age, tended from the seventeenth through the nineteenth centuries to eclipse their festal, popular, orgiastic dimensions.

This is not to say that prizes as administered by the rising cultural officialdom of the early modern period were always a subdued and dignified affair, or that the institutional machinery that propelled them ran smoothly and without resistance. On the contrary, just as those who administered and judged the classical prizes were subject to ridicule and denunciation, so too were leaders of the various official academies and societies. Prizes have proved useful, perhaps indispensable, to the institutional apparatus of cultural credentialing; the expansion of this apparatus as we have become more and more a "credential society" in the twentieth century is a phenomenon inseparable from the proliferation of cultural prizes. But prizes have served not simply as credentials but also, and no less significantly, as stigmas. The whole transaction of judgment, presentation, and acceptance has been an important occasion for contention and dispute over cultural value, an occasion on which the prize represents both a symbolic gain and a symbolic loss for its recipient, depending on where one is situated within the terms of dispute. Prizes have been useful, that is, not just to the bureaucrats of culture but also to those who accrue advantage or profit as they distance themselves from culture's bureaucratic epicenters. With the rise of the prize bureaucracy comes also the rise of the anti-institutionalist (or "independent") position and the prize-bashing rhetoric that attends it.

This is clear if we look at the early history of one such prize, the Gold Medal awarded annually (usually two or three at each annual ceremony) by Britain's Royal Society of Literature in the first few

years after its founding in 1823. Formidable resistance to these medals was mounted even before their existence was officially announced, and they never altogether escaped the mockery and condescension of Britain's leading literary figures, who took care to position themselves at a certain distance from the Royal Society. No less a figure than Sir Walter Scott attempted to dissuade the society's proponents from undertaking the project in the first place. He did so in a letter to the Honorable Sir John Villiers in April 1821, one of the longest letters in his entire correspondence, and one so thoroughgoing in its denunciation of the proposed Royal Society that he sent an apologetic note to a court insider a few days later, urging that his intemperate words not be shown directly to the king. In this wonderful letter—one of the great documents of prize bashing—we find laid out almost the entire litany of objections that the rising cultural officialdoms and their tokens of consecration inspired among cultural independents and individualists.[13]

Scott argued, to begin with, that while the proposed society and its medals might seem to be justified as a new sort of patronage, they were actually in that respect "completely useless." The expansion of the commercial market for literature since the eighteenth century meant that the sort of major national literary figures on whom a royal Gold Medal might properly be bestowed would have no financial need of it: "For such a work of genius as the plan proposes to remunerate with [a medal worth perhaps] £100," he wrote, "any bookseller would give ten or twenty times that sum and for the work of an author of any eminence £3000 or £4000 is a very common recompence."[14] This confidence in the marketplace for "work[s] of genius," which is prevalent in contemporaneous attacks on the Royal Academy of Arts, as well,[15] appears to be stronger in the early and mid-Victorian period than it became later on,

when the ideology of art for art's sake and the figure of the starving artist came to hold a larger place in the public imagination and in the rhetoric of anti-institutionalism. But the fundamental distinction between symbolic and material economies, between truly great writers (whose greatness has nothing directly to do with the marketplace) and merely popular writers (who may or may not be writers of "genius"), is by no means inoperative in this rhetoric; Scott mentions both Coleridge and the gothic novelist Charles Maturin as writers "of great genius and talent" who have completely "miss[ed] the tide of fortune and popularity."[16] The assumption, though, is that the honors and awards of a national institution such as the one being proposed would perforce go to authors of widely recognized genius—that is, to authors who already enjoyed the kind of prestige which, with very few exceptions, gave them plenty of leverage in the commercial market. And this is a criticism that has haunted cultural prizes down to the present day, when the £20,000 Booker Prize can go to a novelist whose annual earnings are said at his divorce trial to be twenty times that (as was the case with Ian McEwan in 1998), when the six-figure architecture prizes are routinely won by multimillionaires, and when even a prize that is expressly designed as an instrument of patronage, such as the MacArthur Fellowship, the so-called "genius award" (which is supposed to afford winners the "freedom to fulfill their potential" by liberating them from "financial constraint . . . at points in their careers when a fellowship could make a marked difference"), often goes to the very biggest stars of American academe, whose salaries dwarf the award and whose conditions of employment already afford them the very opportunity the MacArthur claims to provide: that of "devoting themselves to their own endeavors at their own pace."[17]

Elaborating this point, Scott observes that the new cultural societies and academies, by taking it upon themselves to perform acts of simultaneous consecration and patronage, are caught in a double bind of potential embarrassments. If the Royal Society offers its Gold Medals to authors of indisputable merit (such as Byron, Tom Moore, or Scott himself), it risks the embarrassment of refusal—for these writers have little need of either the financial or the symbolic rewards the society can bestow, and indeed stand to lose more symbolic capital than they can gain by even allowing themselves to be associated with such an institution. Looking at the question from the standpoint precisely of symbolic profits, and employing a resolutely economic terminology, Scott concludes that writers of real stature, of recognized "genius," would intuitively know to "stand aloof" from these sorts of transaction. "Every man who has acquired any celebrity in letters," says Scott, "would naturally feel that the object or rather the natural consequence of such society would be to *average* talent and that while he brought to the common stock all which he had of his own he was on the contrary to take on his shoulders a portion of their lack of public credit."[18] Recognizing that the society would simply drain off some of the symbolic capital of its most illustrious members and honorees as a way to boost the value of its common stock, the prestigious writer would be inclined to invest elsewhere. But on the other hand, if the society sought to avoid the embarrassments of refusal by directing its medals toward lesser writers, it would risk an even greater embarrassment. As Scott puts it, there would certainly be many writers eager to capture such an honor, but "they would be the very individuals whose mediocrity of genius and active cupidity of disposition would render them undeserving of the Royal benevolence or render the bounty of the Sovereign ridiculous if bestowed upon

them."[19] A national institution patronized by the crown which was continually presenting Gold Medals to patent mediocrities, and which proved incapable of attracting into its orbit the very "names" which, for symbolic reasons, it "would be most desirous to have," would inevitably, he concludes, appear as "a jest," a public joke. As he remarks of the formidable but always controversial French Academy, on which the Royal Society was clearly to be modeled, "Even Louis XIV in his plenitude of power failed to make the academie respectable. . . . Those of genius who were associated with it [Scott undoubtedly is thinking of Voltaire and the *philosophes*] made their way at a later period and rather because the academie wanted them than because they required any honors it could bestow."[20]

Scott foresaw other potential embarrassments, as well. Since the most distinguished writers would shun the Royal Society, they would be unavailable to act as judges. The society would be a case of the blind leading the blind, dreary pedants of middling talent and reputation ("excellent judges," Scott remarks, of "old port," "tobacco," and "punch making," but not very reliable "assessors of the fine arts") selecting other writers of middling talent and reputation on whom to bestow their honors. Indeed, says Scott, writers of genuine brilliance would find the prospect of "sitting as judges on each other's performances" a particularly vile and "indelicate" one; this was "a task which with all its unpopularity and odium few would undertake who had the least capacity of performing it well." And even supposing such writers could be persuaded to participate in the judging, their natural fractiousness and independence would assure that the annual deliberations devolved into "a sequence of ridiculous and contemptible feuds, the more despicable that those engaged in them were perhaps some of them men of genius."[21] Kept at

a distance from one another, says Scott, writers "may observe decorum; but force into our body a set of literary men differing so widely in politics in taste in temper and in manners having no earthly thing in common except their general irritability of temper and a black speck on their middle finger, what can be expected but all sort of quarrels fracasseries lampoons libels and duels? Fabiscio's feast of the author in [Le Sage's picaresque novel] *Gil Blas* would be a joke to it." In any case, whoever did the judging and whatever the outcome of that judging, it was certain, Scott believed, that journalists would exploit the occasion to produce great skeins of calumny and abuse. The quarrels within the society over matters of cultural value would prove an irresistible journalistic occasion and a great opportunity for enemies of the crown. Indeed, the entire enterprise was "capable of being most grossly misrepresented . . . [by] Jacobin scribblers [who] would hold it forth as an attempt on the part of the sovereign to blind and to enslave his people by pensioning their men of letters and attaching them personally to the crown"—"precisely the kind of charge which the public beast would swallow greedily."[22] In short, Scott foresaw what we now call "culture wars" as an inevitable byproduct of cultural awards (even if he did not see that his own denunciation of the proposed society was itself exemplary of just this tendency). Far from elevating or dignifying their winners, these ostensive consecrations would produce degrading scandals and quarrels while attracting the cheapest shots of the scribbling profession.

As will become apparent further on, Scott was both astonishingly prescient and quite badly mistaken about the role these emergent societies and their awards would play in modern cultural life. Much of what he predicted would in fact come to pass, not only in connection with the Royal Society of Literature but in connection with

cultural prizes generally; yet these embarrassing and scandalous de-
velopments have contributed more to the success of the prizes than
to their failure. The question to take up here, however, is why, given
such formidably articulate and persuasive opposition (and Scott's
letter gives voice to a widespread disposition among authors and
artists of high standing, dating back to the early days of the French
Academy),[23] the cultural bureaucrats so readily succeeded in found-
ing and expanding the institutions of consecration? More particu-
larly, how was it possible to enlist George IV, himself a cultured
man and an admirer of Scott, in an enterprise that seemed so dubi-
ous of cultural respectability and so certain to attract negative pub-
licity?

As I have already suggested, the answer lies partly in the desire to
extend bureaucratic control over the unruly fields of art, to enlarge
the state's share of the power to produce artistic value (to canonize,
to consecrate, to determine which authors will be *recognized* as
worthy of special distinction—authors who, by virtue of that recog-
nition, will in turn be empowered to confer value on other authors
or works). Whatever the press might say, the production of art
throughout Europe was being increasingly managed bureaucrati-
cally from above, and a failure on the part of the state or the mon-
archy to orchestrate such a system of management could be seen as
weakness. The absence, especially, of any British counterweight to
the powerful French Academy must have played into the king's
thinking. But there was another motivation as well, which points to
the important position prizes had begun to assume on a cultural
field dominated by a new faith in the purity and sanctity of art. Like
so many of the individuals who founded cultural prizes in the twen-
tieth century, George IV was tempted by the lure of "immortality,"
which the Royal Society's supporters very pointedly held out to

him. Writing in the *Literary Gazette* of 1821, William Jerdan, one of the society's most ardent proponents, declared that "the reign of George the Fourth will be sufficiently famous in history; but we will venture to predict, that not the splendour of the warlike achievements which have brightened it; not the gigantic progress of civilization, which has made it memorable, not the wonderful discoveries in science, which have adorned it; will produce such stupendous effects, or constitute an epoch so immortal as the foundation of the Royal Society of Literature."[24]

The notion that powerful individuals are better assured a place in history through acts of cultural patronage than through any other acts or achievements is not new, of course. Certainly Louis XIV had exploited this advantage of patronage quite directly when, upon assuming control of the French Academy in 1672, he established as a sort of unofficial but binding statute that the membership's "principal object" would henceforth be to "dedicate the name of the incomparable Louis to immortality."[25] But by the early nineteenth century the promise of immortality had taken on a more distinctly modern coloration. Informing Jerdan's rhetoric is a modern ideology of art that removes art from the sphere of politics ("warlike achievements"), society and economics ("progress of civilization"), science ("wonderful discoveries")—all things temporal—and establishes it in a distinctly superior realm where such laws as that of mortality no longer apply. While from the standpoint of the artist or aesthete, prizes threatened to drag art down into these temporal spheres ("politicizing" or "commercializing" practices that were no longer to be seen as either political or commercial), from the standpoint of the sponsor or patron, they held out the possibility of a magical intraconversion of capital, whereby temporal attainments

such as economic wealth and political power might be transformed into a place of permanent honor in the heterocosm of art.

This particular conception of art—not as a set of human practices and activities essentially continuous with other practices and activities but as a special, distinct, and indeed transcendent domain—could already in the 1830s present itself as universal, though it in fact extended back only about a century, having its dual roots in the economics and the aesthetics of the early Enlightenment. As we will see, the rise of cultural prizes since the nineteenth century is profoundly linked to this aesthetic tradition; and the ideas of timelessness and immortality, in particular, are invoked constantly in the discourse of and about them. Another way to put this is to say that the modern life of prizes has much to do with their ideological connection to death, a connection perhaps most evident in the many prizes that are presented "in memoriam" of an original sponsor or of that sponsor's beloved friend, relative, or colleague. More than any other aspect of cultural prizes, their memorial function has enabled widely divergent and even opposed agents of cultural production—from the devoted individual student to the local artists' collective to the giant multinational corporation—to fall into alignment, each making a profound and irreversible investment in the institution of the prize. And this capacity to draw into itself diverse cultural agents with their quite different kinds of power, providing a forum not just for the transaction of cultural assets (status among critics, scholarly expertise, administrative savvy, social connections, ethnic representativeness, curatorial authority, money, and so on) but for a negotiation of the terms and rates of such transaction, has been the principle engine of their ascendancy over the past hundred years.

The Logic of Proliferation

> *The government has decided to award the genius a few*
> *new medals—medals he has not been previously*
> *awarded. One medal is awarded for his work prior to*
> *1956, one for his work from 1956 to the present, and*
> *one for his future work.*
>
> —Donald Barthelme, "The Genius," *Forty*
> *Stories* (1987)

We could say, then, that at the advent of the cultural prize's modern ascent, the moment in November 1895 when Alfred Nobel was signing his final will in his Paris house, pledging a "gift to mankind" in the form of perpetual prizes, the prize had established itself as an instrument (an economic instrument, in the full sense of that term) eminently well suited to achieving cultural objectives along three main axes: social, institutional, and ideological. Socially, the prize functions as a rallying point, a structural device, around which ambitious cultural events and festivities may be organized. It is a form of play, of competitive struggle, a "cultural game" which can be articulated with or overlaid on any of the many games of culture that we call the arts. As such, it introduces special excite-

ments and special opportunities for mass spectacle, opportunities to which the arts in question may not themselves ordinarily give rise. As I will discuss toward the end of the book, where the international and global aspects of the cultural prize are considered, the prize begins in the later nineteenth century to facilitate a neoclassical convergence between the arts and spectator sport. As a kind of competitive spectacle, it attracts attention (in particular, journalistic attention, which produces the specifically modern form of capital we call celebrity) not merely to particular artists or works or forms of art, but to the individuals or groups who present the awards and to the site—the neighborhood, town, city, nation—in which the event is held. It can thus be a nodal point for communitarian identification and pride, a means of positing an "us" and an "our" around which to rally some group of individuals, as well as a means of raising the status of that self-avowed community within the symbolic economy of all such groups. More generally, it brings together an unusually wide range of cultural "players"—artists, critics, functionaries, sponsors, publicists, journalists, consumers, kibitzers—providing all of them with an occasion in which they feel they have a certain stake and hence a certain obligation to assert their interests. The prize serves the function of what economists call "communication": it brings disparate players into informed contact with one another so that mutually beneficial transactions may (in theory) take place among them.

Institutionally, the prize functions as a claim to authority and an assertion of that authority—the authority, at bottom, to produce cultural value. It provides an institutional basis for exercising, or attempting to exercise, control over the cultural economy, over the distribution of esteem and reward on a particular cultural field—over what may be recognized as worthy of special notice. In mod-

ern times this control was often, to begin with, state control, but it has gradually migrated away from the state in most countries. Indeed, if the national academies and royal societies of early modern Europe represent an attempt to centralize material and symbolic patronage, prizes in their more contemporary forms demonstrate the general failure of that ambition in the face of proliferating sites of cultural consecration. The prize places a certain power (very widely underestimated by sociologists of culture) in the hands of cultural functionaries—those who organize and administer it behind the scenes, oversee the selection of members or judges, attract sponsors or patrons, make rules and exceptions to rules. It assists, that is, in the bureaucratization of art, even to the degree that it produces as one of its inevitable effects alternative prizes sponsored by hostile counter-groups, *salons des indépendants:* "anti-institutional institutions."[1] For as we might anticipate, these unofficial and antibureaucratic counter-institutions soon become part of the established institutional landscape, targets in their own right of the latest generation of contemptuous independents or outsiders. And while prizes, along with the societies or academies that sponsor them, do on occasion wither away, they generally perpetuate themselves long after the moment of resistance or opposition from which they arose has passed. The fields of art thus become littered with awkwardly redundant consecrations, whose once fiercely guarded points of differentiation have ceased to be discernible.

Ideologically, the prize offers particularly rich opportunities to test and affirm the notion of art as a separate and superior domain, a domain of disinterested activity which gives rise to a special, nontemporal, noneconomic, but scarce and thus highly desirable form of value. Precisely because this notion of art and of artistic value requires continual acts of collective make-believe to sustain it,

there is a need for events which foster certain kinds of collective cultural (mis)recognition. A concert or a play cannot do this very effectively; the artistic performance does not in itself secure any particular apprehension of aesthetic value. But a prize serves the purpose admirably. While it cannot produce perfect agreement as to the value of this or that artist or work (though it can exert a real effect on that value), it does produce, largely in the form of a negative reaction, agreement as to the special, nontemporal value of art as such. For it invariably becomes the occasion for disputes over how accurately the value has been gauged and how legitimately the sponsors and judges may claim the authority to perform the calculation—disputes whose rhetoric is predicated on, and so can only reinforce, faith in the symbolic economy of pure gifts.

What the Nobel did, therefore, was to act as a catalyst for a process that had been gaining momentum for some time. The idea of founding a prize (not, to be sure, a prize on the scale of the Nobels, or with such considerable sums of money being paid out to foreigners—but a prize of some sort) had become, by the time of the great industrialist fortunes of the Belle Epoque, a perfectly natural idea. That is, it followed as a matter of course from a social logic which was by then firmly established and which assured the usefulness of prizes to the cultural economy as a whole by virtue of its usefulness to particular individuals and groups whose cultural aims could be quite various, from state office-holders and wealthy philanthropists to freelance cultural entrepreneurs and loose societies of "independent" artists. This range of agents and aims assured in turn that the essentially competitive character of cultural life, which prizes themselves rather crudely emblematize, would be reflected not just in individual prizes but in the nature of their relationships to one another: that new prizes would emerge to compete with established

ones, to try to tarnish them or at least to steal some of their luster, and that all prizes would struggle to defend or improve their positions on the field of cultural production as a whole. Prizes, an instrument of cultural hierarchy, would themselves come increasingly to describe a hierarchical array, a finely indexed system of greater and lesser symbolic rewards, the negotiation of which constitutes a kind of second-order game or subsidiary cultural marketplace. While not a perfectly independent or discrete system, this game played between and among prizes does have its own rules, its own principles of engagement—what might be called the internal logic of the awards scene. The proliferation of prizes since the turn of the twentieth century (and especially in the last third of that century) cannot, of course, be wholly explained in terms of this internal logic. But it is a logic of cultural *production* in its own right, which should not be simply assimilated to some more sweeping narrative of professionalization, bureaucratization, commodification, decadence, or cultural decline. In tracing the history of the cultural prize forward from the Nobel, therefore, our first task is to come to terms with the highly productive struggle of prize against prize.

The Nobel Prize in Literature (the one *cultural* prize, as we are using the term here, among the original five Nobels) stepped into this second-order cultural game as a formidable player and an enticing opponent. This is partly due to the prize's unprecedented ambition in terms of both the territory it claimed (no genre and no language was excluded) and the sheer scale of its cash award (the 1901 prize was already worth about three-quarters of a million inflation-adjusted dollars). But it also results from the fact that the Nobel managed to condense into a single prize a whole range of historically distinct aims and functions, thereby inspiring widely divergent forms of competitive emulation and antagonism. The prize was

founded in a thoroughly modern way, by a wealthy industrialist whose private foundation, bearing his name, would serve as the prize's perpetual sponsor, gradually laundering his economic fortune and symbolic reputation through a series of cleansing cultural transactions. This was, indeed, the first time that virtually the whole of a great industrialist's fortune was placed in the service of prizes; Nobel's determination to channel all of his capital into the awards and awarding institutions, diverting it from familial claimants, was, at the time, a shocking and (to other wealthy European families) highly objectionable innovation. Yet for all its contemporaneity, the prize also remained deeply rooted in the bureaucratic traditions of early modern royal and national societies. It was, after all, to be awarded by the Swedish Academy (founded by King Gustav III in 1786 to defend the purity of the Swedish language), with members of the French and Spanish academies specifically designated as eligible to make nominations.[2] Even today, laureates receive their medals from the hand of the king, who with the queen presides over the ceremony in Stockholm as guest of honor. Similarly, despite its global ambitions, which (however limited in actual practice) represented a real innovation, the prize remained recognizably a nationalist initiative on the European model, designed to raise the cultural profile and broaden the cultural authority of a self-consciously minor European nation-state.

In terms of its express criteria of evaluation, the prize again seems to have drawn together divergent elements, incorporating in one honor recognition for several distinct forms of cultural achievement, each of which would over the course of the next century come to be attended by its own genre of Nobel-inspired prizes. Most obvious is the genre of the ultimate consecration, or, as it has been rechristened by Hollywood, the Lifetime Achievement Award,

which has become almost an obligatory prize at any annual awards ceremony as well as the principle of induction into the various cultural halls of fame (among which the Rock and Roll Hall of Fame in Cleveland, Ohio, has been a particular success). This sort of retrospective honor again has its roots in the great academies, election to which was generally premised on a long and distinguished career (though that criterion was often secondary to considerations of birth and social rank). Such honors run the risk of belatedness; French writers have occasionally succumbed to mortality just as they arrived at the head of the queue to join the Company of Immortals, and the Swedish Academy has seen almost certain prizewinners (beginning, most notably, with Tolstoy) abruptly disqualified in the same way. Halls of fame are of course not restricted to living artists, but they are nonetheless subject to the same pressures of timing: for both symbolic and commercial reasons, it is generally far better to induct a living legend than a dead one. Even those who live long enough to receive such honors have described them, less than half-jokingly, as the "kiss of death," the stigma that marks the end of their productive lives as artists. But partly because they are bound up with life and death, these lifetime honors participate, even more than other kinds of prizes, in the romantic, heroic conception of the individual artist. And this is a conception which has proven very attractive from the standpoint of cultural promotion, since it enables artists to be "stellified," as Leo Braudy puts it—transformed into celebrities and circulated within a star-centered economy, even in cultural fields as inescapably collaborative as architecture or film.[3] Hollywood's lifetime achievement awards, for example, presented over the past thirty years to such figures as Federico Fellini, Michelangelo Antonioni, Charlie Chaplin, Howard Hawks, Akira Kurosawa, Jean Renoir, and Elia Kazan,

have been a good device for steadily disseminating the auteur theory of directorial practice, thus adding a new class of star to the industry, the class that includes George Lucas and Steven Spielberg, and strengthening one of the important "branding" mechanisms in contemporary film marketing.

But the Nobel is not simply or unequivocally a lifetime achievement award. Testamentary language covering all five of the original prizes specifies that the award is to be presented for a particular "work" or "writing" as opposed to a lifetime of contributions, and the language specifically pertaining to the literature prize seems to reinforce this emphasis with the phrase "the person who has produced in the field of literature the most outstanding work." Moreover, this outstanding work must, according to another general stipulation of the will, have been produced or published (or have made its impact) "during the preceding year"—a clause on which the Nobel Foundation quickly placed a very liberal interpretation: "The awards shall be made for the most recent achievements in the fields of culture referred to in the will, and for older works only if their significance has not become apparent until recently."[4] Even with this loose interpretation, however, which has enabled the academy to shade its prize heavily toward lifetime achievement, one can still see hints of the book-of-the-year award formula that has proved so attractive to publishers, booksellers, and critics' circles, and that has come to dominate the literary awards scene generally. The academy has sometimes appeared to time the prize so that it falls to an author immediately after publication of a new work, in some cases even presenting the award "with special reference" to this particular work, as with Galsworthy's *Forsyte Saga* in 1932 (two years after publication of the final Forsyte work, the story collection *On Forsyte Change*) or Hemingway's *Old Man and the Sea*

in 1954. This ambiguity between prize genres, which marks a tension between the prestige of a particular contemporary work and the prestige of all the past works by its author, is discernible in nearly all book-of-the-year awards (as well as in other annual best-of prizes). In fact, the likelihood that in 1954 the Swedish Academy would seize on Hemingway's "outstanding work" of the "preceding year" may well have weighed on the Pulitzer jury when they declared *The Old Man and the Sea* the best novel of 1953. For while the Pulitzer is a best-novel prize, this does not mean it has no aspirations to define a canon of great American writers, a hall of literary fame; the Pulitzers were, after all, inspired by the example of Alfred Nobel. Those involved in the Pulitzer had been sorely embarrassed when Faulkner won the Nobel in 1949 without having received the ostensibly legitimating national honor of their own award: it was this glaring failure to recognize greatness that opened the door, a few months later, to the founding of the National Book Awards. To repeat such a failure with respect to the even more colossal figure of Hemingway (whom the Pulitzer's board had wanted to honor back in 1941 for his novel *For Whom the Bell Tolls*, but whose politics had been so unpalatable to members of the fiction jury that they would not even nominate him) would have been a great favor to the upstart NBAs.

The third formula that is visible in the Nobel's founding language, specifically in the phrase that says winners must have "conferred the greatest good upon mankind," and in the troublesome stipulation that the honored work must tend in an "ideal direction," is that of the artist-as-humanitarian award. Humanitarian awards as such, which are meant to celebrate exemplary citizens, social visionaries, moral and political leaders, communitarian heroes, have spread as rapidly as cultural prizes over the past three decades. A very partial list of the honors bestowed on Nelson

Mandela, for example, would include the Simón Bolívar Prize, the Alfonso Comín Foundation Peace Prize, the Baker Institute Enron Prize, the Gleitsman Foundation Award, the International Peace and Freedom Award, the U.N. Human Rights Award, the Bremen Solidarity Prize, the Sakharov Prize, the Asturias Prize, the UNESCO Peace Prize, the Tipperary Peace Prize, the Carte-Menil Human Rights Prize, the Anne Frank Medal, the W. E. B. Du Bois International Medal, the Indira Gandhi Award, the Jawaharlal Nehru Award, the Sheikh Yusuf Peace Award, the Jesse Owens Global Award, the Africa Peace Award, two different Third World prizes, the Star of International Friendship, the Spirit of Liberty Award and the Liberty Medal. The great precursor of these awards is of course the Nobel Peace Prize, but the Literature Prize has always carried something of the same moral burden, increasingly so in recent decades as it has come to signify belated recognition of native and minority literatures and to favor writers of strong political conviction who have become icons of moral leadership in their particular national or subnational communities: Wole Soyinka, Nadine Gordimer, Toni Morrison, Günter Grass—all of whom have received multiple humanitarian awards to arrange alongside their literary trophies.

There are a number of cultural awards, such as the Peace Prize of the German Book Trade, founded in 1950 and recently awarded to Chinua Achebe, or the National Urban Coalition Award for Artist/ Humanitarian of the Year (awarded to Michael Jackson in 1989), which explicitly link the two bases of esteem. Others, such as the NAACP Image Awards, founded in 1970, frankly deny any distinction between artistic achievement and ethnic exemplarity: the aesthetic and communitarian agendas are inseparable, since, as the NAACP proclaims, "image is everything." Recently founded super-prizes, such as the $350,000 Lannan Prize for Cultural Freedom

(1999) or the $100,000 Lennon-Ono Grant for Peace (2002), likewise merge artistic and political considerations according to a defining but inexplicit ratio between artistic value and the politics of "freedom" or "peace." This indeterminacy of criteria also appears, in somewhat different form, in the highly favorable disposition of literary and entertainment awards toward historical or biographical works in which moral leadership in the face of historical crisis is represented in uplifting fashion and thereby made available for a kind of celebration once-removed, author or performer serving as cultural surrogate for social hero. (The many awards for Thomas Keneally's *Schindler's Ark* and Steven Spielberg's *Schindler's List* come to mind, or even the Best Actress Oscar for Susan Sarandon in *Dead Man Walking,* which brought the woman she played in the film, Nobel Peace Prize nominee Sister Helen Prejean, to the Academy Award podium alongside Sarandon. Who, exactly, was being applauded, and for what manner of achievement?) What has lately been attacked as a capitulation by prize jurors to considerations of "political correctness" is in fact the surfacing of a tension between two conceptions of artistic greatness with which prizes have always had to contend, and which has been evident not only in the internal disputes among jurors, but also in the contending of prize against prize. Every prize that declares or betrays a social agenda opens the door to new prizes claiming greater purity of aesthetic judgment, while every prize claiming such purity opens the door to new and more explicit articulations of artistic value with the social good.

The point is that while the somewhat contradictory agendas within the Nobel's mission statement have created perennial difficulties for the Swedish Academy, they have assured heavy traffic on several separate avenues of competitive emulation. Other prizes

founded around this time also inspired imitators, both admiring and antagonistic. The Prix Goncourt, for example, the preeminent book-of-the-year award established by the will of Edmond de Goncourt in 1896 (the same year Nobel's will was opened) and first awarded in 1903, spawned its first hostile counter-prize within months: the Prix Femina, whose all-woman jury was proposed as an antidote to the all-male Académie Goncourt.[5] But no prize has been so definitively implicated in the process of proliferation as the Nobel. Beginning with Pulitzer's decision, in 1902, to found prizes for journalism and literature in the United States, the Nobel has served as a direct stimulus to prizes of every description, the observation that "there is no Nobel Prize for [fill in the blank]" being trotted out as justification for every new big-ticket national or international prize in the arts. The fact that the cultural field in question may already be playing host to one or more prizes founded on the very same principle appears not to act as much of a deterrent. The Praemium Imperiale prizes were founded in 1987, with heavy sponsorship from Japan's Fujisankei Communications Corporation (that is, Fuji), to "provide what was lacking in the Nobel Prizes," to "fill the gaps" in Nobel's will—and the press has often obliged by referring to them as the "Nobels of the art world."[6] But by the late 1980s major international prizes already existed in several of the five fields honored by the Praemium Imperiale. In architecture, for example, even if we set aside the gold medals offered by such national and international societies as the International Union of Architects (UIA), the American Institute of Architects (AIA), and the Royal Institute of British Architects (RIBA), the new prize clearly duplicated the aims of the Pritzker, a $100,000 prize whose "procedures and rewards [were] modeled after the Nobels" and which had been founded a decade earlier (in 1979) by Jay Pritzker of the

Hyatt Corporation precisely to honor achievement in a "creative endeavor not included [among] the Nobel Prizes."[7] Nor did the redundancy of the Praemium Imperiale prevent the announcement, just five years later, of yet another "Nobel of the art world," the $250,000 Lillian Gish Prize, whose first winner, Frank Gehry, was, not surprisingly, a former winner of both the Pritzker and the Praemium Imperiale—as well as of the Wolf Prize, yet another six-figure award modeled even more closely on the Nobels and founded even earlier than the Pritzker.[8]

These redundancies present no threat to the Nobel itself. The single-winner axiom underlying the entire prize economy assures that the dominance of the Nobel is in no way diminished (and may even be enhanced) by the increasing field of contenders, none of which can ever rise above a decidedly secondary position. When Larry Tise set about founding the International Congress of Distinguished Awards, whose purpose in part would be to help the media sort out the legitimately important and respected prizes from the ever-increasing rabble of wannabes, he traveled to Stockholm to speak to people at the Nobel Foundation. They were cordial and encouraging about the venture, but seemed to take it as understood that the Nobel itself could never join such an organization; the function of the ICDA would be to secure and defend the upper tier of the awards pyramid—the tier, that is, just below the untouchable pinnacle on which the Nobel alone resides.

This elite but secondary level is one on which, from the standpoint of the established prizes, advantages can seem too difficult to gain and to hold, and barriers of entry too low. If Ricardo Wolf can call his prize the "Nobel of architecture," then why *not* Jay Pritzker, and why not, tomorrow, Warren Buffett or Bill Gates? The aim of the ICDA, and of the more ambitious prize administrators and sponsors, is to bring Nobel-like permanence to the more provi-

sional margins of advantage enjoyed by the players on this secondary tier. But the reality is that these advantages, though slimmer, are often decisive, making it nearly impossible for a newer prize to supersede an older one that has begun to be recognized as the "Nobel" of its subfield. The ambition of the newer prize, rather, is to situate itself in a relationship of marked, and possibly antagonistic, complementarity to the dominant one, establishing its own apparent necessity by reference to some failing or lack in its more esteemed predecessor.

The kind of competitive energies that have driven this propagation of new prizes can be attributed to the whole range of agents that animate the cultural universe. Artists in a particular field or subfield, having made great psychic investments there, can feel envious of artists in a different field or subfield who enjoy much greater symbolic rewards. "The literary world has an abundance of medals. Why not the art world?" asked the art critic Richard Cork at the inaugural Turner Prize ceremony.[9] And once the painters of canvases have their national honors, why not the painters of ceramics? Once the makers of short films and sitcoms are eligible for international awards, why not those who make music videos or television commercials? And once that occurs, why should music video makers in the developing world have to look to London, Cannes, or Los Angeles for the laurels of directorial genius instead of to their own, more proximate cultural centers? By creating awards for themselves, usually but not always under the auspices of a more or less formal professional association, and then by pressing these awards aggressively into the public view, practitioners of a new, neglected, minor, or otherwise less than fully legitimate artistic form assert their desire for wider recognition, for a better place on the cultural field as a whole.

But if it is wrong to imagine that prizes have simply been imposed

on artists by exogenous cultural forces, it is just as wrong to think that artists themselves have provided the only or even the primary impetus for the spread of new awards programs. Nobel envy has been a common malady among wealthy philanthropists and philanthropic trust administrators, who have been understandably covetous of the success with which, through a single philanthropic act, a dynamite and munitions manufacturer made his name a virtual synonym for cultural prestige. The relative inexpensiveness of most cultural prizes, compared with the construction of a university library or the endowment of an opera company, coupled with the potential for enormous long-term symbolic returns (as one's gift is annually repeated and renewed, one's act of putative generosity annually rehearsed and applauded, one's name brought perpetually into association with the names of esteemed artists), has made them an attractive philanthropic option. This has been especially true in the United States, where government funding of the arts is achieved indirectly, though tax deductions for wealthy individuals and corporations, rather than directly, as in Europe and most other countries. In those countries, and especially in Britain, the imperatives of philanthropy have been less important to awards proliferation than those of publicity, as people involved in corporate advertising have seized on prizes as a sponsorship vehicle, similar to sport though generally much less costly, while people in the business or promotional end of cultural production itself have turned to prizes as a way not to achieve "immortality" for themselves but to focus national or even worldwide attention on a particular artist, transform him or her into an instant star, and, as they say, shift a lot of product.

Driven by these differing players or agents on the cultural field, the systemic compulsion both to imitate and to differentiate, to es-

tablish, vis-à-vis the better-established and more prestigious prizes, relationships of carefully calculated complementarity or antagonism, has been uncontainable. Each prize that achieves a premier position in a particular field, and that becomes, however contestably, the "Nobel" of that field, produces a host of imitators with various legitimating claims of similitude and difference. Each successful act of differentiated imitation in turn gives rise to another order of imitators, and so on. The process can at times devolve to the specification of almost laughably narrow cultural niches—"Nobels" of such minor and eccentric domains as to seem artistic equivalents of the "Miss Congeniality" award. There is, for example, a Lichfield Prize "for the best unpublished novel based recognisably on the geographical area of Lichfield District, Staffordshire, set in an historical or present-day context, but not the future."[10] An honor such as this can appear so slight as to be more slight than honor, and it runs the risk of failure due to sheer negligibility, a risk that many prizes hedge by drifting over time toward the cultural mainstream, loosening the bonds of their original remit or testamentary language in order to approximate more closely the scope and criteria of the dominant awards.

Even the awards that are more ambitiously situated at the outset evince this same tendency to creep toward a crowded and ever more redundant cultural middle ground. Having established itself as the anti-Pulitzer, the National Book Award began after a quarter century to resemble its nemesis so closely that the National Book Critics Circle launched its own anti-NBA anti-Pulitzer: the National Book Critics Circle Award. But by 1981 (just six years after the founding of the NBCCA), all three prizes converged on the very same novel, John Updike's *Rabbit Is Rich*. And when, a decade later, two of the three were conferred on the next Rabbit book,

Rabbit at Rest, this initiated a five-year run during which each of the putative anti-Pulitzers coincided twice with the Pulitzer, while in the remaining year they shared a winner between themselves. The same pattern can be observed even in France, where the major literary prizes' express avoidance of double consecration is itself seen as a symptom of their uniform devotion to commercial logic (the justification for ruling out double winners being that they would squander a significant promotional opportunity). France's original maverick prize, the Renaudot, founded by journalists tired of being treated by the Goncourt Academy as publicists for France's major publishing houses, Gallimard, Grasset, and Seuil, itself has come to be associated with the "Galligrasseuil" hegemony.[11] But while this seemingly inevitable slide toward redundancy does kill off some prizes, especially those that lacked from the start any compelling strategy of differentiation, its more pronounced effect is that of further propagation, as the old counter-cultural or independent or minor positions reopen, inviting a new generation of alternative awards. In France, the sense that all the major book prizes— Goncourt, Renaudot, Femina, Médicis—with their carefully coordinated announcement dates and backroom deals, are equally tools of the publishing industry, has made the contrarian Prix Décembre (originally founded in 1989 as the Prix Novembre) an upstart success.[12] Moreover, internationally, the preponderance of successful book prizes in France sparked their proliferation in Great Britain, starting with the Booker Prize in 1969, which founder Tom Maschler explicitly modeled on the Goncourt, and which then became the model for novel-of-the-year prizes in other countries, most obviously with the "Russian Booker," as well as for annual prizes in other fields within Britain (notably the Turner Prize, a.k.a. the "Booker Prize for Artists").[13]

This basic structural pattern characterizes the post-Nobel history of prizes in all the arts. Because the cultural field is a relational one, the logic of furious propagation does not tend, as practically all commentators have imagined it must, toward saturation. It is in fact completely wrong to suggest that the field must by now be crowded with redundant awards to the point of their mutual suffocation. On the contrary, each new prize that fills a gap or void in the system of awards defines at the same time a lack that will justify and indeed *produce* another prize. And while the tendency for prizes to become more alike over time does impose a burden of redundancy, it is a burden that for the most part falls only on the most firmly established—those whose identities within the field are least fragile. For newcomers this moderating tendency is a boon, since it assures that the most obvious or visible positions of "purity," "integrity," "independence," and so forth are rarely occupied for long and are continually reopening in accordance with the temporality of generational succession. Moreover, given that the whole field of play at issue has been expanding with the broad cultural and economic tendencies of "globalization," and with the legitimate demands for cultural recognition on the part of oppressed and marginalized groups both within the metropoles and in relatively disadvantaged and neglected locations, the notion that the horizon of opportunity for new awards must be shrinking is laughable. What we are looking at, even today, is a system ripe for further expansion. To be sure, there are constraints; but as I will discuss further on, they arise mainly from the sheer quantity of labor involved in judging and administering so many prizes, and from the tendency of those who found new prizes to underestimate and severely underfund this labor. The actual *work* of consecration will need, in future, to be better compensated, absorbing a significantly larger

portion of the awards-industry budget. And this will almost certainly put a drag on the industry's growth. But let us make no mistake: precisely because of the expansion that has already occurred since the creation of the Nobels, there are not only more prospective founders and sponsors of awards than ever before, but also, and less intuitively, more positions on the fields of culture where new prizes can be installed.

Prizes as Entertainment

> *I'll do an awards show that's just for awards shows,*
> *made up entirely of recipients and nominees for*
> *awards. "The Dumbest Acceptance Speech," that sort*
> *of thing. If that works, we can do an Awards Channel.*
>
> —George Schlatter, creator of the American
> Comedy Awards and the American
> Television Awards, quoted in Rod Dreher,
> "Everybody's a Winner," *Washington Times,*
> May 24, 1993

If the Nobel has served as model for many of today's cultural prizes, especially those founded in the most legitimate fields of art by individual or corporate philanthropists seeking to effect a conversion of money into cultural prestige, the prize that has offered an alternative model, particularly for official societies, academies, and professional organizations in the less legitimate arts, the fields of "entertainment," has clearly been the Oscar. The Oscars were not the earliest film awards—the Photoplay Magazine Medal of Honor (later renamed the Gold Medal) was first awarded in 1920—but they were the first to be presented by a professional association.[1] The Academy of Motion Picture Arts and Sciences (AMPAS) was founded in mid-1927, and by early 1929 was already handing out

its first set of prizes, with the academy membership (rather than a small panel of judges) handling the nominations and voting for the first time in 1930. By 1935—when the term "Oscar" was just beginning to circulate—the first alternatives to the Academy Awards were being presented, by the newly founded New York Film Critics Circle. Other circles of critics, organized both nationally and by city and state, would follow suit from the late 1940s on, the main public function of such organizations being to issue awards, honors, and top-ten lists. (The Golden Globe Awards, organized in 1944 by the Hollywood Foreign Press Association, can perhaps be included in this group, though it involves significant stretching of the term "critic.")

Also in the immediate postwar period, we find some of the industry and professional groups representing particular fractions of the academy's membership, such as the actors' and directors' guilds, as well as national academies and professional groups in other countries, beginning to assert themselves with awards programs of their own. The Screen Writers Guild, for example, founded in 1921 (and, since 1954, a branch of the Writers Guild of America), presented its first awards in 1949, as did the Directors Guild of America. The first of the "foreign Oscars," the Danish Association of Film Reviewers' Bodil Prize, was presented in 1948, followed by the British Film Association awards (now the BAFTAs, which include television) and Italy's Davids (the David di Donatello awards) in 1954 and 1955, respectively.

Finally, the film festival organizations, which have become even more numerous than the professional associations, emerge in these years as well, each new festival bringing with it a new set of awards. The oldest of these, the Venice festival (Mostra Internazionale d'Arte Cinematografica), began in 1932 as a cinema section within

the Venice Biennale arts exhibition (Biennale di Venezia, first held in 1895). Only audience prizes were awarded that first year, but by the time of the second iteration, in 1934, an official award, the Mussolini Cup for best Italian film, had been established, as well as a parallel prize for best foreign film, and the festival had detached itself sufficiently from the Biennale to become an annual event. The Mussolini Cup was essentially deployed as a fascist propaganda tool until the war forced a three-year hiatus in the festival from 1943 to 1945. Only after the war was the now famous Golden Lion installed as the festival's top honor. In the meantime, the Cannes Film Festival had been conceived in 1939 as a nonfascist answer to Venice, meant to capitalize on the fact that Italy was by then politically off-limits to many key players in the movie industry, who were thus all dressed up with no place to go. But as France was invaded literally during the first screening of what would have been the inaugural festival (the film was *The Hunchback of Notre Dame*), the event was deferred until 1946, when the first Grand Prix at Cannes was finally awarded. (The top prize would be renamed the Palme d'Or in 1955.) The last of the three major European film festivals, Berlin's, was founded as a joint U.S.-German initiative immediately after the war (as part of the American campaign to redirect the cultural machinery of Germany during the Occupation), and began awarding its Golden Bear in 1951.

In the early postwar period, U.S. national academies developed Oscar-type awards programs in cultural fields other than film, beginning with the National Academy of Television Arts and Sciences and its Emmy Awards in 1948 and then the National Academy of Recording Arts and Sciences with its Grammy Awards in 1958. Though the Peabody Awards in radio, initially conceived by a committee of the National Association of Broadcasters, are a prewar

phenomenon, predating the Emmys by eight years, they began as journalism awards explicitly modeled on and against the Pulitzers, and only much later came to compare themselves to the Oscars.[2] Indeed, the desire to be regarded as an "equivalent to the Oscar," which today is an integral part of the promotional rhetoric for hundreds of prizes, did not really become visible until the early 1970s. This was also the start of what has been by far the most intensive period of prize creation, with tremendous growth in every field, driven not only by the establishment of brand new awards programs—several hundred new film festival competitions, for example, including Toronto's "Festival of Festivals" (1976), which today screens three times as many films as Cannes—but, just as importantly, by the expansion of existing programs (see Appendix A). The Venice festival, which involved just a handful of prizes in the 1950s and abandoned the competition paradigm entirely in the turbulent post-1968 period (when the festival's fascist roots threatened to transform its consecrations into stigmata), confers nearly a hundred annual awards today, from the NETPAC award in Asian cinema to the SIGNIS ecumenical jury prize.[3] In the field of television, the Emmys, which comprised fifty-three awards in 1970, had by the end of the century grown to four times that size, with separate ceremonies for programming in Primetime, Daytime, News and Documentary, and Sports. In addition, the Television Academy's regional chapters all launched or greatly expanded their local Emmy programs during this period, increasing the number of local Emmys awarded each year from just a handful to nearly a thousand.

A glance at the résumés of superstar entertainers gives us some idea of the scale of the phenomenon we are addressing. Michael Jackson, whose career perfectly coincides with the period in question, makes a good example. A hugely successful child performer in

the early 1970s, Jackson was already the recipient of eight major music awards before the launch of his adult career in 1979 with an album entitled *Off the Wall*. Between then and the end of the century, he won no fewer than 240 awards: one a month for twenty years straight (see Appendix C).

Even in fields that would seem to lie far from the mainstream of mass entertainment, something akin to an Oscar phenomenon is clearly visible. In classical music, for example, the immediate postwar years saw rapid growth in the number of piano competitions. Though, like most modern forms of the cultural prize, these events date back to the turn of the century, the first Anton Rubinstein International Competition having been held in St. Petersburg in 1890, there were no more than a handful of them before the Second World War: the Chopin in Warsaw (1927), the Queen Elisabeth in Brussels (1937), and the Naumburg (1925) and Leventritt (1940) in the United States. After the war, there was such a rush to found new competitions that a Federation of International Music Competitions had to be established, in 1957, to coordinate dates and publicity. Between 1950 and 1970, the number of competitions increased fivefold, and that number doubled again between 1970 and 1990.[4] By the end of the century, one could find lists of more than five hundred competitions in fifty countries.[5] Since these are multiday events, we can conclude that there is generally at least one, and often more than one, gold medal for a piano soloist being contested on any day of the year. As these prizefests proliferated, the competitions themselves became more competitive with one another, emulating successful strategies of press handling and audience attraction, vying for competitors, sponsors, ticket buyers, and above all television coverage. Their power to direct money, attention, and prestige toward a single grand prizewinner, however minutely differentiated his or her skills and style of play might be from those of

the other competitors, increased tremendously, to the point where today it is almost impossible for a pianist to enjoy a successful career without winning at least one gold medal. Opportunities both to perform before live audiences and to make recordings have come to be tightly keyed to the medal chase, rather than to reviews or word-of-mouth among experts, as was the case formerly.[6] Even the traditionally private and low-profile Leventritt, whose organizers prided themselves on the quiet dignity of their proceedings, was compelled, in the late 1960s and 1970s, to refashion itself along the far more extravagant and Oscar-like lines of the Moscow competition, which in 1958 had turned a little-known former Leventritt winner named Van Cliburn into a major celebrity overnight, as well as of the ambitious American competition that had capitalized so brilliantly on that celebrity, the Van Cliburn International Piano Competition of Fort Worth, founded in 1962.[7]

This sudden and widespread intensification of the awards scene from the early 1970s onward is implicated as both a cause and an effect of much broader transformations in the mode of cultural production. These profound historical shifts have been widely understood in terms of the rise of cultural capital. Already in 1973 Daniel Bell was heralding the emergence of a late or "postindustrial" phase of capitalist societies in which cultural capital, having claimed an ever greater portion of the portfolios of power since the mid-nineteenth century, was finally in a position to trump or in some measure supersede raw economic capital, thereby ushering in a new elite of "technocrats" whose chief resource is "knowledge" rather than land or industrial machinery, and whose capital or "property" takes the form of specialized "skills" rather than wealth in the usual senses.[8] Within a few years of the publication of Bell's book, it had become almost obligatory for sociologists, especially those on the

political left, to come to terms with what many were calling the New Class, the expanding professional-managerial class, composed of intellectuals and technical intelligentsia, whose (growing) share of social power seemed to correlate with their specifically cultural credentials and endowments rather than their material wealth, and who seemed to have no clear place in traditional (that is, Marxist) schemes of class division.[9] The best of these accounts, such as Alvin Gouldner's *The Future of Intellectuals and the Rise of the New Class* (1979) and Randall Collins' *The Credential Society* (1979), attempted to describe the ascendancy of the New Class in terms of what Collins called "the interaction between the cultural market and the material market," an undertaking which required, in Gouldner's words, "a general theory of capital within which the New Class's 'human capital' or the old class's moneyed capital [are merely] special cases."[10] As Collins put it, the "key to the class struggles over control of material production" now had to be sought not in economics proper but in "the political economy of culture" (71, 49). The material struggle was henceforth to be waged on the terrains of cultural value.

This new emphasis on the rise of cultural capital and specifically cultural economies—which, notwithstanding the retreat from the idea of a new *class,* has persisted among sociologists and historians to the present day[11]—signals that we are at least in the vicinity of a historical vantage that could account for the frenzied growth of cultural prizes since the late 1960s. But it is necessary to think of cultural capital in a rather wider sense than most historians of the postindustrial age have done, and to consider its relationship to the economy of prestige (the economy of symbolic cultural production) as distinct from the economy of postindustrial goods and services. Too often, a simple equation is presumed between cultural capital

and (as Gouldner's interchanging of terms indicates) "human capital" in the sense developed by economist Gary Becker. For Becker and his many disciples, human capital is essentially productive technical knowledge of the sort that can be put profitably to work in an advanced economic system, and a firm correlation is usually assumed between this knowledge and formal education. But cultural capital is not quite so tightly linked to the educational system as this suggests, nor is the educational system engaged in a project as unambiguous or socially innocent as simply imparting technical knowledge to its students and measuring the quality and quantity of the knowledge they have absorbed. The hierarchical array into which it sorts the citizenry, its exacting distribution of educational status through grades, ranks, honors, institutional tiers, and so forth, is neither as simple nor as meritocratic as the common wisdom suggests. The rise of cultural capital is much more than a rise of human capital driven by an expanding educational apparatus (and much less than a revolution on the field of power).[12] It is a general expansion of the field on which cultural value in all its forms is produced, driven by a society's greater and greater reliance on the maintenance and manipulation of what are at bottom arbitrary distinctions of symbolic rank or prestige. What has transformed society since the 1970s is not the rise of a new class per se but the rise of a formidable institutional system of credentialing and consecrating which has increasingly monopolized the production and distribution of symbolic capital, especially but not exclusively of educational honors and degrees, while at the same time making the accumulation or control of such capital more and more necessary to almost any exercise of power.

This increasing dependence of the whole system of cultural production on symbolic assets and the institutions that govern their

distribution can be linked, as well, to other accounts of post-1960s social transformation. Economists such as Danny Quah have seen the post-1960s period as a crucial one in the transition to a "weightless economy," a turn marked at least symbolically by the abandonment of the dollar/gold standard in 1971. A weightless economy is one in which a preponderance of activity concerns trade in such intangible forms of property as knowledge or information, news or entertainment, numbers or options or predictions. The increased trade in these "dematerialized" products has meant that the global economy has been able to grow approximately fivefold since 1972 even though the physical mass of everything bought and sold (its literal *weight*) has not risen at all.[13] This would seem to suggest a greatly expanded *economic* market for *symbolic* goods such as, among other things, artistic prestige, as well as for all the services and events through which symbolic forms of capital are circulated.

The radical British geographer David Harvey sees the rise of such services and events as part of a "sea-change in cultural . . . practices since around 1972," involving a shift away from the consumption of goods and into the consumption of new, increasingly "ephemeral" services. These services, among which Harvey includes "entertainments, spectacles, happenings, and distractions," are rigorously subject to the logic of fashion, and mark a further stage in the post-Fordist drive of capital toward ever more flexible forms of accumulation and ever shorter turnover cycles of production and consumption.[14] The rise of entertainment awards and award shows—spectacular distractions that conform with the "new is hot, old is not" temporality of all fashion-dominated fields—can be readily folded into this late-Marxist narrative of the increasing speed and increasing ephemerality of postmodern cultural life.

Not surprisingly, given that celebrity is essentially fame subjected

to the temporality of fashion, the leading historians of fame, such as Leo Braudy, have tended to date our contemporary celebrity culture from this same historical moment. The Hollywood star system was in place a half-century earlier, of course, as was a well-articulated system of gossip columns, personality-driven magazines, gallery owners, book publicists, and other agents of cultural promotion, capable of transforming a respected writer or painter into a cultural superstar—as the examples of Hemingway and Picasso make readily clear.[15] But the burgeoning literature of "celebrity studies" has tended to share Braudy's view that this system of star production acquires radically greater breadth, density, and efficacy in the final quarter of the century.[16] And there is no question that prizes have become the dominant apparatus of star production in virtually every field of culture.

We need to recognize, too, that the very terms "post-Sixties" and "post-1968" evoke, perhaps more powerfully than anything else, historical narratives about the "politicization" of culture, the ever more direct convertibility of cultural with political capital. These narratives stress not so much the rise of a new (economic) class as the rise of the new social movements (the Women's Movement, the Civil Rights and Black Power movements, the Gay Liberation Movement), which began around 1970 to claim a significant share of the cultural field and to reshape it along more representative, if not precisely more democratic, lines. Long reviled for their putative tendency to impose "political" agendas on cultural fields, but also seen as our most prominent barometers of group status, prizes have played an enormous role in the emergence of minoritarian and oppositional cultures into positions of visibility and esteem.

We should note, finally, that this same historical moment marks an important shift with respect to cultural technology. The mass

fetishization of the celebrity, the vast expansion of trade and specu-
lation in weightless and symbolic property, the globalization of
consumer society (with its ever more frenetic temporality of con-
sumption and ever more ephemeral goods and services), as well as
the many concrete cultural gains of the Sixties' new social move-
ments, were all in important ways phenomena of the television:
not produced by this medium in a simple causal sense—not mere ef-
fects of the dominant technology—but so thoroughly mediated and
managed by it that one would not be exaggerating to say that televi-
sion, which was then being leveraged by the new satellite commu-
nications technologies, is a key to understanding these phenom-
ena and their continuing impact. In this connection, the Academy
Awards broadcast of April 7, 1970, which featured a tame but un-
mistakably politicized drama of generational struggle among the
stars, the celebrities of reaction pitted against the celebrities of
youthful opposition, was a pivotal moment in the history of prizes.
John Wayne, the Cold War icon whose persona would morph into
the political image of Ronald Reagan, was finally given a Best Actor
award, and later received a congratulatory phone call from Presi-
dent Nixon; but he was also labeled a "racist" by picketers outside.
The Jean Hersholt Humanitarian award went to a patriot-enter-
tainer of Vietnam troops for the second year in a row, but anti-
war protesters Jane and Peter Fonda were both nominated for
the award their politically conservative father had never won, as
were such icons of the politically disaffected younger generation
as Jack Nicholson, Dennis Hopper (who Fonda senior said should
be spanked for wearing a cowboy hat during the ceremony), and
Goldie Hawn, who won Best Supporting Actress. Commenting on
the presence of Hawn, a star of the TV hit *Laugh-In*, perennial
master of ceremonies Bob Hope told the audience, "This is not an

Academy Awards, ladies and gentlemen—it's a *freak-out*." Hope closed the ceremonies by saying pointedly that the various "troubled, kooky characters that have peopled the screen"—the characters played by Hopper, Nicholson, Fonda, et al.—"are not examples to emulate," and that he looked forward to the day when all the protest and rebellion would have receded into such quietism that the only "fighting will be over a place in line outside the theater."[17]

Broadcast on ABC, the show was seen in 43 percent of all TV-equipped American households—about 25 million of them. In the decade since 1960, when ABC had first contracted for the broadcast, only five shows of any kind on any network had achieved better ratings, and none of these was nearly as long as the two-and-a-half-hour Oscars show, which was thus a far more lucrative advertising magnet.[18] While ratings for the show have fluctuated somewhat since the banner year of 1970, and the Super Bowl has usurped the top spot on the annual Nielsen list, the profits associated with the Oscars broadcast, both to the academy and to the network, have never stopped growing. Starting around 1970, those involved with the Academy Awards ceremony came to see it less as Hollywood's premier event than as *television's* premier Hollywood event. The old Hollywood star system was becoming ever more rigorously subject to the new celebrity logic of the television (a logic of exaggerated intimacy rather than exaggerated distance), which could greatly amplify—or virtually negate—the effects wrought by the cinematic apparatus. The Academy Awards show was now understood to serve as the newly dominated cultural medium's key point of articulation with the newly dominant one.

Its producers came to understand, as well, that compared to virtually every other television event, the Academy Awards show was

a machine for printing money. Where most previous award presentations had appeared, in narrowly economic terms, as gifting rituals—instances of sheer expenditure involving outlays of cash and labor for which there could be only indirect (temporally remote, widely dispersed, and/or strictly symbolic) returns—the Oscars represented a direct and immediate annual windfall for the gift-givers. Even the very first televised Oscars show, in 1952, was a fairly lucrative undertaking, bringing more than half a million dollars (adjusted for inflation) into the Motion Picture Academy's coffers. But by the end of the century, the Oscar had actually managed to invert the economics of the Nobel: on each statuette the academy presented, it was realizing a profit equal to the honorarium that the Swedish Academy was giving away to each Nobel laureate (approximately one million dollars). As for ABC, which prior to the 1970 broadcast had allowed NBC to outbid it for the five-year Oscars contract beginning in 1971, the network made sure to restore its hold on the awards at the first opportunity, and has kept an iron grip on them since 1976. Its profit from the Oscars broadcast, always far higher than from other primetime programming, has become a lifeline in what, since the rise of cable TV, has been "basically a low-margin to breakeven business."[19] By 1999, ABC was lucky to see net revenues of 25 million dollars in any given quarter.[20] The Oscars broadcast by itself could net more than $20 million, on advertising revenues of more than $60 million.[21]

In Part II of this book, where we'll consider the actual work of administration, selection, funding, and promotion that goes into a cultural prize, and the specific dispositions of those who perform this work, the question of motives will be taken up in some detail. Certainly there has always been, in greater or lesser degree and more or less euphemized form, a "profit motive" behind the "gift"

of the prize. But the unparalleled success of the Academy Awards in generating net income has over the past three decades put this motivation into play in much more direct or naked ways. Since 1970, the networks have displayed an unrelenting impulse to confer cultural awards, an impulse which has scarcely been couched in cultural, or aesthetic, terms at all. The years 1972–1974 were particularly important in spreading this awards mania among television executives, for it was in these years that they discovered their power to create awards programs out of thin air. ABC, having lost the Oscars to NBC just when the economic potential of those awards was becoming clear, compounded this mistake two years later by relinquishing the Grammy Awards to CBS after quarreling with the National Academy of Recording Arts and Sciences about the venue. When CBS pulled a tremendous 53 percent audience share with the 1973 Grammy show, ABC began seriously to regret its decision.[22] The network's response was to launch a competing show, the American Music Awards, which, though seemingly disadvantaged by having no history, no stockpiles of cultural prestige, no symbolic net worth whatsoever, had the practical advantage of being unencumbered by official music-industry involvement, with all the professional scruples, bureaucratic machinery, and entrenched conflicts of interest such involvement entails. The AMAs were to be based on sales data and people's-choice polls rather than juries of credentialed experts or membership ballots, and the ceremony was to be administered not by an association of professionals but by a production team led by Dick Clark of the hit show *American Bandstand*. There would be no technical awards, no awards for classical music or jazz, just a parade of pop stars. Though it was in effect *nothing more than* a television production, designed to showcase the year's most marketable performers—the awards themselves

lacking any apparent symbolic function, and simply serving to confirm the values established by the market for recorded music—the first American Music Awards show, in 1974, attracted (thanks to Clark) more high-status musical talent than the Grammys, challenging the latter for credibility in the field as well as for audience share. Within a few years of their founding, the AMAs were consistently winning the ratings war, coming out ahead of the Grammys seven times in the decade of 1978–1987.

CBS reciprocated by adopting the same strategy vis-à-vis NBC/ABC's Oscars: in 1975 it launched the People's Choice Awards, a Nielsen-based awards program with TV, music, and sports categories in addition to movie awards. By then, any doubts about the feasibility of manufacturing awards shows in this way, or about the viability of awards programming in general, had dissipated, and the networks together were devoting more than twenty-five hours per year to awards programs, up from just nine and a half hours in 1971. By 1977, the now ubiquitous complaint of awards overkill was being registered in the newspapers, with satiric pieces announcing, for example, the "American Award Foundation's first annual Awards Awards."[23] Yet by the end of the century, the amount of annual primetime given over to award shows had increased a further 150 percent, to nearly sixty hours, with an additional two hundred hours of awards programming (more than seventy separate awards ceremonies) on the cable channels.[24] There, even some of the most established awards, such as TNT's Cable Ace Awards, seemed to be nothing but excuses to put celebrities onscreen for a few hours at very low cost, while advertising one's own product. In many cases, the prizes appear to go to whichever performers have agreed to show up. Often these performers do double duty as presenters or featured entertainers; when you see them onstage, you know they'll

be collecting an award before long. Bill Maher, who hosted the six-teenth annual Ace Awards in 1995, received the first of two Aces that night (for best host of an entertainment show) almost as soon as he completed his opening monologue. "Great," he remarked sarcastically. "Now I have to host the rest of this crappy show."

Even peripheral or parasitic productions such as the various Oscars pre-shows have become a significant programming niche and a major revenue source for both the networks and cable. The E! Entertainment Channel's Oscar pre-show, hosted by Joan Rivers, was that channel's best-rated show of the year in 1998, and in fact the best-rated show in E!'s eleven-year history. It succeeded so well that the Motion Picture Academy stepped in the following year to defend the value of its contract with ABC, launching an "official" *Oscars Preview Show* on that network and prohibiting non-ABC cameras from covering celebrity arrivals after five P.M. at the Dorothy Chandler Pavilion's red-carpeted entrance.[25]

Thus, although the forces propelling the Oscar, and the cultural terrains falling within the immediate compass of its shadow, have been rather different, over the past several decades it has come to loom as large on the field of prizes as the Nobel. If the latter is the philanthropic model, the model of cultural prize as "gift to mankind," the former is the business model, the model of cultural prize as trademarked property, publicity vehicle, and profitable media franchise. Already an object of envy and emulation in the postwar years, the Academy Awards have, since the early 1970s, spawned direct imitations in virtually every country where films are made, each of these "foreign Oscars" featuring its own nicknamed statuette: the Césars of France (1976), the Genies of Canada (1979), the Golden Roosters of China (1981), the Amandas of Norway (1984), the Goyas of Spain (1986), the Lions of the Czech Republic (1994),

and so forth. Domestically, it has consolidated its position of dominance among the more established film prizes, as well as inspiring an even larger number of newcomers. The movie prizes founded in the postwar period—those sponsored for the most part by the guilds and the film circles—have settled into an orderly system within which the preeminence of the Academy Awards is always implicitly recognized. One feature of this system is a timetable according to which the awards season must culminate in late winter (until recently, always late March or early April) at the Academy Awards, with all other prizes serving through the winter months as little more than leading indicators of the eventual Oscar results ("appetizers" to the Oscars banquet, as one producer put it). Some of these leading-indicator prizes forecast the Oscar winners almost as reliably as the bookmakers in London and Las Vegas. The Golden Globes, which have become the best-known and by far the most profitable of the second-tier awards, duplicated the academy's Best Picture selection sixteen out of twenty times between 1980 and 1999, and its Best Director selection fourteen times. The most perfectly redundant of all such prizes is the award for outstanding direction from the Directors Guild of America, which over the same twenty-year period failed only twice to go to the Oscar winner. Indeed, this prolonged build-up to the Oscars has more and more seemed a kind of build-down, with so many dress rehearsals that the actual opening night comes as an anticlimax. Reacting in part to this problem, whereby a seeming advantage (the coveted final date on the movie-awards calendar) has started to appear as something of a disadvantage, the academy announced in the summer of 2002 that it would be shifting the ceremony to an earlier date, in late February.[26]

As we would expect, the newer, post-1970 prizes have exhibited

a stronger differentiating tendency, promising with their different criteria of eligibility and selection to provide a radical alternative or at least a mild correction to the Oscars. But the majority of these prizes, which range across the spectrum from the most general to more restricted markets—that is, from sheer popularity contests like the People's Choice Awards to prizes of the "independent" "art" cinema like the Independent Spirit Awards (founded in 1986) —are a good deal closer to the Academy Award model than their populist or anticommercial rhetoric would suggest. Not only do they remain faithful to the Oscar-centered awards calendar as well as to the basic Oscar award categories, with their overemphasis on individual achievement and individual authorship, but despite the divergence of their winners lists, they often reinforce the same underlying hierarchy of value that is imposed by the Oscars. Thus, for example, while a look at the record books reveals that the 1996 Independent Spirit Award winners for Best Actor (Sean Penn), Best Supporting Actor (Benicio Del Toro), and Best Actress (Elisabeth Shue), did not receive a single Oscar nomination between them, this is not the whole story. Nicolas Cage, who played opposite Shue in *Leaving Las Vegas,* won the Academy Award for Best Actor; Susan Sarandon, who played opposite Penn in *Dead Man Walking,* won Best Actress; and Kevin Spacey, who played opposite Del Toro in *The Usual Suspects,* won Best Supporting Actor. Moreover, Spacey had been nominated for the Independent Spirit Best Actor award for his other performance that year, in *Swimming with Sharks,* while the screenwriter for *The Usual Suspects,* Christopher Mc-Quarrie, won the screenplay award at both ceremonies.

The differences here are nugatory in comparison with the overlaps, and the whole lineup contradicts the ISA's rhetoric about saluting "unsung heroes of filmmaking."[27] By 1996, the Independent

Spirit Awards had already become a rather big-time affair, staged under a half-acre tent at the beach in Santa Monica, emceed by Samuel L. Jackson (himself both an Oscar nominee and an Independent Spirit winner the previous year for *Pulp Fiction*) and featuring an expensively catered lunch. The whole event was televised two days later on the Independent Film Channel (IFC) and its parent channel, Bravo, during the commercial breaks of the Academy Awards: a commercial "Zap the Oscars" gimmick which the IFC's press agents characteristically described as "an utterly 'noncommercial' answer" to the commercialism of the Academy Awards. Most of those in attendance seemed to regard it as a business event, and the pre-ceremony conversations were overwhelmingly about production, distribution, financial backing for new projects, and so on. Miramax, with ten nominations and with several tables reserved at front-and-center, was the dominant presence; the company was launching what would become an increasingly aggressive—and controversial—campaign for awards over the next few years, culminating in nine Oscars for *The English Patient* in 1997 followed by a sweep of Best Picture, Best Actor, Best Actress, Best Supporting Actress, Best Screenplay, and three other awards for *Shakespeare in Love* and *Life Is Beautiful* in 1999.[28] Throughout the presentation ceremony, it was evident that the audience had less interest in celebrating its supposed "independence" from big-studio money than in cheering Hollywood's biggest stars (Sean Penn and Jodie Foster were the crowd favorites). The television audience was presumed to share this stargazing orientation, since the incentive held out to them for tuning in was "to see stars like Jodie Foster, Harvey Keitel, Quentin Tarantino, Winona Ryder, Alec Baldwin, Sandra Bullock, and John Travolta."

Some of this ambiguity was owing to the increasingly vexed sta-

tus of the "indie" film during the 1990s, when more and more expensive, and often star-studded and highly profitable, projects were being made and financed outside the major film companies. By the time such films started to receive large numbers of Academy Award nominations (the day of the February 1997 nomination announcements was dubbed "Independents' Day"), the industry giants had themselves bought or established nominally "independent" subsidiaries; indeed, Miramax had already been acquired by Disney back in 1993. By the late 1990s, "indie" was looking to many observers like a marketing category within the mainstream commercial studio system, containing products bearing the legitimizing label of a small subsidiary and pitched to a somewhat narrower demographic than the standard commodity, but recognizably Hollywood for all that: a cinematic equivalent of the fake microbrews that were then emerging from the major beer makers. It was in response to this widespread perception of false labeling that the Independent Spirit Awards decided in 1999 to create a new prize category, "Best First Feature under $500,000." Organizers hoped that this category would serve as a refuge for indie authenticity, enabling them to honor genuinely "unsung" filmmakers—without, however, removing any of the telegenic glitz from their annual celebration of stars.

But as we observed in the previous chapter, the tendency of awards to soften their strategies of differentiation over time, to begin to merge with the very prizes that had served as their originary antagonists, is not limited to independent cinema, and is not even, as is usually assumed, an effect of eroding economic independence in general. It is important to guard against subsuming the curious logic of prize proliferation into a ready-made narrative of art's commodification. For one thing, the awards that begin from a more perfectly commercial position than that of the dominant prize tend,

over time, to begin angling for symbolic profits, introducing a jury-based award or a lifetime achievement component, or otherwise diluting the criterion of popularity with more culturally legitimate elements. Some of the dominant prizes themselves have completely overhauled their rules and procedures in order to escape the stigma of commercialism—succeeding in gaining credibility among artists and critics to the point where promoters of the "independent" or "alternative" awards are reduced to applauding themselves for having inspired the changes that wrought their own redundancy and eventual demise. Britain's BRAT awards in popular music, for example, which were run as a satiric feature in *NME (New Musical Express)* magazine in 1993 and then turned into an actual awards show in 1994, can take some credit for the dramatic changes that the British Phonographic Industry (BPI) made to the voting procedures of its BRIT Awards in 1993–1994.[29] Once those changes took effect, however, *NME* found its top awards consistently going to the very same acts that were winning the BRITs; by 1999, after several unsuccessful attempts to redifferentiate themselves, the BRATs simply dropped the satiric name (becoming the Premier Awards), and in effect conceded that the BRITs were no longer a viable target of *NME*'s abuse.

As we have noted already, this kind of closing up, over time, of the gaps between dominant and alternative prizes opens up new opportunities for heterogeneous and heterodox awards; such is the temporal logic of the cultural field as a whole.[30] But the new or avant-garde positions and strategies of differentiation that are thus continually generated are not simply staked out along a single axis of money, with the degree of a prize's "commercialism" determining its place on the field. Differences are often established along social, racial, and ideological lines—as, for example, with the

NAACP Image Awards or the Family Film Awards. To be sure, the rhetoric of "commercialism versus independence" remains widespread in the contemporary awards scene, but unstable ironies have crept into this rhetoric, making the new prizes, whatever their stance with regard to "commercialism," less and less readable as forms either of homage or of critique. The same decades that have seen the Oscars consolidate their dominant position and greatly increase their gravitational effect on other prizes have seen the emergence of a whole shadow universe of mock prizes, parodic clones of "real" awards, whose relationship to respectable consecrations is far from simple.

At closest proximity to the world of legitimate awards are such creations as the MTV Movie Awards, founded in 1992 as the teen moviegoer's "antidote to the Oscars." These awards exerted much the same effect in the 1990s that Dick Clark's American Music Awards did in the 1970s, forcing an even further shift of emphasis from awards *for* entertainment toward awards *as* entertainment. Featuring such categories as Best Kiss, Best Fight, and Best Action Sequence—categories that break with the romantic ideology of individual artistic genius that has dominated cultural prizes—and presenting winners with a statuette resembling a popcorn canister filled with gold-plated popcorn, these young-people's-choice awards would seem to have dispensed with the pretension, the seriousness, and hence the symbolic resonance of the Academy Awards. Yet the nonseriousness of the MTV Movie Awards is itself a very serious business, invoked relentlessly in the awards' multiformat, multimedia publicity materials, and carefully regulated during the show itself. When someone steps over the line of acceptable irreverence, departing too sharply from the rhetorical norms of the cultural-prize ceremony, the transgression is edited out of the

broadcast. An example is winning director Bobby Farrelly's parodic acceptance speech in 1999 in which, referring to the shooting at Columbine High School in Littleton, Colorado, six weeks earlier, he expressed the solemn hope that his work might inspire more high school massacres. This was certainly well within the limits of regular MTV programming in the late 1990s (of the satirical cartoon *Beavis and Butthead,* for example), but was judged unacceptable for the MTV Movie Awards. The fact is, it is the (rigorously controlled) nonseriousness of the awards which has fostered such serious investment in them on the part of the show's young viewers, who do not "throw away" their votes on B-flicks or campus cult classics, but in fact honor many of the same films and performers consecrated by the Academy Awards (for example, Tom Hanks and Tommy Lee Jones in 1994; *Titanic* in 1998; Gwyneth Paltrow in 1999).

These serious investments in the idea of a nonserious awards show have made the show a ratings winner and an important vehicle for exploiting the synergies of the movie and music markets. Hollywood executives look to the awards as the single best gauge of the avidly moviegoing youth market and hence as the one awards show that really matters with regard to funding for future projects.[31] In this respect, the awards occupy a place within the "weightless economy" not only in the category of entertainment but in the equally critical and even more rapidly expanding category of "business knowledge," meaning that they have economic value as information about economic value, as potentially predictive data concerning industry trends. Success on this double register is something that virtually all contemporary prize administrators aspire to in some form; they want to amuse and delight their audience, and they want to be recognized as leading rather than trailing

indicators of value. It is thus not surprising that the MTV Movie Awards have themselves become something of a model for such start-ups as the (now defunct) Blockbuster Awards, and even for the Oscars themselves, which have, for example, adopted the MTV device of running spoof footage from nominated films. The strategic management of nonseriousness is, after all, a fundamental task of prize administrators, who must secure a certain level of investment or belief on the part of those (presumably most of us) who know better than to take awards too seriously—those who, for example, embrace the Oscars precisely for their campiness or cheesiness, and lose interest when the ceremony becomes too sedate or dignified.

The respectability of the MTV Movie Awards show among entertainment prizes was underlined by its rapid ascent into the ranks of awards shows that have themselves won awards, which it first achieved with a Cable Ace Award for best editing in 1993. The oft-heard joke—"There are so many awards these days, they'll soon be giving awards for giving awards"—is badly out of date. Even among art and literature awards, a number of prizes have been honored in recent years, including the Orange Prize, which was short-listed for a sponsorship award in 1998. In architecture, Jay and Cindy Pritzker were presented with the tenth annual Honor Award of the National Building Museum in Washington, D.C. for their role as founders of the Pritzker Prize. In advertising, the Clio Awards CD, a compilation of award-winning advertisements from the mid-1990s, has won several prizes, including an Art Directors Guild of New York Award. Among entertainment awards, the Oscars, Grammys, and especially the Tonys have been winning Emmy awards in the "musical/comedy special" categories for decades, as well as American Comedy Awards since their founding in 1988. At

the 1995 American Comedy Awards, Garry Shandling was nomi-
nated for his performance at the 1994 Grammys, Roseanne Barr for
her performance at the MTV Video Awards, Whoopi Goldberg for
her performance at the Academy Awards, and Jason Alexander and
Ellen DeGeneres for their performances at the Emmys. The produc-
ers and writers and directors of these shows, as well as the hosts,
are all very conscious of competing with one another not only in the
commercial market for ratings and the symbolic market for respect-
ability among artists of film, music, or drama, but also in a subsid-
iary symbolic market for recognition in the field of award-show
production.

As we move further toward the margins of this expanding uni-
verse of not-quite-serious awards, we find prizes for less and less
reputable genres. For example, to keep our focus on film, there are
the Hubcap ("Hubby") Awards, created in 1984 by the satirical
columnist and TV host Joe Bob Briggs, a.k.a. John Bloom, who
proclaimed them the "Drive-In Academy Awards" and presented
them at such venues as the "Chiller Theater" horror movie conven-
tion at Fairleigh Dickinson University. The Hubbys, which featured
prizes for "Best Slimeball," "Best Kung-Fu," and "Best Mindless
Sex Comedy," were never televised (though they were once an-
nounced on the air by Connie Chung) and were discontinued in
1995, but they can be seen as an unwitting precursor to the MTV
Movie Awards, which essentially turned Bloom's satire of big-time
movie awards into a new form of big-time movie award. Yet part of
the reason the Hubbys (and indeed the whole Joe Bob Briggs drive-
in super-fan persona) caused problems for their founder was that
the object or target of their humor was so ambiguous. One could
well wonder whether, in doling out awards for "Best Breast Count"
or "Best Gross-Out," Bloom was effecting a populist inversion of

the legitimate hierarchy of cultural value, asserting the value of sheer mindless pleasure over that of detached aesthetic appreciation, or, rather, casting the cinema in general into aesthetic disrepute, not questioning the superiority of "art" over "trash" but questioning the very capacity of contemporary movies to rise to the level of art—mocking the pretensions of those who treat *Titanic* as though it were *War and Peace*. In honoring *Day of Atonement* as "the finest movie ever made about the true inner workings of the French-speaking Jewish Miami Mafia and the reasons they hate the Spanish-speaking Chilean-born German gangsters who don't respect their heritage,"[32] he would seem to have been asserting his own considerable sophistication of taste—consuming the most vulgar sort of cinematic dreck in the manner of a connoisseur, aesthetically slumming as only the most culturally privileged can do. But this ironized connoisseurship could be seen either as a way of marking his distinction from real-life Joe-Bobs, blue-collar Southerners who are presumed to take these violent, misogynistic films straight, or from the conventional movie critics and average moviegoers (the Oscars constituency) whose sheep-like adherence to bourgeois tastes prevents their enjoyment of the "live worm-eating scene" in *Prison Heat* or the "intergalactic hemorrhoid field sequence" in *Flesh Gordon II*.

With the Hubbys, we can't be sure whether a serious honor is being bestowed on a marginal cultural product judged superior of its kind (an especially entertaining drive-in movie), or whether a mock honor, amounting to a form of dishonor, is being bestowed on a mainstream cultural product judged inferior of its kind (an especially trivial and squalid film), or whether the mockery inherent in the award is ultimately directed at particular styles of consumption (low-cultural or bourgeois) rather than particular styles of produc-

tion. And these uncertainties have increasingly spread across the field of entertainment awards as that field has itself contrived to become more entertaining, the dominant awards being replicated in ever more eccentric and amusing ways. The awards for pornographic videos, for example, while seemingly straightforward instances of honoring a traditionally disesteemed and marginalized form, share a certain ironic or campy ethos with the Hubbys. With the slogan "A Party and an Awards Show (in That Order)," ten tubes of lubricant on every table, and prize categories like "Best Anal Sex Scene" and "Best Specialty Tape: Spanking," the Adult Video News Awards (AVNs) beg not to be taken too seriously. The fact that they are presented at major Las Vegas venues like Ballys and Caesar's Palace, with thousands of gowned and tuxedoed industry people in attendance (as well as many ordinary ticketholders, or "raincoats" in the industry lexicon), paparazzi lining the red-carpeted entranceway, celebrity entertainers like the magicians Penn and Teller, golden statuettes for the winners, and acceptance speeches that (apart from the disconcertingly explicit references to sex acts) mimic exactly the rhetoric of the typical Oscars speech, complete with thanking of parents, seems to heighten rather than lessen the effect of over-the-top parody.

But here again, what exactly is being ridiculed? Do these mock Oscars in fact mock the Oscars? The Academy Awards themselves already represent a major, indeed the exemplary, extension of cultural consecrations onto less legitimate, more popular fields of culture—part of the same tendency that has produced so many country music awards, crafts awards, and literary awards for such popular genres as mystery (the Agatha, the Edgar), crime (the Golden Dagger), Westerns (the Spur), romance (the Golden Heart, the Betty Trask), science fiction (the Nebula, the Hugo), and even

science fiction romance (the Sapphire). Like the Reuben Awards for "graphic novels" (comic books), the awards for erotic film are simply a further unfolding of this logic of mimicry along the expanding margins of cultural respectability. It is a logic which has produced not just an "Oscars of porn" (as the AVNs are known) but people's-choice awards for porn (the FOXEs, or Fans of X-Rated Entertainment Awards), critics' circle awards for porn (the XRCOs, or X-Rated Critics Organization Awards, founded in 1983), foreign awards for porn (the Hot d'Ors, which are to the AVNs what the Palmes d'Or are to the Oscars), and a porn hall of fame (the Legends of Erotica).[33] All of these porn prizes claim, in essentially the same way that the corresponding competitors of the Oscars do, to be aligned with a scale of value preferable to that served by the AVNs: less pretentious (meaning less dominated by symbolic or intellectual capital), less corrupt (meaning less dominated by social capital), or less commercial (meaning less dominated by economic capital).

William Margol, who founded the first major porn awards, the Eroticas, in 1978, and, after these were discontinued, assisted in creating the first adult-movie Lifetime Achievement Awards, told me that the function of porn prizes should be to honor genuine "artistic achievement" and "historical importance" in pornographic filmmaking, and that the AVNs, being industry awards underwritten by the major trade publication, simply endorse the films that sell best. According to Margol, the AVNs lack symbolic weight and are something of a "joke" to insiders.[34] This may well be true, but it isn't exactly news to those involved in the AVNs, who clearly revel in the AVNs' status as a mock award, a status which seems to augment their utility as tools of promotion rather than erode it. And it is difficult to believe that the XRCOs and the Eroticas aren't like-

wise inside jokes, that the whole spectrum of prizes and honors in this field isn't to some extent ironic. Which is not to say that they aren't "serious" awards—that if you worked in this particular cultural field, you wouldn't want to win one, that it wouldn't improve your standing among your peers and even in some way raise your status in the wider society. Nor does it mean that such awards carry no weight with consumers. On the contrary, purchasers of porn videos tend to be drawn with particular force toward award-winning titles. There are few fields of cultural consumption (children's literature is one) in which prizes have a more direct and powerful effect on sales.[35] Porn awards are symptomatic of a broad tendency in the economy of prestige: a tendency for instruments of consecration to take increasingly parodic and self-parodic forms without ceasing to function effectively as economic instruments in either the symbolic or the material sense. They are conceived as cultural entertainments in their own right, rather than simply as evaluations of cultural entertainments; but even where this entertainment function is clearly their primary one, the market functions continue to be served, which is to say that they continue to play a formidable role in establishing the symbolic and economic hierarchies in their field.

Even the comically inverted honors, the "booby prizes" that are bestowed on the "worst" works of culture, are perfectly functional parts of the economy of prestige, operating much more like other, ordinary awards than like the cultural Molotov cocktails they generally fancy themselves to be. These awards are not a new invention, of course; they are essentially satire in its institutionalized form, and enjoy a long tradition in private clubs and salons. In the twentieth century, worst-book prizes seemed to emerge contemporaneously with best-book prizes. In Britain, for example, Barbara Cartland fondly recalled the annual awards ceremony for the

"worst literary efforts of the year" hosted by Osbert and Edith Sitwell in their Chelsea mansion during the 1920s: "The prizes for the Worst Poem of the Year and other 'Worsts' were things like a glazed fish in a glass case. . . . It's safe to say all of the brightest literary talents of the time were magnificently debunked."[36] As with other forms of awards, though, and especially those whose presentation may itself be represented as an entertaining spectacle, these mock awards have proliferated exponentially since the 1970s, achieving in some fields a state of redundancy almost approaching that of ordinary prizes. In cinema, for example, the Golden Raspberry Awards, or "Razzies," founded in 1981, have had to share space with the *Harvard Lampoon*'s various "Poonie" Awards, founded in 1939; the Golden Turkey Awards, which originate from the 1978 book project *The Fifty Worst Films of All Time;* the Stinkers (first awarded in 1979); the many top-ten-worst-movie lists (the earliest of which is again the *Harvard Lampoon*'s, from 1939), and many other similar dishonors. In advertising, the Clio Awards are satirized by the Schmio Awards, which are themselves a variation on the consumer-group sponsored Hubbards. In literature, there are awards for worst book of the year (the J. Gordon Coogler Award), worst translation of the year (the Rack Award), worst-written sex scene of the year (the Bad Sex Award), worst piece of academic writing (the Bad Writing Contest Gold Medal), and worst piece of nonfiction writing (the Silver Rhubarb Award). There are also several prizes for intentionally bad writing, such as the Bulwer-Lytton Grand Prize of Bad Writing, the Dashiell Hammett Bad Writing Prize, and the Hemingway Bad Writing Prize—though these are in fact best-of prizes in the minor genre of parody rather than worst-of prizes in the major genre of literary fiction.

Worst-of prizes often present themselves as parodies or travesties

of the dominant prize in their field, as though the object of their satire were the mainstream consecration and the values it represents. But their actual effects are generally more ambiguous than this suggests. A prize that came fairly close to realizing this stable satiric intention was the Worst Record of the Year Award that was presented at the BRATs. As noted above, though these music awards were set up as a pointed slap at the BRITs (the statuette was a fist with a raised middle finger), the latter's procedural amendments in 1993–1994 prevented the BRATs from successfully differentiating themselves in positive terms—that is, from conferring their chief honors on artists different from those honored by the BRITs. But during the years of their existence, the BRATs did regularly succeed in marking a point of *negative* differentiation from the BRITs, by means of their Worst Record of the Year Award. This award was used to indicate the sort of big-selling bubblegum music or schmaltz that, while risibly dreadful to the BRAT constituency, would still be treated respectfully at the BRITs, even contending for BRIT awards. The Spice Girls, for example, who after their breakup received the BRITs highest honor, the Outstanding Contribution to British Music award, were the recipients of both the BRIT Best British Single and the BRAT Worst Record award in 1997 for their smash hit "Wannabe." The next year, it was anticipated that Elton John's tribute to the late Princess Diana, his "Candle in the Wind" remake, would manage the same double victory—though, in the event, that song was narrowly defeated for both awards. Even as it became more and more difficult in these years to tell the mock prize from the straight prize, the worst-record award served as a reminder that the BRATs were still capable not just of mimicking the form of the BRITs but of actually mocking their content and challenging their regime of value.

More typical of antiprizes, though, are the Golden Raspberry Award Foundation's Razzie Awards, founded in 1980–1981. Though they claim to be "a parody of award shows in general (and the Oscars in particular)," their parody seems not to extend much beyond the format of the Oscars show. Unlike the perhaps unsustainably sophisticated *Harvard Lampoon* awards, which in 1994 (the last time they were presented) went to *Schindler's List, Philadelphia,* and *Forrest Gum*p, the Razzies do not mock the particular cultural preferences, or tastes, that are reflected and promoted by the Academy of Motion Picture Arts and Sciences. The films that are skewered at the Razzies are not the ones that receive Academy Award nominations, but, on the contrary, the very sorts of film that the academy disdains: big-budget flops like *Can't Stop the Music, Ishtar, Howard the Duck,* and *Christopher Columbus: The Discovery,* or commercially successful but pulpy action flicks like *Rambo: First Blood, Part II.* More rarely, they are lower-budget, prestige films that went fantastically awry, like Norman Mailer's *Tough Guys Don't Dance.* Among the roughly twenty-five actors, actresses, and directors nominated for Razzies each year, there are on average three former Oscar nominees or Oscar winners: notably Faye Dunaway, a three-time Academy Award nominee and Best Actress in 1977, who between 1981 and 1998 was nominated for seven Razzies, winning twice; and Kevin Costner, who, after winning Best Picture and Best Director and capturing a Best Actor nomination for *Dances with Wolves* at the 1991 Oscars, became a perennial Razzie target, with nine nominations and five awards over the next seven years. (Part of the comic formula of the Golden Raspberries is to pile up the nominations year after year on a small handful of celebrities, a negative version of the winner-take-all logic of contemporary symbolic markets.) Even in these cases, the

Golden Raspberry Foundation is not really at odds with the Motion Picture Academy, since the specific films and performances honored with Oscars are not those dishonored with Razzies (the sole exception being Amy Irving's nominations for both the Oscar and Razzie Supporting Actress awards for *Yentl* in 1984). And most Razzie winners are well off the map of Oscar territory, nearly half of them being outsider or novelty performers, meaning celebrities crossing over from other fields of entertainment—television (William Shatner, Tom Arnold, Elizabeth Berkley), popular music (Madonna, Prince, Vanilla Ice, Spice Girls), stand-up comedy (Pauly Shore, Adam Sandler, Andrew Dice Clay), or sports (O. J. Simpson, Dennis Rodman). Such figures combine very high public profile—assuring publicity for the Razzies—with rather low standing in Hollywood—assuring that the annual mockery of stars does not actually contest the established hierarchy of the star system. On balance, you could say that the Razzies serve as a negative exercise of the cinematic taste whose positive expression is the Oscars. If you like the films and actors that win Academy Awards, you'll dislike the ones that win Razzies.

John B. Wilson, a movie-trailer writer who is the founder, orchestrator, and unrelenting publicist for the Razzies, likes to say that "bad taste" is what these awards are "all about," and in a sense that's true. The presentation ceremony ("Tinsel Town's tackiest anti-awards show") is notably cheesy and undignified, with transvestite presenters, dirt-cheap trophies (a gold-painted plastic raspberry glued to a mangled roll of Super-8 film), and goofy audience sing-alongs. Yet these "distink-tions" take themselves, and their judgments of taste, more seriously than they say. Wilson hustles press coverage for the Razzies very aggressively, to the point where the ceremony, the last in the long sequence of pre-Oscars awards

shows, and held in the very room where the first Academy Awards were presented in 1929, has become an important and fully integral part of the publicity wind-up for the Oscars. As is suggested by the opening musical number at the 1996 ceremony, aptly based on the *Patty Duke Show* theme song, the parodic celebration of bad taste is less the opposite of a straight cultural consecration than its inseparable twin:[37]

> *While Oscar means block-long limousines*
> *Designer gowns and movie queens*
> *A Razzie's worth about two bucks,*
> *They're always won by total schmucks—*
> *What a crazy scene!*
> *Sure, they're honors,*
> *Though one's a dis-honor, we admit!*
> *They are alike*
> *They're Not alike,*
> *They're really not at all alike*
> *Oh, who gives a shit?!*
> *They're honors*
> *Of two diff'rent kinds!*

Since the judgment of taste is fundamentally a negative judgment, a learned capacity to refuse the pleasures that others (those who lack taste) enjoy, worst-of prizes such as the Raspberry Foundation's "darts of derision" are, from the standpoint of the judges, a more perfect instrument of cultural distinction than ordinary best-of prizes. The foundation members demonstrate their sense of the cultural game better by disdaining the work of Sylvester Stallone, the all-time Razzies winner, than they would by joining in the applause

for Katharine Hepburn, the all-time Oscars winner, particularly since they are able thus to express their cultural preferences without appearing to take seriously the most common (and vulgar) mechanism for doing so—namely, prizes. For all their self-proclaimed "tackiness," the Razzies are more committed to the policing of good taste than are the Oscars, as well as being more elitist in their effects. It is no surprise, for example, that Stallone and other repeat targets such as Madonna, Sharon Stone, and Burt Reynolds are actors firmly marked by their blue-collar backgrounds and cultural orientations. Indeed, in singling out Stallone as the Worst Actor of the Century, the Razzies have seized on the quintessential working-class entertainer. Stallone's career follows a familiar trajectory from utterly inauspicious beginnings (born in Hell's Kitchen on the West Side of Manhattan, with damaged facial nerves that cause slurred speech; shuttled between relatives; repeatedly expelled from school; told by acting teachers that he had no talent) to enormous popular success (his *Rambo* and *Rocky* pictures of the late 1970s and 1980s grossed more than $2 billion) to strenuous but futile bids for cultural recognition and respectability (by the late 1990s he had begun to seek serious acting roles in low-budget, high-status film projects; he has become a collector of modern art, a polo player, a "neo-Expressionist" painter). The Golden Raspberry Foundation, which has gone so far as to include a regular "Eye on Sly" column in its newsletter and to mock other members of Stallone's family (with worst-actress awards for his then-wife Brigitte Nielsen and a worst-song composition award for his brother Frank in 1986), can be numbered among the cultural policing mechanisms that ensure this trajectory will never be wholly realized, that Stallone and his work will always be marked out as vulgar—as something of a joke to those who know better. That this joke is perfectly serious in its cul-

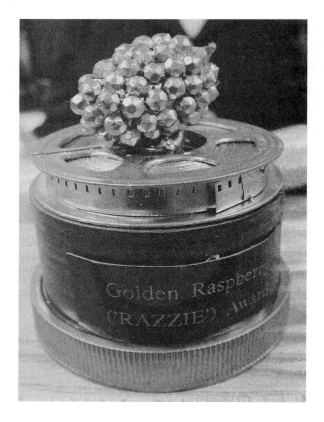

1. "Worth about two bucks": the Golden Raspberry trophy. (Photo by Mike
 Medlock. Copyright © 2001 John Wilson and G.R.A.F.)

tural implications—as serious, at any rate, as any other awards
show in the Oscars orbit—has not been lost on the recipients, only
one of whom, himself conspicuously a foreigner (action director
Paul Verhoeven), has actually been good-humored enough to at-
tend the ceremony and make a mock acceptance speech. The Raz-
zies are good fun for those in attendance, but much of the cultural
work they perform is that of naming the real losers of the "Oscars
race": not the failed contenders who had to be satisfied with a mere

nomination, but those who lie unmentionable at the bottom of the Motion Picture Academy's annual hierarchy, and whose work merely confirms, in the eyes of academy members, their negligible stature as artists.

In a sense, cultural prizes have gone beyond the reach of parody. The mock prize has emerged in recent decades not really as a counterweight or antidote to the prize proper, a sign of resistance to the perceived tyranny of awards in contemporary culture, but rather as an inexpensive and potentially powerful strategy of differentiation. Though the Razzies do not represent a unique or even a particularly interesting set of dispositions and tastes as regards contemporary film, they have managed despite their late start to stake a position of real prominence in perhaps the most crowded of all cultural-prize terrains, putting more symbolic power in the hands of John Wilson and his foundation than can be claimed by much larger and vastly better-funded organizations. At a time when seven-figure budgets have become routine in the entertainment-prize industry, the entertaining strategy of differentiation by inversion—mock-honoring the worst—may be the poor man's best alternative, particularly since the very joke of the "five-hundred-sixty-seven-dollar budget" assists, entertainingly, in marking the difference.

We should therefore see the various aberrational or eccentric manifestations of the contemporary prize frenzy—the mock prizes and antiprizes and booby prizes—not as signs of exhaustion or saturation, but as a measure of the cultural prize's flexibility and of the resourcefulness of those who wield it as an instrument of distinction making. As we survey the many parodies and travesties of "real" cultural prizes, recognizing that those "real" or "serious" prizes themselves are compelled to serve as knowingly risible entertainments, the difficulty we face is in imagining a position of genu-

ine resistance or even exteriority to the cultural system of awards. Awards have become the most ubiquitous and awkwardly indispensable instrument of cultural transaction. Scarcely any of the business of culture can be conducted without recourse to them, not even the business of resisting their putative effects. It is to this business that we will turn in the next two parts of the book: first, to the business of actually funding, administering, judging, and presenting prizes, deploying them effectively as instruments of conversion in the cultural economy; and then to the business of resisting or escaping what has been variously lamented as the "Nobel effect," the "Oscar effect," or the effect of "Bookerization" on our contemporary cultural life.

II. Peculiarities of the Awards Industry

The Making of a Prize

There are more idiosyncratic awards. One, financed by
Guinness, [is] for the arts company that does its best
for [corporate] sponsors.

> —Anthony Thorncroft, in the *Financial Times*,
> July 1, 1997, reporting on the 1997 FT/ABSA
> Awards, designed to honor corporations that
> provide exceptional support of the arts

In the past century, it has become increasingly common for sur-
viving family, friends, or colleagues to commemorate the life of a
beloved and respected person, especially a person whose life was
devoted in some way to literature or the arts, by establishing a cul-
tural prize in his or her honor. Wherever we find a sudden rise in the
rate of death among the cultured classes, we are likely to find a clus-
ter of new prizes. In England, a little flurry of memorial book and
poetry prizes occurred after World War I, supported in part by
funds from war widows. In America, a large number of memorial
art and theater prizes has emerged since the advent of the AIDS cri-
sis in the early 1980s. That this reliance on the prize as a fitting me-
morial gesture has today become almost automatic, even obliga-

tory, was brought home to me when, in the late 1990s, two of my friends from graduate school and two faculty colleagues at Penn all passed away in the space of a few months. In each case, the immediate collective response was to solicit donations for a prize: a prize for "exceptionally fine writing" in one instance, for the "outstanding dissertation" in another, and for more specialized scholarly achievements in the remaining two. The individuals being memorialized in these disconcertingly identical ways had all been successful mid-career academics, literary critics at major research universities whose friends were mostly other literary critics at other research universities. So we are dealing here with what David Lodge has satirized as the "small world" of elite literary academe, a world that has been especially inclined toward prizes at least since the poetry and essay prize competitions of the eighteenth century. But the phenomenon is not simply a local one, either. Recently I received in the mail an obituary of another old friend, a decidedly nonacademic journalist and writer who had led a very active public life well into his eighties. He, too, had immediately been commemorated with an annual prize in his name—and this despite his having steadfastly declined any awards and honors offered to him during his lifetime. In fact, none of these friends would have had much positive to say about cultural prizes; not many people do. Yet we turn without hesitation to the prize as the most appropriate means of honoring their memory.

I want to stress here the fact that prize creation has become an automatic or habitual act, a *thoughtless* act in just the sense that most other forms of gift (no matter how "thoughtful") are essentially thoughtless: we don't ask ourselves whether or not to bring wine or flowers to a dinner party, whether or not to purchase a wedding present or a shower gift. These are acts which are initiated

unthinkingly and without conscious calculation, however much careful thought and reckoning of debts goes into the actual choice of a vintage or a vase. We do ultimately strive to offer something that is appropriate in kind and in scale both to the occasion and to the individual, but the practice of "giving"—something, anything— is presupposed, built into the field of social relations that binds us to one another. The act of creating a memorial prize—on the face of it, a rather complicated and bureaucratic thing to do—has, it appears, been so often repeated over the past hundred years that it has managed to insinuate itself into this zone of cultural habit. We are now able to assume, within the framework of our misrecognized economic dispositions, the fitness of a prize to the memorial occasion. And having done so, we can in all innocence set about perfecting the symmetry between the gift of the prize and the "giving" qualities of our deceased friend or colleague, who may for example have given much time and energy to fostering young musicians, or minority students, or unpublished poets, or some other group that can readily serve to define a pool of eligible recipients. We thereby rehearse and resume the generous self-investments of the friend, flattering ourselves that we, too, are acting generously, both toward the friend who will thus be assured some modicum of immortality and toward the prospective winners of the prize. Far from operating outside economic logic, in a realm of pure giving or sheer expenditure, the act of endowing a prize entails an impulse to balance accounts and even, unavoidably, holds out the temptation of shared symbolic profit. But as we set about balancing accounts in a way that perhaps redounds to our credit, we do not understand exactly what we are doing. Acting on habit, we allow the prize to appear to us in an essentially idealized way. One effect of this is that we blind ourselves to the suffering, however slight, that a prize inflicts on

also-rans and runners-up: the counter-burden of *unhappiness* attendant on even the most joyous award presentation. But a more consequential effect of our idealism is that we rarely pause to consider the merely pedestrian and material dimensions of the undertaking.

In particular, we don't think about the actual business of administering, judging, and presenting a prize every year, the labor that this will demand of ourselves and, more importantly, of others, the costs in terms of time as well as money that will be entailed. Someone will have to gather and manage the funds, see that they are well invested, perhaps solicit donations to the endowment on a continuing basis. Someone will have to choose judges and persuade them to participate. Someone will have to determine, interpret, and enforce rules of eligibility, procedures of nomination, and so forth. Someone will have to arrange for a certificate to be appropriately worded, printed, and framed, or for a medal or statue of some kind to be designed and produced and annually reproduced—or, at the very least, someone will have to compose and deliver a presentation speech or a statement of commendation. Someone will have to identify an appropriate room or hall for the presentation ceremony, ensure its availability, issue invitations to guests, perhaps arrange for catering, orchestrate the event itself. And someone will need to enter the winner's name and other relevant information into various archives, see that the information is published in the relevant programs, newsletters, trade journals, newspapers, or magazines— see that those who may be interested in the award or in its recipient (the survivors of the deceased; alumni of the winner's alma mater; previous winners of the prize) are notified.

Each of these tasks obviously generates additional tasks for additional workers to accomplish. Once judges have been selected, arrangements must be made to bring them together and then they

must get down to the often quite daunting job of examining and assessing all the submissions or nominations or invited performances, deliberating with one another, arriving at consensus. (A relatively small and little-known awards program such as the Deadline Awards, for local journalism, can require between fifty and a hundred judges merely to handle their selection process.) Once the caterers have been hired, their work must be overseen and evaluated, their charges reviewed and perhaps challenged. Once contact has been made with appropriate journalists, special press-release copy may have to be prepared for them, follow-up faxes sent, letters of appreciation written to their editors. And so forth. As anyone who has found him- or herself suddenly responsible for managing a cultural prize can attest, no matter how minor, how local the prize may be, it nearly always turns out to involve more work, more workers, more expense, than its founders envisioned or made provision for.

This is the main reason that, in an era in which the growth of prizes and awards has substantially outpaced the growth of the cultural economy all told, the cultural field is littered with dead, canceled, discontinued prizes. Sometimes whole award programs are abandoned: a mass mailing to cultural prize offices that I conducted in 1998 produced a substantial file of letters from former administrators of discontinued awards programs—the Ethical Culture School's Book Awards, the Continuum Women's Studies Awards, the Harmony Awards, and so on—as well as many letters returned to me from defunct administrative offices. The American Center for Children's Television has not presented its Ollie Awards (for excellence in children's TV programming) since the mid-1990s, citing "financial reasons" for their inability to continue.[1] These awards simply required more labor than the ACCT could support on its minimal budget. The center's determination to present each entrant

with "an honest, constructive review of his or her work, based on the nominating panel's comments" made the enterprise economically unsustainable, despite entry fees as high as $245 per submission.[2] Sometimes an institution or administrative body simply pares down its roster of awards, jettisoning those that seem least central to its mission. This typically occurs after the organization has received all too many "gifts" from "friends," and finds itself saddled with small and perhaps redundant memorial prizes in which no one in the organization has made much of a personal investment. The American Film Institute, for example, discontinued two of its memorial prizes—the Robert M. Bennett Award and the Maya Deren Award—in the early 1990s, but has continued to present its oldest and most prestigious award, the Life Achievement Award, established in 1973. Sometimes an organization that is happily adding new prize categories almost every year nonetheless decides to discontinue one particular award which is judged too difficult or controversial or anachronistic: the Oscar Board (the Board of Governors of the Academy of Motion Picture Arts and Sciences), for example, voted in 1999 to discontinue the prize for Short Documentary. In this case, there was an outcry against the change, with such prominent academy members as Robert Redford and Martin Scorsese calling successfully for the board to reverse its decision.[3] But most canceled prizes simply disappear, without so much as an official announcement, let alone an organized protest. Those responsible for performing the underfunded and underappreciated work of the prize just run out of steam, leaving what is left of the inadequate legacy in a dormant account for someone else, perhaps, to take active charge of in the future.

The sheer burden of award-program labor can be a problem even for the biggest prizes supported by the heftiest endowments or cor-

porate sponsorship budgets. Bequests such as those of Alfred Nobel and Joseph Pulitzer are often quite specific, even overspecific, as to what kinds of artists or works should be honored, the scale of the cash awards they should receive, and other dimensions of the prize conceived as a grand consecration. But on the nuts-and-bolts questions of how the actual labor of executing such a will is to be distributed and remunerated, they have little to say, beyond perhaps proposing that a memorial foundation be set up, and/or designating some existing institution in whose hands the mundane business of nominating, judging, conferring, and so forth is to be placed—often an established academy or society or university whose denizens are vaguely assumed to possess the requisite expertise and plenty of leisure time. Nobel's will was so vague as to invite serious legal challenge from the Swedish branch of his family (joined by influential conservatives who objected to the flow of a Swedish family's capital into the pockets of foreigners).[4] As one historian describes the situation created by this bold but sketchy testament, "The main legatee was an [unnamed] fund or endowment which did not yet exist and which therefore had to be created, while the institutions appointed to select the prize-winners had to have imposed on them heavy duties involving great responsibilities without any provisions being made for their compensation."[5]

Not too surprisingly, several members of the Swedish Academy, hearing of Nobel's proposed literary prize within a few weeks of his death, agitated vehemently against the idea, pointing out, correctly, that the administration and adjudication of such an ambitious prize (with nominees spanning thirty languages and at least that many national literary traditions) would be an arduous undertaking even for a group perfectly suited to the task. This the academy most emphatically was not. Founded in 1786 along the lines of the French

Academy, its official charge was to defend the "purity, vigor, and majesty" of the Swedish language. A hundred years later, its membership still consisted almost entirely of aesthetically conservative, culturally nationalistic philologists, classicists, historians, and clergymen, with few apparent points of connection to contemporary poetry and fiction even in Sweden, let alone in the wider international scene.[6] The prize's opponents argued, as well, that if the academy accepted this enormously laborious new set of obligations, it would surely have to neglect its traditional duties and functions. The Nobel would not just add to the Academy's labors but would transform its cultural place and purpose, overriding the intentions of its illustrious founder, King Gustav III, with those of the middle-class engineer and munitions manufacturer Alfred Nobel.

In voting ultimately to accept the responsibility of the prize, the membership acceded to the views of its Permanent Secretary, Carl David af Wirsén, something of a maverick and a visionary among Stockholm's cultural elite. Far from fearing any deviation from the academy's traditional mission, Wirsén relished the opportunity to expand so vastly the sphere of its literary activities and influence. One of his main arguments during the academy's discussion of the proposal was that if the membership refused to take charge of the literary prize, the money Nobel had earmarked for literature would be absorbed into the nonliterary prizes, a material loss to the literary community worldwide, for which the academy would be forever blamed and reviled.[7] (Indeed, even this was an optimistic scenario, since family members contesting the will were prepared to declare it wholly invalid if even one of the specified academies, or, in connection with the Peace Prize, the Norwegian Parliament, declined to participate.) No doubt the thought of being perpetually in the disfavor of the "leading men of letters throughout Europe"—

the threat of this symbolic loss—was enough to sway some of the academy's members. But it is unlikely that Wirsén could have prevailed had the endowment in this case not been so great that, in addition to the unprecedentedly large cash award for the prizewinner, substantial funds could, with a little tinkering by the newly created Nobel Foundation, be provisioned for the academy itself.

The Nobel Foundation had been made aware of the difficulties they were imposing on the academy (and on the other four prize sections, as well), and drew up its official statutes of 1900 accordingly. It was stipulated that the academy could devote one quarter of its share of the available annual income from the main fund to its own expenses, including expenses not directly related to the prize. This meant that the academicians, many of whom were professors, would each receive an annual honorarium equal to about one third of a professorial salary—not quite the windfall some had been hoping for, but an attractive perk nonetheless.[8] The foundation also promised an initial one-time allocation six times as large as this annual expense budget (more than a million present-day dollars), to be used as the academy saw fit in preparing itself for its new administrative obligations.[9] This rare combination of a substantial annual operating budget with a huge signing bonus—neither of which was in any way specified in Alfred Nobel's will—is what secured the arrangement. Only the sheer enormity of Nobel's fortune ($9 million at his death in 1896: equivalent to perhaps a quarter-billion dollars today) made possible the realization of his vague and nearly unmanageable scheme.[10]

The financial arrangements for most cultural prizes are not nearly as comfortable as this; in general, meager provision is made for those who are expected to do the work. The main exceptions are prizes supported by corporate sponsors. Indeed, sponsorship in

this context often consists of covering the administrative, clerical, promotional, and other bureaucratic expenses of a prize whose original founder and benefactor omitted to take such costs adequately into account. Even where the cash award associated with a prize is substantial enough to attract journalistic attention, it is typically a quite modest portion of the overall budget, and the least difficult to obtain. The founders of the Orange Prize for Fiction managed early on to secure an anonymous endowment sufficient to provide for a £30,000 annual award (and thus to distinguish the prize as, at that time, "the U.K.'s largest award for a single novel"). But after discussions with Martyn Goff of the Book Trust and other experienced award administrators, they understood that in order for the prize to succeed in practical terms they would need a far larger budget to cover operating expenses, in particular the expenses associated with promotion and publicity. They sought a corporate sponsor, and found a capable partner in Peter Raymond of the cellular phone service company Orange PLC, who, without providing exact numbers, informed me that by 1999 Orange's expenditures on the prize—including extensive point-of-sale promotions, book club tie-ins, and other innovative promotional devices—amounted to about a quarter-million pounds annually.[11]

The real cost of the United Kingdom's richest best-novel prize in 1999 was therefore ten times its declared "value," ten times the size of the award itself, and would have required an original bequest on the order of eight million pounds to endow it permanently. This is just a simple fiction prize, with a small management committee that meets each month, a panel of five judges that makes the actual selection, and a two-hour ceremony. A prize such as the Pritzker in architecture, whose judges are not simply mailed a stack of books but are taken, along with an entourage of Pritzker functionaries, on

a worldwide tour of buildings designed by the nominated architects, obviously costs a good deal more; the travel budget alone is in the hundreds of thousands of dollars.[12] Still higher are the budgets for festival-style events in which the nominated artists perform before live audiences, or where nominated works are presented on stage or screen. Though tickets can be sold, revenues rarely approach expenses. In these cases, the costs tend to be shared among a large group of public and private sponsors. The 1999 Vienna Film Festival, for example, was underwritten by twenty-nine "corporate sponsors," twenty-five "promotional partners," sixteen "official suppliers," and five public organizations. The Van Cliburn International Piano Competition, which presents a cash award of just $20,000 to its first-prize winner, costs more than $3 million to run. In 1993, the competition was supported by fifty-seven corporations, thirty-one foundations, numerous individual donors, and arts councils or agencies at every level of government.[13]

I do not mean to suggest that every cultural prize requires a six- or seven-figure budget; my point is only that the endowment of an annual cash award does not in itself provide adequately for the perpetuation of a prize. Yet it is standard practice, not only among "amateur" prize founders, those establishing prizes as memorial or philanthropic gifts, but even among some of those who are launching awards programs on the corporate model, to underestimate the business or work that such an endowment entails. As a result, we find the awards industry staffed to an extraordinary degree with voluntary or very low-paid workers, and highly dependent on networks of professional association and obligation, on friendship and the exchange of favors: on "social capital" in lieu of money. The most glaring example of this is in the employment of judges, who are very rarely paid more than a nominal fee for what can, in some

fields of art, be tremendously time-consuming work. Book prizes probably place the greatest demand on judges, expecting them in some cases to read more than a hundred books—perhaps thirty thousand pages, or three months of forty-hour weeks for a fast reader. "If you do the maths," remarked Booker judge John Sutherland, "it's obviously impossible to read them all. . . . The convention is to lie."[14]

This literally impossible labor is meant, moreover, to be performed in return for a few hundred dollars and free review copies of the nominated books. The quantity of work is so very far out of line with the level of remuneration that administrators often call in their anonymous drones or volunteers (people around the office; friends in the business) to handle all but the final, least demanding but most visible phases of selection and evaluation. This particular division of labor, between the named and the unnamed judges, has in fact emerged as one of the most symptomatic features of the ever-expanding awards industry. To understand the structure of authority and the relations of power in the modern prize organization—which is the burden of the next chapter—we need to consider in more detail this question of visible versus invisible selectors, and to unpack both the mutual dependency and the inherent conflict that characterize their collaboration.

Taste Management

It was astonishing to learn that there has not been a single year in the past nineteen in which she has not been judging a book award. It is a remarkable record and one of which we can all feel a little proud. In no previous epoch could anything like it ever have been achieved.

—*Times Literary Supplement,* on Susan Hill's service as a book prize juror

In observing that judges for cultural prizes are rarely paid even minimum wage for their labors, I may seem to be missing the point. It is obviously not money that motivates people to do this kind of work but (ideally) the love of art, or (more realistically) a sense of obligation to the individuals or organizations involved, or (more cynically) a desire for the social and symbolic rewards that accrue to judges. None of these motives need exclude the others, and in fact prizes could never have attained their current level of cultural efficacy if they did not foster the joining of ideal and material, aesthetic and economic, generous and self-profiting impulses into a single, complex (conscious/unconscious) disposition—what we can think of as the judging *habitus*.[1] Those who serve on prize juries,

even if they do so reluctantly, out of a sense of obligation, nearly always approach the task seriously and honorably, and regard the decision their jury ultimately arrives at as an act of genuinely aesthetic discernment. Whatever their suspicions regarding the "corruption" or "politics" of awards in general, they believe in the legitimacy and relative purity of the cultural work they themselves and their fellow jurors have performed. (In conversations with former judges, I have found this distinction between "prizes in general" and "the prizes I myself have been associated with" to be one of the most insistent points of emphasis.) It would be a great mistake to imagine that prize judges are *cynical.* But this does not mean that their work is free of self-interest or beyond any economic reckoning. In fact, the two views are merely obverse and inverse of the same fundamental misconception of the relation between habitus and field, a relation which normally secures a "good fit" between one's genuine inclinations, one's designated role, and one's best opportunities for advancement. Judges routinely list their appointment to a prize jury on their résumés or in their biographical blurbs, counting it as a credential and an index of status. While their involvement with the prize is not a matter of performing work in exchange for payment, it is an economic transaction insofar as they lend or invest their prestige, put it into circulation, in order to realize a return. The prize itself also realizes part of the total return, profiting symbolically from the transaction.

Indeed, it is the first axiom among prize administrators that the prestige of a prize is reciprocally dependent on the prestige of its judges. Nobel aside, major international prizes are expected to feature international juries of famous, well-credentialed critics, artists, and cultural leaders; and part of being culturally well-credentialed is the experience of having sat on the juries of major prizes. This is

why those in charge of a prize's publicity, normally loath to trumpet other prizes of the same or lower cultural rank, often list approvingly the "prestigious awards" for which their own judges have previously judged.[2] The stature of the judges guarantees the stature of the prize (hence, among other things, the willingness of the designated recipient to accept it), and the stature of the prize guarantees the honor associated with judging it. The seeming circularity of the arrangement, which is not remarkable and in fact characterizes the entire symbolic economy, is perhaps most evident in the scandals surrounding "unqualified" celebrity or ordinary-person judges (judges drawn from outside this closed loop), whose increasingly frequent inclusion on prize juries will be discussed in Part III of the book.

The situation poses a special problem for highly ambitious start-up prizes whose founders aim for instant prestige but have no obvious source of symbolic capital to draw on. Simply paying judges an irresistibly attractive fee—compensating with economic capital for the shortage of symbolic capital, as the Nobel Foundation in effect did—is, for reasons I'll discuss below, more difficult than it may appear. So the best option for administrators of such prizes is often to draw upon all their reserves of social capital—to use whatever connections and favors they can—in order to secure the agreement of several eminent judges in the first year or two of the award, and hope that this launch gives the prize enough cultural velocity to achieve a sustainable level of prestige: a steady orbit from year to year, one set of judges smoothly succeeding another, happy to associate themselves with a prize whose previous judges they recognize as belonging on the same tier of the symbolic universe.

A good example of the way this dimension of the administrative system works, or sometimes fails to work, is the now defunct

Turner Tomorrow Award for Fiction. When media tycoon Ted Turner founded this international award for unpublished visionary fiction in 1990, he backed it with significant funds. Not only was it, at half a million dollars, the largest award ever for a single work of fiction, but each of four runners-up would be awarded a $50,000 prize (larger at that time than the Booker, the Pulitzer, and the National Book Award combined). Of course a big payout in itself cannot guarantee a prize's success, though it can attract some immediate attention, giving the prize an opening on the tightly packed field of more or less similar honors. As another American CEO, James B. Irwin, put it a few years later when he launched a far more successful prize, the International IMPAC Dublin Award (the prize that would *succeed* as the world's largest for a single work of fiction), a "five-pound award" could never get off the ground in the present cultural scene. But, he remarked, even with millions of sponsorship dollars, "I don't think prestige can be bought. . . . Prestige is built by the decisions of the judges over a period of years."[3]

Cognizant of this problem, but perhaps not wholly convinced that prestige can't be bought, Turner extended the unusual largesse of his sponsorship even toward the judges. At $10,000 apiece, the juror's fees were the highest ever offered for judging a literary prize. But $10,000 is still small potatoes for writers of international stature, who can earn that much for a one-hour public reading, and sell some books in the process. For the Turner Tomorrow Award, they would be expected to make at least one overnight trip to New York (in some cases, from distant countries), attend a long and potentially acrimonious meeting, and read a dozen typescripts by unknown amateurs. This was a light workload by ordinary book-prize standards, the Turner people having taken the common practice of "prejudging" or advance screening to an extreme, employ-

ing anonymous "professional readers" to plow through more than 2,500 entries from fifty-eight countries, thus completing 99.5 percent of the selection process before the *named* (that is, symbolically potent) judges even entered the game.[4] Nevertheless, asking some of the world's leading literary figures to evaluate several thousand pages of manuscript for what amounts to about seventy dollars an hour is, as a strictly economic proposition, a nonstarter.

Moreover, the prize was handicapped in its quest for prestigious judges by its dubious cultural pedigree and its all-too-visible commercial motives. After all, Ted Turner's most famous contribution to American culture has been orchestrating the colorization of our classic black-and-white films, a practice that makes good commercial sense but was widely attacked by film historians and denounced as "cultural butchery" by members of the Directors Guild of America.[5] In the case of the Tomorrow Award, whatever manuscript won the prize would automatically be under contract with Turner Publishing and its partner Bantam (whose founder, Ian Ballantine, his wife Betty, and their bestselling science fiction author Ray Bradbury, were duly installed on the jury), and it was clearly hoped that the hype surrounding this largest-ever prize for a single novel would generate enough publicity to assure strong sales. The movie rights were also part of this award agreement, and some observers felt that the unusual criteria of eligibility amounted to the specs for a made-for-the-movies or made-for-a-miniseries novel.[6] (The rules specified that manuscripts range "from 50,000 to 100,000 words," "be set in the near future," thematize "positive solutions to global problems," and end with "the survival and prosperity of all life on the planet"—in other words, inspirational science fiction novellas with happy endings.)[7] These contingencies placed the prize in a special and doubly ambiguous category of awards—occasionally

found in elite fields, as with the many first-book poetry prizes sponsored by university presses, but most common in connection with commercial genres such as romance fiction or Western landscape painting—in which an explicit contractual element has been superimposed on the (already duplicitous) gifting ritual.

The fine print of such prize competitions can be startling in its detail and in the extent to which it dispenses with the ethos of the gift that traditionally enshrouds the cultural prize. The annual "Arts for the Parks" competition, sponsored by the (vaguely, but misleadingly, governmental- and nonprofit-sounding) National Park Academy of the Arts, is typical of these contractual awards.[8] All artists who enter their paintings agree to grant the academy "exclusive use of the artist's image," with one-time flat-fee royalties of $100 if the image is reproduced for posters and $50 if it is adopted for note cards. The top one hundred finalists agree to have their paintings sold by the academy, which retains an industry-standard 40 percent commission. The awards themselves are called "purchase awards," and are scarcely distinguishable from ordinary transactions of sale. Here, the etymological connection between "prize" and "price" (both come from the Latin *pretium,* meaning "value") has been perfectly concretized: under the terms of the entrance contract, the prize *is* the price, regardless of how much above or below the artist's asking price it happens to fall. The artist gives/sells his or her work to the sponsor in exchange for the prize/price. And prices are, of course, set at a level that assures the academy a profit. The cash value of all the purchase awards can be more than covered by entry fees (which exceed $100,000 total), with further revenues to be realized through sales commissions on the order of $1,000–$3,000 per painting.

The awkward resemblance between a prize like this—a glorified

"motel-art" award whose symbolic value is attenuated by the explicitness of its commercial purposes—and the far more culturally ambitious Turner Tomorrow Award was only exacerbated by the unusually large fees the Turner organization paid to its judges. These fees tended to make the judging process look too much like part of a business deal, with the illustrious authors hired as commodified cultural celebrities for the sake of the preannounced $50,000 promotional campaign—that is, to give an unknown novel a better launch into the major book reviews and a stronger appearance of high-literary legitimacy. The prestige of a prize—the collective belief in its cultural value—depends not just on the prestige of the jurors, the scale of their cultural portfolios, but on their own apparent belief in the prize, their willingness to invest in it personally. Our belief in a prize is really a kind of belief by proxy, a belief in these others' belief. If their belief is seen as feigned and cynical, if their interest in the prize is perceived as having been bought, then the whole virtuous circle is imperiled. In the case of the Turner Tomorrow, Jonathan Yardley, a former Pulitzer and National Book Award judge and a cultural critic for the *Washington Post,* attacked the prize on precisely these grounds, writing that the arrangement proved literary people are "more obsessed with money than is the Wharton School of Business" and "will do just about anything" for ten thousand dollars.[9]

Faced with these considerable difficulties regarding its (vast but culturally illegitimate) economic resources and its (negligible) symbolic resources, how was Turner Publishing able to assemble a jury that included such formidable literary figures as Carlos Fuentes, Nadine Gordimer, Rodney Hall, Peter Matthiessen, Wallace Stegner, and William Styron? Social capital is the currency on which such transactions ultimately depend. The Turner organization

could not have gotten this prize off the ground, for any amount of money, without extensive, intimate connections in elite literary circles. They established such connections by persuading Thomas Guinzburg to serve as the award's managing director. Guinzburg, a lifelong literary man whose father had founded Viking Press (of which he himself had been CEO), and former chairman of the board of the American Book Awards, was one of the most well-known and well-liked people in the New York publishing world: a perfect mediator between literary and economic capital. Gordimer and Matthiessen had both published with Guinzburg at Viking in the mid-1970s; Stegner and Styron had both won National or American Book Awards while Guinzburg was associated with those prizes; Matthiessen was a judge and Styron the presenter of the ABA National Medal for Literature (a prize sponsored by Guinzburg's family foundation) when Guinzburg was ABA chair in 1982; all six authors had used him as a consultant or adviser since then (he had helped Hall publish a title with Viking-Penguin in 1983); and he was, in Styron's words, a "friend to all of us."[10] Guinzburg persuaded them to participate, and even succeeded in staving off their resignations when the low quality of the submissions (one of which was said to have consisted entirely of the word "pray" repeated a hundred thousand times) and misgivings about the motives of the Turner organization led them to attempt an early exodus.

Guinzburg could not, however, succeed in preventing an ugly dénouement to the whole affair when the six judges he had brought in, forming a majority bloc (against a minority bloc comprising the Ballantines and Bradbury), voted not to award the half-million-dollar grand prize at all, but simply to single out one of the four $50,000 prize winners, Daniel Quinn's *Ishmael,* for special com-

mendation. This deviation appealed to the majority "literary" faction, who chafed at the thought that the largest prize ever awarded a novel would go to a work in which they saw so little literary distinction. (Matthiessen remarked that *Ishmael,* which consists of a series of telepathic philosophical conversations between a man and a gorilla, contained many "valuable ideas," but simply was "not a novel.")[11] To the minority "publishing" faction, on the other hand, as well as to the prize's sponsors, whose interests this latter faction represented on the jury, denying the winner his half-million-dollar prize was unacceptable. Not because it turned the gift of the $50,000 prize into a kind of insult—though it certainly did that, and Quinn was understandably angry when he got wind of these intentions—but because it represented an interference by the "symbolic" judges in the "economic" side of things, an unwelcome tampering with the carefully designed package of promotion, publicity, publication, and screen adaptation. The managers of the Turner organization thought so little of the jury's decision that they summarily overruled it and presented the grand prize to Quinn anyway, without even bothering to tell the judges. And when Styron and others publicly complained, saying that Turner Publishing had denied them the absolute authority that had been promised them when they agreed to serve as judges, a Turner executive made clear that this was business—that Turner Publishing was management and that the judges, for all their international prestige, were simply workers whose contracts expired when they received their pay: "I don't owe Bill Styron a thing. As far as I know, he cashed his check."[12] As for the half million dollars presented to Quinn, the executive remarked: "It's not William Styron's money."[13]

The labor relations inherent in a cultural prize are rarely this visible, let alone this acrimonious.[14] But Ted Turner's abortive venture

into the book-awards industry marked out a hierarchy of power typical of much better-established and culturally more powerful prizes, a hierarchy in which the power to judge is not as firmly in the hands of the judges as one might be led to believe. Open and direct impositions by a corporate sponsor, such as occurred here, are relatively unusual—and suggest in this case that Guinzburg, who as the chief administrator would normally "handle" any intractable judges, was himself less tractable than Turner's people would have liked. (The underlying weakness of the award was its reliance on Guinzburg's friendships with major novelists, friendships in which he had far more at stake than he would ever have in the award or in his relationship with Turner.) But it is never the case that, as Styron professed to believe, the judges of a prize are "free to make any prize-winning decisions [they] want to," or that they can enjoy "autonomy" from the management of the prize organization.[15] On the contrary, the outcome of a prize rests largely on judgments and decisions over which the nominal or official judges have no control, and in which their individual tastes and preferences figure anything but autonomously. In order to impose those preferences and bring the prize into accord with their interests rather than those of the sponsors and administrators, judges have to negotiate the bureaucratic constraints of the prize with unusual skill or aggression.

Constraints on judging are imposed, first of all, by the practical necessity of limiting the range of possible winners, something that is achieved in several steps or stages. The first stage involves formulating and enforcing rules of eligibility, matters over which judges generally have no authority. Works which might readily win the judges' recognition, and which would seem to meet the stated criteria of genre, national origin, gender, thematic content, and so on, are often excluded on more or less technical grounds such as the citizen-

ship of the artist, the size or length of the work, and the date of release or publication. For example, a film cannot be eligible for the Academy Award for Best Documentary Feature unless it was shown in a Los Angeles or New York City theater for at least seven consecutive days at some point during the preceding year. This and other peculiar criteria of eligibility have been imposed by the academy's board quite deliberately as a way of constraining the judges (who have overlooked such crossover hits as *The Thin Blue Line, Paris Is Burning,* and *Hoop Dreams* in favor of more obscure and "academic" documentaries) and redirecting them toward more popular, less "controversial" decisions. The rules for many awards stipulate that only artists who have agreed in advance to appear at the award presentation may be considered as finalists; this, too, removes from the judges' purview potentially winning candidates whom the administration, for its own reasons, deems undesirable.

The range of possible winners is narrowed further through the nomination process, which again generally falls outside the scope of the judges' authority. That is, divisions of labor can appear not only between preliminary and final-round judges but, prior to that, between those who are allowed to put forward nominations, those who gather and screen the nominations, and those who prejudge the nominated works. Where the nomination process is sufficiently "closed," the complexion of the jury makes little difference; even if the judges were inclined to wield their authority in an adventurous or subversive way, counter to the aims (or simply the tacit inclinations and dispositions) of the administrators, that possibility would have already been ruled out. The administrators at the Tate Gallery used to issue fill-out forms each year on which "public nominations" could be entered for the museum's Turner Prize in British Art. When an arts editor at the *Daily Telegraph* urged his readers to

take the Turner people up on this offer in 1994, some 2,300 nominations, ten times the usual number, flooded into the Tate, almost two thirds of them proposing Nick Park's superb animated short film *The Wrong Trousers* as the year's best work of art. In the event, however, these nominations were discarded on the grounds that, as Tate director Nicholas Serota put it, they were not submitted by "experts."[16] The nomination process, as everyone knew all along, was not intended to be so "public" that the prize's judges would have to consider work from outside a normative, and in fact quite narrow, range of possibles.

In extreme cases, the categories of nomination are not even presented to the judges. The Clio Awards, an interesting border case between industry trade awards and art prizes, are meant to honor artistic "creativity" in advertising, but are nominated and distributed according to product categories rather than artistic ones. Instead of dividing awards by creative genre—such as humorous ads versus nonhumorous ones or film versus animation (as one finds at the Mercury Radio Awards and as was once the case at the Cinema In Industry Awards, or CINDYs)—or according to different divisions of creative labor, (such as screenwriting, music, cinematography), the Clios are awarded for best alcoholic-beverage ad or best banking/financial-services ad.[17] As longtime Clio director Andrew Jaffe acknowledges, this practice is commercially motivated: "It's more useful to an agency to be able to say they did the best automobile ad last year than that they did the most humorous ad, if they are trying to get a contract with a car company."[18] Jaffe and his staff are continually adjusting these categories—discontinuing some, adding others—depending on where the major advertising revenues are being generated; in the late 1990s, new categories were created for Home Entertainment and Internet Advertising, for ex-

ample. What's interesting, in the present context, is that the Clio judges undertake their deliberations without reference to these categories, viewing all the nominated advertisements on one plane, as it were, and deciding which ones to honor with gold, silver, or bronze, irrespective of the products being advertised. If their top four choices all happen to be Internet ads, so be it; that does not prevent the Clio administration from sorting things out into a "Best Automobile Ad," and so forth, even if the best ad in some categories is judged unworthy of a gold or silver statuette and finishes among the many bronze-award winners. Thus, the logic that establishes which ads are submitted to the judges for consideration and how the awards will be hierarchically distributed at the presentation ceremony—the determining logic of the whole award program, one would think—is in the hands of the administrators and is unaffected by whatever logic governs the judges' evaluations of creative merit.

A third level of screening is that of prejudging. This practice is becoming more and more widespread as the sheer number of cultural prizes increases far more rapidly than the supply of recognized experts, especially of experts willing to contribute large amounts of unremunerated time to the work of a prize jury. Even where the field of eligible contenders is sharply limited, as with local theater awards, administrators are finding it necessary to resort to this mechanism. For the first few years after their founding in 1995, the Barrymore Awards (the Tonys of the Philadelphia nonprofit theater scene) were decided by a single group of a dozen judges. But in 1999 the organizers realized that few if any of the judges were actually seeing all of the hundred or so potentially eligible productions before they cast their votes. So the Barrymore oversight committee introduced a screening process that involved sixty prejudges

(called "nominators"), divided into three groups, each of which was responsible for attending about a third of the plays. These groups would then pool their favorites to create a shortlist of finalists from which the fifteen actual judges could select a winner.[19] But even this process was seen as impractical (among other things, it was difficult to find so many willing nominators, and to secure sufficient complementary tickets for all of them), so in recent years the oversight committee has continued to modify its prejudging system. As of 2002–2003, the pool of nominators had been reduced to forty, from which a specially empowered group of six was drawn at random; the nominations of these super-nominators were then deemed "Barrymore eligible" and passed on to a final jury of ten. Modeled on the selection process of the Helen Hayes Awards in Washington, D.C., this may well be a good solution to the increasingly difficult problem of how, practically, to get the work of judging done without cutting so many corners that you compromise the perceived legitimacy of the process. But the very elaborateness and multilayeredness of the arrangement tends to suggest the intractability of the problem itself.

Of course, for many awards, particularly those set up as open competitions, there are far too many entrants for any judge or group of judges to take them all into consideration. In these cases, preliminary judges may be used to write up evaluative reports on each entrant or nominee, to synopsize critical reviews, to compile biographical or other background information, perhaps to offer a tentative ranking or to asterisk especially strong contenders, and in general to package the nominated artists and works for much quicker and easier evaluation by the judges. While the judges for such prizes do in theory have access to the entire range of nominees, their attention is quickly, and in most cases decisively, focused on a

few favorites. With other prizes, the preliminary judging involves actually eliminating some—perhaps the vast majority—of submissions, and thereby shrinking the range of possible winners and the differences among them to the point where the judges' deliberations, for all their symbolic importance, exert a trivial effect on the outcome.

These preliminary, behind-the-scenes judges can thus exercise a more definitive power of decision than the judges that are part of the public face of the prize. And they represent a more direct extension of the administrator's power, since the process of their selection is largely free both of procedural niceties and of the constraint of public scrutiny—factors that somewhat limit the tendency of prize administrations to install judges whose cultural orientation coincides happily with their own. If the prize is administered by a larger institution, the preliminary judging is usually done by the administrator's own assistants or interns—"people around the office," as more than one awards coordinator explained it to me— with the administrator himself or herself (often having already performed a first, rough cut of the submissions without any input from others) acting as chair of this ad hoc jury. If there are not sufficient in-house personnel to handle the preliminary phase of the selection process, the people who are enlisted are generally friends and associates of the administrator—preferably professionals in the field, but not people with significant public profiles. Anyone possessing both expertise and celebrity will be reserved for the actual jury.

To take an example, the Beverly Hills Theatre Guild, founded in 1977 to support a neighborhood equity-waiver theater, found itself after a few years (this being no ordinary neighborhood) with a significant surplus of funds. Following the late twentieth-century pattern, the guild decided in 1980 to devote this money to an annual

prize. Their playwright-award competition was renamed in 1983 for the guild's most illustrious member, Julie Harris, with a first prize worth $5,000; and other members stepped up over the years to endow a $2,000 second prize and a $1,000 third prize. (This produces a certain congestion of names: the third-place prize is called the Dr. Henry and Lilian Nesburn Foundation Prize of the Beverly Hills Theatre Guild–Julie Harris Playwright Award Competition.) By the late 1990s, the competition was attracting 550 to 600 submissions and more than 1,500 inquiries a year, and a three-tier judging system with two levels of preliminary screening had been established. First, there were "readers" to select the top 10 percent or so of the entries, which were then passed on to "semifinalist judges," who selected perhaps 20 percent of those (or about a dozen plays, representing just 2 percent of the original submissions) for the "final judges" to consider. Thanks largely to Julie Harris' good offices—she is, after all, the *grande dame* of American theater—these final judges have generally been world-famous playwrights, directors, and actors of the sort who have themselves won much bigger prizes, including Emmys, Writers Guild Awards, a Pulitzer, and many Tony Awards. (Harris herself has won more Tonys —five—and received more nominations—ten—than any other actor.) By contrast, the readers and semifinal judges have been lesser lights—independent film distributors, minor actors, spouses of celebrities. The selection of these preliminary judges is, the guild's president assured me, entirely in the hands of the competition coordinator, Marcella Meharg, who says she tends to rely on some of the same people every year, drawn from a relatively small circle of supporters and associates.[20]

The pattern here, which can be generalized to most awards that are organized as open competitions, is that roughly 98 percent of all

submissions are removed from contention by what is in effect the administering organization or institution itself—that is, through an essentially internal screening process. The choices that remain for the elite judges are rather narrow ones, and while the much broader judgments that have already been made may well be in line with the final judges' aesthetic dispositions, there is no guarantee that this is the case. The situation that occurred at the Turner Tomorrow Award, where judges found themselves manipulated by the administrative arrangement so as to lend their seemingly fervent endorsement to a work they regarded as middling at best, is not unusual; and Styron and Matthiessen are far from the first judges to speak deprecatingly of a winner that they themselves have ostensibly "chosen."

And yet, tightly constrained though it is, this system allows more room for judges to impose themselves than the example of the Turner Tomorrow Award suggests. One might suppose that the larger the jury—the more weighty the combined prestige of the judges—the greater the opportunity for the overall distribution of power in the prize to shift away from sponsors and administrators. In fact, just the opposite is the case. When administrators are unhappy with the way their judges have decided a prize, a standard remedy is to enlarge the jury. For example, after the National Book Award jury passed over Toni Morrison's bestselling and widely acclaimed *Beloved* in favor of Larry Heinemann's *Paco's Story* in 1986, the National Book Foundation, embarrassed by this idiosyncratic choice, increased the number of prize judges from three to five. The tendency for factions to emerge in a larger jury, especially given the greater scope for administrators to install a "celebrity," a "man in the street," or some other ostensible representative of ordinary tastes, drives these groups toward consensus and compromise,

toward safe, obvious, and expected choices. By contrast, when a prize is decided by a single judge—who has to be chosen primarily on the basis of reputation and credentials in the specific field in question—the results are less predictable, and can stray further from the expectations of sponsors and administrators.

One form of prize that typically relies on a single judge is the first-book prize in poetry. Such prizes, which enjoy considerable cultural legitimacy, make an interesting point of comparison with more doubtful ventures like the Turner Tomorrow Award. As already mentioned, they share with the Turner an explicit contractual element, the winning manuscript being automatically contracted for publication with the sponsoring press, usually with a guaranteed print run somewhat larger than is typical for a first book of poems, since a prizewinning collection can be expected to sell particularly well.

The use by sponsor-publishers of the term "prizewinning" to sell poetry to which they themselves have awarded prizes, especially as a way to market the work of young, unknown poets, is not in itself a recent innovation. At the very least, it dates back to the Seatonian and Newdigate prize-poem competitions at Cambridge and Oxford in the eighteenth century. As Erik Simpson has noted, Cambridge's Seatonian prize, first awarded in 1750, included publication of the winning poem as part of the standard prize arrangement; by 1810, both Cambridge and Oxford were occasionally publishing collections or anthologies of their prizewinning poems; and by 1830, even a losing submission to these competitions might be marketed as an "unsuccessful prize poem" (anticipating the later use of such marketing phrases as "nominated for," "runner-up," and "short-listed").[21] In post-Revolutionary America, where aspiring poets were unlikely to see the "Newdigate man" as representing a cul-

tural ideal, poetry competitions tended to be more public, less strictly academic affairs. In fact, the most famous such competition was sponsored by no less a figure of public entertainment than P. T. Barnum, who used it as part of his phenomenally successful advance publicity campaign for the concerts of Swedish singer Jenny Lind in 1850.[22] (The winning poem was set to music and sung by Lind at her New York debut.) Like the university poetry contests in England, these competitions were seized upon as a marketing opportunity by independent publishers, who issued such titles as *Boston Prize Poems,* an 1824 collection of odes submitted to a contest sponsored by the Boston Theatre to promote its three-day "Shakespeare Jubilee."[23] (This particular collection has attracted attention because one of the losing poems that appears in it anonymously turns out to have been submitted by seventeen-year-old Henry Wadsworth Longfellow, making it the first appearance of his verse in a book.)[24] This whole tradition of public poetry competitions, with its clear traces of prizes' classical roots—the poems, usually odes or other dramatic forms, being publicly performed as part of a larger event of celebration and festivity—appears to have faded by the end of the nineteenth century, and with it the kinds of books that capitalized on the market appeal of gold-medal poems. But with the rise of the modern system of cultural prizes in the twentieth century, a new, less public and more elite variation on the formula emerged: the first-book poetry competition, conceived as a support both for undiscovered poets and for the generally small, nonprofit or low-profit publishers of poetry.

The first and still the most prestigious of these prize competitions was that of the Yale Series of Younger Poets, founded at Yale University Press in 1919 and reconfigured along its present lines in 1933. But there are more than fifty others, and they have become an

integral and indispensable feature of the contemporary American poetry scene. Because the amounts of money involved in these competitions are so small (generally $500–$1,000, in lieu of an advance on royalties), the arrangements are not suspect in the way they are for a prize like the Turner Tomorrow Award. But it is a mistake to imagine that their contractual dimension is a mere formality with no real economic importance for the presses. Among established competitions, the symbolic value of the prize can be leveraged as a marketing tool to the point where the financial risk usually attaching to first books of poetry is effectively vitiated. Winning volumes in Yale's Younger Poets series have, since the 1940s, been virtually assured of review in the most important papers and journals, and since the press began issuing paperback editions in the 1950s a number of the books have sold several print runs and tens of thousands of copies. The sales record is held by Michael Casey's *Obscenities,* winner of the Yale prize in 1972, which went through three printings before being picked up by a mass-market paperback publisher with an initial run of 117,500 copies.[25] This kind of success, in turn, raises the profile of the prize, enabling it to attract more submissions. (There was a substantial jump in submissions to the Yale competition after Casey's win.) With entrance fees typically in the range of $15 to $25 and the typical competition receiving 400 to 800 entrants per year (Yale averages about 700), the sponsoring press can take in more than $10,000 from a contest—several thousand dollars above the production costs for a fifty-page book. (Rules for the Yale prize stipulate that submitted manuscripts must be "at least forty-eight pages and no more than sixty-four pages in length"; most of the other poetry book prizes impose similar restrictions.) No effort is made to discourage yearly resubmissions by greeting-card sonneteers or outright lunatics. Indeed, at

any given time there are hundreds of completely hopeless manuscripts circulating and recirculating through the mill of America's poetry book competitions. One competition administrator has said that fully a quarter of the submissions are of the sort that are "printed in silly typefaces or with drawings by the authors' children."[26] Many such manuscripts are resubmitted every year, and the presses welcome them as easy revenue, since they take no time at all to dispense with in the preliminary screening. Even the dimmest hopes are apparently kept aloft by the stories of poets like Susan Wheeler, whose *Bag 'o' Diamonds* was entered in contests eighty-eight times before it won the University of Georgia Press award in 1993, or Gray Jacobik, who claims to have entered her book *The Double Task* in at least twenty contests a year for fifteen consecutive years, expending perhaps $5,000 in fees, before finally winning the University of Massachusetts Press's Juniper Prize in 1998.[27] These stories are especially encouraging because of the tendency, here as elsewhere, for symbolic riches to beget symbolic riches. Wheeler's book went on to win the American Poetry Society's Norma Farber First Book Award in 1994 and to be shortlisted for a *Los Angeles Times* book award; her next book, *Smokes*, won the Four Ways Book Series Award in 1996, and two years after that she won a Guggenheim Fellowship. Jacobik rode the momentum from her Juniper Prize to a second manuscript competition victory the very next year, when her *Surface of Last Scattering* won the 1999 X. J. Kennedy Prize from Texas Review Press.

A further reason for optimism among the sea of noncontenders is the fact that these prize competitions are known to be decided by a single judge, with the position periodically rotating to a new poet, in some cases on a yearly basis. Repeat submitters can imagine that all they need is to strike a chord with one particular reader on one

particular day. Of course the reality is that only 2 or 3 percent of the submissions ever come before the eyes of a judge. A great many are dismissed practically the moment they land on an editor's or assistant editor's or junior intern's desk, and a vast majority of the rest are ruled out after more careful consideration by the preliminary judges. But the fact that these prizes rely on a single judge *is* significant, and does open opportunities for poets who would otherwise be shut out.

The most striking example of this is W. H. Auden's tenure as judge of the Yale Younger Poets series. Starting in 1946, Auden habitually enraged the poetry editors at Yale University Press by choosing a winner from outside the handful of finalists they had selected. His first two winners, Joan Murray's *Poems* and Robert Horan's *A Beginning,* were both unsubmitted manuscripts that he had acquired through other channels after pronouncing all the press's finalists unworthy.[28] Murray was not even eligible, according to the press's rules, since she had died three years earlier. In 1955, Auden again rejected the press's selections out of hand, and contacted two young poets of his acquaintance, Frank O'Hara and John Ashbery, asking them to send him whatever manuscripts they had. In these cases, the poets had in fact submitted official entries to the competition, but their manuscripts had been weeded out early in the process by Yale's editors. When Auden's letter declaring Ashbery's *Some Trees* the winner arrived in New Haven, the in-house reader who had rejected the manuscript angrily resigned from his post as a reader for the prize.

No judge in the history of first poetry book prizes has so consistently flouted the desires and expectations of press personnel, or been so steadily pressed for a resignation, as Auden was. Yet it is precisely because he dominated the Yale prize so single-mindedly

and for so long (his was the longest tenure of any judge of the competition) that the Younger Poets series enjoys such a wide margin of preeminence among the dozens of similar poetry book competitions. In addition to Ashbery, the winners Auden chose in the 1950s included Adrienne Rich, W. S. Merwin, James Wright, and John Hollander. It is no mean feat to identify figures of such major importance so consistently when choosing among hundreds of manuscripts submitted by young, unknown writers. (None of these poets was older than thirty when Auden saw their submissions; Merwin was only twenty-four, and Rich just twenty-one.) For the sake of comparison, consider the five winners just before and the five just after Auden's stint as judge: between 1941 and 1946 the winners were Jeremy Ingalls, Margaret Walker, William Meredith, Charles E. Butler, and Eve Merriam; between 1960 and 1964, George Starbuck, Alan Dugan, Jack Gilbert, Sandra Hochman, and Peter Davison. Some of these latter poets still have books in print, but none has been anywhere near as celebrated, as influential, as widely taught and written about, as those selected by Auden. No doubt poets such as Ashbery, Merwin, and Rich would have occupied important places in postwar American poetry regardless of Auden's interventions on their behalf. But the Yale prize did matter to their careers, not only because it got them into print but because it assured their books unusually serious attention in *Poetry, Partisan Review*, the *New Yorker*, and the *New York Times Book Review*. This had not been consistently true of Yale Younger Poets winners prior to Auden's period as judge; his personal stature, which is what enabled him to stretch and even exceed his prescribed role as series editor, also enabled the press to obtain more than the usual publicity for the series titles, and hence to give a stronger boost to the early careers of the authors than would otherwise have been possible.

During the Auden years, in other words, the Yale prize worked just as such prizes are ideally supposed to, making daring selections, launching important careers, increasing its own cultural legitimacy and effectiveness by operating in approximate alignment with advanced and discriminating tastes in the field. But this was possible only because Auden worked strenuously against the prize's established protocols and administrative constraints, imposing what he felt to be the interests of poetry over and against the interests of publishing, and of prizes as such. Among his other transgressions were his refusals, in 1950 and again in 1955, to award any prize at all. Unlike the administrators of the Turner Tomorrow Award, the editors at Yale did not overrule these decisions; they could not risk an open dispute with the one poet on whose judgment their own credibility rested. But they certainly would have liked to. Apart from forcing a break in the annual series—and hence in the reviews and articles which, in addition to promoting the winning poet, serve as an important form of publicity for the press itself—Auden's refusals damaged the relationship between the press and the hundred-odd poets who submitted their manuscripts and entrance fees in all good faith. It was awkward enough to have to suppress the fact that Auden's first two winners had been insiders who had never actually entered the contest; far more awkward was a public announcement the following year that none of the manuscripts received would see publication.

After all, the goodwill of most of those who submit their work to first-book competitions depends on their accepting either a sporting or a gaming conception of the contest: it is a competition to be the best or a lottery to be the luckiest. Either way, *someone* must win, and it might even be someone who has entered and lost a hundred times before. By refusing in certain years to make any award at all,

Auden imposed a different paradigm altogether, an aesthetic paradigm in terms of which only a handful of people (genuine artists) are actually capable of producing authentic works of poetry, and the failed attempts of others cannot be said to hold any artistic value whatsoever. The only defensible purpose of an instrument such as the Yale Younger Poets Series, from this perspective, is to provide recognition for genuine works of art. It is not a question of being the best in a particular entry pool or of being graced with good fortune, but simply of being *recognized:* recognized as an artist by an artist, recognized by an artist who is himself a recognized artist. And because there is no connection with sport or with chance, there is no reason for the judge to worry about "fairness" or to nurture the hopes of perennial resubmitters who may be viewed, in these strictly aesthetic terms, as ineligible.

The example of Auden is not merely of historical interest. Judges for these kinds of prize competitions have continued to impose their tastes and their interests to a greater degree than is possible for judges of most other awards, overruling the editors and other preliminary judges, exercising a self-assigned veto power, forcing a break in the sequence of winners. For example, when Alice Fulton was judge of the 1998 Walt Whitman Award (at $5,000, the country's richest award for a first poetry book), she had so little faith in the preliminary screening process administered by the Academy of American Poets that she asked to see 200 rejected manuscripts, and chose the winner, Jan Heller Levi's *Once I Gazed at You In Wonder,* from among these official discards.[29] A few years earlier, Denise Levertov had rejected all submissions to the Anhinga Prize for Poetry, and instructed the press not to award any prize. The editors at Anhinga Press, who had to endure angry complaints and a sharp reduction in entries the following year, saw Levertov's exercise of a

veto as causing "a blow to the press's reputation."[30] It may be the case, however, that these strong interventions by judges ultimately do serve the interests of the prize and its administering institution, as Auden's did for the Yale prize. The current director of the Younger Poets Series said that W. S. Merwin's withholding of the prize in his first year as series editor (1998) produced at least as much publicity for the press and the series as publication of a new book could have done.[31] And even if submissions fall off for a year or two, the press has realized a several-thousand-dollar windfall by relieving itself of the obligation either to pay out for a prize or to publish a book. (The fine print makes clear that entry fees are never returned.) Nevertheless, these incidents help to illuminate the structural rift between the nominal judges of a prize and the administrative machinery that under normal circumstances in fact accomplishes the lion's share of the judging. That machinery is always geared to produce a winner, and a winner that falls within a certain range. When a judge insists on recognizing the value of what lies outside that range, and/or denies the value of anything that lies within it, he or she calls attention to one of the real struggles that is always taking place in prizes, a struggle between the cultured individual and the cultural institution, between the kind of cultural power that rests with prestigious individual artists and the kind that rests with more complex cultural agents.

What is at stake when judges and administrators struggle over the withholding of a prize is the very power to produce cultural value. When it erupts, as it periodically does, into scandal, this struggle tends to be represented from either one side or the other. From the standpoint of a judge who, in evaluating a field of candidates, would refuse to award any prize at all, only the judge holds the power to declare someone a poet; the prize is simply the codified

or material form of the symbolic value that the judge alone is empowered to attach to a manuscript. Poetic value and poetic reputations rest on what respected poets say and think, not on what prize administrators can produce with their administrative teams and their hype machines. From the standpoint of an outraged prize administrator, on the other hand, the prize itself does hold the power to "make" an artist. The judge is just one of the devices or techniques deployed by the prize toward this end (and only at the very last stage of the evaluative process), and is, under certain circumstances, entirely dispensable. The important cultural fact, the one that is recorded in the cultural memory, is that a certain person won a certain prize; scarcely anyone ever knows or cares what went on in the judge's chambers, or in the intercourse between judge and prejudge.

This either/or version of cultural struggle is, of course, a mere journalistic convenience. There could be no struggle in the first place if either the judge or the prize and its administrative personnel held a monopoly on cultural power. The prize really *is* an agent in the cultural economy, producing and circulating value according to its own interests—that is, according to what is good for the prize and for prizes in general. But to serve its interests effectively, the prize must also serve the interests of its artist/judge, recognizing the judge as possessed of special power, special capacity to make distinctions where others cannot. The prize administrator who attempts after the fact to deny or retract this recognition, to contest the legitimacy of a judge, begins to unwork the symbolic magic of the prize itself. Even a slight symbolic loss of this sort may be fatally compounded in subsequent years if the most eligible of potential judges—whether out of solidarity with the artist against the cultural bureaucrat, or out of self-interest in not wanting to be tainted

by association with a symbolically dubious award—prove unwilling to serve. This was certainly the situation faced by the Turner Tomorrow Award after its turbulent debut.

At the same time, the judge is in a position of complex dependency on the prize and its administrators. The judge's own stature or authority (the particular endowment of capital that put this individual in position to be a judge in the first place) probably rests in part on the prizes the *judge* has won. It may be possible for an artist to attain a position of influence in a particular cultural field without winning any prizes (though this is becoming difficult to imagine), but such an artist will not be invited to serve as a prize judge. An overly suspicious or antagonistic posture toward prizes which discourages administrators from inviting a person to serve as judge, or a posture of outright refusal and self-declared autonomy, however it may play out on the public stage of cultural gesture, will prevent the artist from wielding what is perhaps today the single most powerful instrument for conferring value on a piece of work. It is not only the administratively intractable artist who is thus shut out of a major portion of the economy of prestige, but also the whole set of (up-and-coming, as yet unconsecrated) artists whom this individual is specially positioned to recognize, and who, in being recognized, would incline the cultural field a little more favorably toward their recognizer.

A kind of game is thus constantly being played between those who are generally understood to be the judges of awards and those who, though largely anonymous and seemingly mere functionaries, wield no less power over the processes of selection and exclusion. *More* power, perhaps, since the figure of the lone judge—in whom the capacity to resist a prize's internal tendencies of selection finds its most concentrated and effective form—is, for that very reason,

becoming increasingly rare. While the individual judge or the very small jury will tend more often than the large committee to make a perverse, unthinkable choice, we may not want to lend our support to the process that resists such breaches of cultural reason. The outcry over the National Book Award jury's selection of Larry Heinemann's now out-of-print war novel *Paco's Story* over Toni Morrison's *Beloved* seems proper if we conceive of the struggle, which took place at the very onset of the late-1980s "culture wars," as a skirmish between Morrison (and those seeking greater recognition for African American women novelists) on one hand and Heinemann (and those seeking to maintain the special status of white male soldier-novelists) on the other—and we will consider this aspect of the imbroglio further on. But if we understand the struggle here also to be one between artist and administrator, it looks rather different. Under executive director Barbara Prete, the National Book Awards organization had only recently emerged from an embarrassing phase (1980–1986) as the American Book Awards (briefly using the acronym TABA), during which Prete had failed adequately to disguise or euphemize the commercial and corporate makeover that she was undertaking in an effort to please her publishing-house sponsors. The number of prizes swelled to as many as twenty-seven (in 1983) as the organization tried to extend the marketing tag "award-winning" to as many books and publishing houses as possible, and the presentation ceremonies became ever glitzier and more Oscars-like. Stung by criticisms, and by a boycott led by some forty previous NBA winners who objected that the whole administrative framework and jury process of the ABAs was designed "to transfer decision making from those who write books to those who sell and buy them,"[32] the publishing executives who constituted the board decided to sever all formal ties between the

awards and the Association of American Publishers, to eliminate all but the two main prizes (for fiction and nonfiction), and to revert to the prizes' traditional name, the National Book Awards.

In 1987, the first year of this new, more culturally respectable arrangement, Prete and the board desired above all for the fiction prize to be awarded to an undeniably major and serious writer, a writer already well consecrated, for a novel both commercially successful and critically acclaimed. Morrison and *Beloved* fit the bill perfectly: the novel had received rave front-page reviews in the Sunday book sections of both the *Los Angeles Times* and the *New York Times,* and was firmly lodged on the bestseller lists. But as part of its bid for greater legitimacy, the award now concentrated the power over the selection process in the hands of a small, three-person jury composed entirely of writers, rather than the larger panels of writers, editors, and publishers that had decided the ABAs. Chaired by novelist Hilma Wolitzer, a veteran of the Bread Loaf writers' conference, the 1987 jury included Richard Eder, lead book reviewer for the *Los Angeles Times* (and winner the previous year of the National Book Critics Circle Award for excellence in book reviewing), and Gloria Naylor, herself an African American novelist who had won the National Book Award for fiction in 1983.

This jury was not inclined to make the obvious selection. Though all three members remained tight-lipped about their deliberations and votes after the announcement, it appears that Eder and Naylor both favored the Heinemann novel. Eder, who had written very favorable reviews of all the other nominated books (calling *Paco's Story* a "deeply original and affecting book," a work of "remarkable intensity") had conspicuously *not* reviewed *Beloved;* that assignment was given to the freelancer John Leonard, a devout admirer and personal friend of Morrison's, who praised the book in

the most lavish imaginable terms.[33] For her part, Naylor's vote may be inferred from the degree to which she was ostracized afterward by the many offended partisans of Morrison. Her planned month-long residency at SUNY Stony Brook, for example, was reportedly canceled by June Jordan, a member of that faculty and a friend of Morrison's who had led the public outcry against the NBA decision.[34]

I will have more to say about this whole "scandal" and the rhetoric in which it was conducted further on, when we consider the strategies, or styles of play, of the various agents in a prize controversy. Here, my point is simply that, whatever we may think of the specific decision the NBA judges made in 1987, it was a decision that demonstrated a somewhat rare degree of autonomy, deviating as it did from the aims and desires of the awarding institution and its administrators. A larger jury would have been less likely to exercise independence of this sort. The Pulitzer, for example, also involves a three-person fiction jury, but this jury's responsibility is simply to propose up to three finalists to the much larger Pulitzer Prize Board (currently nineteen members), who make whatever final decision they like, even if it means discarding all of the jury's nominees. With this many selectors in the mix, their overwhelmingly journalistic backgrounds inclining them to approach literary greatness through the optics of visibility and respectability, the Pulitzer has tended to land on the safe, consensus choice. And it is taking nothing away from Toni Morrison to say that in 1987 the safe, consensus choice was *Beloved*.

When, in the event, Morrison did receive her Pulitzer, amid general relief and acclaim, the NBA's frustrations were compounded. Having just undertaken a radical restructuring of the awards to restore their legitimacy, the NBA board found its institution posi-

tioned, vis-à-vis its chief rival among American book prizes, either as possessing less specifically literary competence (unable to distinguish a truly great work of literature from a run-of-the-mill war novel) or as less culturally and politically progressive (wedded to the retrograde values of a white male literary tradition). The administration responded, tellingly, by enlarging the fiction jury from three to five members—larger than any major American book prize jury other than the twenty-four-member board of the National Book Critics Circle.[35] Though the publishing executives on the NBA board would not exercise direct control and veto power over the author-judges, as the journalists on the Pulitzer advisory board did, they would, by increasing the number of judges they appointed, effectively increase their power to orient the selection process and to rein in the maverick tendencies of individual authors. Seemingly doing the bidding of the "literary community," the National Book Foundation was in fact using the Morrison scandal to do what that community had objected to so vehemently during the American Book Awards phase. By enlarging their role as the "selectors of the selectors," Barbara Prete and the prize's administrators were finally managing to effect the shift of power that they had been unable to sustain a few years before.

This shift of power, which has been fundamental to the rise of prizes since 1900, is not, however, accurately characterized by authors who call it a "transfer [of] decision making from those who write books to those who buy and sell them." For one thing, contrary to conventional wisdom, the correlation between commercial success and the kind of prestige that major prizes confer has grown weaker rather than stronger since the early twentieth century. If one compares the bestseller lists in such fields as literature, film, and popular music to the lists of winners of Pulitzers, Oscars, Gram-

mys, and so on, one finds a general pattern of divergence, with less alignment between the two lists now than there was fifty years ago, especially in literature (see Appendix B). Indeed, if we are looking for a positive trend in these correlations, it is that the major prizes have come in recent decades to provide bigger sales boosts for their winners.[36] In this sense, they are indeed more implicated in commerce: they have become more powerful marketing instruments. But this has occurred as they have increased rather than decreased their autonomy from the axis of bestsellerdom. The specific form of symbolic capital they produce and circulate has become more valuable in strictly economic terms, while sheer commercial value has become less liable of conversion into, or even convergence with, this kind of prestige.

Apart from these typical errors and simplifications, the dominant optic of art-versus-money neglects to take account of the intermediaries, the awards administrators or functionaries whose specific interests coincide neither with those of artists nor with those of publishers, producers, and marketers.[37] Their immediate concerns are neither aesthetic nor commercial but are directed toward maximizing the visibility and reputation of their particular prize among all the prizes in the field. The prize's commercial clout—its economic value to cultural retailers—is part of this, as is its respectability among artists—its symbolic value to potential recipients, judges, presenters, and so forth. But it is also a matter of social and even specifically administrative reputation. Is the prize well-run? Does it keep within its operating budget? Does it treat its prejudges and judges well? Is its ceremony appropriately staged, pleasant to attend? Is its administrator well liked, well connected, capable of pulling in favors? These things matter, and as more and more cultural power has come to be located in the administrative offices of

prizes and awards, the stakes and expectations have risen for administrators, and the strategic demands of their work have intensified. They must find ways to exercise their increasing control over the contentious and always potentially calamitous processes of evaluation, adjudication, and selection without appearing too openly as the bosses of the prize workplace, managing to be seen more as facilitators of decision making than as decision makers in their own right. They must contrive to remain in the background of the cultural field even as they assume an ever larger and more powerful role in our contemporary processes of canon formation.

Trophies as Objects of Production and Trade

The Oscar was to have been the centerpiece of Christie's "Entertainment Memorabilia" auction on Friday and was highlighted on the catalog cover. It had carried an estimate of $300,000–$400,000.

—*New York Times*, July 22, 2003, reporting on Christie's withdrawal of Orson Welles's Oscar statuette for screenwriting, pending resolution of a legal battle with the Motion Picture Academy

Little serious attention has been paid to the actual objects—the honorific medals or plaques, specially inscribed editions, silver cups, crystal sculptures, busts, bronzes, and statuettes—that are presented to the winners of cultural awards. They are generally thought of as cheesy, trivial things, obligatory tokens devoid of any real meaning or value in themselves, the cultural equivalent of bowling trophies. Yet these objects clearly constitute a basic and enduring feature of prizes, one without which the awards industry would not really know how to operate. A consideration of their form and function can help to bring more sharply into focus the

tendency of that industry to grow itself not simply by churning out new prizes but also by unfolding new, secondary or tertiary, ever more remote though still parasitic or interdependent economies—systems of valuation and exchange that evolve from and depend upon the original award transaction, but that develop their own distinct logics and rules, their own strategies of accumulation, their own opportunities for profit or loss, success or failure. If we want fully to understand the principle of elaboration that underlies the awards frenzy of the late twentieth century, ensuring continual expansion of the awards industry in the face of unceasing anti-award jeremiads and narratives of saturation, then we need to consider the curious lives of trophies themselves, from the varied processes of their material production, to their accretion of multiple and sometimes contradictory symbolic burdens, to some of the further and less expected paths of their circulation.

The awarded object is the most concrete and material representation of a prize's symbolic value. The cash that in many cases comes with it is not at all a concretization in the same sense. As we know, minor awards can carry six-figure cash payouts while some of the most important prizes offer no cash at all. The correlative relationship of cash to prestige is not negligible, but it is generally so dominated by other factors that prize money is understood simply to accompany an award, never to stand for it. Trophies, by contrast, are precisely a kind of stand-in, the only objects capable of embodying or giving material shape to the honor bestowed. It is thus perfectly natural for a prizewinner to say, when displaying a trophy, "Here is my Emmy," or "Here is my Thurber Prize." And yet, tightly yoked as they are to the symbolic value of the award, these honorific objects carry other, quite distinct sorts of value, and circulate in other markets, connected to but distinct from—and in certain ways at odds with—the market for cultural prestige.

To begin with, such objects are manufactured out of recoverable materials that themselves have a specific monetary value. Such value fluctuates, and in the case of certain materials at certain moments can supersede the other kinds of value that the object carries. This is true even in connection with the most prestigious awards. The Nobel science and literature medals, designed in 1901 by Erik Lindberg and cast by Myntverket, the Swedish Mint, traditionally contained seven ounces of pure gold. These were always rather valuable objects, but their value became a special concern for German medal-winners during World War II. As a supremely fungible and portable form of wealth, gold always rises dramatically in value during times of international upheaval, and the Nazi regime made it a capital crime—especially for Jews, whose assets they were confiscating—to hide gold or to send it out of the country. When the Germans began their occupation of Denmark in 1940, the great Danish atomic physicist Niels Bohr was rightly concerned that his Institute of Theoretical Physics in Copenhagen had in recent years become a harbor not only for leading German physicists but for the Nobel medals of some of the German laureates who had taken refuge there—in particular James Franck and Max von Laue. Since winners' names are engraved on Nobel medals, these were particularly dangerous pieces of evidence against Bohr's colleagues. Anticipating a raid on his facilities, Bohr managed, just hours before the Nazis arrived, to have the medals dissolved—a more demanding chemical operation than one might think, and not one for which a theoretical physics lab is well suited. The resultant jars of liquid meant nothing to the military officials conducting the search, the institute was spared, and after the war the gold was recovered from its solution and returned to the Nobel Foundation, which had new medals cast for the two laureates.

If it seems a little bizarre for award medals to stand at the center

of this life-and-death wartime drama, that is because we are not accustomed to thinking of them as fungible wealth. There would be nothing surprising about a box of jewels or a bundle of cash occupying center stage in such a drama; what is unusual is such a total eclipse of a powerfully symbolic object's symbolic dimension. To be sure, valuables smuggled out of Germany did bear the symbolic freight of disloyalty to the Reich. But the normally dominant value of the Nobel medals—that of cultural prestige—did not, at the moment of the raid on Bohr's institute, enter into the calculus at all. The issue was not, for example, that the Nobel Prizes won by Germany's Jews represented an embarrassment to the regime; von Laue was a Protestant. The issue was simply that between them von Laue and Franck had smuggled nearly a pound of pure German gold into Denmark.

There has been no comparable moment since the war, but the sheer commodity value of the Nobel medals did rise steeply in 1979–1980, when the Arab oil embargo caused gold prices to balloon to more than $1,500 an ounce (in 2005 dollars). Even with a prize as prestigious as the Nobel, this created a certain incentive to treat the medal as a mere disk of precious metal. Its value to collectors was not at that time very great. A particularly desirable collector's item, the 1933 Nobel Peace Prize medal of Sir Norman Angell, British author of the pacifist classic *The Grand Illusion,* was auctioned by Sotheby's in 1983 for just $12,000 (about $25,000 in 2005 dollars), suggesting that a run-of-the-mill chemistry medal would in those years have been worth scarcely more than its $6,000 (adjusted) commodity value.[1] Moreover, we could expect that family members would prefer quietly to sell the medal to a jeweler for its gold value than to put it on the public auction block, where it might seem an insult to the memory of their illustrious forebear, not

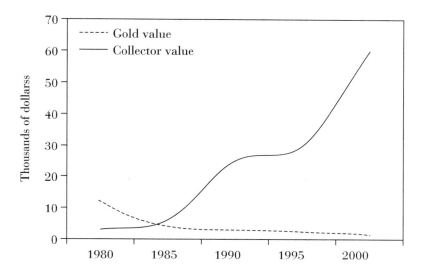

2. Cashing in: the commodity value of Nobel Prize medals—that is, the value of the gold they contain—versus their collectible value.

to mention that of Alfred Nobel. As one auction specialist has put it, selling the family's awards is sufficiently disreputable to encourage secrecy: "In a sense, it's like dealing drugs."[2] Perhaps with this concern in mind, the Nobel Foundation instructed the Myntverket in 1980, as gold prices hit their record highs, to begin diluting the alloy of the medals from twenty-three karats to eighteen, reducing the gold content by about one fourth. Gold prices soon came back down in any case, while the value to collectors, even of very minor Nobel medals, began a dramatic, sustained climb. Figure 2 depicts the value of a Nobel medal as a material object compared to its average value as a collectible symbolic object (in inflation-adjusted dollars) over the course of two decades, and shows how radically this relationship has changed.

The incentive for medal melting in this particular case has clearly

ebbed. But there is a long and continuing history of prizewinners or their heirs weighing the symbolic or sentimental value of an honorary medal against its simple value as silver or gold. Prize administrators, though highly cognizant of the need for their prize to involve a suitably distinguished award-object, have had also to be alert to the unfortunate incentives that are created by *too* valuable a trophy.

This long-standing concern was nicely encapsulated two centuries ago by the behavior of Robert Southey after he won the Royal Society of Literature Gold Medal in 1827. Like Sir Walter Scott, who received the society's other medal that year (and whose damning letter about the society and its medals we looked at earlier), Southey condescended to accept the prize but refused to appear in person for the conferral, offered no acceptance speech, and wrote disparagingly of the whole affair in his letters. By 1830, he had had a silversmith appraise the medal, and wrote a buoyant letter to his daughter-in-law saying that it was worth enough to cover the cost of a "large and handsome coffee pot" for her, with sufficient remainder for a silver "cake basket" or a "sugar basin" or whatever else she would like.[3] The transaction was indeed carried out, a coffee pot was commissioned, and Southey even penned some lines of satiric verse to be inscribed on the pot's side:

> *A golden medal was voted to me*
> *By a certain Royal Society:*
> *'Twas not a thing at which to scoff,*
> *For fifty guineas was the cost thereof:*
> *On one side a head of the king you might see,*
> *And on the other was Mercury!*
> *But I was scant of worldly riches,*

And moreover the Mercury had no breeches;
So thinking of honour and utility too,
And having modesty also in view,
I sold the medal, (why should I not?)
And with the money which for it I got,
I purchased this silver coffee-pot;
Which I trust my son will preserve with care,
To be handed down from heir to heir.
These verses are engraven here,
That the truth of the matter may appear,
And I hope the Society will be so wise,
As in future to dress their Mercuries.

In his 1945 study of the Royal Society, David Gardner Williams wryly noted that Southey's treatment of the prize medal amounted to "a kind of reverse alchemy. The medal went into the crucible and gold became silver."[4] But Southey's more telling alchemic reversal was his unworking of the very magic by means of which the Royal Society had transformed the coin of the realm into cultural capital, into the much "higher" or rarer form of value proper to the realm of art. The real point of Southey's gesture was to deny the society's (and King George IV's) claim to possess this alchemical power in the first place. Such power, as artists and writers by then had come to understand it, could reside only in the hands of individual artists themselves. Whatever the antiquarians of the society or their royal patron might inscribe on a medal, whatever ceremony of consecration they might perform with it, the medal would never be worth anything more than the material it was made of. In a sense, the well-off Southey was not even interested in its economic value. Like Scott, who had first broached the idea of unloading the royal medal

at a silversmith's, Southey intended not only to reduce the value of the honor to its economic dimension, but to cash in the economic value for the use value—"thinking of honour and utility too," as he put it. Or, in Scott's words, "converting the medal of the *Honorificotudinitatibus* into something useful . . . a substantial bread basket . . . [or] a tureen."[5]

This would be the ultimate "reverse alchemy," negating as far as possible the social power to raise earthly material toward the level of the symbolic, the level of virtual disutility or purposelessness. And Southey obviously intended to perform this negation in as dismissive a way as possible. In the end, there was not enough space on the coffee pot to accommodate his doggerel, but the point of his verses was clearly to thumb his nose at the sponsors of the medal. His jokes about "that *sansculotte* Mercury" may remind us of the frequent references to the bare bottom of the Oscar statuette (whose very nickname is said, in one account, to originate in a remark by Bette Davis on the similarity between the statue's buttocks and those of Oscar Levant). But while references to the "lower bodily stratum" are a standard means of contesting claims to special status or dignity, comments about the Oscar's behind do not really serve as put-downs; whatever satiric sting they might once have had has faded as the Academy Award statuette has become an icon as fondly familiar as Mickey Mouse. Besides, the Academy of Motion Picture Arts and Sciences, a modern trade organization, has never set itself up in quite as lofty a cultural position as the Royal Society of Literature did in 1820s England. With the king on one side and a Roman god on the obverse, the Royal Society's medal implies a double claim to absolute and timeless value: that of the monarchy and that of classical art. Southey did not go so far as to challenge the authority of George IV directly, but his seemingly

lighthearted gibes about the medal's classical god, like Scott's pseudo-Latin term *Honorificotudinitatibus,* have real teeth, and point up the serious difficulty the Royal Society was meeting with in its quest for cultural legitimacy, or specifically cultural power.

A second way in which cultural trophies are yoked to the world of material commerce is in their emergence from a competitive market of trophy design and production in which they have, like any merchandise, a market price. Before they are presented to the award recipient, medals or other trophies must be contracted for and purchased by the awarding institution. Already here, though, we find the market price inflected by considerations of prestige, especially in the case of the less artisanal, more mass-produced trophies. The R. S. Owens Company of Chicago, for example, which dominates the high-end statuette market, is rumored to make little or no profit on its sale of Oscar statuettes to the Motion Picture Academy. Financial details of the transaction are never divulged by either party, but production-cost and sales-price estimates were widely discussed when, a week before the awards ceremony in 2000, some fifty-five statuettes were stolen en route from Chicago to Los Angeles. According to insiders at Owens, the cost of the statuettes was then a few hundred dollars apiece, or $15,000–$20,000 for the full annual run (about one third of the amount paid as reward to the sanitation worker who eventually recovered them from a dumpster in L.A.'s Korea Town). The academy apparently gets the trophies at close to cost. But even if Owens supplied them gratis, this would still be a winning transaction from the company's vantage point. After all, $20,000 is what one pays for a small ad in *Entertainment Weekly,* and a company of 200 employees and 80,000 square feet of manufacturing facilities in three states would happily absorb that cost to preserve a contract that serves as the

cornerstone of all its promotional efforts. What film director Frank Capra famously said of the Oscar statuette back in 1935—that it was "the most valuable, but least expensive, item of worldwide public relations ever invented by an industry"—is true not only for the makers of movies but for the makers of statuettes, as well.

Medal and medallion specialists—of which Recognition Products International (RPI), supplier of both the Pulitzer and the Peabody medals, is the leading player—are part of this same loss-leader economy in which the low-profile prizes subsidize the heavy-weights. Indeed, on the basis of a strictly commercial logic, one would expect an Owens or an RPI to *pay* high-prestige, high-profile awarding institutions to use its products, much as a sports equipment manufacturer pays a professional team for sponsorship rights. Such an arrangement makes financial sense, since these companies are realizing a huge symbolic profit from their contracts with the Pulitzers or Academy Awards, a symbolic profit that they quickly put to work generating new and more directly lucrative business. But as is always the case with prizes, the parties in the transaction have to be cautious not to let their interest in money profit lead to an erosion of the symbolic magic that makes that money profit realizable in the first place. While it is in the interest of the statuette manufacturer to publicize its connection to a major prize, the awarding institution does not want its trophy to be perceived as a factory good, the manufacturer's name competing with the prize's name for brand recognition. This is why the medals manufactured by RPI, Medallic Art, and the other major award-medal companies bear only the conventional (and in some cases legally required) foundry and precious-metal-content marks, discreetly die-cut into the edge at the six-o'clock position, rather than corporate logos or other more commercially inflected icons.[6] From the standpoint of

the prize ceremony, the trophy should be disconnected from mere commerce in trinkets. It should appear as though arising out of nowhere, out of the "world apart" in which prizes perform their magic—less like a factory good than like a work of art. The marketing people in the trophy industry (or "recognition industry," as they refer to themselves) of course understand this perfectly well. As a publicity brochure from RPI's Protocol Group expresses it, "The creation of an award medal by our staff is the marriage of Artists to Artisans. . . . It is the *antithesis of high technology.*"

Indeed, the notion that a trophy is not just an icon or synecdoche of a particular field or practice of art, not just the symbol of achievement in an art but a work of art in its own right, is aggressively disseminated by awarding institutions. To be sure, the promotional brochures detail the iconic or allegorical aspects of the award-object. Some organizations are content to indicate a general association of their award with artistic achievement; the Spanish Motion Picture Academy, for example, presents winners with a bronze bust of Goya, Spain's "greatest artist." Others make an obvious allusion to the specific art at hand: winners of Canada's Arthur Ellis Award for crime writing (known as the "Arthur") receive a sculpture of a wooden figure dangling from a gallows; recipients of the (American) Horror Writers Association's Bram Stoker Award are given an eight-inch rendering of a haunted house, with their name and winning book title inscribed on a brass plaque inside the front door.

In some cases these allegories become rather more elaborate and inscrutable. The Emmy, a winged woman holding aloft an atom, is said to signify the muse of art uplifting the science of television; the five spokes of the film reel on which the Oscar figure stands are meant to symbolize the original five branches of the Motion Picture

3. Trophy as allegory of the field: the "Arthur" statuette. "Hand-carved by Canadian artisan Barry Lambeck . . . a wooden articulated jumping-jack figure with a noose around its neck that 'dances' when a string is pulled." (Photo © Giulio Maffini. Text and photo courtesy of Crime Writers of Canada.)

Academy: actors, writers, directors, producers, and technicians. Almost without exception, however, the promotional literature represents this allegorical dimension not as merely a generic feature of trophy design, but as evidence of a particular trophy's coherence or integrity *as a work of art in itself*. Much stress is placed on the beauty of these objects, their classical motifs, elegant lines, inspirational form, profound spirituality, and other assumedly artistic qualities. The person who designed or crafted the piece is often named, and a biographical blurb provided to establish both the adequacy of the person's artistic credentials and the suitability of his or her specific (national, regional, cultural, ethnic) background to the prize at hand—neither of which is necessarily at all obvious.

The trophy mask of the British Academy of Film and Television Arts, for example, is based on a design by Mitzi Solomon Cunliffe, who was born and lived most of her life in the United States, but

whose long residence in Manchester, England, where she crafted the original version of the mask for the Guild of Television Producers in 1955, is played up in the BAFTA literature.[7] The mask, we are told, bears on its concave reverse-side "an electronic symbol round one eye and a screen symbol round the other, linking dramatic production and television technology." But the more important link is that between the TV award and classical art, underscored by the fact that the trophy remains a work "based on the traditional concept of the theatrical tragicomic mask." The ability to sustain a classical sensibility on the fields of contemporary art is evidence, the BAFTA brochure tells us, of the "consistent integrity" of Cunliffe's vision, "which springs from a deep understanding of sculpture and its application," and is coupled with "an evident delight in its execution." These, in turn, are strengths "which reflect the excellence in film and television production, performance and craft for which the trophy is awarded." In this way, the status of the trophy designer as an artist is deployed not just to establish the artistic value of the trophy but to secure the status of television as a legitimate field of art.

This sort of talk about prize-objects in terms of artistic origins and aesthetic integrity, highly typical of awards brochures and promotional websites, belies the fact that most award institutions are perfectly willing to modify their trophies to suit their practical, budgetary, or symbolic purposes. The BAFTA mask itself was more than once altered from the original Cunliffe design, and the history of prizes is littered with discarded versions of trophies. The Golden Bear statuette of the Berlin International Film Festival, designed in 1932 by Renée Sintenis, originally raised its right arm in greeting; perhaps concerned that this gesture might suggest fascist elements at the roots of the festival, the board decided in 1960 to commission a redesign of the statuette such that the left arm would be

raised instead. Followers of the Booker Prize are often surprised to learn that that prize originally included a large, twenty-inch-tall Art Deco sculpture of a draped female figure holding a bowl over her head. After three years of jokes and quizzical expressions from prizewinners, the organizing committee decided the statue was too unwieldy and commissioned its sculptor, Jan Pienkowski (who had not yet established himself as king of the modern pop-up book), to redesign and recast the thing on a smaller scale. The Booker organization purchased five of these new, ten-inch statues, but when, in 1978, that supply had been exhausted, they decided to abandon the trophy part of the award entirely.[8] More recently still, in 1996 the Peabody board decided that the medal it had been awarding for fifty-six years was insufficiently grand for display purposes. But since their award is called the Peabody *Medal,* the board could not very well start presenting a crystal figurine or a silver cup. Their solution was to add a substantial black marble base to the medal, transforming it into a more trophy-like object.

The rhetoric of artistic integrity in which these objects are frequently couched should therefore be taken with a grain of salt. It can be part of a virtuous circle of award promotion in which, for example, the symbolic value of the prize is said to be supported by the artistry of a medal or statuette whose artistic value is in turn established by reference to the designer as an "award-winning sculptor."[9] What matters, though, is not the sincerity or legitimacy of the claims that are made for these trophies as works of art, but the sheer ubiquity of such claims. We think of the object as deriving its value from the prize, as not having any real life or meaning except insofar as it concretizes the prestige of the award. Browsing through a catalog of off-the-shelf medals, for example, their faces strangely blank except for a border of laurel boughs or an empty

unfurled scroll ("your name here"), one is struck with the full force of the "trinket effect." Disconnected from any recognized cultural authority, lacking any guarantor of their symbolic value, these objects seem preposterously trivial. And as we shall see below, this notion that the relationship between awarded objects and those who award them allows for the transmission of value in only one direction is heartily promoted by certain awarding institutions. But in the particular sense we have been considering, it is the prize that in fact seeks to derive a certain value from the object, whose cultural worth as art is used to secure a kind of symbolic credit or credence for the award.

In rare cases, newly founded prizes have managed to obtain, as trophies, original works signed by artists of great critical renown, recognized "geniuses" whose signatures serve as powerful emblems of legitimacy, differentiating a prize from other newcomers and giving it an immediate seat at the cultural table. The Pritzker Foundation prevailed upon Henry Moore, the dominant British sculptor of the twentieth century (and one whose stature had already been called upon, by more conventional means, to add luster to the work of contemporary architects), to create original, signed works for winners of its architecture prize from the prize's founding in 1979 until Moore's death in 1986. At that point, however, the organizers found themselves in a bind, and had to fall back on a more ordinary award-object, commissioning a brass medallion with no artistic pedigree beyond its being supposedly "based on the designs of" the great Chicago architect Louis H. Sullivan.

The problem, of course, is that unlike matching statuettes or medals from a foundry, "genuine" or "original" works of art—works bearing the signature of a *recognized* artist—are strictly limited in number: they belong to a "signed, limited edition." Even if

Moore had made and signed seventy of the Pritzker statues instead of just seven, the organization would have eventually faced the need to come up with a new award-object. By then, however, the chief benefit of the signature effect would have been realized, since it is during the years immediately following its founding that a prize is most in need of the symbolic backing an artist's signature can provide. And once a prize has established itself, it can usually endure the awkwardness of trying to introduce a new award-object or icon while, as always, insisting on the values of tradition and continuity that are so fundamental to awards rhetoric.

Emilie Kilgore, who in 1974 established the Susan Smith Blackburn Prize for women playwrights in memory of her sister, was fortunate to count among her friends Willem de Kooning. De Kooning, by then a legendary figure of the New York School of abstract expressionist painters, had begun working in sculpture a few years earlier, and he offered to create a statuette for Blackburn prizewinners. But Kilgore persuaded him instead to do an original lithograph—a better option from the standpoint of the prize, since that was a medium in which the de Kooning signature counted for more. Kilgore stipulated as well that de Kooning should have five hundred copies of the lithograph printed, so that the Blackburn Prize would not face the need for a new award-object until it was very firmly established among the American theater prizes. She did not, however, intend for the supply of lithographs to last five hundred years, for only thirty of them had the word "Winner" printed in the space beneath "The Susan Smith Blackburn Prize." An equal number of them had "Director" written in that spot, so that directors of the winning plays could also be honored; and two hundred were labeled "Judge," since Kilgore had decided also to use these works of art as payment for judges, of whom there were to be six

4. *L'art pour l'art:* Willem de Kooning, in 1974, putting his signature on one of the Susan Smith Blackburn Prize lithographs. With him is Emilie S. Kilgore, who founded the prize in memory of her sister. (Photo by Cal Norris. Courtesy of Emilie S. Kilgore and Susan Smith Blackburn Prize, Inc.)

per year. Even more unconventionally, she had "Sponsor" printed at the bottom of sixty of the lithographs, and offered these to any supporter of the prize who would contribute a gift of $1,000 or more to the Blackburn endowment.

In this particularly successful co-optation of the artist signature by a newly founded prize, the symbolic value of the de Kooning signature, acquired through an expenditure of social capital (often, as we've noted, the primary component of a new award's capitalization), was multiply leveraged. It assisted the new prize, as such signatures are always meant to do, in assuming a mantle of legitimacy among serious arts and theater people, and especially among potential winners of the prize. At the same time, it was put

directly to work in the transaction between administrator and judge as a means of attracting a high-prestige jury—which, as we have seen, is one of the most critical challenges facing a start-up award. Edward Albee, perhaps the most prestigious of the Blackburn's judges in its first decade, came forward in 1998–1999 to request an unprecedented second stint on the judging panel. Notwithstanding his genuine commitment to supporting women playwrights, he admitted his pleasure in having de Kooning's Blackburn drawing as a conversation piece on the wall of his SoHo studio, and expressed the hope that, in exchange for another term as judge, he might receive a second print for his house in East Hampton.

Finally, the value of the artist signature was put to work here to attract economic capital for endowment to assure the prize's long-term survival. This, too, was critical, since, as I have pointed out, when a memorial prize is initially conceived, the substantial costs of administrative labor are routinely neglected by the founders. In the short run, this problem of undercompensation can be overcome through the wealth of goodwill that exists among friends and family members. But when the initial founder or organizers (often, as in this case, a single close friend, offspring, or sibling who has taken the full burden of administrative work upon herself) must pass the torch to a second-generation administrative staff, an endowment adequate to support this staff becomes indispensable. Again, it is not denying a sponsor's genuine commitment to women playwrights to suggest that the de Kooning has served as a fairly powerful enticement. Even in the absence of any particular interest in supporting the Blackburn's cultural aims, one might see a $1,000 donation (or about $700 after taxes) in exchange for a signed de Kooning lithograph (worth at least that amount) as a rather painless act of philanthropy.[10] Not surprisingly, the supply of "Sponsor"

prints was exhausted by the late 1990s. And the Blackburn endowment, $30,000 at the end of the prize's first year, had climbed to more than $1 million, close to the amount needed to support a paid administrative staff in perpetuity.

The economic value of the award-object is, in the case of the Blackburn Prize, high enough to raise the possibility of a secondary market, as winners or other recipients put their lithographs into further circulation. Thus far, the issue has arisen only once, to the knowledge of the organization. A former judge, elderly and facing unsupportable medical expenses, contacted Kilgore to ask whether he might sell his lithograph to a dealer. Nothing in the informal contract between the prize's board of directors and its judges would prohibit such a sale—and, after all, their own practice of presenting the lithographs to sponsors in exchange for $1,000 gifts had already to some extent broken the normally closed loop of prize-object exchange, opening it to anyone with sufficient cash to buy in. Nevertheless, the idea of a judge selling off his Blackburn lithograph raised concern among the directors. In a deft maneuver, they quietly made a cash gift to the man in the amount of the proposed sale price, so that he could enjoy the small economic windfall without surrendering the gift of the lithograph—and without some third party acquiring the lithograph through an entirely uneuphemized (nongift) money-for-art transaction.

The susceptibility of these honorary objects to strictly mercenary exchange is, however, an important aspect of their circulation, and underscores yet another form of value that they carry: their value to collectors. This, too, is a complex form of value, comprising both economic and symbolic aspects that cannot be cleanly separated. One Chicago dealer who has established an organization that promotes the collecting of awards and trophies has attempted to

"highlight the advantages of collecting awards as compared to art," while at the same time telling prospective collectors that awards are "more like art than like money"—a blurring of differences and similarities that merely begs the question.[11] The collectibility of a prize trophy, as of any cultural good, depends on its perceived prospects as an appreciating monetary investment, but that depends in part on its symbolic value or standing among other prize trophies—or rather, on the degree to which it is capable of reflecting or passing on some of its prestige to a new owner, of increasing the pride and status of a possessor other than the original recipient. This capacity to convey status serially to one possessor after another depends, in turn, not just on the prestige of the prize qua prize, or of the original winner of the prize, or even of the place the prize assumes within various biographical narratives (especially narratives of origins or "firsts"), various hierarchies of works (collective determinations of "best," "most important," "most influential"), various historical conjunctions (the prize's coincidence with moments of scandal, moments of war), and so on. It depends also on interconnected fields or subcultures of collectors whose practices of collecting define their own terms of scarcity and significance, their own basis for pride of possession and borrowed glory.

Ernest Hemingway's 1954 Nobel medal, for example, would doubtless be a kind of holy grail for the fanatical collector of Hemingway memorabilia, an object to place at the very center of the display case. But that collector would be competing with others in whose collections the medal would occupy quite a different place. There are, for example, collectors of Nobel memorabilia, for whom Hemingway's only significance would be his laureateship. (Indeed, items connected with the Nobel prizes are so avidly collected that the Nobel Foundation must allow for extensive theft of its sil-

verware at the annual prize banquet. According to the banquet's maître d'hôtel, about a hundred coffee spoons are stolen each year.)[12] There are collectors of royal medals and militaria from the Cold War era for whom a mid-1950s Nobel to an American writer would be an outstanding acquisition (though not nearly so alluring as the medal left unclaimed by Boris Pasternak in 1958). Each individual collector seeks to establish a personal identity through his or her collection, whose specific logics of acquisition and arrangement thus bear psychoanalytic significance, connecting with childhood longings, with longings both of and for childhood. But even the most personal desires are socially produced: the rare, the scarce, have no meanings other than collective meanings; the very habitus of the collector could never emerge except through and within that totality of relationships among collectors and cultural consumers that is the field of cultural consumption. As Susan Stewart has concluded, even the most highly individuated collection bespeaks in its particular form "an aesthetic value so clearly tied to the cultural (i.e., deferment, redemption, exchange) that its value system *is* the value system of the cultural."[13] Even the seemingly "pure" collector, the collector who sells nothing and who disdains the vulgar profit seeking of the dealer-investor types, cannot simply break free of capitalist political economy, cannot avoid making minutely economistic calculations: of opportunity costs (if only of opportunities for making different additions to the collection), of short- and long-term investment prospects, of price itself.

Looked at one way, the capacity of awarded objects to continue to convey symbolic value to possessors long after the original recipient has died, to extend their magic far beyond the original ceremony of award, and, partly as a result of that symbolic fungibility, to become more and more valuable in monetary terms, is a splendid

index of their efficacy. But looked at the way most prize organizations look at it, this transferability not only from one possessor to another but from one economy to another, one market to another, is a threat to the very essence of the prize and needs to be aggressively policed.

This is most apparent in connection with the highest-profile arts and entertainment trophies, which have come to be worth a great deal in the booming market for collectibles. A Hollywood memorabilia dealer such as Stairway to the Stars carries a substantial inventory of award-related objects, which over the years has included Golden Globe statuettes, local Emmy awards, Academy Award nomination plaques, Walt Disney Duckster awards, and so forth. Even minor, peripheral items such as the miniature director's-chair statuettes used to mark place settings at the Directors Guild of America awards dinners are worth hundreds of dollars in this market; a Golden Raspberry statuette that had been handled but refused by Ben Affleck, who won it for his widely panned performance in *Gigli* (2003), was touted on eBay as "your chance to touch (semi) greatness," and sold for $1,375. (The buyer, a collector from New York, says that he had entered a high bid of $5,000.)[14] At the other end of the value spectrum, the Golden Globe statuette awarded to Marilyn Monroe as World Film Favorite (Female) for 1961 brought $189,000 at a Christie's auction in 1999. But the most coveted collector's item is, of course, the Oscar statuette, several of which have sold for hundreds of thousands of dollars, and some of which would undoubtedly be worth many times that much if they could be brought successfully to market. The rare "juvenile" or "baby" Oscar awarded to Judy Garland for her performance in *The Wizard of Oz*, for example, was briefly listed in a spring 2000 auction catalog for $4.5 million. But that

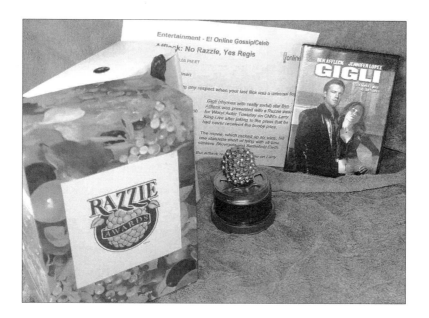

5. Ben Affleck's Golden Raspberry trophy for Worst Actor (*Gigli,* 2003). Rejected by Affleck, this trophy was put on auction by the Golden Raspberry Award Foundation in March 2004. Though the Razzie song lyrics say the trophy is "worth about two bucks" and a more recent press release by the foundation puts the "estimated street value" at $4.79, the winning bidder paid more than $1,300. Several higher bids were derailed when eBay temporarily halted the auction, concerned—unjustifiably—about its legality. Razzie Awards packaging material appears in the foreground. (Photo by John Wilson. Copyright © G.R.A.F.)

sale, like many others, was blocked by the Academy of Motion Picture Arts and Sciences, which has for the most part contrived to prevent the circulation of their award statuettes in what its former president Karl Malden called the arena of "mere commerce."[15]

The device AMPAS has employed to obstruct this market is contractual. When the heirs of Sid Grauman, founder of the legendary Grauman's Chinese Restaurant, attempted while dividing his estate in 1949 to sell the special Academy Award he had won the

year before, the academy not only swooped in quickly to purchase the Grauman statuette but instituted a new requirement that all award recipients sign a "winner's agreement" giving the academy the right of first refusal to purchase, for a nominal sum, any Oscar put on sale at any time. Of course, the statuettes awarded prior to this policy may still be sold—and their value has benefited from the absolute scarcity that AMPAS' policy has conferred on them.[16] In recent years, Clark Gable's 1934 Best Actor award for *It Happened One Night* sold for more than $600,000, and Michael Jackson paid more than $1.5 million to acquire the 1939 Best Picture award for *Gone with the Wind*. Even the far less collectible statuette awarded to George Stoll for composing the score to *Anchors Aweigh* (1945) brought more than $150,000 at a Butterfields auction in 2001— though, in an interesting twist, the "mystery buyer" turned out to be two-time Oscar-winner Kevin Spacey, who purchased the trophy as a (return) gift to the academy, saying he "strongly feels that Academy Awards should belong to those who have earned them— not those who simply have the financial means to acquire them."[17]

The arguments that have been marshaled on both sides of the fight over trophy selling are symptomatically various and contradictory. The directors of AMPAS say that buying or selling a statuette debases it, because a statuette represents something inalienable and hence inherently nontransferable—namely, individual achievement. Richard Kahn, former president of the academy, said in 1989, "These awards are given for individual achievement. They honor the best of the best, like a battlefield commendation, a medal of honor. I think anyone would turn aghast to see that offered for sale as a collector's item."[18] The analogy here is a curiously self-defeating one, given that the trade in military medals has been widespread and vigorous for many decades. Indeed, it is precisely upon

the militaria collectors that the international market for medals and awards is centered. Battlefield commendations, campaign medals, and medals of valor are, of all awards, the *least* subject to qualms or doubts about their suitability to be "offered for sale as a collector's item."

On the other hand, the taboo attached to selling the "gift" of a specifically cultural prize is sufficiently strong that Kahn is justified in imagining that some people besides the academy's administrators might "turn aghast" at the prospect of an Oscar statue on the auction block. Many of the individuals who have sold their statuettes, or the statuettes of close relatives, have clearly been embarrassed by the transaction and have wanted to remain anonymous. The leading dealer in Oscar statuettes during the 1980s, Malcolm Willits, has had to reckon with this discomfort on the part of many of his clients: it was he whom I quoted, early in this chapter, comparing the trade in cultural medals and trophies to drug dealing. And even with military or diplomatic awards, when family members are putting a medal onto the market, they frequently contract with the dealer for a "quiet" sale, meaning that the buyer as well as the dealer must refrain from publicizing the transaction in any way.

Still, there is a difference between taboo and illegality, and the Motion Picture Academy's long-standing legal battle to prevent the circulation of Oscars as "mere commerce" has struck many observers as an absurdity. Where there is a possibility that someone might pass himself off as the actual recipient of an award, a compelling case can be made for establishing legal obstacles to trade. Congress made it illegal to circulate the Congressional Medal of Honor outside a recipient's family, for example, after a court judge was found to have been using an acquired medal to increase his social and political standing in Washington. Such prohibitions date back to the

early Renaissance, when the "buying and selling of honours," as Andrew Marvell put it, was deemed a crime of imposture. But AMPAS obviously can't offer any such rationale, and its claims to be conferring "medals of honor" so pure that any brush with commerce would irreparably soil them have been met with considerable skepticism. Cyrus Todd, whose attempt to auction the Oscar won by his grandfather (producer Michael Todd) was derailed by the academy in 1989, said it was "hypocritical" of the academy to accuse him of "trying to go commercial with the award," given the scale of the academy's own commercial ambitions with the whole Academy Awards extravaganza. Indeed, though Todd does not point it out, the academy's unrelenting legal battles on another front—against those who allegedly infringe their copyright or trademark by selling miniature chocolate likenesses of the Oscar statuette, marketing an "Academy Award" style of women's undergarments, naming a deli sandwich the "Oscar," and many similar appropriations—have been aimed explicitly at guarding AMPAS' monopolistic right to exploit the Oscar commercially. As its attorneys pointed out in the 1955 ladies' underwear trial, the academy was already at that time entering into "legitimate license agreements" with commercial entities willing to pay the asking price; but the company selling "Academy Award" undergarments held no such license.[19] And even the legitimate licensees, dating back to the Bulova Watch Company, which in 1949 paid the academy $145,000 for limited rights to use both the name "Academy Award" and the Oscar emblem, have gotten no more than they paid for. When Bulova tried to stretch those limited rights, the academy successfully sued the watchmaker (thereby assuring the scarcity of the 1950 Bulova "Academy Award" watches, which, in the original "Oscar Stage" box, are worth at least $2,500 today).[20] If there were

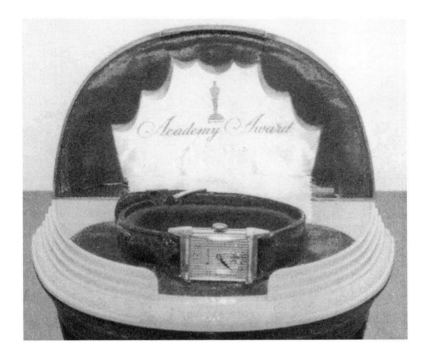

6. A 1950 "Academy Award" watch by Bulova, with original box and "Oscar Stage" case, as advertised by Stairway to the Stars, dealers in Hollywood memorabilia. Estimated value a half-century later: $2,500. (Photo by Rick Spector. Courtesy of Stairway to the Stars.)

no commercial profits at stake for AMPAS, the academy would have no legal case against those who appropriate its icon or the award's nickname.

Malcolm Willits, who was to have handled the 1989 auction for Todd, has not only insisted on the natural and necessary connection between the symbolic value of a trophy and its commercial circulation, but has argued that over time the former may actually depend on the latter. In the long run, he argues, the dignity or status of the Oscar statuettes is somewhat precarious, and his auctioning of

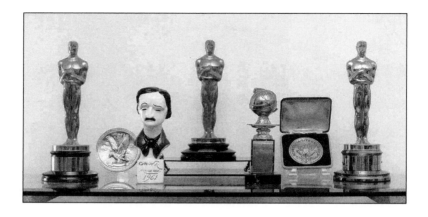

7. A selection of award trophies at Stairway to the Stars. The three Oscar statu-
ettes are (from left to right) Best Sound for *Sayonara* (1958); Best Special Ef-
fects for *Crash Dive* (1943; note the smaller, prewar marble base); and Best
Sound for *My Fair Lady* (1964). The eagle medallion is an undated Directors
Guild of America Award presented to Sheldon Leonard. The medallion in the
square case is a Writers Guild Award (then known as a Screen Writers Guild
Award) for Best American Drama, presented to John W. Cunningham for
High Noon (1952). The miniature bust of Poe is a 1961 Edgar Award for hor-
ror screenwriting; a "B" on its base would seem to identify it as the trophy
won by Robert Bloch that year for *Psycho*. Finally, the Golden Globe trophy
was awarded to Steve McQueen in a now-obsolete category, "World Film Fa-
vorite." The award presented to Marilyn Monroe in this category for the year
1961 was sold at a 1999 Christie's auction for $189,000. (Photo by Rick
Spector. Courtesy of Stairway to the Stars.)

them, far from being a debasement, actually augments their sym-
bolic luster. "Oscars have been sold in pawnshops and garage sales
for years by people who don't want them," he points out. "Marlon
Brando used his as a doorstop before he gave it away to a friend,
suggesting he make a lamp out of it. If anything, we're restoring
worth and value to Oscars by auctioning them. You know any
man willing to pay $15,000 for an Oscar is going to cherish and re-
spect it."[21]

Willits' rather self-serving argument is rooted in the view that money itself today carries a positive symbolic value in cultural fields —that a big price tag has a certain cultural prestige in its own right, such that a trophy's proven capacity to attract buyers redounds to an award's credit among artists, authors, critics, and other interested parties. Of course this is not perfectly true, since even today an association with cash and commerce that is too intimate or unalloyed can and often does interfere with a prize's symbolic ambitions. The negotiation and manipulation of this imperfect convertibility of (economic) capital with (symbolic) capital is precisely the "game" being played—by AMPAS, by Todd, by Brando, by Willits himself. If money and prestige were simply and perfectly convertible—or if they were wholly inconvertible, such that commercial value and cultural status were always inversely correlative—then there would be no game to play, people would devote far less attention and energy to prizes, and we would not have been seeing such a wild proliferation of awards over the past hundred years.

The commercial afterlife of trophies should thus be viewed as an extension and amplification of their original function—as a component of the awards game itself, rather than as a violation of the founding rules of that game. And this is the case not because the award-object was always only about money, which is certainly false, but because every transaction involving that object—from its production by artisan or specialist foundry to its pointedly undignified display as a doorstop, its reproduction and circulation in the form of a Nobel Medal Commemorative Stamp (an intentionally collectible form of legal tender) or an "Academy Award" watch (an intentionally collectible form of commodity), its acquisition at auction or its permanent loan to a museum or hall of fame—involves

8. Nobel commemorative stamps, from the first two years that Sweden Post
 Stamps began issuing annual Literature Laureate commemoratives. Derek
 Walcott (1992) and Toni Morrison (1993) are commemorated. Extra value is
 conferred by a cancellation stamp marking the first day of issue. (Walcott
 stamp original by Eva Ede; engraved by C. Slania and P. Naszarkowski. Mor-
 rison stamp original by A. Prah and H. Marcus; engraved by L. Sjöblom and
 P. Naszarkowski. Printing by Sweden Post Stamps. Copyright © Sweden Post
 Stamps.)

strategic attempts to exchange and manipulate complex forms of
value rather than to guard simple ones. Far from representing a cor-
ruption of the cultural realm, such acts of exchange and manipula-
tion—which prizes have served increasingly to facilitate—in fact
constitute cultural practice as such.

III. The Game
and Its
Players

Scandalous Currency

The Booker Prize is rubbish.
> —*The Times* (London), October 19, 1982

Everyone hates the Pulitzers.
> —*Newsweek,* April 21, 1986

The Turner Prize . . . is an odious and disgusting scandal.
> —*Daily Telegraph,* November 29, 1995

As we've already noted, the discourse surrounding cultural prizes has long been predominantly negative in tone.[1] Historically, it is difficult to find anyone of any stature in the world of arts and letters who speaks with unalloyed respect for prizes, and still more difficult to find books or articles (other than those underwritten by the prize sponsors themselves) that do not strike the familiar chords of amused indifference, jocular condescension, or outright disgust. It seems moreover to be the case that the most prestigious awards draw the most intensely critical sniping. It is not the little start-up prizes, or the eccentric, whimsical prizes, or the prizes in low-prestige genres like romance or pornography, which "everyone hates" (though these are often the object of dismissive, just-what-we-need-

another-prize remarks), but rather the very prizes which we should have thought everyone wanted to win: in America the Pulitzers or Academy Awards, in Britain the Booker or the BAFTAs, nearly everywhere the Nobel. And not only are the high-prestige, high-culture prizes the ones most frequently and bitterly derided, but the most derisive commentators tend to be the highest-prestige authors and artists and critics—the very people who constitute the pool of potential judges and prizewinners, and from whom we might therefore have expected a certain degree of diplomacy, if not an actual endorsement.

What sort of event or system of exchange is this, which seems to secure cultural esteem by maximizing the flow of disesteeming discourse through and around it? How and why do cultural prizes discourage, except in blandly official statements, unequivocal expressions of affirmation and assent? And if we are not really expected to believe in the prize, to take it altogether seriously, then in what sense is it an effectual practice of "collective make-believe" or "social alchemy"? What collective cultural function can the prize possibly serve when so many consequential participants have announced in advance their disdain for its procedures and outcomes?

These are the questions I will be taking up in this third part of the book. They are important questions because, to begin with, they get to the heart of the *game* element in prizes, the unspoken rules and unconscious strategies that structure everything from acceptance speeches to op-ed commentaries, and that cue observers to praise an adept or expert "player" like Dustin Hoffman at the 1985 OBIEs ("This is a very tough fucking *house*. How can you *beat* this house?") or Bill Murray at the 1999 New York Film Critics Circle Awards (removing his coat and rolling up his sleeves: "We might as well get comfortable. I'm going to be up here for a while") while

deprecating a maladroit one like Sally Field at the 1980 Academy Awards ("You *like* me! You really *like* me!").[2] But they are also important questions because they point to a central difficulty in the critical analysis of prizes—namely, the fact that critique, at least in its usual forms, is itself a fundamental and even in many circumstances an obligatory part of the game, a recognizable mode of complicitous participation. One cannot get very far toward understanding what prizes are and how they work, let alone toward challenging the material and symbolic bases of their efficacy, simply by joining with the long-dominant tendency to abuse them, labeling them a farce and a circus and an embarrassment, or permitting oneself to tolerate their existence with barely concealed distaste. Rather, we must subject this tendency itself to critical examination, tracing its recent history and assessing the kind of cultural work it performs in our era.

Because it is a tendency that becomes stronger rather than weaker as the prize in question becomes more valuable and the field of its application more elevated or culturally legitimate, I will focus in this part of the book on the higher, "art" end of the art-entertainment spectrum, where the forms of critical sniping at the prize and, to borrow another term from Bourdieu, the "strategies of condescension" at work within the prize presentation itself, are somewhat more elaborate. Of course there is no shortage of attacks on "entertainment" prizes: sometimes it seems as if the whole point of the Grammys and the Tonys and the Emmys is to give newspaper columnists an opportunity to hurl abuse at them. Remarking that the Oscars are "a joke" and the Grammys "an even bigger joke," a writer for the *San Francisco Chronicle* adds that, "as for the Emmys, the idea that they actually give awards for series television is probably the biggest joke yet."[3] But prizes for painting, literature,

opera, sculpture, dance, and so forth—the fields belonging to the "sphere of legitimacy," the sphere over which academic authorities exercise their legitimate domination and enforce their methodical hierarchies and universal claims—are different from prizes for sitcoms and docudramas.[4] If prizes for these legitimized arts can still be derided as a kind of joke, it is a somewhat different joke from that of the Emmys. It is not a matter of the supposed aesthetic worthlessness of the entire field being honored, the illegitimacy of its claims to value (though, as we will see, there are moments when that broadly satiric view of, say, contemporary literature or contemporary art is put strategically into circulation). It is, rather, a question of the awkward or embarrassing or somehow compromised relationship between that field and the kind of honor the prize represents. If prizes for daytime talk shows are an idiocy, prizes for poetry or painting are a *scandal*. And there is perhaps no device more perfectly suited than scandal to making things happen on the field of culture; it is the "instrument *par excellence* of symbolic action."[5]

Though there seems never to be a shortage of prize scandals, the scandals invariably sort out into just a handful of basic and well-established types, all of which ultimately derive from the scandalous fact of the prizes' very existence, their claim to a legitimate and even premier place on the fields of culture. While any of the participants in a cultural prize—from sponsors or administrators to winners and losers to friends in attendance at the ceremony—can be fodder for the journalistic apparatus that produces awards scandals, the most common and generic scandals concern the judges, specifically the judges' dubious aesthetic dispositions, as betrayed by their meager credentials, their risible lack of habitus, or their glaring errors of judgment. The Nobel Prize in Literature set off a judging scandal

in its very first year, when the Swedish Academy failed to name Leo Tolstoy its laureate, presenting the prize instead to the minor French poet Sully Prudhomme.[6] And then, amid the consequent storm of protest, the academy was loath to appear contrite (or vulnerable to the pressure of public opinion) and so persisted in neglecting the Russian until his death in 1910.[7] The scandal of appalling omissions from the roster of Nobel laureates (Tolstoy, Hardy, Ibsen, Kafka, Proust, Valéry, Rilke, Joyce, and others), so often invoked against the prize by present-day observers, was thus already firmly lodged in the field of discussion by 1902.

In this case, the scandal was the judges' blindness to great art, their inability to mark a distinction between truly extraordinary and relatively undistinguished work. The academy's scandalized critics, including forty-two Swedish writers, critics, and artists who signed a statement of protest, stressed above all the "genius" of the artist who had been passed over. Just as often, however, these scandals are concerted around the choice of an egregiously "bad" artist, one who affronts the dominant taste with work that appears pornographic, morally corrupt, politically unpalatable, or simply "worthless" according to prevailing standards of evaluation. In such cases, the ostensible deficiency of the judges' taste is a matter not of their undervaluation of true art, but of their overestimation of "garbage" or "gibberish." Allen Tate and his fellow New Critics, who in 1949 awarded the inaugural Bollingen Prize to Ezra Pound, came in for just this sort of abuse; the *Pisan Cantos* were derided as fraudulent nonsense, while Pound himself, an indicted and incarcerated fascist war criminal, was seen as beyond the pale of consideration for national honors and awards. Since this was a prize administered under the auspices of the Library of Congress, it enjoyed the implicit endorsement of the federal government, an unusual feature in U.S.

literary awards (though more common elsewhere), and one that led outraged congressmen to join the chorus of book reviewers and literary journalists in their harangues against Tate, T. S. Eliot, and the other Bollingen judges. Indeed, the outcry was so fierce that Congress withdrew from the library its license to make awards of this kind—reinstating that power only in 1989, with the founding of the biennial Rebekah Johnson Bobbitt National Prize for Poetry.[8]

Whether critics of a prize focus positive attention on the loser or negative attention on the winner—and whether they take a populist or a high-culturalist perspective, attacking the jury for its elitism or for its commercialism, for the inaccessibility or rather for the aesthetic unambitiousness of its selection—their cries of "scandal" are directed not at some minor imperfection in the prize's structure or bylaws (though they sometimes seem to be) but at its very roots. With the Nobel, the Bollingen, and countless other prizes, judging scandals arise practically from the moment of the inaugural award presentation precisely because such scandals go to the very heart of the prize's initially fragile claim to legitimacy. Every new prize is always already scandalous. The question is simply whether it will attract enough attention for this latent scandalousness to become manifest in the public sphere.

Most of the other types of judging scandal in which prizes become enmeshed are simply variations on this original outcry against the jury's imposition of wrong aesthetic preferences. There are, for example, corruption scandals, in which judges presumably capable of making correct artistic distinctions are accused of selling, trading, or otherwise rigging their votes for the sake of personal gain. As mentioned earlier, this type of scandal has hounded prizes since their invention by the Greeks, and no prize can be immune to it. The furor over Pia Zadora's 1981 Golden Globe Award for Best

Actress was only the most notorious instance of the perennial corruption scandals that surround those awards and the voting members of the Hollywood Foreign Press Association—a group that is widely regarded as both undercredentialed and overeager to cast votes in the direction from which the most lavish trips and presents are flowing. (Among other enticements, Zadora's husband flew the entire association membership to Las Vegas.)

Often, judging scandals concern alleged corruption not by money but by some undeclared conflict of interest. In the small, quarreling-family milieu of British book prizes, for example, such conflicts have been attributed to a judge's desire to please a spouse or lover who happens to be on the slate of nominees. These scandals of excessively *intimate* social capital began at the Booker Prize in 1974, when Kingsley Amis' wife, Elizabeth Jane Howard, was on the panel of judges that shortlisted Amis' *Ending Up*. In 1994, the chair of the Booker judges, John Bayley, withdrew a novel by his wife, Iris Murdoch, from consideration; but a fellow juror, James Wood, was denounced for not following suit with respect to a novel by *his* wife, Claire Massud, which he supported for the shortlist. As Mark Lawson (himself a former Booker judge) put it in the *Independent*, other judges may have blundered from time to time, but "we all got through our duties without running the risk of the £20,000 winner's cheque being sent to our own address."[9] A year later, Sheridan Morley, one of the judges for the AT&T Non-Fiction Prize, was chastised for arranging to have his fiancée, Ruth Leon, fill another spot on the panel, and then withholding from his fellow judges the fact of their engagement. Told after the fractious ceremony that Morley and Leon were a couple and would soon be married, the chair of judges, Lord Clark, reportedly said, "They deserve each other."[10] Somewhat less entertaining variants of these conflict-of-in-

terest scandals may involve a judge who is perceived to be returning a favor to an editor, publisher, or producer (the sort of scandal that has been virtually normalized in the major French book awards) or reciprocating an artist who has recently supported the judge when their roles were reversed (as has sometimes occurred in American poetry prizes). All such scandals are pitched against the "politics" of prizes, their inescapable entwinement with the movements not just of money but of social capital. As we have seen, social capital is often an even more important factor than symbolic capital (and far more important than money) in persuading a prestigious artist or critic to serve as a judge; it is an indispensable currency for any new cultural prize. By the common or journalistic definition, therefore, prizes are unavoidably "political" from the moment of their inception, and hence always open to scandals of this kind.

Here again, scandals can take either positive or negative form: critics may accuse judges of having too cozy a relationship to the (unworthy) winner or harboring unfair, merely "personal" animosity toward a (more worthy) contender, or even nursing such fierce antagonism toward a fellow judge, administrator, agent, or other player as to preclude support for that person's candidate. The latter form of scandal, concerned with grudges and hostilities and quarreling in the back rooms of the prize, is the staple of countless journalistic exposés and tell-all cultural memoirs. "Prizefighting," as it is called in many headlines, is the very stuff of awards lore. Yet although such insider accounts are routine, they themselves are often treated as another form of scandal—the scandalous lapse of etiquette that leads a judge or other insider to air the prize's dirty laundry in public. When someone whispers a scandalous bit of backroom gossip to the press, the scandal of the "leak" is often given more play than its ostensible substance.

This capacity on the part of commentators to cast the very fact of a scandal as itself a scandal—and thereby to layer scandal upon scandal, implicating all sides of a dispute—is an increasingly significant feature of the awards scene. It is apparent in such instances as the 1994 Booker Prize, when the scandal of the prize being awarded to an "unreadable," "interminable," and "obscene" 500-page novel of densely rendered Glaswegian dialect in which the word "fuck" reportedly appears more than 4,000 times (James Kelman's *How Late It Was, How Late*) was bound up with the scandal of the especially fierce bickering and maneuvering of the judges, who appear to have landed on Kelman's (altogether remarkable and important) novel not because it was anyone's first choice but because it was used by several judges in their efforts to block the first choices of others. This scandal was, in turn, bound up with the outrageous behavior of one judge, the rabbi Julia Neuberger, who proceeded immediately after the award ceremony to denounce the winning novel ("crap"), its author ("just a drunken Scotsman"), and her fellow judges in a public statement condemning the bad faith and excessively political nature of the decision-making process, a process that she described as "completely mad."[11]

Breaches of etiquette such as this are scandalous not only because they violate the acknowledged rules of the game (judges agree to keep their deliberations confidential), but because they violate a broader and less explicit code of what might be termed cultural sportsmanship. Neuberger was behaving as a sore loser; her book didn't win, so she sulked and complained and did everything possible to tarnish the victory of Kelman. A great deal of the anecdotal lore through which the history of prizes has been conveyed is organized around these transgressions of a presumed collective sense of cultural sportsmanship—not only as regards judges but, especially,

in connection with winners and losing contenders. The commentary on prizes assumes a certain investment, on the part of readers, in the question of whether an artist is a good sport; and structuring that question in all its various forms is a broader assumption: that we all recognize a game-like element in cultural practice and have a shared sense of the rules of the game. Or, to put this differently, one function of prize scandals is to clarify and disseminate, as well as at times to assist in modifying, the contemporary rules governing the behaviors and dispositions of "artists" or other authorities in matters of art—rules which are understood to be different from those that obtain for ordinary people in ordinary walks of life, meaning those outside the art-game. The astonishing degree of journalistic interest in how the participants in an award ceremony behave, how the losers take the news, how the winners express their gratitude, how the old grudges and rivalries manifest themselves, is more than idle curiosity about celebrities. At stake in the minute and always ready-to-be-scandalized attendance to matters of prize etiquette is the very belief in the Artist as a special category of person, and hence in Art as a special domain of existence. And, as we will see, the scandalous currency that prizes put into circulation functions not to deflate this belief but, on the contrary, to keep it aloft, assuring its persistence in the face of heavily contrary historical pressures.

The New Rhetoric of Prize Commentary

Such outrage! Such piety! Such wounded feelings!
> —Vincent Canby, "Hollywood's Shocked and Appalled by Miramax? Oh, Please!" *New York Times,* March 25, 1999 (referring to the Miramax scandal at the 1999 Academy Awards)

In describing what I see as an important shift in the commentary on prizes, I will focus initially on Britain's Booker Prize for Fiction, by far the most successful of all the hundreds of literary prizes founded since the mid-twentieth century. This is, after all, the *literary* prize whose annual dinner and award ceremony, which has been held at a succession of prestigious banquet halls (the Café Royal, Claridge's, the Stationers' Hall, two decades at the Guildhall, and most recently the British Museum), is televised live in prime time, to an audience of some half a million, by the BBC. The coverage is full scale, with a roving floor reporter covering the live action while a studio team comprising well-known literary people offers ongoing color commentary as well as pre- and post-ceremony

analysis. Of late, there has also been a team of (extraordinarily articulate and telegenic) "ordinary readers" to contribute their own thoughts about the shortlisted books and choose a winner of the BBC People's Booker. Meanwhile, another set of commentators back home writes detailed reviews, not of the event itself, but of the *television coverage of the event,* which has itself apparently become a cultural production worthy of critical scrutiny.

The Booker is a particularly glaring instance of how, in the world of prizes, rapid prestige accumulation is often coupled with nearly constant ridicule and disparagement on the part of experts in the arts press and the popular media. Indeed, it is an increasingly open secret that the success of the Booker Prize—its seemingly magical power to attract the attention both of the broad book-reading public and of the most critically respected British novelists—is bound up with the annual flurry of scandal that attends it in the dailies and in the literary press. But the precise nature of its dependency on this rhetoric of scandal, and the gradual modulation of that rhetoric as prize journalism has evolved and expanded over the past quarter-century, have never been given the careful scrutiny they deserve. A crucial part of any cultural game is the art of the put-down, the art of expressing derision. It is an art practiced by various participants at various moments in the awarding process, from the judges in their private deliberations to the recipients in their acceptance speeches, but not least by the commentators, who, far from being outside observers of the game, must be counted among its most savvy and vital players.

When Tom Maschler, then a publishing *Wunderkind* at Jonathan Cape, approached executives of the Booker company in 1968, he could scarcely have envisioned that the literary prize he was proposing would become a household word and a nationally televised

extravaganza. But he saw that an opportunity existed in Britain for an annual prize-event of considerable cultural magnitude. Maschler had spent time in Paris during the October prize season some years earlier and had been struck by the fact that there was no prize in Britain comparable to France's Goncourt (or even, one might add, to America's Pulitzer). Unlike the Goncourt and Pulitzer, which had been organized by entrepreneurs in publishing and journalism and hence promoted with great vigor and competence from the start, the earliest surviving book prizes in Britain—the James Tait Black and the Hawthornden (both contemporary with the Pulitzer)—had neither sought nor attained the limelight. To Maschler, this meant that an upstart prize in Britain had the rare chance to become *the* prize, to seize belatedly the virtually unassailable position of the *prize of prizes:* a position that is mandated by the single-winner axiom that underpins the entire prize economy, but which, in Britain, appeared to be unoccupied. Nothing if not an energetic publicist for the kind of "quality" fiction that is featured on the Jonathan Cape list, Maschler determined, in 1968, to fill this vacuum with a well-heeled, high-profile prize for the novel of the year.

But why did he, along with Cape managing director Graham C. Greene, approach Booker Brothers, a food-products concern with sugar-cane operations in the Caribbean, and why did Booker agree to serve as sponsor? It was not just the fortuitously bookish name, nor was this simply a matter of what I have called cultural money-laundering—though certainly Booker, like other colonial agribusiness companies in the early postcolonial period, was seeking to diversify into the service sector (especially the financial-services sector) and to improve its domestic public image. There were in fact already some direct material ties between the two parties. A diversified company, Booker had gone into the book business in a small

way a few years before, taking advantage of special provisions in the tax law to purchase the copyrights from bestselling authors such as Agatha Christie and Ian Fleming (the latter was one of Cape's premier cash cows), and then to cycle the income through a tax-reduction accounting apparatus before making payments to the authors. The Artists' Services division was immediately successful (producing profits of £100,000 in 1968, four times that by the mid-1970s) and, though no more than a small entry on Booker's balance sheets, consistently outperformed the rest of the company.[1] Sponsorship of a major book prize made sense as a way of promoting this line of business. It could give Booker's tax-shelter specialists more intimate access to publishing insiders, improve the company's visibility with high-income writers, and perhaps boost overall sales in the segment of the book trade that concerned Booker—namely, fiction.

Of course, Maschler stood to gain more or less the same things: higher visibility, improved access, and better sales—not only for novels in general but specifically for Cape's novels. (And indeed, over the first twenty-five years of the Booker Prize, Cape was the greatest single beneficiary, with as many shortlisted books—twenty—and as many winners—four—as the next two houses combined).[2] For Booker, the expense (initially £5,000 for the actual award, plus something less than the same amount to fund lunch meetings, host a modest prize reception at the Stationers' Hall, pay the judges, and so on) was not of great consequence. And for Cape there would be no costs at all; the reason for seeking out a sponsor in the first place was clearly to avoid the difficulties involved in promoting a prize underwritten by one of the publishing houses whose books would be competing for it. (Even so, Maschler's rather special involvement with the award has been seen as a compromising advantage.)

Thus, there were perfectly sound business reasons for injecting some capital into the book-prize economy. But the fact that a prize makes good economic sense does not mean that it makes good symbolic or cultural sense. In many respects, the Booker was not well positioned to succeed. The prize was hardly alone on the field of English book awards. Not only had it missed by half a century the important symbolic distinction of being the oldest book prize in England; it also trailed the "second generation" of book prizes, which had emerged during World War II with the John Llewellyn Rhys Memorial Prize (a war-widow initiative), followed by the Somerset Maugham (1946), the W. H. Smith (1959), and a few others. In 1968, the Booker was competing, as well, with a vigorous cluster of newcomers: the Guardian Prize and the Geoffrey Faber Memorial Prize had been founded in 1965, and the Silver Pen had just been announced earlier in 1968. It is usually assumed that the Booker's large cash value set it decisively apart from these other prizes. But although its £5,000 was indeed higher than others initially, this did not remain the case for very long, and the gap was never so dramatic as to be a significant differentiating marker. Over the years, Booker management has increased the prize money, but not through any effort to guard a perceived symbolic advantage; the administrators have never bothered to match or exceed the cash payouts of new entries such as the NCR Book Award, the Orange Prize for Fiction by Women, the *Irish Times*–Aer Lingus International Fiction Prize, or the IMPAC Dublin Literary Award (the last of which has been worth as much as $160,000). It is true that none of these is in direct competition with the Booker, since the NCR was a nonfiction prize and the latter three are open to non-British novelists (and even, in the case of the IMPAC, to novels in translation).[3] But even among the British-only fiction prizes, the Trask, the Whit-

bread, and the *Sunday Express* awards have all offered more cash than the Booker at various times since the early 1980s. This trend appears now to be on a reverse swing: as part of its arrangement with a new sponsor, the Man Group, Booker management announced in early 2002 that the cash value of its prize (now renamed the Man Booker Prize) would be more than doubled. But these periodic shifts and reshifts of the Booker's position in the cash-value ranking of Britain's literary prizes merely confirm that such rankings do not in themselves hold the key to the Booker's special status and phenomenal success.

Unremarkable in terms of its age and its money value, the Booker was also unremarkable in its professed criteria and aims: true to Maschler's intentions, it was a national novel-of-the-year award of the most generic sort, one more would-be Prix Goncourt. Indeed, in this respect most of the higher-profile fiction prizes (except those reserved for younger writers, such as the Somerset Maugham and the John Llewellyn Rhys) seem identical, and their selections even sometimes duplicate one another: in 1981 the Booker and the Whitbread both went to Salman Rushdie for *Midnight's Children,* the Yorkshire Post went to Paul Theroux for *The Mosquito Coast,* and the James Tait Black was divided equally between Rushdie and Theroux.

There thus seems to be no clear symbolic distinction underlying the foundation of the Booker Prize. In fact, the Booker was a precarious enough proposition that the whole venture was very close to folding within just a couple years of its launch. The private correspondence and the minutes from committee meetings of 1970 and 1971 read like the black-box transcript from a crashed plane: publishers were threatening to stop nominating books; people invited to serve as judges were routinely declining to do so; Maschler in-

sisted on acting like the chair of the management committee, to the point where the actual chair resigned; the Book Trust was abruptly brought in to assume administrative responsibility, even though it had never administered a prize; and the sponsor, though contracted for an initial seven years of funding, was already making noises as if preparing for an early exit.[4]

But what happened instead is that the Booker began, in 1971, to deliver a series of annual scandals. The best known of these—the one that gets mentioned in every capsule history of the prize—is that of John Berger's rude acceptance speech in 1972. Awarded the prize for *G.,* his novel about French migrant workers (which also won the James Tait Black and the Guardian Fiction Prize), Berger stood before the assembled Booker executives in the Café Royal on Regent Street, denounced their corporation as a colonialist enterprise built on the backs of black plantation workers in Guyana, and declared that half his prize money would be donated to the London branch of the Black Panthers.[5] The specific political content of this incident is certainly of interest: although there were no immigrant or non-English figures involved, and the very category of "postcolonial fiction" had not yet emerged, it was perhaps at this moment that one could first glimpse the Booker's ultimately quite powerful institutional and ideological role in the struggle to define a postcolonial literature subject to domination (and commercial exploitation) by the London metropole.[6] But in a certain sense, the specific political content was irrelevant. What mattered was rather the outward shape or form of the incident, certain basic and familiar features that brought it into line with the inclination and ready ability, on the part of the handful of journalists assigned to cover the event, to represent it in the rhetoric of scandal.

Indeed, the Berger incident could not have given such an enor-

mous boost to the Booker's public profile had it not been prepared for by a modest scandal the previous year that, despite its directly contrary political orientation (which positioned the prize as subversive of traditional English values), conformed to a similar general pattern and offered similar opportunities for journalistic treatment. This was the resignation from the jury by Malcolm Muggeridge, a conservative Christian journalist and Sunday-morning BBC program host, popularly known as "Saint Muggs." Withdrawing at mid-year, Muggeridge wrote to the Booker secretary that the nominated books "seem to me to be mere pornography in the worst sense of the word, and to lack any literary qualities or distinction which could possibly compensate for the unsavouriness of their contents." The Booker organization promptly issued an enticing press release which made sure to emphasize Muggeridge's charge of "pornography," and the Sunday papers, capitalizing on Saint Muggs's Sunday ubiquity, obliged with the Booker's first real dose of publicity.

Berger's scandalous remarks fit nicely into the tracks laid down by the Muggeridge incident. Berger, in 1972, was just coming off a hugely successful run on the BBC with *Ways of Seeing*, his lively introduction to Marxist art criticism and a cheeky counterpoint to Kenneth Clarke's *Civilisation* series. Berger, that is, was not just a novelist, but, like Muggeridge, a bona fide TV celebrity—who moreover had published a nonfiction book (spun off from the BBC series) that was heading onto the bestseller lists.[7] His gesture was thus "scandalous" not just in the sense of being somehow improper but also in the sense of possessing wide resonance among the non-literary public, having at its center a so-called public figure rather than a strictly literary one. Just as the Muggeridge episode had enabled journalists to reanimate the stale dichotomy between art and

"obscenity," restaging it around a journalistically compelling narrative of celebrity misbehavior, the Berger episode afforded them a journalistically credible way to reanimate the old dichotomy between art and politics, staple of Britain's "long" culture war, as of America's. For the purposes of scandal, the crucial impropriety in Berger's acceptance speech was not any specific political position, but rather politicization as such, the determination to drag politics into a friendly literary luncheon, the insistence that even literary practices of the most benign appearance, such as book-prize sponsorship, had political dimensions that should be publicly probed and discussed.[8]

The following year, this journalistic opportunity to report the conferring of the Booker award as a scandal was renewed by J. G. Farrell, who received the prize for his *Siege of Krishnapur*. Farrell spoke pointedly in his acceptance speech of a future, better day when British miners "would get higher priority than businessmen, and rich people would not be able to buy privileged schooling for their children."[9] Though more temperate than Berger's remarks and lacking the celebrity signature, Farrell's speech was immediately seen as conforming to the same template. His implicit denunciation of the Booker executives in attendance (rich people whose children enjoyed privileged schooling) was so readily connectable to Burger's speech the year before that journalists could invoke the one through the other, and Muggeridge's through them both, and thus get a sufficient quantum of celebrity into the mix by association.[10]

By early 1974, after these three successive scandals—two of them powerfully leveraged by the crossover with television, and the third virtually guaranteeing that the other two would be revisited (and the whole sequence retraced) in all the arts pages—the tone of frustration had entirely disappeared from the committee's minutes.

They were congratulating themselves on "very satisfactory" results, and particularly on the fact that "publicity for the prize has now gained its own momentum."[11] Press coverage, which had risen to about fifty stories in 1971 and two hundred in 1972, had risen again in 1973;[12] publishers had stopped complaining about the entry fees, prestigious judges had become easier to find, and Booker PLC happily renewed the seven-year sponsorship agreement. Within a few more years, the BBC had decided to televise the award ceremony, a development which in turn led the Booker's management committee to revise its procedures along more Oscar-like lines, such that the judges' decision could be kept absolutely secret and the shortlisted authors could be assembled, under conditions of maximum anxiety and close public scrutiny, to endure the announcement. This "celebrity sadism," as one commentator called it, ensured that incidents of scandalous misbehavior (Salman Rushdie pounding his fists on the table, cursing at the prize's administrator, saying the judges knew "fuck all" about literature, and so forth) would occur even more often and could be even more eagerly anticipated. Journalists covering the Booker would always have "cultural" material of just the sort they required.[13]

The arrival of television at the book-prize ceremony could be counted on to produce other sorts of scandal, as well, such as when celebrity reporters—interlopers from the TV side of the event—would stumble in their efforts to make literary small talk. The most notorious incident of this kind occurred when the vapid Selina Scott, doing roving interviews for the BBC in 1983, managed to interview one of Britain's most eminent novelists, Angela Carter (who was a judge that year), without recognizing her, and then asked the chair of judges, Fay Weldon, if she had actually read the nominated books. Those commentators who wished to characterize the real

scandal of the Booker Prize as its complicity in the dilution of literary value by the values of television (where a pretty face is worth more than an advanced degree in English) merely had to make reference to the "embarrassing" Selina Scott.[14]

The upshot of these various interrelated developments was that, just a decade after its near collapse, the Booker outstripped all other British literary prizes combined in terms of the sheer volume of publicity, renown, and book sales it could generate for its winner. Even to be shortlisted for the Booker was a distinction of greater value—symbolic as well as monetary—than any other prize could muster. To win it, as Thomas Keneally's editor said when Keneally received the 1982 prize for *Schindler's Ark,* was "like an avalanche hitting you all at once."[15]

It is well known that in the decades after World War II there was a general reshaping of the relationship between journalistic and cultural capital, celebrity and canonicity.[16] Starting in the early 1970s, prize sponsors and administrators—particularly in fields that enjoy programming time on television, as literature does in England, Sweden, Germany, Austria, France, and to a much lesser degree the United States—became adept exploiters and manipulators of this relationship. The Booker's chief administrator, Martyn Goff, a major figure in the history of prizes, was fully and actively complicit in exploiting the association of the Booker with scandal, wagering that the prize stood to reap the greatest symbolic profit precisely from its status as a kind of cultural embarrassment. It was Goff who, in his first months as administrator, made sure to alert the press about Muggeridge's attack on the "pornographic" and aesthetically worthless character of the kinds of novels the Booker applauds.[17] And Goff came to realize early on that each new Booker scandal provoked objection not just to a particular jury decision or

management policy or winner's acceptance speech, but to the very existence of the prize. The Booker's critics do not simply weigh in on one side or the other of a given evaluative controversy, but use each controversy to rehearse the more fundamental dispute over the Booker Prize itself. In the *Times,* the Booker has been dismissed as "rubbish,"[18] mere "razzmatazz, . . . a laughing stock," "an annual rusty nail . . . hammered in the coffin of fiction."[19] The *Daily Telegraph* has called it "an embarrassment to the entire book trade."[20] And the *Economist* has pronounced it "a sad and shoddy farce," adding that it is high time "for the backers to call it a day."[21] Such wholesale denunciations, appearing in the most powerful journals, are clearly not an unhappy side-effect of the promoters' publicity strategy, but a central aim. It is the charge of fundamental, irremediable illegitimacy that keeps the prize a focus of attention, increasing its journalistic capital, *and* speeds its accumulation of symbolic capital, or cultural prestige. Far from posing a threat to the prize's efficacy as an instrument of the cultural economy, scandal is its lifeblood; far from constituting a critique, indignant commentary about the prize is an index of its normal and proper functioning.

Until quite recently, however, there has not been much room in the game to acknowledge this simple fact of complicity or convergence of interests between the more or less lofty and disdainful cultural commentators and those who have a direct stake in promoting the prize and enlarging its cultural role. Instead, commentators tended, misleadingly if not disingenuously, to describe the relationship between the Booker's increasingly privileged cultural position and its perceived scandalousness as a paradoxical one, the prize having miraculously succeeded "in spite of" all the outraged and scandalized book critics. "Throughout its twenty-year history," states the *Sunday Times,* "the prize has frequently been derided as a

tasteless horserace, a culturally bankrupt publicity stunt. *But* its profile as the nation's most eminent award for fiction is now beyond dispute."[22] "*In spite of* the jibes about 'hype' and 'ballyhoo,' etc., that go with the Booker Prize," said a flag-waving Anthony Thwaite after serving as chair of judges, "the Booker is internationally recognized as the world's top fiction prize."[23] Less optimistic after her own stint as judge, Margaret Forster nonetheless followed the same logic, suggesting that a prize which "since its birth in 1968" has been so mercilessly "dogged by controversy . . . and hostility" may be unsustainable, and that the Booker "needs all the help it can get."[24] Even Bill Buford, a savvy literary promoter in his own right, having noted that the Booker's publicists seem awfully eager to stress its most "scandalous" moments, slipped into the standard rhetorical pattern, remarking as if surprised that "*nevertheless,* the award ceremony has become the most important literary event in Britain."[25] What this rhetoric keeps out of view is the fact that the swarm of critics whom Thwaite defensively refers to as "parasites who simultaneously jeer at the prize and make a living out of telling lies about it" have actually been more fundamental and indispensable to the prize than the much smaller group of apologists (who have tended to be, like Thwaite and Forster, recent judges still feeling the sting of those journalistic "jibes" and "jeer[s]"—and who often decide, within a few years, to do some modest jeering of their own).[26]

The tendency of commentators automatically to describe the situation in this way, as a strange deviation from the proper and expected course of things, has depended on their convenient misapprehension of the economy of cultural prestige and of their own place in that economy. Arts editors, book reviewers, and authors and academics who write for the newspapers or engage in book

chat on radio and TV are by no means perfectly opposed to the sponsors and administrators of prizes, nor, where the two sets of interests do diverge, would the writers stand to gain by driving prizes off the cultural field altogether. Prizes are as useful to them as to the sponsoring corporations and societies, of which in many cases they are members or proxies. In fact, nearly all the Booker-bashers I have been quoting are former judges, winners, nominees, and so forth, or else literary people of the sort who might well be called to serve on future judging panels, or whose novels might one day be nominated for consideration. One gets accustomed, in reading satiric or critical pieces about prizes, to the paragraph that confesses the writer's own history of participation as judge or contender. "I should perhaps add," remarks John Gross (toward the end of a piece in which, according to an editor's subheading, he "deplores the showbiz atmosphere that puts celebrity before literary merit"), "that I have been a judge myself, and found it, for the most part, an agreeable experience."[27] The wickedest satire of the Booker I've seen anywhere is the first chapter of Malcolm Bradbury's *Doctor Criminale* (1992), and no one was more thoroughly integrated with the prize than Bradbury, who, when he died in 2000, had been chair of judges twice, a shortlisted author once, and a longtime member of the management committee—as well as being director of the creative writing program at the University of East Anglia, whose teachers and alumni have featured so prominently in the Booker that there have been grumbles about an East Anglia "Mafia." (When Bradbury chaired the jury in 1989, one of his fellow judges, Helen McNeil, was an East Anglia colleague, as was one of the shortlisted writers, Rose Tremain. The winner, Kazuo Ishiguro, was an East Anglia graduate and a former student of Bradbury's.)

Where this particular cultural game is concerned, the outsiders

are the insiders: the prize-bashers who call so stridently for an end to it all are the very people whose capital is augmented by its circulation through the prize economy. And the situation is much the same in the United States, where prize-bashing has traditionally taken the same basic forms and where similar overlaps appear between the bashers and the participants. One of the more biting pieces on the U.S. book prizes was a *New York Times Book Review* cover article by the novelist William Gass in which he asked, in connection with the Pulitzer, how anyone could refuse "the opprobrium of the honor." The prize's "record of failure," he observed, "approaches perfection."[28] Gass was simply following here a long tradition of what one Pulitzer historian calls "critical sniping and outright disdain"—a tradition that extends back to the prize's earliest years, when one would routinely find pieces in the *Nation,* the *New York Tribune,* and other papers observing that the Pulitzers "mean next to nothing."[29] Indeed, reviewing the situation in the mid-1970s, the *Times Literary Supplement* (*TLS*) observed that Americans so disparage their Pulitzers that the establishment could destroy the reputations of oppositional writers simply by arranging to have them win the awards.[30] But just as in Britain, those who lead the rhetorical charge against book prizes in the United States are the insiders of the economy of literary prestige. Gass not only is a prizewinning novelist and a winner, for his work as a critic, of the National Book Critics Circle Award, but also has served as a judge for the National Book Awards and even gave the keynote address at the 1990 National Book Awards ceremony. Carlos Baker, who in 1957 published one of the most thorough denunciations of the Pulitzers ever written, not only was a member of the fiction jury from 1955 until 1957, but was invited to serve again after his scathing piece appeared.[31]

It is thus no exaggeration to say that antiprize rhetoric is part of the discursive apparatus of prizes themselves, produced by those whom they enlist as their own agents and serving interests that those agents share with sponsors and administrators. Apart from being a means of derivative consecration for journalist-critics (since members of this fraction often receive the symbolically subsidiary but structurally primary honor of being asked to serve as nominators or judges), prizes have traditionally been useful in providing regular occasions for such critics to rehearse Enlightenment pieties about "pure" art and "authentic" forms of greatness or genius, and thereby to align themselves with "higher" values, or more symbolically potent forms of capital, than those which dominate the (scandalously impure) prize economy as well as the journalistic field itself. Such rehearsals do nothing to discredit the cultural prize, and in fact serve as a crucial support for it inasmuch as they help to keep aloft the collective belief or make-belief in artistic value as such, in the disinterested judgment of taste, the hierarchy of value or prestige that is not a homology of social hierarchies, not a euphemized form of social violence. Like the mid-century magazine profiles of "great writers on vacation" memorably described by Roland Barthes in *Mythologies,* the journalistic coverage of prizes has served by its very emphasis on the banal, the social, the petty side of cultural life—the bickering or cheating, the insider deals, what is often referred to as the "politics" of arts and letters—to reinforce belief in the higher, apolitical, "intrinsically different" nature of artists and artistic value.[32] The prize has depended on this collective belief, since its own currency, however tainted or debased, is understood to derive from this other and purer form, which stands in relation to the economy of cultural prestige as gold did to the cash economy in the days of the gold standard—perfectly magical guarantor of an imperfectly magical system.

The long-standing fiction claiming that scandalized commentators stand outside of and in opposition to the cultural-prize game —in a stance of independent critique rather than "dependent independency"—has, however, finally begun in recent years to give way. Increasingly one finds these commentators, journalists and academic critics alike, acknowledging a prize's dependency on denunciation by "independent" writers such as themselves, its need to be represented by them as a scandalous and degrading instrument of cultural manipulation. Mark Lawson, a book-review editor at the *Independent* who has himself served as a Booker judge and been involved in more than one book-prize scandal, observed in 1994 that the function of the Booker Prize is not simply "to promote the cause of serious fiction . . . [but] to provoke rows and scandals, which may, in due course, promote the cause of serious fiction."[33] Richard Todd, an academic who in 1996 published an entire book on the Booker Prize, dismisses as "fatuous" the kind of "highbrow literary" denunciations that have been directed at the prize, and he takes it as "surely evident" by now that the prize's loftiest critics are its best allies, that the Booker thrives "precisely by 'getting it wrong'" (as it cannot fail to do) in the eyes of so many established experts.[34] More recently still, Robert McCrum, weighing in on the months-long controversy over the Booker's rumored intention, under new sponsorship, to extend eligibility to U.S. authors, noted that all the frantic hand-wringing about the prize's commercialist logic, its corrosive effect on traditional British literary culture, and so forth, the whole frantic debate, was just what Martyn Goff had hoped for in floating the (almost undoubtedly false) rumour, and that the commentators, himself included, were simply doing the bidding of the new sponsors at the Man Group: "On some corporate top floor in the city, a bunch of suits must be hugging themselves with excitement." Commented the American academic

Elaine Showalter, visiting London that spring, "everyone knows the flap over the Booker may even be part of the publicity and promotion. . . . That's all part of the game."[35]

Alongside this creeping readiness to acknowledge the smooth working relationship between cultural prizes and their critics, we find more and more a kind of playful or reflexive prize commentary in which "scandal" seems to circulate in scare quotes, with winks and nudges passing between the ostensibly scandalous artist or jury member, the ostensibly scandalized critic, and the reader. The whole event is seen as being pinned on what a chair of judges at the NCR Non-Fiction Prize called "the hope that there might be a row, in inverted commas."[36] Doubtless a certain conscious duplicity or jocularity has always been observable in coverage of the Booker (and in British cultural journalism generally), but it has become far more conspicuous over the past decade, with fewer critics sounding the note of sincere outrage and more of them openly *playing around* with "scandals" that are at least partly of their own invention. Geraldine Brooks, in an account of the 1992 award dinner, recalls the feeling of disappointment as things wound down without an embarrassment or a controversy. The judges that year failed even to choose an outright winner, dividing the prize between Barry Unsworth and Michael Ondaatje; the evening seemed flat, anticlimactic, given over to timidity, compromise, and decorum. But soon after the two winners made their acceptance speeches, Ian McEwan, a shortlisted also-ran for the second time, took his publishing entourage and left the Guildhall. Brooks seized eagerly on this gesture. "Is it possible?" she wrote. "Yes! He's walking out! Before the closing speech and the toast to Poor Salman, Who Can't Be With Us! . . . What a relief. The Booker Prize for 1992 will have its scandal after all."[37]

This new rhetoric of amused complicity in the manufacture of scandal is an instance of what Bourdieu calls a "strategy of condescension," a strategy that enables one to enjoy both the rewards of the game and the rewards due to those who are seen as standing above the game.[38] It does not permit outright denunciation or implacable opposition, except as a kind of put-on, a form of trashtalk, ritual insults within the bounds of a game; it does not allow one to say explicitly and in all seriousness that, as a "literary critic" or "intellectual," one is above such stakes as are at issue in the prize economy. It does still enable one to gesture toward that imaginary separate space on which the ideology and institution of modern art have been predicated, the space outside all economies, where artistic genius is a gift rather than a form of capital and where the greatness of great art is beyond all measure or manipulation except by the sure determinations of Time.[39] But the gesture, which is in any case no longer obligatory, seems more and more often to be oblique, apologetic, ironized. It has come to involve a certain acknowledgment, though always a partial and incomplete acknowledgment, that this "world apart" is a matter of collective make-believe. What used to be describable as the "sincere fiction" informing commentary on prizes, and indeed underpinning the entire economy of cultural prestige—the fiction of socially unmediated aesthetic value—does remain in place as a kind of necessary predicate. But this new (or rather, increasingly dominant) rhetoric suggests new difficulties in the very problematic of *sincerity* as it applies in such instances. What Bourdieu calls the *illusio* of literature—the fundamental belief in the literary game and in the value of its stakes —has been complicated or compromised by something that is neither a perfect lucidity regarding "the objective truth of literature as a fiction founded on collective belief" nor a radical disillusionment

from which literary practice can seem only a form of "cynical mystification or conscious trickery."[40] We are, rather, dealing with a kind of suspension between belief and disbelief, between the impulse to see art as a kind of Ponzi scheme and the impulse to preserve it as a place for our most trusting investments. Under these circumstances, cultural prizes can be, at one and the same time, both more dubious—more of a joke—than they used to be, and more symbolically effectual, more powerfully and intimately intertwined with processes of canonization. That is the central paradox of our contemporary awards scene.

Strategies of Condescension, Styles of Play

> *But I do want to thank the bureau . . . I mean the*
> *committee, the organization, for the $10,000 they've*
> *given out. . . . Tonight they made over $400,000. And*
> *I think that I have another appointment—I would like*
> *to stay here, but for the sake of brevity I must leave. I*
> *do want to thank you. I want to thank Studs Terkel. I*
> *want to thank Mr. Knopf, who just ran through the*
> *auditorium, and I want to thank Brezhnev, Kissinger—*
> *acting president of the Unites States—and also want to*
> *thank Truman Capote, and thank you.*
>
> —Professor Irwin Corey, accepting the
> National Book Award on behalf of Thomas
> Pynchon, April 18, 1974

While the Booker is among the most talked-about of high-cultural prizes, its relationships to criticism, scandal, and the field of journalism are largely unexceptional. Even in fields of culture to which the press pays far less attention than it does to literature, when a prize makes the news it is generally due to some "scandal" which takes the same basic form—the increasingly (though never per-

fectly) parodic or *insincere* form—that it does in connection with the Booker. Indeed, we find other prizes more and more often being compared to the Booker, usually in statements alluding to the "Bookerization" of the whole cultural-prize phenomenon.[1] So that when a "scandal" or "row" breaks out in connection with some literary or arts prize these days, those who attack and denigrate or embarrass the prize are less likely to be perceived as acting within the long tradition of sincere animosity between artists and bourgeois consecrations—artistic freedom fighters on the old model of art versus money—and more likely to be seen as players in a newer cultural game whose "rules" and "sides" are rather more obscure and of which the Booker happens to be the best-known, and hence the most generic, instance.

This situation can be brought into focus if we consider the scandals of refusal that periodically, and memorably, interrupt the regular ceremonies at which prizes are awarded and received. Award ceremonies are rituals of symbolic exchange, requiring all participants to acknowledge and show respect for the conventions attendant upon the giving and receiving of gifts. Any display of indifference or ingratitude on the part of the honored recipient must be executed with great care or it will provoke indignation not only from the presenters of the prize, but from the entire participating community (including, for example, the other nominees as well as all past recipients). For this reason it has always been difficult to profit, in symbolic terms, by refusing a prize outright. Traditionally, in order to do so, one had to have already accumulated a wealth of symbolic capital of the sort that would be regarded as virtually nonfungible with prizes, awards, and trophies—the sort, that is, which accrues not to just any recognized aesthetic innovator but only to those who are also resolute social oppositionists or heretics,

"old-style intellectuals."[2] These are artists who have deployed their prestige, or symbolic capital, in their particular and more or less discrete fields of art to carry out a broader "mission of prophetic subversion," a political mission in which the existing social order is consistently denounced, and the rewards it places within reach are consistently rejected, in the name of autonomy.[3]

Even for these symbolically powerful figures, refusing a prize has always been a delicate and risky maneuver. Sartre's exemplary refusal of the Nobel in 1964 was, in his own view, an unfortunate entanglement, which he had tried to ward off in advance by asking the Swedish Academy to remove his name from the list of candidates. Had the academy's secretary not misplaced Sartre's letter, which tactfully explained that a lifetime of refusing all such awards (Soviet as well as Western) would be compromised by any special exemption for the Nobel, the entire affair could have been averted. In the event, Sartre was as low-key and apologetic as possible about refusing the prize. Nevertheless, his refusal was widely regarded as an act of formidable symbolic violence—and rightly so.[4] After all, Sartre could have taken the route of George Bernard Shaw, accepting the prize reluctantly, tactically, keeping none of the substantial monetary award for himself; he might have exploited the high-profile occasion of the acceptance speech to focus attention on the needy parties (perhaps some of the anticolonial movements in Francophone Africa) to whom he would be redistributing the money. By refusing even this much contact with the Nobel, Sartre was attempting to maximize the barriers to exchange, the "trade barriers" of the symbolic economy, between his cultural capital—his specific importance and value as an artist and intellectual—and the capital that the Swedish Academy held out to him. In his view, such an exchange transaction would be so much to his disadvantage, would

issue in such a substantial net diminishment of his symbolic wealth (not to mention the gain to the Nobel, which would then be the one prize that even Sartre accepted) that the academy's proffered "gift" was in effect a Trojan horse.

In 1964, it was still possible to occupy a position on the cultural field from which such a sincere and implacable refusal made symbolic sense. The field was still understood to conform in a broad way with what we habitually think of as the high-culture / mass-culture opposition—the "dualist structure" (Bourdieu's term) that has prevailed since the nineteenth century. It was characterized, that is to say, by its two subfields of cultural production: the restricted field, in which avant-garde artists produced art for one another and for university intellectuals ("a field that is its own market, allied with an educational system which legitimizes it"), and the extended field, in which artists of more conventional habitus produced work for a wider public of bourgeois art-lovers and, later, for a mass-entertainment audience ("a field of production organized as a function of external demand, normally seen as socially and culturally inferior").[5] And a field structured (or, as I would prefer to say, understood to be structured) in this way was still capable of producing prophetic-subversive intellectuals more or less on the model of Zola, who could put their symbolic capital, initially hard-won on the restricted field, to work politically by linking autonomy with truth. Even in the early 1970s, the last period of widespread anti-corporate, anti-establishment attitudes and practices, there was clearly some measure of symbolic efficacy in such refusals if the artist declining the award was sufficiently admired by others in the field; the Academy Award refusals by George C. Scott, Marlon Brando, and Luis Buñuel come to mind. These figures, along with other Oscar-boycotters of the period such as Dustin Hoffman and

Woody Allen, treated the prize not simply as a joke or a nuisance, but as an abomination. "Nothing would disgust me more [than to win an Oscar]" said Buñuel. "I wouldn't have it in my home." And they could rely on their peers to recognize the maneuver and the rhetoric of refusal as, in Scott's terms, the best means of sustaining one's "real commitment to the legitimate theater"—that is, to the purest or most autonomous subfields of art—in the face of a relentlessly expanding general field on which all events and activities of production were made to accord with the logic of commerce, were "contrived," as Scott put it, "for economic reasons."[6]

But by the time the great Austrian novelist Thomas Bernhard wrote, in a 1982 novel-memoir, of his own decision in the 1970s not to accept any more literary awards (on the grounds that, for the serious artist, "receiving a prize is nothing other than having one's head pissed upon"), this Flaubertian posture seems already a self-consciously dated and curmudgeonly one, Bernhard's novelistic representation of an old-style artist-intellectual who finds himself out of place and strategically at a loss on the contemporary field.[7] Bernhard himself had in fact resumed accepting awards by then, however begrudgingly or ironically, just as George C. Scott and Dustin Hoffman had taken to attending the Academy Awards ceremony. To have done otherwise, to have maintained the position of incorruptible refuseniks or prophetic subversives, would likely have made them appear not more authentic or serious as artists but more out-of-date, more plainly part of an earlier generation of artists whose positions had been voided and tactics superseded. At worst, they could have been perceived as frauds, poseurs, presumptuous claimants to a kind of purity they could not possibly possess.

One can still refuse a prize, of course, but the refusal can no longer be counted upon to reinforce one's artistic legitimacy by un-

derscoring the specificity or the properly autonomous character of one's cultural prestige, its difference from mere visibility or "success." On the contrary, owing to the increasingly acknowledged complicities between those who ostensibly affront or embarrass the prize and those who promote its interests, the scandal of refusal has become a recognized device for raising visibility and leveraging success. When Julie Andrews refused a nomination for a 1996 Tony Award, no one even considered taking the gesture seriously as an attack on the Tonys, much less as a defense of the integrity or autonomy of the "legitimate theater." Instead, it was seen as a media event carefully "staged" by Andrews, "the biggest star on Broadway, playing in one of its biggest-grossing hits," and intended "to help [her] show" attract even more paying customers. The media "scandal" surrounding her refusal, despite its involving many disparaging observations about the commercialism of the Tonys, was widely recognized as doing those awards far more good than harm in terms of their future capacity to produce visibility and put it into cultural circulation. As Peter Marks expressed it in the *New York Times,* Andrews' action succeeded in "doing what Broadway publicity agents thought was the impossible, . . . turn[ing] the Tony Awards into a tabloid story"—an outcome that "did not displease some involved with the promotion of the Tonys."[8] Indeed, the televised Tony Awards ceremony that year opened with Julie Andrews jokes and seemed to have been consciously and happily orchestrated around the mock-scandalous fact of her absence.

Being already a recognized move in a game characterized by insincere or duplicitous antagonisms, the refusal of a prize can no longer register as a refusal to *play.* Nor can the reluctant player make appeal to some proper home on the cultural field where such games are unknown and where the symbolic money that prizes rep-

resent is no good. The artists, writers, and intellectuals who today are major holders of symbolic capital, those whom the culturally esteemed themselves esteem, have for the most part left the task of denouncing prizes to conservative journalists and old-guard humanities professors, while they themselves pursue the game more tactically.

A transitional moment, perhaps, was Thomas Pynchon's notorious acceptance of the National Book Award for *Gravity's Rainbow* in 1974. At that time, Pynchon was certainly still capable of refusing a major prize outright, as he did in a deliberately "rude" letter declining the 1975 Dean Howells Medal of the American Academy of Arts and Letters ("I don't want it. Please don't impose on me something I don't want").[9] A decade and a half later, he showed himself willing to accept such an award with no display of reluctance, as he did the MacArthur "Genius" Award in 1989. An ambiguity of position between these two extremes was nicely captured by his handling of the National Book Award, for which he sent the professional comic Irwin Corey to accept on his behalf. Corey, in character as "Professor Irwin Corey," offered by way of an acceptance speech an incomprehensible amalgam of awards-banquet platitudes, academic jargon, political rant, and pure nonsense, bewildering most of those in attendance at the ceremony and annoying many. This was not exactly a way to renounce the symbolic and material profits associated with the prize. The event increased Pynchon's specific visibility as an "invisible" recluse writer, thereby augmenting both his celebrity and his special symbolic position as an artist who shuns celebrity (a position he shares with J. D. Salinger).[10] The event also increased the sales of his (academically acclaimed but commercially resistant) novel, enabling an imposition of specifically academic preferences on the broader book mar-

ket. Professor Corey's appearance also brought visibility and symbolic stature to the prize itself, which by selecting Pynchon as its winner and securing his acceptance (even on comic terms) gained some ground in its originary and ongoing struggle to unseat the Pulitzer as America's most legitimate book prize—that is, as the prize most closely aligned with the academically legitimated hierarchy of literary value. (The Pulitzer fiction jury had proposed *Gravity's Rainbow* as its sole nominee that year, but, in a "scandalous" though amply precedented imposition of its journalistic preferences and constraints, the Pulitzer's governing board had rejected the jury's choice, calling the novel "obscene" and "unreadable," and voting not to award a prize at all.)[11] At the same time, however, Pynchon clearly made the award ceremony a kind of parodic version of itself, a false or pretended exchange, a simulation of a consecration, an event which, however well it succeeded in accomplishing its purposes, could not quite be taken seriously. His tactics thus suited the postmodern circumstances of the prize—its paradoxically increasing effectivity and decreasing seriousness—as well as prefiguring the whole range of mock prizes, antiprizes, and flippant pseudo-prizes which have symptomatically come to shadow and even to merge with the prize industry proper.

In connection with this latter point, we might consider the Scottish artists Bill Drummond and Jimmy Cauty, whose participation in the early 1990s as both winners and sponsors of British art and music prizes involved some especially elaborate and colorful tactics. Formerly a very successful pop-music act called, variously and more or less simultaneously, the Justified Ancients of Mu Mu (or the JAMs), the Timelords, and KLF (for Kopyright Liberation Front), Cauty and Drummond semi-abandoned the field of music in late 1992 and reconstituted themselves as conceptual artists called

the K Foundation. During the short span of its existence, the K Foundation produced a small set of works known collectively as *Money: A Major Body of Cash,* whose centerpiece was a work called *Nailed to the Wall.* This work consisted of £1 million of KLF's pop-music proceeds, in bundles of £50 notes, mounted with nails on the wall of an exhibition space. Initially, Cauty and Drummond planned to offer the work to the Tate Gallery as a charitable gift (amusingly valued for tax purposes at half a million pounds), on condition that the Tate maintain it on public exhibition until the year 2000 before selling, spending, or investing it. If the Tate refused to accept the gift on these terms (terms that would mean recognizing it as a work of art and recognizing the K Foundation as artists), Cauty and Drummond would, they vowed, burn *Nailed to the Wall.*

This planned attempt to force, among other things, a reversal of the normal relationship between art and philanthropy—to make an artwork of the gift rather than a gift of the artwork—was aborted after lawyers advised against it, but Cauty and Drummond did proceed to burn the piece, still unexhibited, on the Hebridean island of Jura in August 1994. This act was in turn documented in a one-hour silent film, *Watch the K Foundation Burn a Million Quid,* which the artists screened the following year at a series of unorthodox venues—including a craft fair, a prison, two comprehensive schools, and a pub filled with rival football team supporters.[12]

This brief description of *A Major Body of Cash* will tend to suggest a naïve or anachronistic quality to Drummond and Cauty's work, with its old-style subversive intentions regarding the dominant relationships among social, economic, and cultural capital. Not surprisingly, their interventions were largely dismissed as old news by the arts establishment; Nicholas Serota of the Tate Gal-

lery was just one of several powerful critics and curators to refer to them as "derivative." And indeed, it's hard to differentiate the K Foundation's works, in their aesthetic or philosophical implications, from explorations of the interplay between art and money by earlier artists, particularly the conceptualists of the late 1960s whose work was described by *Life* magazine in 1969 as "Paper Money Made into Art You Can Bank On." As an object for exhibition, *Nailed to the Wall* is strongly reminiscent of such works as Arman's *The Content Is the Money* (dollar bills in a slab of Plexiglas), for example, or Abraham Lubelski's *Sculptural Daydream* (a bale of 250,000 one-dollar bills—worth, in 1968 money, not much less than the K Foundation's million quid).

But Cauty and Drummond's relationship to established venues, institutions, and audiences, and especially to the system of cultural sponsorship, was somewhat different from that of Arman, Lubelski, or better-known money artists of the late twentieth century such as J. S. G. Boggs (whose elaborate works of production, circulation, and documentation are designed to trouble the boundary between legitimate acts of artistic representation and exchange and criminal acts of counterfeiting).[13] Though there was certainly a naïvely avant-gardiste quality to many of the interventions that constituted *A Major Body of Cash*, Drummond and Cauty displayed a firm and nuanced grasp of the contemporary cultural scene when they extended their peculiar brand of hostile philanthropy into the domain of prizes. Their cultural game-playing in that domain also showed, however, just how readily the contemporary artist's most innovative gestures of refusal, mockery, or condescension can be absorbed by a prize and put to positive use in enlarging the prize's symbolic power.

This was a difficulty they had already experienced first-hand,

having made a rather ineffectual attempt to disrupt the economy of cultural gift-exchange when they appeared, as KLF, at the 1992 BRITs (the British Grammys) to perform their music and then to receive the award for Best British Band. They opened the ceremony by joining with the hardcore thrash band Extreme Noise Terror in a violently raucous performance of KLF's 1989 rave tune "3AM Eternal." The performance took place under the watchful eyes of security and legal staff who had been called in to prevent Cauty and Drummond from throwing buckets of sheep's blood at the audience, as they had planned to do. (They had also planned to carve up a sheep carcass onstage, but Extreme Noise Terror—being a *vegetarian* thrash band—refused to go along with this, so they had the carcass dumped in the lobby of the BRITs reception hotel instead.) The performance succeeded in driving Sir George Solti, there to accept the award for Best Classical Record, out of the auditorium; it concluded with Drummond firing blank rounds from a real machine gun at the music execs and their trophy dates in the VIP orchestra seats. As the PA announced that "KLF have left the music industry," Drummond and Cauty, now retired, headed for an anti-BRITs rave on the other side of the city, later dispatching a friend in motorcycle messenger gear, who, having no pass or credentials, had to sneak onto the stage and snatch their "bauble" from the presenter when they won the top prize a couple of hours later. (Security staff caught up with him in a corridor and retrieved the statuette.)[14]

This mockery of the protocols of the award ceremony was certainly antic enough, but it was in no way worrying to the BRIT Awards—which in fact needed just this sort of "scandalous" misbehavior to increase their street credibility as well as to improve their watchability on television. Irreverence toward the music industry is crucial for pop-music awards in Britain, as elsewhere, and the

BRITs' ultracorporate profile had increasingly discredited them through the 1980s, to the point where (as mentioned earlier) the explicitly anti-BRIT "BRAT" awards, launched in 1992 by the magazine *NME* and symbolized by a bronze statue of a hand with upraised middle finger, had become the most coveted of Britain's music prizes. Though their expressed intention was to "spoil everyone else's good time" at the BRITs and to upset the music-industry awards racket, KLF in fact did the industry sponsors and organizers a good service with their upraised middle finger of a performance. The BBC cut virtually none of KLF's high-jinks from its evening broadcast, the music press and the daily papers gave KLF's "scandalous" behavior plentiful coverage for weeks afterward, and the BRITs' ratings began a strong climb as the youth market began finally to tune in. It would be exaggerating only a little to say that KLF saved the BRITs.

This apparent failure did not, however, dissuade Cauty and Drummond from trying again—this time from the other side of the exchange relationship—to turn prizes at least partly against those whose interests they normally serve. When they made the transition from KLF to K Foundation, they also made a transition from major prize winners to major prize sponsors, announcing via full-page newspaper ads in August 1993 the inauguration of an enormous cash prize for art—the largest such award ever established in Britain. As no one could fail to notice, the K Foundation Prize for Worst British Artist, at £40,000, was worth fully twice as much as the £20,000 Turner Prize, the so-called Booker Prize for Art sponsored by British TV's Channel 4, and administered by Nicholas Serota of the Tate Gallery and the Patrons for New Art.[15] The K Foundation's prize also mimicked the language of the Turner, perfectly inverting its criteria—it was to be awarded to the artist "who

in the opinion of the jury has produced the worst body of work in the preceding twelve months"—and its shortlist consisted of precisely the same four artists who were shortlisted that year for the Turner. Its presentation, moreover, was made just outside the entrance to the Tate and was timed to come immediately after the presentation of the Turner. And the winner was of course the very artist who had just been awarded the Turner, the sculptor Rachel Whiteread. Consistent with the K Foundation's other works of art, the prize took the physical form of £40,000 nailed to a gilt-framed board in £1,600 bundles, and was offered as a kind of philanthropic gift on condition that, should the recipient fail to accept the award, it would be burned immediately, before the many assembled photographers and journalists (some of whom had earlier been given the opportunity to assist in nailing the prize together). Whiteread, not at all amused, felt compelled to step outside and formally receive the prize, her spokesman later explaining that such a substantial amount of money should at least be donated to needy artists—that is, redirected along the proper channels of cultural-philanthropic expenditure.

In forcing an acceptance of its richly insulting gift, the K Foundation pulled off a rare coup. Artists don't normally show up to receive worst-of prizes; only one winner has ever attended the Golden Raspberry ceremony, for example. The big perennial winners of those prizes (Sylvester Stallone, Sharon Stone, et al.) are livid about them and won't even allow interviewers to raise the topic. And unlike the administrator of the Razzies, Cauty and Drummond were at pains to avoid giving the impression that their prize was all in good fun. They insisted strongly on the badness of Whiteread's work and on the irrelevance and bankruptcy of the Turner Prize. But money in this unwonted context had an irresistible effect.

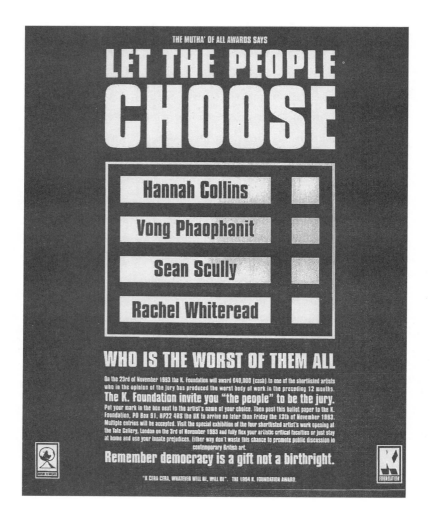

9. The K Foundation's full-page advertisement for the Worst British Artist prize, *Sunday Times* (London), August 26, 1993. The pretense of inviting votes from "the people" is a further mockery of the Turner Prize organization, whose elitist, inner-circle character would be satirized again the following year by the *Daily Telegraph* in its write-in campaign for animator Nick Park.

Mock prizes and antiprizes invariably offer trivial, valueless award-objects: a dead fish, an imitation popcorn bucket. Winners of the Razzie get an oversized plastic raspberry glued to a mangled roll of super-8 film, spray-painted gold and worth, according to organizers, "about two bucks." As we have seen, the material value of an award is meant to be in rough alignment with its symbolic value, and in this respect as in many others, the antiprize shows itself as the prize's companion or twin rather than its true inversion, restaging on a comic register the very game of the legitimate economy of cultural prestige. The K Foundation prize effected a rare scrambling of that economy, with the relationships of economic, artistic, and symbolic value set momentarily askew from their late twentieth-century norms.

To take first the relationship of economic to symbolic value, it is a commonplace for arts journalists to refer to any big-money prize as "prestigious" or "distinguished." While everyone concedes that some of the most prestigious prizes (the Prix Goncourt is the classic example) carry little or no cash value, this does not prevent big-ticket start-up prizes from seizing the ground of journalistic attention and respect. (Indeed, the "prestige" of the Goncourt is generally explained in terms of the tremendous increase in book sales it effects: the Goncourt winner becomes an instant millionaire.) When the International Congress of Distinguished Awards was founded in the early 1990s—as a kind of conduit of information between the awards industry and the media—the chief criterion for the "distinguished" prize was a six-figure money value. By presenting its award for Worst British Artist in the form of the richest cash prize on the field of British art, the K Foundation not only guaranteed the prize something other than merely dismissive treatment by the press, but also interfered with the automatic rhetoric of journalis-

tic promotion surrounding the Turner, which invariably yoked that award's "prestige" to its £20,000 cash value.[16] Here was an award worth twice as much—and promoted at a cost of at least £200,000—being offered to the same artist for the same body of work, but emphatically uncoupled from claims of prestige: a booby prize for a bad artist whose work it declared to be "crap."[17]

Similarly, the Worst British Artist prize scrambled the normative relationship between the symbolic value of the award and the *artistic* value of the award-object. Antiprizes, booby prizes, rehearse in negative form the normative equation of art (trophy) for art (work) by offering an artless trophy for artless work. Drummond and Cauty, however, did position their material award-object at some level as serious art: what they presented to Whiteread was not merely £40,000 sterling, a board, some nails, and a frame, but an assembled work of art drawn from the evolving corpus of the K Foundation itself. It is a work which Whiteread evidently dismantled and pieced out as philanthropic expenditure, and whether its specifically artistic value would have stood up in the long (or even the short) eye of history is of course a rather idle question.[18] But to my mind at least, the K Foundation Prize for Worst British Artist was the stand-out work in *Money: A Major Body of Cash,* and constituted a trophy of far more convincing artistic pedigree than, say, a Peabody medal or a BAFTA statuette. To donate it as a prize to the Worst British Artist was yet another means of disturbing the system of unspoken or assumed reciprocities that organize and sustain the market for cultural prestige.

But while Cauty and Drummond deployed their guerrilla tactics with real flair, and at the very point on the field of cultural production where the terms of exchange between money and art are most effectively negotiated (that is, via prizes), they no more damaged

the Turner Prize and its patrons or sponsors than they had damaged the BRITs the previous year. Press coverage of the Turner was more extensive and somewhat less hostile than usual that year (with much of the hostility deflected onto the K Foundation). Whiteread, already a celebrity owing to the campaign to preserve her concrete sculpture *House* from demolition by borough council authorities, received far more renown for pulling off what the *Times* called a "unique art double" of Best and Worst than she would have for winning the Turner Prize alone.[19] Even Channel 4 did well by the K Foundation, which paid at least £20,000 for its advertisement during the Turner broadcast.

Indeed, as Drummond and Cauty were clearly aware, their intervention amounted to something other than a classic modernist denunciation of cultural prizes or an act of straightforward antagonism toward the institutions of art. They did not claim to have given up the game or somehow to have escaped from the field into a margin of purity. Part of what they succeeded in demonstrating was that their own Worst Artist prize, for all its economic irregularities and disequilibria, didn't in the end function much differently from the Tate's Best Artist prize; that best and worst, most serious and most frivolous, most legitimate and most commercial, were no longer readily mappable binaries; that the presumed dualist structure of the cultural field, while still alive discursively, had been fundamentally scrambled. The artists themselves, after all, had to be understood as *both* ultracommercial pop stars *and* fringe avantgardistes of the conceptual art world, producing, out of the "material" of their own pop stardom, works that had no apparent commercial value at all. Their antics suggested, to be sure, that the Turner Prize was already a mock prize, a booby prize, a joke; but also, less obviously, that their mock prize was for real, imperfectly

distinguishable from economic instruments such as the Turner: it, too, was a device for converting "heteronomous capital" (money from the mass market) into specific symbolic capital (stature in the legitimate art world) by way of journalistic capital (visibility, celebrity, scandalousness). And it, too, presented artists as well as sponsors (not to mention artist-sponsors) with an opportunity to manage or negotiate these conversions—through acts of acceptance or refusal, tactics of embrace or condescension—in ways that might advance their own interests. Indeed, a number of artists actually responded to the K Foundation's publicity campaign by phoning the Tate Gallery to inquire about entering their own work in the competition for Worst Artist.[20] And in a sense, they enjoyed just this opportunity in the end, since a key aspect of Whiteread's strategy of reciprocal condescension toward the K Foundation prize was to have the prize money redistributed in the form of competitive (jury-selected) awards to financially strapped, self-nominated artists.[21]

Because the seriousness of prizes has been eroded without any corresponding erosion of their efficacy, the playful tactics of artists like Drummond and Cauty, though at times genuinely provocative and illuminating, remain always within the bounds of the contemporary prize game. In fact, there has been as much comic play, or playing around, with the different forms of capital and their convertibility by recipients of the Turner Prize as by the K Foundation. Two years after Whiteread won the Turner, the award went to Damien Hirst for his already famous work (exhibited previously at the 1992 Venice Biennale) entitled *Mother and Child, Divided,* which consisted of mutilated cow and calf carcasses immersed in formaldehyde. Hirst played his win for all it was worth, giving the press the kind of scandalously boorish sound bites that define his persona: "It's amazing what you can do with an E grade in A-level

art, a twisted imagination, and a chainsaw."[22] And the press dutifully mounted a great show of outrage, calling the award an "odious and disgusting scandal" and (with reference to the ongoing panic over BSE-infected beef) a case of "mad-judges disease."[23] The arch-conservative Brian Sewell, whose frequent TV and radio work, prissy advertising voice-overs, and regular column in the *Evening Standard* had made him the most visible and audible of Britain's arts journalists, expressed disdain for the winner in every available medium, even parodying Hirst's work with a picture of his own head immersed in formaldehyde on the cover of *Alphabet of Villains,* a collection of his essays whose publication was timed to coincide with the Turner announcement.

Much of this was certainly play-acting. Hirst's win was among the least surprising, least newsworthy events of the year. The leading figure among the emergent "brat pack" of young British artists since about 1990 and perhaps the best-known artist in the country, Hirst had been shortlisted twice already for the Turner, and was rated a prohibitive four-to-five favorite by the bookmakers at William Hill (which offers odds on all the major prizes as part of its "culture file"). The arts editors who wrote of the event in tones of shock and horror were simply advancing their interests in an ongoing factional struggle between the so-called New British Art—what its most trenchant critic, Julian Stallabrass, has labeled "high art lite"—and the defenders of traditional artistic standards and values.[24] The latter were thoroughly implicated in the cultural-prize scene, several of them serving as judges for the avowedly anti-Turner Jerwood Prize for Painting (founded in 1993 and worth £30,000), and Sewell having announced some weeks before Hirst's win that he had just founded an even more rabidly anti-Turner award to be called the Hayward Annual. The sheer hyperbole of

their rhetoric (Hirst's work was said to have "the aesthetic value of a bucketfull of spittle")[25] suggests again that the "scandal of the middlebrow" in which modern cultural prizes have always been implicated has become a highly self-conscious game of positions, journalist-critics seizing on the prize as a way to reanimate flaccid oppositions between art and money, culture and society, fortifying their own positions with reference to an inadequate but still habitual binarist scheme. (Even before Hirst's victory, the *Sunday Times* had run a clever piece by David Mills detailing the rhetorical recipe for Turner-bashing.)[26] In these journalistic games of scandal, the defense of "art for art's sake" is mounted not by a determined avant-garde willing to make long-term investments (that is, willing to labor in obscurity and poverty for decades toward the goal of ultimately prevailing against the dominant tastes), but by the most comfortably established artists or professors and the most risk-averse journalist-critics—even and especially those who are underwritten by, and whose habitus brings them into accordance with, the increasingly active cultural wing of the corporate right. (We find, for example, Hilton Kramer, chief art-lackey of the Olin Foundation, among the anti-Turnerites.)

Without disappearing, the modern discourse of autonomy has become a tactical fiction, or at least an imperfectly sincere one, most often and most effectively deployed in the interests of reaction, by the high-art right that emerged in the last two decades of the twentieth century.[27] It is thus a treacherous if not a hopeless tool for the young or avant-garde or minority artist seeking specific legitimacy. What we see in the most recent awards scandals is that these latter artists have been forced, not to relinquish their interest in autonomy properly understood, but to pursue it by means of strategies of differentiation, styles of play, which defy a simple

dualist, two-axis / four-quadrant geography of cultural positions— a geography in which autonomy can appear only as a kind of far corner or remote sanctuary for artists as such.

To take one further example of these new ways of playing the prize game, we might consider Toni Morrison, who since the 1980s has been perhaps the most active and enthusiastic collector of literary awards, lobbying for them and openly embracing them as a form of "redemption."[28] Even by contemporary standards, she seems to have capitulated too fully to the awards mania, abandoned too completely the protocols of condescension. And this has left her vulnerable to the charge of having exchanged artistic integrity for cultural prestige.

These concerns erupted into "scandal" during the book-awards season of 1987–1988, when Morrison's *Beloved* was in the running. At that time, only a small number of African American authors had ever won a major American book prize. Following Ralph Ellison's National Book Award for *Invisible Man* in 1953, nearly thirty years passed without a single black winner of the NBA or the Pulitzer Prize for Fiction. This had begun to change with the emergence of African American women writers in the early 1980s. In three successive years, the National Book Award went to Gloria Naylor, Paule Marshall, and Alice Walker. But Morrison, the most highly regarded figure in this cohort, still remained an also-ran on the prize lists. And despite the fact that *Beloved,* her fifth novel, had been published to thunderous critical acclaim and nominated for all the major prizes, this situation did not seem likely to change. As the awards season progressed, the novel was passed over first by the National Book Award (which went to a little-known Vietnam veteran named Larry Heinemann, at a ceremony to which Morrison had confidently brought three tables of her friends and associates)

and soon after by the National Book Critics Circle Award, leaving her in contention only for the Pulitzer, the prize which, of the three, had historically been most resistant to the claims of African American authors. What followed was a prize controversy of the sort peculiar to our era, centering upon the preemptive tactics employed by several dozen prominent African American partisans of Morrison, who made a collective effort on her behalf to disrupt the normal unfolding of the Pulitzer process and ensure that the prize would go to *Beloved*.

Their intervention took the form of an open letter to the *New York Times Book Review* signed by the poet June Jordan and the literary critic Houston A. Baker Jr. Appended to the letter was a "Statement" reiterating its main points and signed by Jordan, Baker, and forty-six others, including Maya Angelou, Toni Cade Bambara, Amiri Baraka, and Alice Walker.[29] Writing shortly after the death of James Baldwin, Jordan and Baker raised the issue of book prizes in connection with this internationally acclaimed writer's geographic and cultural exile from his own home. "It is a fact that James Baldwin, celebrated worldwide and posthumously designated as 'immortal' and as 'the conscience of his generation,' it is a fact that Baldwin never received the honor of these keystones to the canon of American literature: the National Book Award and the Pulitzer Prize: never."

The statement then connects Baldwin to Morrison, another deeply beloved writer of "international stature" who "has yet to receive the national recognition that her five major works of fiction entirely deserve . . . has yet to receive the keystone honors of the National Book Award or the Pulitzer Prize." The writers assert their own "rightful and positive authority" in making this assessment, and conclude with what amounts to a preemptive presen-

tation speech for the Pulitzer that Morrison has not yet won, delivered in the cloying language of gifts and gratitude that is so characteristic of award presentation ceremonies: "[We offer] this simple tribute to the seismic character and beauty of your writing . . . [presented] in grateful wonder at the advent of *Beloved*, your most recent gift to our community, our country, our conscience."

Since the Pulitzer jury and board did end up awarding the prize to Morrison, with individual jurors letting it be known that they had already been staunch supporters of *Beloved* long before the letter and statement appeared; and since, as well, both author and novel continued to rise in stature during the subsequent years—to the point where, today, one must regard Morrison as America's most esteemed novelist and *Beloved* as her most indispensable book—one might have thought that scandal had in this case been averted. After all, as we have already noted, it was the National Book Foundation that found itself facing "outrage in the literary community and publishing industry" over its decision.[30]

Yet the securing of Morrison's Pulitzer has registered in the annals of prize commentary not as a successful intervention on the side of great literature but as a scandal and a "controversy" (the word appears in dozens of articles treating the event), serving as one more corrective anecdote demonstrating the culturally degrading effects of prizes. This is partly owing to the fierce cultural and racial politics of the late 1980s. It was in just these years that Reagan conservatives began extending their anti-affirmative-action assault onto the field of culture, attacking the universities, the National Endowment for the Arts, the National Endowment for the Humanities, various museums and curators, and, inevitably, the major prizes and awards, for ostensibly according value to works of art on the basis of an ethnic and racial quota system rather than on

the basis of inherent artistic worth. Seeking nomination for the top post at the National Council on the Humanities, Carol Iannone took just this line of attack on Morrison's Pulitzer. Having strategically denounced *Beloved* during the run-up to the prizes (calling the novel a mere litany of "oft-repeated miseries"), Iannone later denounced "the group of black writers [who had] demanded and obtained the Pulitzer Prize for Toni Morrison's novel" as one example of how America's "most prestigious awards" were being degraded by judges who "sacrific[ed] the demands of excellence to the 'democratic dictatorship of mediocrity.'"[31]

But even these extreme detractors could see that Morrison and *Beloved* make singularly bad targets for the decline-of-standards polemic. While the Morrison Pulitzer affair may have dovetailed with the agenda and tactics of the political right—providing an opportunity to trash black culture and disrespect the country's most important black writer in the name of "nonpolitical," transcendent literary standards—it never served as the central event or rallying point for this particular group of prize-bashers, who directed most of their venom toward the prizes won by Alice Walker and Charles Johnson.[32] The prominent place accorded Morrison's Pulitzer in the anecdotal repertoire of award scandals has less to do with the Reagan and Bush era campaign against multiculturalism and "political correctness" than with broad shifts within the whole system of cultural gift-exchange. The affair was used to raise questions about what I have been calling cultural play, questions of protocol and etiquette (which are themselves, of course, by no means racially or politically innocent). The scandalized rhetoric that has surrounded Morrison's Pulitzer derives from the residual but still forceful imperative that the artist stand above prizes even while participating

in their ceremonies—that the artist, one way or another, through some kind of strategy of condescension, help to maintain a discernible degree of separation between the scale of aesthetic value and that of public acclaim, between true genius and mere success on the awards circuit.

The strategy of Morrison and her proxies was in effect to assert the identity, or at least to exaggerate the degree of convergence, of these two hierarchies. Far from rejecting the prize as a corrupt and damaging economic instrument or even treating it as a decorous but ultimately hollow bauble, the Morrison letter positioned it as the very pinnacle of the literary field, the "keystone to the canon." Even in an acceptance speech, this sort of rhetoric would be somewhat compromising, since the gift of the prize is meant to be a kind of partial and inadequate affirmation of an achievement that has already been more reliably measured elsewhere and otherwise: a worthy winner (and what prize wants an unworthy winner?) brings her value, and indeed her (future, if not present) canonicity, to the prize, not vice versa. But as part of an advance lobbying campaign, the rhetoric was even more improper, since it entailed an insistence that the writer at hand was the *only* nominee worthy of occupying this lofty seat in the literary domain. To insist that you alone deserve a prize can be an amusing publicity stunt—the comedian Jackie Mason took the conceit so far as to file a $25 million lawsuit against the organizers of the Tony Awards in 1994 for failing to recognize his personal greatness—but such an insistence, pursued with all seriousness in one of the most esteemed fields of cultural practice, and among such fellow nominees as Philip Roth (another author whom we might have expected by then to have won his first Pulitzer) is, according to a still-powerful cultural logic, unseemly.[33]

Christopher Hitchens complained loudly of this transgression when he recounted the controversy in a *Vanity Fair* piece decrying the contemporary mania for awards:[34]

> In 1987 the essayist and poet June Jordon and the novelist Toni Morrison decided that Ms. Morrison, who had just published *Beloved,* deserved and *needed* a prize. They deplored the fact that she had been nominated for the National Book *and* the National Book Critics Circle awards but had not won. Very revealingly, if not very eloquently, June Jordon said that "the awards are the only kind of validation that makes sense in the literary world." She drummed up a letter to (where else?) the *New York Times Book Review,* and got co-sponsorship from Houston Baker, who professes English at the University of Pennsylvania. With more than forty others, including Alice Walker, Maya Angelou, and Amiri Baraka, they in effect demanded that Toni Morrison be upgraded to prizewinner seating. As the N.B.C.C. agonized over its evenhandedness, . . . the [solemn words of the] letter signers . . . were respectfully reported [by the press].

"The thirst for trophies," reads a highlighted sentence from the article, "is putting writers through hoops that ought to embarrass even a hardened Oscar seeker." What may be excusable vulgarity among the lower orders of Hollywood is outrageous in a literary artist. The literary artist who acknowledges, even by proxy, her craving for a prize is an embarrassment and a scandal to the modern ideology of art "because, of course, great, brave, original writers don't need their 'immortality' to be 'validated'" by awards committees. That such a writer as Baldwin could give even half a thought to the book awards, much less share Jordan's view that "the awards are the only kind of validation that makes sense in the

literary world," strikes Hitchens as an absurdity: "Baldwin got his imperishable reputation the old-fashioned way—by writing hard and being lonely and breaking the hearts of readers who had never heard of the N.B.C.C."[35]

This word "lonely," a recurring positive term in award scandals, nicely underscores the function of a piece like Hitchens'. In effect, his rhetoric of scandal, for all its prize-bashing bluster, serves to redirect a genuinely deviant or critical intervention, a contemporary departure from the old scheme of art versus money, art versus politics, onto the established paths of the modern ideology of art. What Morrison and her supporters did was to recognize and critique the prize for what it is—a thoroughly social, economic, and (racist) political instrument—*and* to credit it with real, even potentially decisive power in determining long-term literary valuations, *and* to make an open and candid bid for it as such, leveraging their own forms of social and symbolic capital toward that end. From the standpoint of the prize, this is playing the game rather too knowingly and too explicitly, laying out the various interests and stakes and balance sheets, and publicly proposing a "deal." But the ostensible prize-bashers such as Hitchens can be counted on to scold the interloper and to escort her back to her proper place above or beyond or outside the proverbial backrooms where literary value is so scandalously manufactured by committee—that is, by groups of merely human agents.

The question of what strategies and tactics fall acceptably within the rules of the prize game, or where the artist can legitimately stand vis-à-vis the prize, thus comes down to the question of where the artist stands in relation to society. The line taken by those who rage against the book prizes is that any writer truly worthy of our collective admiration should have no interest in strictly social at-

tainments—indeed, should actively avoid them. "For most of the novelists I really admire, past or present," observes John Gross in a typical *Times* piece deploring the "baneful influence" of the Booker Prize, "going through the prize-winning rites would have involved a positive loss of pride."[36] This is just another way of saying that the artist's place is someplace else, somewhere outside society. "As another [Booker] contest comes round," Gross concludes his piece, "I find myself recalling Henry James's advice to a young man who told him that he wanted to be a novelist: 'The word you must inscribe on your banner is Loneliness.'" Of course, society may ignore the banner of loneliness and insist on disturbing the writer with its trinkets and baubles; but the writer must never encourage or join actively in these "rites."

Morrison and her supporters undoubtedly share in the ideology of art, and believe in a distinction between artistic value and social esteem. But this does not prevent them from investing a great deal in the economy of prestige and its dominant instrument, the prize, and from doing so openly, in all frankness, even to the point of awkwardness for the prize itself. By treating the major book prizes quite explicitly as the "keystones to the canon of American literature"—despite the staggering discontinuities between the canon at any given moment and the lists of past prizewinners,[37] and despite the prizes' wide vulnerability to charges of corruption and bias[38]—they recognize that it is precisely by such embarrassingly social-commercial-cultural mechanisms as these that the canon is formed, cultural capital is allocated, "greatness" is determined. Morrison's strategy is one of negative affirmation, treating the prize as a more false (in particular, more egregiously racist) *and* a more true (more perfectly in correspondence with the "legitimate" or the "ultimate") measure of cultural value than its traditional critics would

ever allow. And this strategy has served her well in her struggle against the organized cultural right, which has done everything in its power to resist the rising prestige of African American literature in general and its expanding place within the university curriculum in particular, but has found itself hopelessly outmatched with respect to Toni Morrison, whose symbolic coffers are now overflowing with every form of wealth.

Whatever Morrison's own beliefs, the emergence of such a strategy is further evidence of an ongoing shift in the *illusio* of literary practice. For if the prize is declared the base camp of canon formation, it is deprived of its higher legitimation on the ground of art and hence of its capacity to circulate capital in *misrecognized* form. The veil of magic, of collective make-believe, that prizes have traditionally cast across the scene of their concrete social effects becomes more transparent, revealing more explicitly the differences among the various classes of people whose relations to cultural capital the prize economy regulates, and exposing the political stakes of the struggles waged within that economy. As long as these strategic encounters between the contemporary artist and the cultural prize can still, with a wink and a nudge, be absorbed into the discourse of scandal, prizes will continue their dominance of the cultural scene. But it is possible that what we are seeing with the new rhetoric and new styles of play in the awards game is the beginning of the end of that era of domination, the weakening of the collective magic by which aesthetics has for so long been levitated, the gradual revelation of a hidden support system extending upward from the ground of social practice to the higher level of art. Such tendencies, effecting the decline of the modern ideology of art, will not diminish the pleasures and excitements of cultural life, nor will they put an end to all collective ceremonies of celebration and esteem. But as we

lose our ability or our willingness to see the prize as a fundamentally scandalous institution, there is bound to be a period of painful contraction in the awards industry. Faced with the withdrawal of what has been by far their richest and most reliable source of publicity, prizes may after so many years of uncontainable expansion at last show some signs of fatigue.

IV. The Global
Economy of
Cultural
Prestige

The Arts as International Sport

> *Those 12-to-1 odds are massively generous—I'd make*
> *Hawke a narrow second favourite behind McKellen,*
> *given the growing Hollywood feeling Rings may well*
> *sweep the board. But remember 1978, when Alec*
> *Guinness was nominated as Supporting Actor for the*
> *"Gandalf" role in Star Wars, alongside a fellow-Brit, a*
> *Russian, an Austrian, and lone American Jason*
> *Robards? Robards' win proved the power of vote-split-*
> *ting was even mightier than The Force.*
>
> —Neil Young, "The Oscar-Betting Lowdown,
> 1999–2002," *Neil Young's Film Lounge,*
> www.jigsawlounge.co.uk/film (March 7,
> 2002)

It is possible to think of art or literature in any historical period as a "game" in the broad sense of that term: a competition among various cultural players or agents for better, more advantageous or "monopolistic" positions on the field of artistic production. But one of the arguments of this book has been that certain developments in the *institutional* framework of literature and culture, in particular those relating to prizes and awards, have shaped the *specific* forms and valences of cultural competition over the past cen-

tury, differentiating it from what came before, and then, in recent decades, subjecting it to an unprecedented intensification and a further refashioning. These developments have much to do with what we now call "globalization," a process that began with the advent of capitalism (since the drive toward capital accumulation has never respected national boundaries), but first became strikingly manifest in the technological, ideological, and economic innovations of the later nineteenth century.[1]

To trace out this process as it pertains to the economy of cultural prestige, I'll begin, not with Max Weber, but with an old Monty Python skit, in which fans pack into a Dorsetshire football (i.e., soccer) stadium to watch Thomas Hardy write his latest novel, *Jude the Obscure*. As Hardy struggles to form a first sentence, his supporters cheer and groan while expert announcers offer their color commentary:

> "And the crowd goes quiet now as Hardy settles himself down at the desk, body straight, shoulders relaxed, pen held lightly but firmly in the right hand. . . . And he's off! Its the first word—but it is not a word! . . . Oh no, it's a doodle way up on top of the left-hand margin. It is a piece of meaningless scribble, and he's signed his name underneath it. Oh, dear, what a disappointing start. . . ."
>
> "Yes, looks like *Tess of the D'Urbervilles* all over again."[2]

The Python troupe often get their history surprisingly right, and while they mix up quite a few details about Hardy, it was an apt choice to develop this skit about literature-as-football around the 1895 novel of a writer whose career coincided with the beginnings of literary modernism in Britain.

To sketch very briefly a complex history, we can observe first that

modern football was invented around the mid-nineteenth century. That is, the game was given a strict definition and standardized rules to distinguish it definitively from rugby and the many other related ball-and-goal games, varying from place to place and dating back to ancient Greece and China. The oldest stadiums in England and Scotland date from the late 1860s; the oldest surviving football ticket is from an 1872 match of England versus Scotland. This was in fact the first-ever international match; the standardization and codification of the game's rules had opened the door to competition across national as well as regional boundaries. By the 1890s, new stadiums were being built throughout Europe, with the sponsoring cities aggressively promoting their teams within an emergent system of not merely inter-urban but genuinely international competition and touristic attraction. Professionalism had by then emerged, and been legalized, as both the economic and symbolic incentives for sponsoring cities and countries became clear. By the end of the century, a dozen nations besides England—from New Zealand to Chile to Finland—had established national football associations, and the game's global future was assured.

Alongside this developing system of international sporting events, we can trace a parallel rise from the 1850s to the 1890s of the festivals of fine art and culture, as these events, too, emerged in more expressly international form in major European cities such as London, Paris, and Rome, and then in the United States, differentiating themselves from the essentially domestic urban cultural festivals and rural *eisteddfodau* of the past as well as from other rising forms of global exposition or "world's fair" in which art took a back seat to industry.

Around the time Hardy published *Jude the Obscure,* these parallel histories began to intertwine. Art and sport were coming to be

thought of as related or analogous practices in which some of the same interests were at play and some of the same stakes were at issue. Expositions and festivals of the fine arts became simultaneously more international and more explicitly competitive, not only in the sense that sponsoring countries used their festivals as instruments of national self-assertion, but also in the sense that artists from the different countries were in effect competing with one another for cash prizes or medals, often delivering speeches from a winner's podium, and so on.

The year 1895, for example, brought the first Esposizione Internazionale d'Arte della Città di Venezia, now known as the Venice Biennale of International Art. The Biennale's energetic promoter and effectively its founder, Riccardo Selvatico, was, to be sure, looking at the arts expos in other Italian cities (chiefly Rome, Milan, Naples, and Turin) as the immediate objects of competitive emulation. But in conceiving the basic aims and contours of his new festival, it was the rise of international football that he turned to. Though *calcio* (as the game is still called today) had a long history in Italy, the sport in its modern, international form had only just arrived with the founding of the Genoa club in 1893. Nevertheless, it was clear from the example of northern Europe that international football matches would soon be taking place all across the country. (And indeed, within a mere five years, such formidable squads as Juventus, Udinese, Inter Milan, and Lazio would all be founded.) Alert to this trend, Selvatico, who had no interest in actually promoting Venetian football, put it to Venice's senators that if you could fill a city with tourists for a competition among footballers of different nations, why not for a competition among those nations' artists?[3]

Admittedly, in its earliest years Venice was far from a perfectly le-

gitimate arena of "international competition." For one thing, the organizers, and those whom they appointed to the juries and selection committees, were so focused on promoting their city, and as a consequence so biased in favor of local artists who painted evocative views of Venice itself, that many foreign artists saw the Biennale as a losing proposition. Nevertheless, with its declared foundational commitment to cultural internationalism, and with its international advisory committee comprising such artists as Gustave Moreau from France, and John Everett Millais and Edward Coley Burne-Jones from Britain, the festival had strongly differentiated itself from earlier exhibitions in Venice and elsewhere, which had been *national* events designed primarily to cement, through the celebration of national art, an idea of national identity across the highly fragmented cultural space of post-unification Italy.

The Biennale moreover employed from the start an especially inventive advertising and publicity arm, which began within a decade to reach across Europe and ultimately into North America. Such innovations as the Critic's Prize, a substantial cash award for the best piece of journalism *about* the festival, and the specially designated "press area" *(sala dei giornalisti)* within the exposition hall, were typical of the Biennale's aggressive moves to raise its international journalistic profile.[4] By 1909, the festival's impressive attendance figures (up to 450,000, from 220,000 in 1895) and percentage of works sold (likewise doubling over this period, from about 35 percent to 70 percent) lent not only international respectability but an irresistible commercial luster to the gold medals that had been introduced in 1903. More than 400 foreign artists exhibited in Venice that year, accounting for nearly 60 percent of the works in competition.[5] In short order, Venice had eclipsed the earlier festivals, be-

coming not just the world's largest and most publicized exhibition of contemporary art, but the prototype of the modern juried biennial and the institutional base from which would be launched, two decades later, the dominant form of festival in the twentieth century—namely, the international film festival, complete with its awards, statuettes, grand jury prizes, and special honors.

Emerging almost at the same moment as the Biennale were two other important institutions: the Olympics, first held in 1896, and the Nobel Prizes, announced at the reading of Alfred Nobel's will that same year and first awarded in 1901. The modern Olympiad emerges out of the philhellenic idea of "athletics as a liberal art," a concept increasingly promoted during the late nineteenth century in the schools and universities of England, France, Germany, and North America, centered on an ideal of masculinity composed equally of physical and intellectual "strength": "muscles and ideas coexisting in brotherhood," as the founder of the International Olympic Committee, Pierre de Coubertin, symptomatically put it.[6] No less symptomatic is the fact that this phrase comes from a speech he made to the Parnassus *Literary* Club in Athens—which involved itself instrumentally in the Olympic revival movement, fully believing its own literary and more broadly cultural interests to be bound up with the success or failure of the Athens Olympics. Coubertin described for them, as for other cultural groups comprising potential backers, the growing popularity, as he had witnessed it in his travels around Europe and North America, of both international mass spectator sporting events and large-scale international cultural expositions. The Olympiad, as he conceived and pitched it, was no mere throwback but a grand merging of these two altogether contemporary trends. It effected a revival of the classical spirit through an active embrace of the new. At the first five games (prior to World War I), medals and olive branches were awarded

not just to the Olympic athletes but to musicians, artists, and writers as well. Commenting on the presentation of an olive branch to a poet whose Pindaric ode concluded the 1896 games, Coubertin observed that "music had opened the games, and poetry was present at their close, and thus was the bond once more renewed which in the past united the muses with feats of physical strength."[7] Coubertin himself was presented with an Olympic gold medal for poetry at the Stockholm games of 1912.

Among turn-of-the-century institutions engaged in awarding gold medals and crowning laureates, the Nobel Foundation looms at least as large as the International Olympic Committee. In the Nobel Prizes—and especially, for our purposes, the Prize in Literature—we see another institutional concretization, international in scope and function, of the homology between art and sport, imaginative power and muscular strength, cultural achievement and victory over competitors. This admittedly was not Alfred Nobel's optic, but it was the perspective assumed by much of the popular press. Contemporary newspaper accounts occasionally referred to the newly founded prizes as the "cultural Olympics," a tag which, in various forms, still enjoys journalistic life today. (And the several initiatives over the years to launch a quadrennial "cultural Olympiad" have always involved Nobel tie-ins.) Starting almost immediately after the 1901 Nobel award (to Sully Prudhomme), various articles appeared listing the "favorites" or "front-runners" for the 1902 prize, their advantages and disadvantages of position, the likely reasons for their disappointing loss the preceding year, their odds of victory. (It is likely that some informal wagering on the Nobels began to take place in these early years, long before Ladbrokes, William Hill, and other legal bookmakers opened their "culture files" and started laying Nobel odds in the 1980s.)

It is no exaggeration to say that the institutional developments

signaled by the co-emergence of the Biennale, the Nobels, and the Olympics marked the beginnings and set the terms for the sphere of arts and letters through the modernist period and down to the present moment. As I have described, over the past hundred years, prizes, awards, festivals, and other competitive cultural events have grown both in number and in economic scale at a disproportionately rapid rate, greatly exceeding the more general growth of the cultural economy. If, as many historians have observed, economic life over this period has become increasingly dependent on "cultural" practices (from ad writing to moviemaking to software user-interface design), cultural practice itself has in its turn become ever more dependent on institutions of cultural competition and award. The *work* of culture, especially the work of producing cultural value, has increasingly been accomplished through these institutions. It has become common, indeed automatic, to define writers or artists by their wins and losses, and this is all the more true of foreign or global-diasporic artists, whose uncertain relation to the domestic cultural arena seems to be susceptible of no other measure than that they are "winner of both the Pulitzer and the Mercury music prizes," "the only winner of both the Booker Prize and the National Book Critics Circle Award," "winner of Grand Jury prizes at Venice, Cannes, and Toronto," and so on. The striking change in the language of cultural obituaries noted earlier—their collapse into mere skeletal catalogs of victories and podium finishes, is a further example of this reconception of art on the model of athletics. (The newspaper I read on the morning I first drafted this paragraph was typical of our transformed cultural discourse, which by now seems thoroughly natural. There were two featured obituaries: the first, for Peter Stone, was headlined "Award-Winning Writer of *1776* Dies at 73" and included a photo captioned "Peter Stone, who won

Oscar, Emmy, and Tony Awards"; the second, headlined "Mike Larrabee, 69, Double Gold Medalist in 1964 Olympics," included a photo captioned "Mike Larrabee won Olympic gold six weeks shy of his thirty-first birthday."[8] Who, today, would even find this strange—that prizes and awards in cultural fields, like championship medals and world records in sports, are treated as the most prominent, the defining features of a life?) In this respect, the institutions of cultural competition, as they emerged in the Belle Epoque, succeeded in redefining artists, changing not only the terms in which they were described but those in which their value to the world was figured. The symbolic economy of arts and letters was made to conform more closely to that of international spectator sports. This rearrangement and intensification of the competitive character of cultural life should be apparent even to cultural critics (no doubt a majority) who view the competitive model of cultural practice as a flawed and reductive one.[9]

It is important to emphasize not merely the global scale of this phenomenon (which would still allow us to regard it as an imperial extension of local—say, European or North American—practices), but its fundamentally global nature, which assures that even the most nationally rooted competition has had to be understood as part of a system or relational field whose boundaries and rules and ultimate stakes exceed and subsume national cultures. This is not to say that cultural nationalisms are of little moment, or that national governments and institutions are necessarily weak actors, within this competitive paradigm. On the contrary, this whole convergence of art with sport was, to begin with, and for at least the first five or six decades of the twentieth century, a matter of fundamentally *inter-national* festivals and prizes, by means of which nations were understood to be competing (in a "healthy" and benign, mutually

edifying way) against other nations. But even at the outset of these developments, a certain challenge to cultural nationalism was implicit, a deviation from more traditionally nationalist cultural practice. Alfred Nobel was, after all, just one of many wealthy industrialists who founded prizes in the sciences and occasionally in other fields all through the later nineteenth century. This was a busy period of philanthropy, and with that came much activity in the area of prize sponsorship. What made the Nobels new and different, part of a distinct paradigm—justifying their status as "the first truly international prizes"—was not so much the sheer size of the monetary awards, but the fact that these large sums would be going, according to decisions arrived at by an effectively "neutral" Swedish jury, to foreign nationals, an unprecedented and highly controversial feature.[10]

The vast and still unmatched fortunes of the Belle Epoque industrialists and financiers who served as the new patrons of (international) culture, were, after all, a consequence of the tremendously intensive and extensive globalization that occurred during this period. It is during these years that the great technological advances and capitalist innovations in the areas of media and communication—submarine cable networks, regional news agencies (Havas, Reuters, Wolff, the Associated Press), daily newspapers, and the advertising industry—were put into service to produce new kinds of popular international "events" or "happenings." Even events which, unlike Scotland versus England, could not be attended by a mass audience, and which had no particular appeal as spectacle, could be "followed" by more or less rabidly nationalist "fans" or hooting detractors via the wire-serviced dailies. While the Nobels took at least a decade to achieve much legitimacy in the scientific community (they were rarely even mentioned in the scientific jour-

nals before 1915), their function as a high-stakes international competition made them—especially the Literature Prize and the Peace Prize—an immediate smash hit in the popular press. Some 500 journals (including more than 150 outside Europe and North America) published pieces about the Nobels after the first award ceremony, and the number grew steadily thereafter.[11] Some of this coverage might as well have appeared in the sports pages. For example, as with the Olympics, media reports soon began to feature the now familiar lists of medal totals per participating nation—gloatingly in the German journals, worriedly or suspiciously in the journals of Britain and America, where the sense of being over-matched by the powerful and supremely well-organized German "team" struck a deep nerve. These boasts and anxieties concerning national competitiveness, the relative preparedness of the different nations' cultural athletes, became, as we would expect, especially clamorous in the years immediately preceding the Great War. But the terms of the discourse had already been established a decade earlier, and have persisted without intermission.[12] The Nobel Prize in Literature (like the Olympics, the Biennale, and all the other in-struments of this emerging apparatus) sold newspapers, kept the news agents and their intercontinental communication systems busy, by providing a dependably serial event with the very con-tours—a win/lose competition, global in scale, nationalist in ap-peal—most suitable for journalistic consumption.

Today it is more than ever apparent that the economy of cultural prestige is a global one, in which the many local cultural markets and local scales of value are bound into ever tighter relations of interdependence. Not only can we observe the tendency over the past half-century for successful European and American prizes to be reproduced by imitation in one country after another, serving as

formal models in an increasingly global process of cultural diffu-
sion and adaptive appropriation ("the Oscars of Taiwan," "South
Africa's Emmy Awards," "the Catalan Nobel," "the Russian
Booker Prize," and so forth), but, within this McWorld of awards,
we can see how the outcome of one prize competition immediately
registers as a factor in other, geographically remote ones—the sort
of "action at a distance" that, for Anthony Giddens, characterizes
the era of globalization.[13] The decisions of the jury at Cannes or
Sundance or FESPACO not only influence the selection of films at
other festivals worldwide, but they can alter, within minutes, the
odds set by bookmakers on the BAFTAs and the Oscars. The Swed-
ish Academy's choice of a new Nobel laureate is immediately cele-
brated as a symbolic windfall by those involved in the more local or
regional prizes that the laureate can already count among his or her
palmarès, since it greatly strengthens those prizes' claims to legiti-
macy.[14]

We can readily observe, too, how the most ambitious prizes are
more and more obliged to reach beyond national boundaries both
for objects of esteem and for (other) sources of legitimacy. The
Praemium Imperiale prizes of Japan are fairly typical of the many
international "super prizes" that have emerged since the 1970s.
These prizes have been conceived on the model of the Nobels, and
they share the Nobels' pretension to global authority. It is thus no
surprise that, in 1995 for example, the Praemium Imperiale prizes
were awarded at a Tokyo ceremony to a Chilean-born French
painter, two French-born American sculptors, a British composer, a
Japanese theater director, and an Italian architect. But whereas the
Nobels, at the organizational and ceremonial level, remain a rela-
tively insular Swedish affair, the Praemium Imperiale prizes seize
eagerly on symbolic support from extranational sources. In 1995,
the board of advisers included former heads of state from three

countries; the annual press announcement was made in London; and a reception was hosted by the queen of England. Such institutional arrangements—more reminiscent of the Olympic Committee than of the Swedish Academy—bespeak the existence of a global economy of cultural prestige deeply interwoven with the international circuits of political, social, and economic power.

But even the Praemium Imperiale prizes are not based just anywhere; they are not without native roots or national utility. They were established under the auspices of the Japan Art Association in 1989 in accordance with the final wishes of Prince Takamatsu, as a way of improving Japan's poor national image among its trading partners. At that time, the country was widely perceived (especially in North America and Britain) as a kind of machine for maximizing exports and trade surpluses and then buying up "trophy assets" in the resulting debtor nations. In the United States, the image of the cash-laden "Japanese Invader" was fueled by Japanese acquisitions of Rockefeller Center, Pebble Beach Golf Course, and the venerable Hollywood studio Columbia Pictures Entertainment. Funded in large part by the giant Fujisankei media group, one of the very corporations that had "invaded" New York a few years earlier, the Praemium Imperiale awards were conceived as a symbolic gesture of international goodwill and cultural understanding, a display of spontaneous generosity to counteract the national reputation for programmatic acquisitiveness. And the elaborately orchestrated "internationalism" of the awards has continued always to be framed as *Japanese* internationalism—that is, as evidence of the Japanese people's underappreciated capacity to embrace and support foreign cultures.

The same logic of nation-specific internationalism characterizes nearly all prizes of this sort. The Neustadt International Prize for Literature, to take another example, is truly a multilingual, multi-

cultural event, featuring both juries and shortlists drawn from eight or ten different countries and a range of languages. Some recent nominees have been from Nigeria, Haiti, Guyana, Portugal, China, Finland, and other countries far from the major nodes of literary production and consumption; recent winners have come from Colombia and Somalia. But in its promotional literature the Neustadt also makes much of its Americanness and is intent on positioning itself at the top of a *domestic* hierarchy of literary prizes—taking pains, for example, to define its genre in such a narrow way that it stands alone, "the only international literary award [of its kind] emanating from the United States," and claiming, like dozens of other prizes, that it is "often referred to as the 'American Nobel.'" The prize is part of a stable of literary enterprises that help to promote an American regional university—the University of Oklahoma —and was established by its founder, the critic Ivar Ivask, with an eye toward a specifically national context in which Oklahoma is made to serve as the very type of the cultural backwater and as fodder for jokes about creationist bumpkins.[15] The Neustadt Prize is thus a mechanism for tapping into the international economy of prestige to raise the status of the subnational in the context of the national.

This logic, by which the local relevance and rationale are sustained for prizes that adhere to a global formula and aspire to global reach and impact, is coupled with another, by which even the world's most powerful prizes may be subject to the specific and highly variable constraints of the localities over which they presume to extend their global authority. Thus, for example, in the early 1990s a Pritzker Prize jury headed by Frank Gehry was reportedly forced to postpone honoring Tadeo Ando until it had satisfied Japanese protocols of seniority and succession by first honoring Fumihiko Maki. Not to have done so would have caused just the sort of

crisis of cultural misunderstanding and recrimination that awards such as the Pritzker are intended to overcome through multicultural appreciation and respect. In order to fulfill its professed global agenda, the Pritzker organization had to defer to Japanese rules and values.[16]

These kinds of tension within what we can think of (adapting the terms of Immanuel Wallerstein and his school)[17] as the "*cultural-capitalist world system*"—tensions between local and global, domestic and foreign, indigenous and imported or imposed forms of cultural capital—are the focus of discussion in the two chapters that follow. I am concerned in particular to trace out some of the changes that have been taking place in the international system of prizes and awards as a consequence of the intensifying and broadening globalization of the past few decades. My general argument is that, however skeptical we may be about the claims made by globalization theorists regarding the diminishment or eclipse of the nation-state as an economic agent within the new world order, these claims appear to have a certain validity as regards the world economy of prestige.[18] Symbolic capital, at least, is less and less tightly bound to national markets; even the sort of capitulation to national protocols and values that I just mentioned with regard to Fumihiko Maki's Pritzker is becoming anachronistic—a vestige of the way such transactions used to be conducted.[19] I hope to show that this erosion of the value of specifically national cultural prestige has opened up some new opportunities both for the agents of "local" cultural production and for "interstitial" artists from the former colonies. But we will see, as well, that for all they have done to improve the competitive position of local and minor cultures, the institutions and marketplaces of global prestige have been at best a mixed blessing for those engaged in the ongoing project of cultural postcolonialization.

The New Geography of Prestige

*Which will force me to reflect on the many spaces of
literary history—province, nation, continent, planet . . .
—and on the hierarchy that binds them together.*
> —Franco Moretti, *Atlas of the European
> Novel* (1998)

For roughly the first two thirds of the twentieth century, the tensions between local and global aspects of cultural prestige tended, in their ideological dimensions, to conform with a narrowly (inter)nationalist paradigm—that is, with a view of cultural competition as taking place between and among nation-states (or other nationalist entities) through nationally representative artists. Cultural value was exchanged and circulated in what Goethe, in the early nineteenth century, had already perceived as an emergent "world market of exchange" where "all the nations offered their goods."[1] This was no less true of the still-emergent nations of the Third World than of the established ones of Europe and North America. 1900–1970 was, after all, the period of rising national lib-

eration movements, which began seriously to challenge the colonial order in the decades leading up to World War II, and had largely dislodged the formal system of colonial power by the late 1960s. As the era of explicit colonial occupation and control began to wane, cultural prizes—long intertwined with the apparatus of colonial indoctrination, and widely deployed to that end in schools and colleges—became (without altogether surrendering this earlier function) part of the struggle to formulate and project a coherent indigenous national culture.

This struggle faced the inherent difficulties of restoring "traditional" cultural practices where these had been catastrophically interrupted and systematically devalued, and where, as in sub-Saharan Africa, there had never been a substantial *written* culture (either literary, musical, or theatrical) that could be readily reconstructed from the archive. The struggle to advance the interests of indigenous cultures along an axis of national resistance also entailed practical challenges with regard to the economy of cultural prestige. It required development of a specifically national system for production and distribution of symbolic capital—the establishment of an autonomous national marketplace for esteem, and hence of a domestically controlled hierarchy of prestigious "native artists" and "native intellectuals," at least partly distinct from the hierarchy that had been produced by the colonial (exported European or British) educational and cultural systems. But it also, increasingly and somewhat contradictorily, entailed the quest for wider, European and metropolitan recognition of a national culture whose undervaluation on the broader and still European-controlled symbolic market supported demands for redistributive justice. It was necessary, that is, both to take national ownership of the local fields of cultural production (to "nationalize" the local culture industries) and

to pursue international cultural exchange with a view toward the kinds of symbolic profit that can only be realized outside strictly domestic markets.

In a certain sense, this nationalist renegotiation of the terms of exchange between local and global cultural value was already occurring in the prizes established by the European colonial intellectuals themselves. A prize such as the Algerian Grand Prix Littéraire—though founded, in 1921, by a group of French-colonial writers (the Association des Ecrivains Algériens) some thirty years before the Algerian independence movement fully emerged (with the founding of the Front de Libération National in 1954)—was already a vortex of fierce contention between the more European-oriented writers and intellectuals affiliated with the journal *L'Afrique Latine* and a "nativist" faction, many of whom were aligned with the association's house journal, the *Revue de l'Afrique du Nord*. When the judges unexpectedly awarded the inaugural prize to a writer of nativist tendency named Ferdinand Duchêne over the prolific exponent of a de-Africanized "Latin Algeria," Robert Randau, the decision was angrily condemned both within the Association des Ecrivains Algériens (where despite the nativist tendencies of some of its journal editors, the membership had been assuming a tacit consensus in favor of Randau) and in the pages of *L'Afrique Latine* and other journals of the Algerian literary press. For the writers in these journals, none of whom were indigenous Algerians, the prize nonetheless became a focus for polemic on "la question indigène en Algérie." Randau was praised as a writer whose work focused on the social and cultural lives of the French colonials, detailing their customs and institutions, and "exalting Latin energy" as the key to Algeria's future. By contrast, Duchêne's work was said to document, all too obsessively, the grimmer cir-

cumstances of the non-French Algerians, or, as one critic put it, their "indigenous torpor and misery."[2]

But while the French-colonial journals were eager for an occasion to air their preference for celebration of the enterprising *colons* over empathy for the backward *autochtones,* such views could not in themselves stand, in these literary-critical journals, as an argument against the justice of the jury's decision. That required, of course, an appeal to Randau's "superior literary merit." Such appeals, however, simply ran once again into the problem of *locating* the relevant cultural field, defining its center and its periphery. For Randau in effect wrote like a distinguished French novelist who happened to be in Algeria, while Duchêne wrote novels that reflected in their narrative form something of the strain, the productive tension, between that European invention, the novel, and the site of its colonial dissemination. Partisans of Duchêne could point to the high regard for his work among readers and critics in Algiers, while supporters of Randau could readily demonstrate *his* greater reputation in France and elsewhere in Europe (where he was sometimes, if not very helpfully, referred to as "the French Kipling"). From the standpoint of this latter group, if the Association des Ecrivains Algériens wished to exercise any symbolic effect, it had to "valorize its prize with regard to the Metropole," and this it could do only by presenting the *grand prix* to "a writer already respected in Paris."[3] By selecting instead an author whose work had a distinctly local orientation and readership, the prize commission had damaged the credibility of Algerian claims for literary significance and prestige beyond its own provincial borders.

To this reasoning, however, came the obvious reply: that an "Algerian" literary prize which merely confirmed the established tastes and hierarchies of Paris could not do anything to advance the pres-

tige of *Algerian* literature or to increase the symbolic power of Algerian writers; it would be an act of cultural abnegation rather than cultural self-assertion. The whole affair dragged on inconclusively for some years—perhaps one could say for the remaining forty-year history of the Association des Ecrivains Algériens, which, like other colonial cultural organizations of the same type (and even, we might add, literary academies and organizations in British Commonwealth countries like Canada and Australia), was never entirely certain what, to bring most credit to itself, its prize should honor: the distinct cultural achievements of the colony, or the successful advancement on colonial terrain of Europe's metropolitan culture.[4]

The same questions were being differently wrestled with in Paris itself, where, in the same year, 1921, the Prix Goncourt aroused much controversy by being awarded for the first time to a black writer, the expatriate Martiniquan René Maran, for his novel about French-colonial Africa, *Batouala,* subtitled *Un véritable roman nègre* (A Genuine Black Novel).[5] Ridiculed by some as a minor and even a foreign (hence ineligible) work, unworthy of France's most prestigious literary award, the book was hailed by others as an example of the new, properly "colonial novel," in which the distinct cultural character of the colonies was finally being given literary expression, and whose emergence should be celebrated by the Parisian literary institutions (which claimed, after all, to hold positions not merely of domestic importance but of imperial and indeed global cultural authority). Among the champions of this emergent literature was Marius-Ary Leblond—the pseudonymous collaborative team of Georges Athénas ("Marius") and Aimé Merlo ("Ary")—who had grown up on the East African island of Réunion (still today a *département* of France), had been the first colonial-born author(s) to win the Prix Goncourt (in 1909), and were,

by the mid-1920s, publishing an influential manifesto on the "colonial novel" and founding in Paris the Société des Ecrivains Colonials (Society of Colonial Writers)—with, soon after, its own prize for colonial writing.[6]

Neither in French Africa nor in Paris were these struggles to define and celebrate colonial literary prestige ever exactly a question of colonial versus anticolonial political interests. French-colonial promoters of specifically Algerian culture were obviously not nationalist revolutionaries. Athénas and Merlo saw the promotion of distinct French-colonial literatures as an important part of the larger colonial enterprise; it was a way of demonstrating the cultural vigor of the colonies and hence the success of their colonization by France. Maran was himself a colonial administrator in the French government, and for all his importance in the interwar cultural scene of "Black Paris" (beginning with the first Pan-African Congress of 1919) and in the wider Négritude movement that emerged among black francophone intellectuals in the early 1930s, his concept of the "véritable roman nègre" was never advanced as part of an anticolonial cultural enterprise.[7] Still, what was already appearing with some urgency at this time was the question of the status and function of colonized nations in the cultural space of modernity. Where, on a map drawn in accordance with colonial designs, should one mark the borders of a *national* field of cultural practice? And in terms of symbolic economies, how can one secure the value of a national currency without simply pegging it to the imperial standard?

The many prizes and festivals established by native intellectuals in the later years of colonialism and the early years of independence play out ever more vexed versions of this very serious cultural game, in which the stake is that of national cultural autonomy

but the field is already and inescapably globalized in ways that tend to obstruct strictly nationalist configurations. Native intellectuals, with their colonial-European or British educations (acquired either in colonially administered educational institutions or in the European cultural capitals), would in many respects tend toward a European or British cultural habitus, bringing to bear in the realm of art precisely those dispositions that such an education was meant to instill, and advancing some version of cultural Europeanization ("enlightenment" of the sort they themselves had been consistently rewarded for, often with prizes and fellowships) as the only means of raising the stature of locally produced art. Their ideas for a national culture would be virtual transpositions of the metropolitan template onto a flattened or "prepared" local terrain. Those unlettered in Western traditions, meanwhile, or those among the elite who determined to shed or negate their colonial education, might form an unsustainably narrow idea of national art as tribalist art, failing to recognize its irrevocable involvement and implication, via the colonial encounter, in cosmopolitan culture both at home and abroad. Their ideas for a national culture would tend toward visions (themselves inescapably a product of colonial ideology) of a miraculously reborn and purified local scene of indigenous cultural tradition.

An event such as the first World Festival of Negro Arts, held in Dakar, Senegal, in 1966, is characteristic of this historical moment. It represents one way that cultural prizes and festivals were then beginning to be deployed toward new articulations of the local with the global, bypassing the seeming choice between a postcolonial nationalism based on European ideals of modernization and a postcolonial nationalism based on ideals of local purity. Compared with the African *eisteddfodau*—the intertribal competitive cultural festivals that had been administered by colonial welfare departments in

accordance with their "civilizing" mission from the early 1930s through the 1950s—the World Festival in Senegal was both a more indigenous (postcolonial) and a more global (diasporic) kind of event. With prizes awarded both to local traditional music groups and to African-American jazz bands, to poets of Nigeria and of Harlem or Paris, the festival undertook a complex project of revaluation, aiming to increase the international prestige of indigenous or "tribal" forms of art by establishing a new, more flexible domestic economy (only partly derived from the Négritude movement) in which, for example, Ella Fitzgerald or Langston Hughes could be claimed as a heritage asset. As one presenter expressed it, "the status of African tribal art in the world" depended fundamentally on its status "in Africa itself," where it was viewed with "indifferen[ce] or hostil[ity]" by "the great majority of Negro intellectuals, . . . who seem to despise the 'art of the bush.'" While the festival was meant to "propagate knowledge and appreciation of the Negro arts in the world at large," it would need, in order to achieve that end, first and "above all" to "propagate such appreciation among Africans." And this it would accomplish by involving them in a global celebration, a "world festival," of a (transnational) "native" culture both more "tribal" and more "worldly" than they might have imagined.[8] Such rhetoric, in which the production and dissemination of cultural prestige were centrally at issue but the nation as such did not significantly figure, was strikingly new.

As the pace of economic and cultural globalization has accelerated since the 1970s, this tendency of prizes, festivals, and related forms of competitive cultural events to facilitate exchange of symbolic capital between the indigenous and the metropolitan marketplaces—often by circumventing strictly national institutions—has become much more pronounced. Though still capable of exerting

powerful symbolic effects through their own proper systems of reward and penalty, the national fields of cultural production have seen their significance seriously diminished. This is not, however, simply because they have been subsumed within a vast transnational field on which an artist's national prestige is recalculated according to ever more disadvantageous (or Disneyfied) rates of exchange. It is, even more critically, because the "local hero," the artist celebrated at the subnational level of indigenous community, can now be fed directly into a global market for indigenous cultural production without any reference to a national standard of value. Indeed, as regards prizes and awards, the national honors which used to serve as prerequisites for "Nobelization" now themselves often trail behind global consecrations, serving merely as post-facto adjustments or corrections of the domestic symbolic market; the global awards, meanwhile, depend on a particular sifting of local or "fourth world" prestige as a basis of eligibility for global celebration.

This way of describing the contemporary economy of prestige may seem to understate the specifically national field of practice on which local or indigenous cultural prestige is won, while overstating the degree to which the local scale of artistic value is articulated with (if not in thrall to) a global system of exchange. But even the kinds of cultural honor that would seem to conform with a more straightforwardly local quest for political and cultural self-determination, celebrating indigenous or tribal cultural forms in local contexts, valorizing traditional community, and eschewing all reference to the "world at large," quickly reveal themselves to be caught up in the dynamic of globalization—and in ways that are not simply malign. We might consider, for example, the rise of "traditional" African music competitions from the 1960s to the 1980s,

from the relatively spontaneous choral slams known as *dzokpikpli* among the Anlo-Ewe in Ghana, to the more formally administered *isicathamiya* singing competitions among the Zulu in South Africa.[9] The South African case is particularly interesting, given the extraordinary importance of popular music to that country's global cultural emergence, and the fact that this emergence of the country as a significant producer of "Afropop" and "world music" coincided with the final stages of black struggle against white minority rule.[10] (Consider that virtually the entirety of South Africa's designated "national day" at the 150-nation Lisbon expo of 1998, the last international expo of the twentieth century, and the first for post-Apartheid South Africa, was given over to musical performances.) Here, at least, we might expect to see a system of prizes and awards that maps neatly onto a Manichean scheme of local versus global, with black-national interests of cultural pride and solidarity being advanced through local indigenous-music competitions, while the dominance of white-minority cultural interests is sustained through more global, Eurocentric and North-American-oriented honors and awards.

And indeed, the informal system of largely black-controlled choral competitions did function under Apartheid as a kind of local counterpart to the official, industry-sponsored and state-controlled system for allocating musical prestige. The isicathamiya contests, generally held in nightclubs or rented auditoriums, with admission charged not only to listeners but (in the form of entry fees) to the competing choral groups themselves, could last all night before the prize of a goat, a blanket, or an envelope of cash was awarded by the judge (who was empowered to make an independent aesthetic judgment, though he was often guided by local social and political considerations and/or bribes, as well as by the audience's prefer-

ences). As Veit Erlmann has argued, to compete in these contests, and especially to win the prize, was an important means of displaying power through artistic practice. Given the deep association of township choral music in general with the struggle for black liberation, the specific combination of self-praise (intrinsic to the competitive boasting of the isicathamiya genre) and praise (intrinsic to the prize) in effect promoted the winning artist to the role of hero—a role with obviously strong sociopolitical resonance among black South Africans under apartheid.[11]

The contrast with the official awards system is striking. The so-called "Grammys of South Africa" were originally the SARI (South African Record Industry) Awards, but these were slightly renamed as the Saries when the state-controlled SABC Radio took them over in 1965, around the same time that the isicathamiya choral competitions, which had struggled with venue and attendance problems since the establishment of the townships and the imposition of pass laws, began to enjoy a renaissance in the urban clubs. This happened also to be the year that Joseph Shabalala founded officially what would become the best-known of all isicathamiya groups, Ladysmith Black Mambazo (meaning the Black Axe from Ladysmith). By briefly retracing Black Mambazo's trajectory through the local, national, and global systems of music prizes, we can see ways in which here, as elsewhere, the effect of globalization was to facilitate intraconversion of "local" with "transnational" forms of symbolic capital, depreciating the strictly national forms of prestige wherever they threatened to obstruct these new global transactions.

Between 1965 and 1972, Ladysmith Black Mambazo conquered the local music scene around Ladysmith and Durban and quickly went on to dominate the much larger competitions (some involving

upwards of fifty acts) in Johannesburg and other cities. According to Shabalala, the group walked away with so many prizes that organizers began to discourage them from participating.[12] Other choral groups (no longer assured of winning anything even on their home terrain) and some judges (no longer free, in the face of Mambazo's crowd-pleasing power, to make special "advance arrangements" in return for bribes) were complaining that the presence of Mambazo was ruining the contests. By the mid-1970s the act was mostly doing solo shows, having as it were outgrown the local prize scene.

They were also by this time, and largely as a result of their many prizes, getting significant airtime on the Zulu service of SABC's Radio Bantu (the crucial venue for local musical artists), and selling quite a few records, having released nearly a dozen LPs with the Gallo label between 1972 and 1976. Though South African law included no provision for "needle time" royalties (state-controlled radio offered no compensation whatsoever to musical performers), and the contracts between Gallo and Mambazo were such that these recordings produced typically paltry income for Shabalala and his group, the albums consistently went gold or platinum, selling briskly among the consumers of township music.[13] And while these consumers were almost exclusively black, the group did start to build a small following among white listeners, and began to include occasional English-language songs on its records of the late 1970s.

Despite the group's rising status and commercial success, however, Ladysmith Black Mambazo was systematically ignored at the annual Sarie Awards. The Saries were not a whites-only award program; black musicians performing in established white genres, such as the young folk-pop singer Jonathan Butler, won Saries in the late

10. Local versus national institutions of musical prestige. Above, a publicity
photo for the 1971 Sarie Awards, with Elwin Morris and Paddy O'Byrne, co-
hosts, admiring the springbok statuette. The springbok, unofficial national
symbol of Apartheid South Africa, served as emblem both of the SABC's Eng-
lish/Afrikaans "third station," Springbok Radio, and of the Sarie Awards,
which were broadcast on that station until the late 1970s. Opposite, a pub-
licity poster for a 1968 isicathamiya singing competition in Johannesburg.
(Sarie photo © SABC. Concert poster courtesy of David Marks, the Hidden
Years Music Archive, and Third Ear Music.)

1970s and 1980s. But SABC, which sponsored and administered
the awards, effectively excluded acts like Mambazo by maintaining
firm distinctions between "traditional" and "contemporary" and
between "local" and "international" musical practices. SABC had
provided Mambazo and other isicathamiya acts with their major
career break, not only by giving them airtime on Radio Bantu but
by mentoring and producing them in the SABC recording studio in
Durban, helping to shape their practice both as performers and as

THE CONCERT

COTHOZA MFANA ABAFANA BEMBUBE CHOIRS NABO ABACULI B-SE THEKWINI
BAVAKASHELE EGOLI LAPHAYANA EHOLLO LASE

Jabulane Mans Hostel

30 TH

MHLAKA

SAT., 16th NOVEMBER 1968

NQAKHOKE BAFOWETHU SICELA LAMA KWAYA

Durban Choir VS Johannesburg Choirs

- Hellem Brothers
 Five Roses
 Danger - Express
 Swinging Brothers
 Intuthuba
 Buhle - Be Benoni
 Telegram
 Dlamini Home Defenders

DURBAN - CROCODILES
King Boys

Uhlelo Lomdlalo Lumi Kanjena

1st Competition

LADIES WELL DRESSED

2nd

Gents Swanking Competition

boke abafana abagibela iGagasi Sebefike ngezinkani asazike zinsizwa zase Goli
oba nani niyazazela Zimiseleni ngempela zimbi lezi nsizwa akumi Lutho Phambi
Kwazo wozanike nonke nizozi bonela ibhilayaswela umsila ngokuyaleza

Joining Fee R5 each Choir

nission 30c all round

E YIMINA OWENU OZITHOBILE MR J. J. KHESWA, I Ndoda odumo E Thekwini

composers. But the agenda was always a segregationist one: the township choral groups were encouraged to cleave to tribal "tradition," eschewing English or Afrikaans words, for example, and while these groups were given extensive—even, perhaps, in view of their relative undanceability, disproportionate—airplay, their exposure was restricted to the stations specially set up for black listeners. In this way, SABC positioned isicathamiya, an evolving form of contemporary urban pop music, as static and traditional, an exotic anachronism, while restricting its audience to local township-music fans and government or university ethnomusicologists.

The Saries, controlled by the same arm of the national cultural apparatus, naturally followed the same Apartheid logic, leaving groups like Ladysmith Black Mambazo doubly ineligible. As a "traditional" African music act, the group could not be matched to any award category at the Saries, which were set up to promote the country's musical contemporaneity. As a "local" group, Mambazo could not even compete in the one Sarie category aimed at black artists: the category of "international" music. For though the Saries were ostensibly intended to promote "local" or indigenous talent, which in a 90 percent black country one would expect to mean black musicians, the awards' administrators deployed the term "international" in a specially inflected, though readily understood, way to mean "acts that sell to whites"—domestic acts that had succeeded in the K-Mart-dominated and largely white "international music" market, and thus were presumably palatable to the white listeners whose taste in black music (judging by K-Mart's sales figures) ran to such foreign stars as Michael Jackson and Joan Armatrading.[14] As the editor of the journal *African Music* put it in 1987, when we see the term "international" in connection with South African music, we must read "for white ears."[15] Black artists

classified as "local" and/or "traditional" were eligible for the so-called Black Saries, but these underfunded, underpublicized, and white-run awards were generally regarded as an afterthought and a farce, a symbolic ghetto for musicians entirely lacking in national stature.[16]

By the early 1980s, however, in part as a cumulative result of various prizes, competitions, and festivals throughout Africa, "worldbeat" or (as it would later be called) "world music" was emerging as a formidable niche in the international music market, and "local" acts working in "traditional" forms—especially those from Africa—began to be prized as global innovators bringing new energy and creativity to the moribund scene of post-punk Western pop.[17] The collaboration of American singer-songwriter Paul Simon with Ladysmith Black Mambazo and other South African acts on his 1986 album *Graceland* vastly extended the emergent audience and raised the global prestige for world music in general and for Ladysmith Black Mambazo in particular. The album won Record of the Year at the Grammys, an award whose publicity value was greatly leveraged by the "scandal" of what many critics characterized as Simon's neo-imperial, economically exploitative appropriation of African tribal music, not to mention his and Shabalala's violation of the U.N.-sponsored cultural boycott of South Africa.[18] Mambazo emerged from the subsequent torrent of controversy with a contract from Warner Brothers, winning their own Grammy for Best Traditional Folk Album in 1988, and then receiving five Tony nominations and a Drama Desk Award for their score to *The Song of Jacob* in 1992, a pair of Clio Awards for their Lifesaver and 7-Up commercials, eight more Grammy nominations, and a host of other American and international prizes in various media and genres.[19] For all the criticism Mambazo endured from advocates of indige-

nous cultural purity, the group had become one of the dominant acts of world music and a fixture of the global prize scene. When, to put its symbolic mark on the end of Apartheid, the Nobel Foundation awarded its 1993 Peace Prize to Nelson Mandela, it was no surprise that Ladysmith Black Mambazo accompanied Mandela to Norway and performed at the prize celebration. For many Europeans, Asians, and North Americans, the group had become the major *cultural* symbol of global solidarity with the new, democratic regime in South Africa.[20]

It is not very helpful to think of Ladysmith Black Mambazo's success in the global market for cultural prestige simply as their profit for selling out the local musical tradition or for conspiring in that tradition's hijacking by savvy American record producers. Any act with some sort of local base or following that ends up with a gold record or a Grammy Award will be accused of selling out its local roots; this is perhaps the single most indispensable trope in the discourse of popular-music journalism. What's interesting about the case of Mambazo is that the kind of conversion of local into global capital—symbolic as well as commercial—which is the very condition of possibility for the concept of "selling out," had, by the 1980s, come to obtain even for African artists whose status in their *national* arenas was, for whatever reasons, quite sharply constrained. The local cultural institution of the isicathamiya prize competition, and the rewards that its practitioners could gain, had become more interwoven with a global system of musical prestige and value than the Saries ever were. The "local" in this case was part of, or proximate to, the "global": the musical practices and practitioners defined, nationally and as it were officially, as lacking an "international" dimension, as too local and too indigenous to enjoy a properly national prestige, were in fact oriented toward or

attuned to an emergent "world" style which attached universal value precisely to new and hybridized forms of indigenous particularity. As Louise Meintjes observed in a lengthy examination of the *Graceland* affair, what made this collaborative project so "pivotal" both politically and culturally was its embeddedness in "the dialectic between the value of musical 'indigenization,' i.e. of localizing sounds and their meaning, and of musical 'internationalization.'"[21]

Furthermore, the rather special kind of prestige Ladysmith Black Mambazo came to possess in South Africa and, especially, abroad was possible only on a cultural field where a kind of symbolic bonus accrued to those who could combine the most *restrictedly* local forms of honor (township-music prizes *but no Saries*) with the most visibly global forms (Grammys, Golden Lions). In celebrating such already celebrated artists, the institutions of cultural prestige could feel they were celebrating themselves and their capacity to recognize forms of value both too restricted and too general for the purposes of the (more or less suspect) national economies.

But the case of Mambazo begins to hint at some further rearrangements to the old international geography of cultural prestige, as well. The group's formidable economic and symbolic successes in the global markets were achieved concurrently with the economic and symbolic decline of the isicathamiya contests, which have been atrophying since the late 1970s. In effect, Joseph Shabalala and Ladysmith Black Mambazo were consecrated as global artists just as their local field, starved for capital, was shutting down. Their symbolic elevation occurred simultaneously with their geographic delocalization. Such ambiguous trajectories suggest some of the costs entailed for local cultures as the global market for cultural prestige imposes its increasingly transnational system of values. Indeed, some would see here evidence that, in its global dimensions,

the symbolic economy is a mere shadow form of the money economy, following the same logic of intensifying devotion to the blockbuster/superstar model, and finding value in minor forms only to the degree that they may be repackaged or recontextualized for mainstream consumption.

Such concerns will be taken up in the next chapter. What I wish to emphasize at this stage is that the recent frenzy of prizes and awards has begun to foster not merely a denationalization but a more radical *deterritorialization* of prestige, an uncoupling of cultural prizes, and even of symbolic fields as such, from particular cities, nations, even clearly defined regions.

This tendency for prizes to support what may be thought of as "floating" or "offshore" forms of cultural value is evident, for example, in certain kinds of diasporic or exilic film festivals that have sprung up since the 1980s. With respect to the geography of cultural prestige, these festivals depart quite radically from the established paradigm. As discussed earlier, the film festival originated in Venice, where, like the Biennale from which it soon spun off, it was conceived along essentially classical lines. That is, the festival was intended, as the Athenian festivals had been, to draw tourists into the city—especially rich and influential tourists, VIPs from abroad. Even if the financial costs of the event were not immediately recouped by the free spending of visitors on holiday, there would be a substantial symbolic profit (with ultimately economic effects) through enhancement of the city's reputation as a cultural capital. Of course, as a fascist innovation, the Venice film festival was also intended to serve the economic and, especially, the symbolic interests of the nation-state, for example by showcasing and celebrating fascist propaganda films. (We should recall here that the Golden

Lion for 1939—at that time still called the Coppa Mussolini—was shared by Leni Riefenstahl's *Olympia* and a film made by Mussolini's own son.) The interests of the national government were pursued through the promotion of Venice as its cinematic capital; Mussolini could showcase Italian modernity by repositioning Venice as a mecca for those seeking the most up-to-date form of aesthetic stimulation and financial opportunity.

The same is true for all the festivals that sprang up immediately after the war to compete with Venice. The festivals in Cannes, Locarno, Berlin, Edinburgh, London, Vienna, and so on were part of a competitive struggle among nation-states (including the United States and the Soviet Union, whose rivalry shaped the early agenda of the Berlinale). And in each case, a single city was promoted as the site where cinematic prestige—a relatively new form of cultural capital, still enticingly speculative—would be produced and distributed, in turn bringing prestige, and pride, to the city itself. The film festival thus emerged and has taken shape not only as a firmly located cultural event, but as a cultural event that is all *about* location, such that the very name of the host city becomes resonant of symbolic fortune: such phrases as "to win at Cannes," "to be an official selection at Vienna," "to be a sensation at Venice," bespeak a symbolic profit shared between artist and city. Historically, the rise of film festivals has as much to do with the spread of "place promotion" in its contemporary form—a blending of modern marketing practices into urban planning and public policy—as it does with the proliferation of prizes and awards.[22] Though often organized by business people, professional associations, or foundations allied with the film industry, festivals have typically been sponsored by municipal governments and tourism boards and incorporated prominently into the cities' municipal promotion campaigns. And

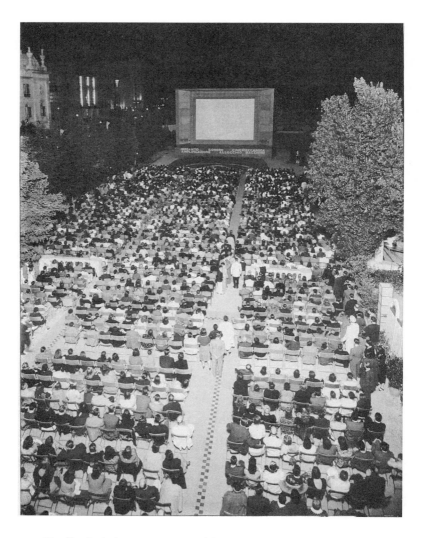

11. The film festival as consecration of the city. Promotional photos from Ven-
ice, at the inaugural festival of 1932 (above), and from Locarno, at a screen-
ing in the Piazza Grande in 2002 (opposite). Serving as a spectacular stage for
the production of cultural value, the city itself realizes a symbolic profit from
its gifts of golden lions, leopards, or bears. (Venice photo courtesy of La Bien-
nale di Venezia. Locarno photo © Roberto Buzzini.)

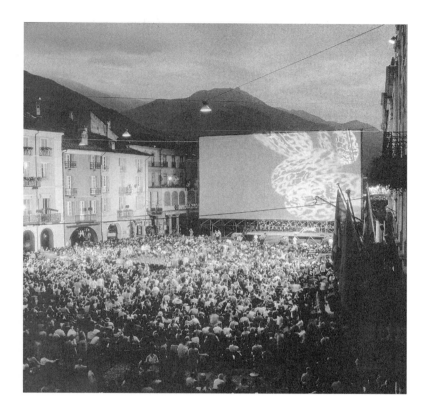

in their own promotional campaigns, the festivals have sought to capitalize on the glamour and status of their host cities, for example by using publicity shots in which the spectacle of the cinema itself is framed or redoubled in the spectacle of its consumption by an urban crowd against an urban (or resort-town) backdrop. The open-air venues that have typified festivals from their invention down to the present day underscore the desire to stage as much of the cultural activity as possible, even of the movie-viewing itself, on the streets, in the piazzas, rather than in interior movie-hall spaces that might be just anywhere.

The profound interdependence between festivals and their host cities is nowhere clearer than in the negative example of the International Film Festival of India, first held in 1952. Though only a year younger than the Berlinale and older than any of the North American or British festivals (Edinburgh dates from 1954, San Francisco from 1961), the IFFI stands in stark contrast to other festivals of the first generation—a curiously unstable, unsettled event, lacking a clear identity on the international festival circuit. Nor is this simply because the IFFI has been a rather ill-run affair, state-controlled and over-bureaucratized, held at highly irregular intervals in its early decades and tending to oscillate between competitive and noncompetitive formats and between third-world and first-world (or domestic Third Cinema and First Cinema) orientations.[23] Other festivals have been plagued by these same inconsistencies, occasionally skipping a year, altering the ratio of competition to out-of-competition films on their program (Venice itself was entirely noncompetitive in its first year), and constantly adjusting the mix of European and American, first-world and third-world, industrial and artisanal entries, without suffering any particular crises of identity or status. What has set the IFFI more decisively and damagingly apart from these other festivals is its lack of a defining location. The very first IFFI, though held in Bombay, was then circulated as a road show through Calcutta, Delhi, and Madras. The second iteration of the festival was held in Delhi. For a time in the 1970s and 1980s, the festival was divided into two separate events, one in New Delhi and the other (a noncompetitive event called Filmostav) revolving among Bombay, Calcutta, and other cities. Since 1989, when this rather confusing bifurcation ended, the reconsolidated IFFI has been held in ten different cities over fifteen years.

This relative lack of symbolic investment in (and by) its location is, I believe, the main reason that, in terms of its stature and competitiveness among the first-generation festivals, the IFFI is a failure. Though it became, in 1965, the first festival of the developing world to be ranked in the "A" category by the Fédération Internationale des Associations de Producteurs de Films (the French-based organization that attempts to regulate the selection of juries and awarding of prizes among international festivals), the IFFI almost never appears on reference lists of "major" festivals today, even those that claim to reflect the FIAPF categories. (Among festivals of the Global South, São Paulo, Cairo, FESPACO, and others enjoy higher profiles.) Just as tellingly, perhaps, an upstart festival in Innsbruck seized the IFFI acronym in the early 1990s, even claiming the www.iffi domain name (albeit with the Austrian .at suffix).

The IFFI's inability even to guard first-mover advantage in the matter of its own name—which, after half a century, should be a valuable trademark—suggests just how difficult it has been for an international film festival to achieve global legitimacy without adopting the originary agendas of urban place promotion and touristic attraction. To succeed on the European model, a festival must be more than a periodic event; it must establish itself as a periodic *destination,* a temporary but regular and reliable meeting-place for the holders of economic, social, political, cultural, and journalistic capital. The film festival is above all a literal, physical site for the kind of intraconversions of capital, the mutually profitable transactions between, say, critic and movie actor or producer and journalist, that the prize industry as a whole exists to facilitate. It is for this reason that festivals have experienced such difficulty sustaining a commitment to the noncompetitive format. The in-

creasing dependence of the entire economy of cultural prestige on prizes has made an awards night practically obligatory for any festival that hopes to exert a measurable symbolic effect on the cinematic field, or even simply to raise sufficient funds to cover its expenses. And since "noncompetitive" festivals already perform much the same economic function as competitive ones, it is difficult to provide a compelling rationale (along the lines of "artistic purity") for the awards-free event.[24]

All of this may seem to be simply restating, in slightly elaborated form, the standard objection to Cannes, Venice, and the rest: that international film festivals are big business, that their symbolic fortunes depend on their being oriented toward the commercial heart of the global cinema industry, and that the kind of honors they confer are little more than euphemized forms of paid advertisement. Certainly, festival judges and organizers can be made to feel strong pressures (where they have not already comfortably internalized them) to maintain an alignment between prizes and money. When judges at the Berlinale failed to award any prizes to John Schlesinger's *Midnight Cowboy* in 1969, United Artists retaliated with a boycott that lasted ten years, denying Berlin any share in the considerable hoopla that surrounded such UA releases as *One Flew Over the Cuckoo's Nest, Annie Hall,* and *Apocalypse Now.* But such episodes, however often invoked as evidence of money's absolute dominion over the festival industry, should not obscure the fact that festivals, in order to thrive, must serve as genuinely transactional sites. At a well-functioning festival, commercial power cannot simply dominate but must negotiate with other, social and symbolic forms of power that are capable of their own maneuvers and stratagems. It is not in fact clear that United Artists profited from its attempt to discipline the judges of the Berlinale.

Prominent writers and directors affiliated with UA rallied around the festival throughout the boycott; George Stevens and Eleanor Perry served as presidents of the International Jury in 1970 and 1972, for example, and even the notorious Oscar-refusenik and mocker of prizes Woody Allen graciously accepted a Silver Bear for Lifetime Achievement in 1975. In assessing the commercialism of festivals, we should keep in mind as well that, at least since the rise of the multiplexes (which coincided with the most explosive period of worldwide growth in festivals), the festival circuit has come to be the single most indispensable venue, as well as the most accessible source of symbolic start-up capital, for independent, avant-garde, documentary, short-form, and various sorts of minor and Third Cinema. Indeed, it has been primarily through the agency of the festivals, which have promoted these minor, avant-garde, or oppositional forms within a touristic program of bourgeois attraction, that low-budget, small-audience cinema has garnered and retained its high cultural value in the age of media conglomeration and blockbuster dominance.[25]

Festivals that lack a stable home, a place-identity, have thus faced special difficulties not because festivals are merely commercial instruments but, precisely, because they are more than that. A festival needs to establish itself as a potentially profitable destination for holders and seekers of every form of capital involved in the production of film, including money but also including those forms least susceptible to conversion from and into money. It may seem surprising, therefore, that recent years have witnessed not the disappearance but the rapid proliferation of migratory, virtual, un-homed, or seemingly "anyplace" film festivals, festivals even more radically disengaged from the project of urban place-promotion than the International Film Festival of India. But this emergence has

been driven by the same process of global postcolonialization that has been reshaping the geography of cultural prestige for half a century. If the IFFI found itself the one homeless festival of the first generation partly by chance, it was also partly by reason of its being the only postcolonial festival. By 1952 the peoples of South Asia had been subjected to occupation, partition, migration, and diasporic relocation on a scale beyond the imagining even of the Berliners or Venetians. India's cinema industry, among the very earliest to emerge outside the West, was already marked by this history of displacement and dislocation. And by the 1980s and the 1990s, at which point the IFFI was finally being held on an annual basis and might have refashioned itself on the European model as the New Delhi International Film Festival, Indian cinematic culture had become even more thoroughly conditioned by dislocation. When, at the end of the century, a group of Bollywood producers and other industry people decided to organize an "Indian Oscars," an annual industry-sponsored academy awards ceremony for Indian film, they went so far as to decouple the event physically from the Subcontinent. In acknowledgment of the double-dispersion of Indian cinema—both on the level of production (with diasporic directors such as Mira Nair and Gurinder Chadha enjoying major careers), and on the level of reception (with the vast diasporic audience enabled by VCR technology)—the awards were dubbed the *International* Indian Film Academy Awards, and were first held in London, followed in successive years by ceremonies in Sun City (South Africa), Malaysia, and Johannesburg.

This is simply to say that, from the beginning, the Indian cinema's relationship to both local and global terrains was quite different from that of the Italian or French or American cinemas. There have long been, and are now more than ever, areas of convergence

and overlap between Indian cinema and what Hamid Naficy calls
the "accented cinema" of postcolonial exile and diaspora. This lat-
ter is a cinema produced by "figures who work in the interstices of
social formations and cinematic practices," typically artists "from
the Third World and postcolonial countries (or from the Global
South) who since the 1960s have relocated to northern cosmopoli-
tan centers where they exist in a state of tension and dissension with
both their original and their current homes."[26] The difficult ques-
tion with regard to these filmmakers, as Naficy observes, is how to
situate them in geocultural terms. The question presents itself with
special force in connection with the thriving festival circuit, on
which these accented artists are particularly dependent. For, as we
have been considering, festivals have tended to be among the least
ambiguous of all the instruments of cultural prestige as regards the
location of culture: firmly situated themselves, they offer recogni-
tion of a sort that assumes and affirms the (originally *national,* now
very often *local*) situatedness of cinematic production. If the conse-
cration of "world culture," including world cinema, has tended to
redraw the maps of cultural competition and cultural prestige in
ways that diminish the importance of nations, charting new paths
of trade between local and global that are not routed through na-
tional gateways, then the consecration of exilic and diasporic cul-
ture has, at least in some of its forms, begun to diminish the sym-
bolic importance of the local itself.

An example of the sort of emergent institution I have in mind
here is the International Exile Film Festival, founded in 1993 by the
Iranian-born cinematographer Hossein Mahini in Göteborg, Swe-
den. Göteborg had already established itself as an important stop
on the festival circuit with a large-scale international festival held
annually since 1978. But the Exile Film Festival was not set up as a

parasitic fringe- or counter-fest to this major tourist event, the kind of satiric shadow festival that unavoidably amplifies the effects of the event it seems to mock. (Indeed, this kind of sidebar activity—the ultra-indie Slamdance festival at Sundance or the pornographic Hot-d'Or festival at Cannes—is the surest sign of a festival's symbolic effectiveness.) On the contrary, the Exile Festival is held in October, three months before the Göteborg International Film Festival, and well past the end of the local tourist season. In recent years, the week-long event has not even been held in the city of Göteborg, but has strayed out to Boras, a much smaller town fifty kilometers to the east. Mahini's background is reflected in the particular emphasis the festival has placed on films of the Iranian and more broadly Persian diaspora. In 2001, for example, English-language films included *My Brother's Wedding,* by Ramin Sherri, an American of Iranian descent, and *East Is East,* adapted from a play by the British actor Ayub Kahn-Din, son of an English mother and a Muslim father who immigrated from Pakistan. But this festival is not competing directly with the Iranian Diaspora Film Festival (a migratory event that alternates among Montreal, New York, and Toronto) or the many other festivals devoted to specific diasporas; its programs are designed to explore the exilic mode in general, capturing the diversity of flavors and orientations within exilic cinema.

What the Exile Festival clearly does not emphasize is any vital connection to Göteborg. This is not a city with an especially large exilic population. (According to the Göteborg Yearbook for 2002, the city, which is the second largest in Sweden, currently receives only about 1,000 migrants a year, many of those from the former Yugoslavia. The net migration rate for Sweden as a whole is about half that of Denmark and a quarter that of Germany.) Neither Göteborg nor Boras is a center of exilic cultural production, cine-

12. Festival of "world" cinema. This poster for the 2001 Cannes Film Festival features a cosmopolitan gentleman with the whole world in his head, an icon of worldliness. (Copyright © Michel Granger / Festival de Cannes.)

13. Festival of "unhomely" cinema. The poster for the Second International Ex-
ile Film Festival, Göteborg 1995, features a passport, in negative, as an icon
of unhomeliness. (Poster by Freshteh Fazeli. Courtesy of International Exile
Film Festival.)

matic or otherwise, nor is it an aim of the International Exile Film Festival to initiate a transformation that might ultimately make them such. The festival's slogan, "The World Is My Home," thus does not invoke the world in the way the traditional festivals do, as a means of extending the geocultural range of a firmly centered symbolic compass, the host city's bid for global stature supported by its festival's distribution of prestige among all the nations, or all the "local heroes," of the world. On the contrary, to gesture toward "the world" as the exilic home is to mark the lack of a more concretely specifiable locality. The exilic subject is not the cosmopolitan European gentleman with the whole world in his head (as shown in the publicity poster for Cannes 2001), but a border subject, a subject of and in transit, aptly symbolized (in the poster for the Exile Festival of 1995) by the negative image of a passport photo.

The prestige that is produced and circulated through festivals of this sort is a symbolic currency appropriate to what Hamid Naficy (following Homi Bhabha) calls the "interstitial mode of cinematic production."[27] That is, it is a globally legitimate, creditable form of prestige, produced in the cosmopolitan spaces of the developed world through a recognized institutional mechanism. It is not a local or "traditional" coin whose value holds only on the "margins" of the cultural-capitalist world system, or only after being generously recognized and converted by the cultural bankers of the metropolis. Yet it is nevertheless "accented" in a way that distinguishes it from the global prestige of a Palme d'Or or a Golden Lion. The exilic festival offers a kind of global but unhomely recognition of artists who are themselves culturally unhomed, however firmly lodged in the metropolis it and they may be.[28] Such festivals are by definition minor, and there is no question of them supersed-

ing Cannes, Venice, and Berlin anytime soon. But the global interstitial network of cinematic agents and institutions of which these festivals are a critical part represents a growing force in the economy of prestige. The globalization of the field of cultural competition has ushered in these new institutional players and thereby introduced new wrinkles into the game. To advance one's cultural interests and secure symbolic advantage on this field today requires not just less in the way of a national base (either material or symbolic), but, at times, less of the kind of local credentials and credibility that the major institutions of global consecration have for several decades been accepting in lieu of national endorsement. The fact that this latter process continues, however, and that its logic can be expected to dominate the symbolic markets for some time yet, should keep our optimism in check with regard to the artists of the interstices, the kinds of capital they will have at their disposal, and the likelihood of their effecting a general postcolonialization of positions and relationships on the field of global culture.

Prizes and the Politics of World Culture

*Mobil's interest lies in bringing people together cultur-
ally as well as economically.*

> —Lucio Noto, chairman and CEO of Mobil
> Oil Corporation, explaining the rationale for
> the Mobil Pegasus Prize in Indigenous
> Literature, 1999

The symbolic capital of prizes has taken on a special importance in the context of the increasing globalization of the media and culture industries, since it is seen as a potentially powerful counter-currency even while it is attacked in some quarters as a mere shadow form of money itself. As British, European, American, and multinational cultural and philanthropic institutions have turned, however belatedly, to the task of identifying artists from the postcolonial nations for inclusion in their purportedly global pantheons—either by creating new, parallel prizes especially for "indigenous" or "third-world" or simply "world" artists (a World Music award category was added to the Grammys in 1996; World Cinema first appeared as a category at Sundance and other major festivals around the

same time),[1] or by widening the implicit criteria of eligibility and assessment for prizes that were ostensibly global all along—the effort has followed a course analogous to that of foreign investment of financial capital. Viewed on the one hand as a necessity for the postcolonial world and an ethical obligation on the part of the major powers (a matter of genuine respect and recognition, not mere symbolic philanthropy), the investment of foreign symbolic capital in emergent symbolic markets has been seen on the other hand as a means of sustaining less overtly and directly the old patterns of imperial control over symbolic economies and hence over cultural practice itself. It is not a problem from which the prizes can hope to extract themselves: to honor and recognize local cultural achievement from a declaredly global point of vantage is inevitably to impose external interference on local systems of cultural value. Even simply to reinforce, to restage in a larger arena, the cultural hierarchies that already obtain within a particular local community is obviously to lend symbolic power to one side in a scene of ongoing shifts and struggles, as well as to encourage the various parties of cultural struggle to orient themselves more concertedly toward global stakes (by altering the timing or rhythm of their activities, for example, in accordance with the world awards calendar). There is no evading the social and political freight of a global award at a time when global markets determine more and more the fate of local symbolic economies.

In the same year that *Graceland* won the Grammy award, 1986, the Swedish Academy marked its 200-year jubilee with special emphasis by presenting its Literature Prize for the first time to a writer from the African continent (indeed, for the first time to any writer of African heritage): the Nigerian poet and playwright Wole Soyinka. The event was by no means cause for unequivocal celebra-

tion in the African literary world. While the Western press focused on the "cheering crowds" who greeted the laureate when he flew into Lagos after the announcement, and described the proceedings in Stockholm as providing a much-needed "boost to Nigerian morale," the actual response in Nigerian literary circles was more complex.[2]

As is often the case with Nobel laureates, Soyinka had come very close to winning the prize the year before (1985), and the resulting disappointment of expectations had provided the Nigerian press with an occasion for a dress rehearsal of what would prove to be fierce and prolonged debates over the value of the Nobel Prize in Africa. A clear majority of those who participated in the debates desired this recognition for their compatriot, expressing dismay that Soyinka had been passed over in favor of Claude Simon (one of the less prominent founders of the French *nouveau roman*) and renewing the call for an African laureate. But Soyinka's critics, who had been attacking him for his "Euromodernist" orientation since the 1970s, saw no more reason for ordinary Africans to covet the Nobel Prize than for them to admire Soyinka's "unintelligible" plays and poetry. Indeed, according to Soyinka's nemesis, a critic and newspaper columnist named Chinweizu, the two made a perfect match: a Nobel for Soyinka would be a nice instance of "the undesirable honoring the unreadable."[3] For Chinweizu and others, the playwright's selection by the Swedish academicians, far from constituting an act of welcome recognition of Nigeria's and Africa's formidable literary achievements, would simply affirm European prejudices regarding African cultural deficiency. To embrace the award, to view it as a great honor, was, in this view, a way of rejecting indigenous and vernacular culture in favor of global European hegemony.[4]

All this had been said in both the literary and the popular press in Nigeria from the moment of the first rumors that Soyinka was in the running for the prize; the event itself simply intensified the rhetoric. And though Soyinka's detractors may strike us as singularly insensitive readers of his work, not to mention overly shrill polemicists (standard though such "fighting" words may be among Nigerian men of letters), their arguments, no less than the lobbying of Stockholm that had been carried out on Soyinka's behalf, were a predictable and legitimate response to the Swedish Academy's decision in the 1980s to lend its unrivaled symbolic agency to the task of extending the international economy of literary prestige to more fully global dimensions.

For years Nobel-watchers had expected that the first African winner of the prize would be Léopold Sédar Senghor, a monumental figure in twentieth-century letters, cofounder and major exponent of the Négritude movement, president of Senegal for the first two decades of its independence, and a hero to those who believed that, for Africans, both personal identity and political sovereignty must be rooted firmly in authentic African cultural traditions and resources. Senghor had been elected to the French Academy in 1984, and certain members of that powerful body (which is after all the model on which the Swedish Academy is based) had begun campaigning for his Nobel laureateship. But the rhetoric of *authenticité* and specifically black-nationalist identity—which had served as such a powerful weapon during the period of anticolonial struggle and in the early years of independence—was, further on in the postcolonial period, rapidly losing its cultural and political utility. It was a language suited to cultural nationalism rather than to cultural globalism, being rooted in a paradigm of resistance that, as Michael Hardt and Antonio Negri have argued, has become in-

creasingly anachronistic and ineffective with the rise of a new, transnational form of sovereignty (which they call "empire"). Senghor's discourse of black cultural nationalism lacked a strategy for articulating in this new context the particular with the universal, or for putting local forms of cultural capital into circulation in a rapidly evolving marketplace of "world" culture. It clashed, moreover, with the strain of liberal humanism that, then as now, dominated the thinking of most members of the Swedish Academy—and so the votes could never quite be mustered for Senghor. Viewed cynically (and this is how many Francophone African émigrés in Paris saw it), the French were given Claude Simon's laureateship as compensation for the Swedish Academy's decision, already in 1985, to put the younger, postcolonial (and Anglophone) Soyinka rather than the older, anticolonial (and Francophone) Senghor at the front of the queue for Africa's first Nobel.[5]

Soyinka, in fact, was the most prominent African writer of the backlash *against* Négritude, which he had famously mocked by observing that tigers do not go around declaring their "tigritude." In 1975 he had published in *Transition,* the leading magazine of cosmopolitan culture in postcolonial Africa, a withering attack on literary critics of the *authenticité* school, in which he dismissed the idea of producing African literature from wholly native resources as "neo-Tarzanism," a "poetics of pseudo-tradition."[6] His own work, at times rather dense and obscure linguistically as well as avant-gardist in its formal procedures, had arguably succeeded better in Britain (where he had won the Jock Campbell Prize and shared the John Whiting Award with Tom Stoppard) and on the Continent (where his honors included Italy's Eni Enrico Mattei Prize) than in Africa. He enjoyed, as well, the support of symbolically powerful African American writers and academics—including Ishmael Reed,

Anthony Appiah, Maya Angelou, who had nominated him for the Neustadt Prize, and Henry Louis Gates Jr., who had been Soyinka's student at Cambridge and had acted as his lead nominator for the Nobel. In his own country, though he was without question a major figure (having won a number of prizes there, as well, starting with a poetry prize at the Nigerian Festival of Arts when he was still a schoolboy),[7] his success in British and European theater circles was sometimes held against him, and his polemics against the agenda of cultural authenticity had earned him, in Chinweizu's circle, the label of literary "quisling." He was, to his critics at home, the chosen "pointman and demolition expert" for British, American, and European neo-colonials looking to destroy the reputations of authentically indigenous Nigerian writers.[8]

The academicians in Stockholm knew all this, of course, and there was nothing innocent or uncalculated in their choice of laureate. Outgoing secretary of the Academy, Lars Gyllensten, described Soyinka in his presentation speech precisely as a cosmopolitan writer for whom African elements supply only one aspect of a complex and highly original vision. He presented the award to Soyinka for having managed "to synthesize a very rich heritage from your own country, ancient myths and old traditions, with literary legacies and traditions of European culture." In this respect, it was quite true that the Nobel Prize was being deployed against the interests of the most outspokenly "localist" and black-nationalist factions, in favor not exactly of European neo-imperialism, but of what would within a few years come to be called, in Nigeria as elsewhere, cultural globalization.[9] This globalist strategy, by means of which the terrain subject to the "Nobel Effect" ("Nobelization" of the markets for literary esteem) was in the process of being greatly expanded, depended crucially on the identification of writers with

particular local or regional—but not necessarily national—fields of production. Soyinka, who donned an *agbada* (traditional Yoruba ceremonial robe) to receive the prize, made it emphatically clear in his acceptance speech and in numerous statements to the press that his award was to be understood as Africa's award. His position as laureate was a representative one; he received the prize "as an African," and lost no time in leveraging it in the cause of the anti-Apartheid struggle in South Africa. At the same time, his deepest pleasure in the prize came, he said, not from being the first African to receive it but from having the opportunity to bring it home as a "national honour" for Nigeria. "To me, that is the great thing about the prize," he said, "that it was really a national thing."[10]

These kinds of statements, which would be echoed by a number of subsequent laureates, at times threatened to over-accent the "federalist" dimension of the Swedish Academy's strategy, or to overestimate its interest in national fields of culture—and led the Academy's spokesman to offer clarifying remarks to the effect that the prize was not simply being awarded to a Nigerian, or even to an African, but to "one of the world's great writers . . . who has his roots in black Africa."[11] The ambiguity here, whether manifest in particular utterances or in the seeming divergence of the laureate's rhetoric of national and regional representativeness from the Academy's rhetoric of transcendent genius and unique multicultural fusion, arose from a conscious strategy aimed at honoring writers of *world literature* who could nonetheless and simultaneously be identified with *local* roots or sites of production, and indeed whose place within world literature was a function of their particular relationship to those local roots. In the decade and a half following Soyinka's win, there were laureates from Egypt, Mexico, Saint Lucia, and Trinidad, as well as the first African American and Chinese

French recipients. These writers *represented* not just particular local (or diasporic) literary communities, but the highly selective emergence of those communities, or certain of their aspects, into the global articulation of world literature. The prize was not intended as recognition for local achievements, as a kind of accession to a localist or nativist cultural agenda, much less as mere confirmation or amplification of specifically national stature. But neither was it meant simply as a further advancement of European literary hegemony, proof that European tastes and standards could not only be applied but could attain legitimacy in the farthest reaches of the earth. Rather, the prize had become a means of articulating, across the various and far-flung sites of its production, a particular category of literature that might be recognized as properly "global," a literature whose fields of production and of reception could be mapped—and whose individual works could be valued—only on a world scale.

As Paul Hirst and Grahame Thompson have remarked, what makes a globalized economy "a distinct type from that of the international economy" is that "in a global system distinct national economies are subsumed and rearticulated into the system by international processes and transactions."[12] What I would argue is that this process of subsumption and rearticulation has reached a more advanced stage in the symbolic economies than in the economies of money and material trade (where national interests have strongly reasserted themselves of late, and a trajectory of increasing globalization remains far from clear).[13] The Nobel's foray into Africa is part of the strengthening of a global economy of literary prestige that often draws upon and makes profitable use of national literary hierarchies and systems of value, but without simply affirming or reproducing them and at times by discounting them quite radically.

It thereby constitutes a corpus of world literature that (like world music) is notably nonidentical with the "best" literature (or music) from the many countries of the world as determined by the symbolic economies of those nations, or indeed of any other particular nations, including the United States (or Sweden). At least, we should say, it is not *initially* identical: for while the global production of this canon of world literature can and increasingly does flout national hierarchies of prestige, it is certainly difficult in the long run for a national market to support a scheme of symbolic pricing that is radically different from that which obtains on the global market. While works of nationally distinctive literature that have no truck with the evolving criteria or institutional apparatus of world literature continue to be widely read and praised by critics in every country of readers, just as certain national regimes in Africa and Asia continue to patronize only the most unwaveringly "traditional," anti-Western musical performers while suppressing attempts at fusion, it appears likely that the best-established figures of world literature and world music, from Chinua Achebe to "King" Sunny Adé, have already opened a status gap, even in their home markets, in relation to their more nationally "representative" peers.

One might well object to the view of "world literature" as a phenomenon roughly analogous to and historically simultaneous with world music. Certainly, there is ample ground for insisting on the term's deep historical roots. It dates back, after all, to Goethe's coinage of 1827 *(Weltliteratur)*, and has essentially served, at least since the early decades of the twentieth century, to name the canon of comparative literature—a canon constructed in and for the core Euro-American educational apparatus, but which includes texts drawn from peripheral cultures.[14] Scholars have plausibly argued that, to judge by a century of "world literature" anthologies,

recent deployments of the term represent no more than a modest and economically opportunistic expansion, along multiculturalist lines, of this still relatively stable, still essentially Western, literary canon.[15] It is thus not a *new* category, a novel effect of late twentieth-century globalization, in the way that world music appears to be.

But there is something missing from this view of contemporary "world literature" as merely a culturally and geographically expanded version of a familiar object. In large part through the geographic diffusion of literary prizes, something more emphatic has happened to the term, some new inflection has attached to it, which, while difficult to specify, is disclosed precisely in the suspicion or distaste with which it is now in some contexts pronounced. As it has become a more symbolically potent category over the past two decades—coming to signify something more particular and loaded than Goethe's "best [literary] goods of every country," or even than "great literature from around the world"—world literature has been subjected to exactly the same forms of critique and dismissal as world music. There is, to begin with, the anticommercial critique, which is based in the far from irrational suspicion that cultural "globalization," no less than economic globalization, is a mere alibi for world domination by U.S.- and European-based conglomerates (and in particular, the five giant media and communications conglomerates).[16] The proliferating anthologies that can be found on the "World Literature" shelf at the chain bookstores—not merely updates of the perennial standards like *The Norton Anthology of World Masterpieces* (which included Soyinka as one of the first three non-Western authors in its 1985 edition) or Clifton Fadiman's *Lifetime Reading Plan: The Classical Guide to World Literature* (which, in its new edition, now includes two authors

born after 1925: Achebe and García Márquez), but also more markedly contemporary projects like the Prentice Hall series "Timeless Voices, Timeless Themes: World Literature," with its accompanying array of videos, workbooks, and teachers' guides—have been seized upon as evidence of the merely commercial character of the phenomenon, just as the box-set CDs of world music (such as those from Rough Guide, the World Music Network, and Rounder) or the world music compilations from Starbucks are taken as an index of that category's reducibility to mere marketing hype. As Ian Anderson, founding editor of the British journal *Folk Roots,* has said of "world music," a term whose widespread use he traces to a meeting of independent record company executives in the mid-1980s, "it's just a bin in the record store." That is, the term is just a commercial convenience, a device for "rack[ing] unstockable releases," not a name for any particular musical phenomenon or intrinsic musical qualities.[17]

But there is a second and overlapping critique that does perceive certain generic qualities, certain discernible tastes and preferences, albeit repugnant ones, in these "world" forms of cultural production. From this standpoint, world literature, like world music, is not just a marketing niche into which certain formerly market-resistant (read: translated) cultural goods may be profitably inserted; it is an essentially false and touristic product, specially, if not always consciously, made for Euro-American consumption, masquerading as a representative form of indigenous cultural expression. Chinweizu, attacking the Swedish Academy's tastes in African literature, sounds much like the critics of Afropop who mocked the Grammy judges' enthusiasm for *Graceland* earlier the same year. In Africa, wrote Chinweizu, the Nobel can be won only by a writer of "sophisticated literary versions of airport art," a writer who carefully ap-

plies just enough "Africanesque patina and inlays" to his Euro-assimilationist texts to satisfy a "Western tourist taste for exotica."[18] From this vantage, world literature, no less than world music, is a neo-imperial euphemism for what Graham Huggan has termed the "postcolonial exotic."[19] It is the general form of the particular case of the "post-Rushdie, postcolonial novel" of India, which, as Francesca Orsini has argued, is a form of evasion or neglect rather than transcultural contact, a form through which "the West can settle down to contemplate, not India, but its latest reinterpretation of itself."[20]

Finally, there is a third critique to which both world literature and world music have been frequently subjected, along with the system of global prizes that, by consecrating their leading artists, has greatly assisted in constituting the categories themselves. This critique is framed not as a localist objection to the abandonment, under pressure of transnational capital, of cultural particularity, but, on the contrary, as a metropolitan objection to the abandonment, under pressure of "political correctness," of universal aesthetic principles. The charge is that most world literature is valued as such not on the basis of any specifically literary excellence, but because those who control the global status hierarchy (the well-positioned literature professors and book reviewers, and, overlapping with these, the judges and administrators of the major literary prizes) systematically conflate literary value with social value, literary greatness with presumed political heroism, a more multicultural canon with a more democratic or socialistic or egalitarian world. "World literature," from the standpoint of this critique, is all "world" and no "literature." And the same has been said of world music, world cinema, and all the other variants of the phenomenon.

It should be recognized that this ostensibly universalist critique is in fact a long-established form of nationalist and racist resistance to the globalization of cultural prestige. It emerges precisely with the first black winners of European cultural prizes—as when a French critic commenting on Maran's Prix Goncourt sneered that "some people are quite lucky to be black."[21] And it is still discernible today, as when a British novelist complained that if the new sponsors of the Booker Prize extended eligibility to Americans, "black American writers, who only have an oral tradition" would enjoy an unfair "advantage" over the less innovative British authors, who are fettered to Austen and Shakespeare.[22] Nevertheless, this critique of world literature points to a real conflation or category problem that, as mentioned earlier, has long haunted the Swedish Academy and other major institutions of cultural award, and that has become more conspicuous with the intensification of the international superprize scene since the 1980s. The very ambitiousness of these "world" prizes—not only the vastness of their scope, but the romanticism of their rhetoric, the heroism of their designs—though perhaps inevitable when the financial sums involved run to the hundreds of thousands of dollars, makes it even more than normally difficult for them not to favor individuals whose "lifetime achievement" is as manifest in their admirable lives as in their work. Soyinka's championing of freedom of political speech in Nigeria (for which he spent more than two years in solitary confinement) might seem more relevant to the concerns of the Peace Prize judges than of the Academy members, but it unquestionably made him a stronger candidate for first African winner of the world's leading literary prize than he would otherwise have been. As Raoul Granqvist observed, Soyinka was far better known in Sweden as a political dissident than as a poet or playwright.[23] Nadine

Gordimer's strenuous efforts in the struggle against Apartheid likewise contributed to her selection as the African continent's second laureate a few years later. Similarly, the appeal of *Graceland* and Ladysmith Black Mambazo to judges of global music prizes was clearly connected with the rising international movement to end Apartheid and free Nelson Mandela (a movement that enjoyed especially strong support among British and American university students, perhaps the most critical sector of popular-music consumers and tastemakers). The group's official appearance at the celebration of Mandela's Nobel in Oslo, mentioned earlier, might also be seen as a sign of this convergence between aesthetic and humanitarian categories of distinction.

Moreover, where this dovetailing of award categories has traditionally been something of an awkwardness or embarrassment for prize judges and administrators (since it exposes the interdependence and ready convertibility of artistic with political capital), it has, during the recent boom of big-ticket international cultural awards, become far more explicit and unabashed. To take just one example, in 1999 the Lannan Foundation—an organization devoted to literary philanthropy—added a $350,000 Prize for Cultural Freedom to its stable of major awards. Since Lannan was already sponsoring a $250,000 Humanitarian Prize as well as a $200,000 Prize for Lifetime Literary Achievement, and since both of these prizes were already founded in the cause of "cultural freedom" (winners of the literary prize have included Edward Said), the new prize was clearly intended to bring the double set of criteria even more explicitly into play and to honor figures who manage to straddle or fall between the ever more narrowly separated categories. Without joining the opponents of "political correctness" and "literary affirmative action," we can observe that geopolitical con-

siderations do seem to weigh more heavily than artistic ones in the calculations of such prizes' sponsors. J. Patrick Lannan Jr. himself remarked that in some years the Cultural Freedom prize might not be awarded to anyone in the arts at all, but rather to "someone in indigenous populations."[24] Meaning, to judge by the founding language of the prize, someone who, though not an artist, advances "the right of individuals and communities to define and protect valued and diverse ways of life currently threatened by globalization." It is an admirable statement of symbolic mission, but fails to take into account the fact that, precisely by virtue of this sort of award, the Lannan Foundation itself will inevitably be perceived in certain localities as a threatening form of cultural globalization. And while the exact nature and degree of the threat will continue to be debated, the perception itself is well justified. For one profound if little-noted effect of globalization has been the rising power of cultural institutions like Lannan's to select and consecrate a set of cultural heroes from all the localities of the world, installing these as figures of special prominence in the arenas, themselves partly constituted by this very process, of world literature, world music, world cinema, "world culture."[25]

We can think of world literature in its contemporary context, then, as a cultural category produced through institutions and processes and subject to suspicions and critiques similar to those that impinge on world music and other such formations, all of them subsidiary to an emergent idea of world culture as something quite distinct from "all the culture of the world" or again from "the most representative (or most celebrated) culture of each nation-state." What Pascale Casanova has described as a "world republic of letters" that has in effect defined the true field of literary competition for symbolic rewards since before the Industrial Revolution, has of

late become a good deal more global and less international than her own account suggests. If it still operates like the forum of "a literary world cup," to borrow Benedict Anderson's disdainful phrase, the important competitors no longer address one another primarily as national figures staking nationalist cultural claims and possessing symbolic endowments underwritten by their respective nation-states.[26] The game now involves strategies of subnational and extra-national articulation, with success falling to those who manage to take up positions of double and redoubled advantage: positions of local prestige bringing them global prestige of the sort that reaffirms and reinforces their local standing. Just as important, those who have the largest role in officiating and adjudicating these cultural games (by which I do not mean simply the judges of individual awards, but the selectors of judges, the philanthropic overseers or corporate sponsors, and the media that publicize the triumphs and the scandals) do so from an increasingly transnational vantage, less and less dependent on state sponsorship of cultural awards (which has been undergoing a steady worldwide decline since the 1970s) and more and more indifferent to national literatures as such— which, while still discernible, are no longer a decisive consideration. What Goethe claimed, wrongly because prematurely, back in 1827, that "nowadays, national literature doesn't mean much: the age of world literature is beginning," has finally become a supportable statement.

The current state of this global market for literary esteem is suggested by the fate of the curious novel *the bone people*, which the New Zealand writer Keri Hulme published in February 1984 with a tiny nonprofit feminist press in Wellington called Spiral Collective.[27] Over the next few months, the book received a few good, if not very prominent, reviews in the Maori and alternative press and

managed to sell out two 2,000-copy print runs.[28] This was quite a coup for Hulme and the three-woman team that constituted Spiral, since *the bone people* manuscript had made the rounds of the major national publishing houses in the early 1980s, and been flatly rejected everywhere. Hulme was a published poet and short-story writer (winner of the Katherine Mansfield prize for one of her stories), but a first-time novelist, and her novel was a long and somewhat perverse mixture of genres, styles, and languages, sloppily edited and riddled with typographic errors—by no means an obvious winner in the marketplace. As the literary editor at the London *Times* later remarked, "I do not see it going a bomb in station bookstalls."[29]

But this nearly "unpublishable" novel was only just getting started. (Hulme described it as a "monster unleashed.")[30] In June and July of 1984, while Hodder and Stoughton rushed to put out a new edition of 25,000, *the bone people* won two prizes, the New Zealand Book Award for Fiction and the Pegasus Prize for Maori Literature. The first of these is a standard-issue national book-of-the-year prize, founded in 1977 and, along with the older Wattie's Book Award, then the premier annual book prize in New Zealand.[31] The jury for the NZBA was impressed by Hulme's novel, taking its fusion of Anglo ("Pakeha") and indigenous (Maori) elements within a dreamlike narrative of trauma and recovery as a kind of national allegory. They were impressed, as well, by the author's long struggle to get the book published, and by the fact that a small crew of volunteers at Spiral had successfully launched a novel into the national arena. (The narrative of Hulme's rejection letters and of Spiral volunteers working the photocopy machine into the wee hours—another national allegory, perhaps—was prominently recounted in the NZBA press releases.) Hulme, an author of mixed Scottish,

English, and Maori heritage, was heralded as a promising new voice in the relatively small world of New Zealand fiction.

The other prize Hulme received in the early summer of 1984, the Pegasus Prize for Maori Literature, was much more of a novelty. There were already various annual prizes in Maori literature; Hulme herself had won a Maori Trust Fund Prize in the late 1970s. But the Pegasus was the first *global* indigenous-literature prize in New Zealand. Founded in 1977 by the transnational petroleum giant Mobil (now ExxonMobil), the Pegasus revolves among the many countries in which Mobil has subsidiaries. The stated aim of the Pegasus is to promote international, and especially North American, awareness of local literary cultures that have been marginalized by linguistic and/or economic circumstances. Mobil's public-relations office decides which subsidiary is to receive its cultural largesse, and then a board of advisers frames the category of competition and appoints a local literary figure to select a team of judges and orchestrate the selection process. We should note here the various layers or levels of selection. Public-relations officers, themselves of course selected by senior management at Mobil, select a group of literary advisers—drawing from their own house (Gregory Vitiello, editor of the Mobil corporate-image magazine *Pegasus*) but also from the field of legitimate literary production (for example, Paul Engle, an important figure in the institutional history of world literature, inventor of the modern "writers workshop" and founder of the International Writers Project at the University of Iowa—an endeavor which netted him a Nobel Peace Prize nomination). This advisory board then selected Sidney Mead, professor of Maori at Victoria University, to select the jury, whose ultimate decision, though free from direct meddling by Mobil, is nonetheless a product not just of their individual and collective tastes

but of this whole layered process of strategic sifting and sorting. The books that emerge from this process as Pegasus winners, which may be as many as ten years from their original publication date, are translated into English at Mobil's expense, then published in the United States and distributed in North America and Britain by arrangement with Louisiana State University Press.

Of course, Hulme's novel did not need to be translated into English. It did need, however, to be translated, or borne across, from its still quite local or "indigenous" field onto the field of global literature, a task for which the New Zealand Book Award was not at all well suited. Indeed, the long-standing failure of the NZBAs to register anywhere beyond the national literary arena recently prompted Glenn Schaeffer, an American leisure-resort magnate who vacations in New Zealand (and is a former student of Paul Engle's at Iowa), to launch a new superprize through the International Institute of Modern Letters he founded at Wellington University. This prize openly aspires to participate in the global economy of social and symbolic prestige in a way that New Zealand's other book prizes have never done. With an advisory board of global cultural celebrities that has included Salman Rushdie, Oliver Stone, and Jacques Derrida, and boasting a $60,000 value that eclipses the NZBA's $15,000, the first Schaeffer Prize was presented to Catherine Chidgey in 2002 by no less exemplary a figure of world literature than Wole Soyinka, holder of the Schaeffer Chair in Creative Writing at the University of Nevada Las Vegas.

Even this prize, though, conforms in its criteria of eligibility and selection to the traditional national-literature paradigm, and for that reason may struggle in its effort to supersede the NZBA. The Schaeffer is unquestionably a symptom of the trend toward "glocalization" of symbolic economies by transnational cultural in-

stitutions, but it is a less striking case than the Pegasus, which preceded it by a decade and a half. Touching down in New Zealand on just the one occasion in 1984, the Pegasus probably had a greater impact than any prize ever won by a New Zealand novel. Such symbolic effectiveness was possible only because the Pegasus was honoring a literary species—Maori literature—that, despite being written in English, selling briskly, and enjoying acclaim on the national level, could be seen as marginal and endangered (and thus in need of Mobil's transnational symbolic assistance) in ways that New Zealand literature was not. By focusing its apparatus of scrutiny and judgment on a body of literature within or beneath the national literature, Mobil assured that its selection would have more rather than less global resonance.

For one thing, consecrating *the bone people* as a (world-transcendent) work of Maori literature made for controversy of a kind that readily circulates across national borders. While Hulme's receipt of the New Zealand Book Award scarcely raised an eyebrow, her Pegasus Prize drew fire from several quarters, notably from the critic and novelist C. K. Stead of Auckland University, a prizewinning author prestigiously situated on the national literary field. Stead objected to the very classification of *the bone people* as a Maori novel and of Keri Hulme as a Maori novelist, given that she, like her protagonist Kerewin Holmes, was at most one-eighth Maori and had basically been raised and educated as a white Anglophone New Zealander.[32] In the United States, this scandal of racial inauthenticity fit neatly into the emerging discourse of the culture wars, with their increasingly clamorous overtones of white resentment toward symbolic advantages ostensibly accruing to nonwhites. That same summer, for example, a scandal arose over the Rosenthal Foundation Award of the American Academy and Insti-

tute of Arts and Letters. The Rosenthal had been awarded to
"Danny Santiago" for a first novel about Chicano street life in Los
Angeles that turned out to have been written not by a talented
young Chicano writer, as the jury had been led to believe, but by a
well-to-do elderly white man named Daniel James.[33] The resulting
controversy made the front page of the *New York Times* and other
American papers and was still being invoked as an outrage or em-
barrassment a year later when Hulme was touring the United States
to promote the Louisiana edition of her book and to act as an of-
ficial Maori "cultural ambassador" from New Zealand. It was at
this time, too, that *the bone people,* which, on the strength of its
Pegasus Prize, Hodder and Stoughton had now published in Brit-
ain, overcame long odds to win the 1985 Booker Prize.[34] (Hulme
was in Utah when the BBC phoned for a statement.) The British
press, like the American, was already primed to seize on the au-
thor's race as a point of controversy, quoting Stead and others who
had wondered about Hulme's ancestry and questioned the Pegasus'
valuation of the novel as a book deserving of special attention and
reward as a work of "Maori literature." Such challenges fed neatly
into the kind of conservative, arch-nationalist cultural journalism
that flourished during the Thatcher years, as well as conforming,
more narrowly, with what we have seen to be the equally flour-
ishing sport of Booker-bashing. Noting that since 1981 the prize
had gone to writers from India, Australia, South Africa, and now
New Zealand, critics on the right condemned the Booker jury's de-
cision as part of a growing pattern of national self-laceration and
postcolonial political correctness in all matters cultural. (This, de-
spite the fact that the jury that year, chaired by Norman St. John-
Stevas, was, in terms of political affiliation, a relatively conservative
one.) Indeed, it has often been said that *the bone people* was the

most controversial of all the Booker selections—a strong claim given the prize's perennial success at producing literary controversy.

These widely dispersed expressions of resentment concerning the disintegration of the old national literatures, and their symbolic eclipse by various racially defined subliteratures of dubious legitimacy and merit, had a predictably backfiring effect. The "international controversy" over Hulme's status as an indigenous writer simply intensified her rhetoric of Maori self-identification and tightened her solidarity with the established Maori literary community, whose representatives had dominated the Pegasus jury and who did not appreciate having their boundaries policed by the likes of C. K. Stead. As with most awards scandals, this scandal of racial inauthenticity thus largely benefited the author, her novel, and the prizes, bringing to all three a windfall of publicity. The closing of Maori ranks around Hulme has, among other things, deflected any close scrutiny of the Pegasus Prize and of the role such global prizes play in the production of indigenous cultural value. The novel's allegorization of colonial contact through a trauma-and-recovery paradigm centered on familial dysfunction and child abuse, coupled with its unabashedly New Age mysticism, should, I think, be taken neither as representative tendencies of specifically Maori literary culture nor as telltale symptoms of contamination and inauthenticity that expose Hulme's Pakeha roots. They are, rather, signal features of a properly global brand of indigenousness, in this case of a Maoriness that can hold its value as such on the worldwide field of English letters (the field onto which, after all, the Pegasus is supposed to *translate* "indigenous" writing). It is just such universally recognizable signs of indigenousness that prizes celebrate across all the domains of "world culture." The Grammy Award for Best World Music Album, for example, has several times

been won by albums that were officially catalogued (and marketed) as New Age, not as World Music records. Such seemingly category-crossing judgments occur not so much because the New Age movement is a truly global one (though it is scarcely alien to New Zealand) as because New Age, with its recurrence to tropes of "the earth" and "the planet," its conceit of addressing, through various "traditional" holistic practices of self-healing and self-realization, the spiritual dimensions of the world, lends itself with especial ease to universalizations of the particular—and, equally important, to universalisms that can be claimed as and for the particular. In Hulme's case, the more or less familiar late twentieth-century (New Age) universalisms of *the bone people* made it a strong candidate among Maori novels for "world literature" status precisely because they could be taken for world-readable signs of its legitimate Maoriness.

Partly as a consequence of being, still today, the sole winner of a global prize in Maori literature, Hulme is routinely described as the world's "most famous contemporary Maori author."[35] As Chris Bongie has pointed out, the descriptions of Hulme on successive paperback editions of *the bone people* betray a "revealing shift in which her [mixed] European origins get erased" and she becomes "simply a 'Maori writer.'"[36] The novel itself is now firmly established as the one Maori novel in the world literature canon. It is taught as such in contemporary world literature and postcolonial survey classes; it is discussed by journalists and scholars of world literature in articles and at conferences (one bibliography lists more than a hundred articles); most tellingly, perhaps, it remains in print in the United States and the United Kingdom some twenty years after its original publication, while other novels from the same period, including virtually all of the others that won the New Zealand

Book Award, have long since disappeared from the international marketplace.[37] It is not as a New Zealand novel that *the bone people* has become a classic, but, as declared on or inside the cover of every paperback edition since the late 1980s, as a world-certified, globally consecrated Maori novel. The book is in this respect a typical product of world culture: a work of *subnational* literature whose particular (New Age, magical indigenous) form of sub-nationality is the basis of its eligibility for global renown, and whose global renown in turn secures its place on the field of sub-national or indigenous writing. Without the sort of prizes that have been proliferating under the auspices not only of globally conscious philanthropies like the Lannan Foundation but also of multinational corporations like ExxonMobil, novels like Hulme's could still be written and could still find international readerships. But they would not, I think, be recognized and consumed in quite the same way, as works of world literature, nor would they likely hold, in our globalized economy of prestige, positions of such advantage over other works of similar origin and vintage. The case of *the bone people* thus affords us a view not only of the new geocultural relationships that have come to be packed into the term "world culture," but of the extent to which those relationships have been produced and facilitated through the agency of the cultural prize.

APPENDIXES

NOTES

INDEX

The Rise of the Prize

A quick indication of just how rapidly and dramatically cultural prizes have spread over the past hundred years is provided in Figures 14 and 15, representing the fields of cinema and literature.

Cinema

The most notable finding here is that by the end of the twentieth century, the number of film awards distributed each year exceeded the number of full-length films being produced. The annual worldwide production of feature-length films rose from approximately 300 a year in 1900 to more than 3,000 by 1910. While the number has risen and fallen by as much as 50 percent in the years since 1910, there has been no vast expansion. The *International Film Index* lists 3,300 films in 1920 and the same number in 1970, with mostly lower totals in between, and a gradual decline from 1970 to 1990. The *UNESCO Statistical Yearbook,* whose numbers go back only to 1970 but provide a better count of films made outside North America and Europe, shows world production fairly steady at about 3,500–4,300 feature-length films since the mid-1970s, with gains in some countries (notably India, China, Hong Kong, the Philippines, and the United States) offset by erosion of many smaller national film industries (such as those in Japan, Korea, and Pakistan). Movie prizes, meanwhile, have been rising stratospherically, driven in large part by the spread of film festivals, several dozens of which have emerged just in the past five years,

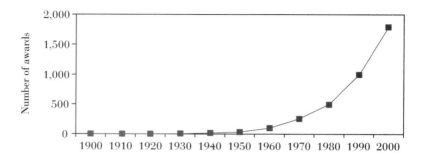

14. The rise of the prize in cinema: number of film awards per 1,000 films produced, worldwide, 1900–2000. There are now more film prizes awarded each year than there are feature films produced.

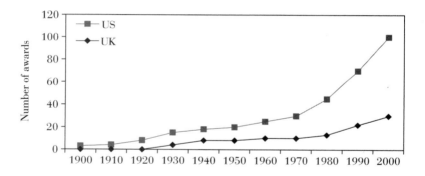

15. The rise of the prize in literature: number of literary awards per 1,000 new titles published (fiction, poetry, drama) in the United States and Britain, 1900–2000. The ratio of prizes to new titles has risen tenfold since the 1920s.

and by the tremendous internal expansion of existing festivals and awards programs. (The Academy Awards now involve presentation of 37 different prizes, and more than twice that many are presented at the Venice International Film Festival.) My random sample of 50 of the roughly 900 festival and award programs listed in the Internet Movie Database suggests a current average of nine prizes per

event (based on press releases or other official event literature from the most recent year, and not on the IMDB itself, which tends to undercount individual prizes). Assuming that the actual number of such events has now reached at least 1,000, we can say with some confidence that the number of movie prizes presented each year is somewhere in the neighborhood of 9,000, or more than double the number of full-length movies produced. Needless to say, some of the prizes are awarded to short films and other categories that fall outside the production figures we are using. But it remains clear that movie prizes are proliferating quite independently of any expansion in cinematic production—or, indeed, of the cinema audience, which has been shrinking for two decades.

Literature

The proliferation of literary prizes, though somewhat less dramatic, has also outpaced by a wide margin the growth in literary publishing. Because the international data, both on book publishing (see the entry in Altbach and Hoshino cited below), and, especially, on literary prizes, tend to be scarce or unreliable, I have restricted my graph to Britain and the United States. The latter has only recently surpassed Britain as the world's leading publisher of new books, and in the combined categories of adult fiction, poetry, and drama (the first of these accounting for roughly 90 percent of the total), the output of the two countries has been comparable since the British fiction market began its resurgence in the early 1980s. Since then, new titles in Britain have doubled, from about 3,650 in 1981 to about 7,000 at the turn of the century (with at least half again that many new editions and reissues of older titles, which accounts for the higher totals that typically appear in the scholarship on book publishing). This latter figure represents a roughly threefold

expansion since the prewar peak of 2,400 in 1937, and a fivefold expansion from the wartime low of 1,350 in 1943. Numbers for the United States are significantly lower in the prewar years, but generally higher in the third quarter of the century. Since 1975, the United States has tended to publish 10–30 percent more new fiction titles than Britain, with peak years in 1996 and 2000 (more than 9,000 new titles, or 13,000 including new editions). There has also been a sharp rise in U.S. production of adult fiction titles since 2001, though that falls outside the boundaries of Figure 15.

At the time of the prewar boom in literary publishing, there were no more than a half-dozen significant British literary awards (Bessie Graham lists five in the 1935 edition of *Famous Literary Prizes and Their Winners*)—perhaps two or three per thousand new titles. That ratio climbed during World War II, more as a result of the decline of the publishing industry than the rise of the awards industry. Since the war, however, the spread of awards has consistently outpaced the resurgence in literary publishing. By 1981, new fiction and poetry titles had risen to 3,700, about half again as many as in 1937, but the number of significant literary awards had expanded roughly tenfold, to more than 50. By 1988 we find 90 prizes, awarded by 60 organizations, listed in Strachan's *Prizewinning Literature,* and a combination of the sources cited below suggests that that number had more than doubled by the year 2000. These are rather conservative figures; people in the publishing and bookselling business have estimated that the actual total is closer to 400.

On the U.S. side, we find the number of literary awards (excluding Canadian) listed in Bowker's series *Famous Literary Prizes and*

Their Winners and its successor, *Literary and Library Prizes,* climbing from 21 in 1929 and 48 in 1935 to 232 in 1959, 310 in 1964, and 367 in 1976. The first seven editions of the PEN *Grants and Awards Available to American Writers* show comparable numbers for the period 1969–1976 (though the PEN and Bowker lists are not identical, and could be combined to produce higher totals). From 1976 to 1996, the PEN listings double to about 700, and then begin a somewhat steeper rise to about 1,100 at the end of the century. As with the movie awards, many of these literary awards are not in the categories of book production from which I have drawn my data. Some are in journalism or travel writing, for example. On the other hand, there is significant undercounting of every category of literary award in all these reference books, British and American. This is owing partly to the difficulties of compiling exhaustive lists of this kind (my own research has turned up many dozens of prizes which are not listed in any reference book), and it is also partly by design. The Bowker editors warn that they have omitted "prizes which are little known or of strictly local importance"—but of course a great many prizes, especially in their early years, differentiate themselves precisely by emphasizing their "strictly local importance"—that is, their value to a minor or marginal community typically neglected by the dominant award institutions. The PEN editors note that they have for the most part restricted their recent editions to awards "that offer a cash stipend of $500 or more," again assuring that large numbers of prizes are simply omitted. The vast array of literary prizes awarded by academic institutions, either to students or according to other more or less internal criteria of eligibility, has been excluded from every list. All our data could thus be subjected to further refinement, but there is no question

that, on balance, the graphs in Figures 14 and 15 capture a genuine and quite remarkable statistical trend, and one that could be generalized across the other fields of art and entertainment.

Sources: Alan Goble, ed., *International Film Index on CD-ROM* (London: Bowker-Saur, 1996); 1999 *UNESCO Statistical Yearbook;* Internet Movie Database (IMDB) Awards and Festivals Browser; "International Book Production Statistics" in Philip G. Altbach and Edith S. Hoshino, eds., *International Book Publishing: An Encyclopedia* (New York: Garland, 1995), 163–186; *Bowker's American Book Publishing Record* (New Providence, N.J.: Bowker, various years); Whitaker Bibliographic Information (www.whitaker.co.uk); "The UK Book Industry in Statistics" and "New and Revised Titles 1996–2002," Publisher's Association (www.publishers.org.uk); Ian Norrie, ed., *Mumby's Publishing and Bookselling in the Twentieth Century,* 6th ed. (London: Bell and Hyman, 1982); Anne Strachan, *Prizewinning Literature: UK Literary Award Winners* (London: Library Association, 1989); Richard Todd, *Consuming Fictions: The Booker Prize and Fiction in Britain Today* (London: Bloomsbury, 1996); *Famous Literary Prizes and Their Winners,* 1st and 2nd editions (New York: Bowker, 1929, 1935); *Literary and Library Prizes,* 4th, 5th, 6th, and 9th editions (New York: Bowker, 1946, 1959, 1967, 1976); *Grants and Awards Available to American Writers,* 9th–23rd editions (New York: PEN American Center, 1969–2003); *Awards, Honors and Prizes,* 1st–20th editions (Detroit: Gale Research, 1969–2002).

APPENDIX B

Prizes and Commerce

Part of the standard wisdom about cultural prizes is that they have furthered the dilution of cultural or aesthetic value by commercial value; they have helped to bring about an ever closer alignment between the works recognized as "best" or "most important" and those which are simply the bestselling or most popular. "The grip of the holders of [economic] power over the instruments . . . of consecration," declares Pierre Bourdieu in *The Rules of Art,* "has undoubtedly never been as wide and as deep as it is today—and the boundary has never been as blurred between the experimental work and the *bestseller*" (347). One aim of this book has been to insist on a more complex history of the relationships between the different forms of capital, the different markets, and the different hierarchies of value whose interactivity, effected in part through the agency of prizes, enables cultural production. The rise of the prize has transformed these relationships, but not in a way that may be adequately described in terms of a progressive commercialization or commodification of art, a consecration of the bestseller.

Figures 16 and 17 suggest some of this complexity. With respect to American literature prizes, the data clearly diverge from the received view of awards as essentially commercial instruments in disguise, effecting a gradual penetration and domination of literary hierarchies by money. From the 1920s through the 1960s, roughly half of all Pulitzer winners were drawn from the top-ten bestsellers of the previous and/or current year. Since then, only one of more

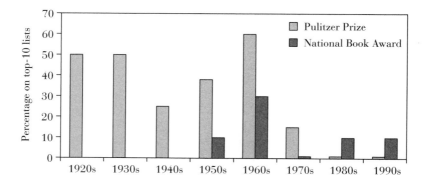

16. Literary prizes versus bestsellerdom: percentage of winners of U.S. fiction
 prizes—Pulitzers and National Book Awards—that have appeared on top-ten
 bestseller lists, 1920s–1990s. Contrary to conventional wisdom, the likeli-
 hood of a major American book award going to a bestseller has diminished
 over the past half-century.

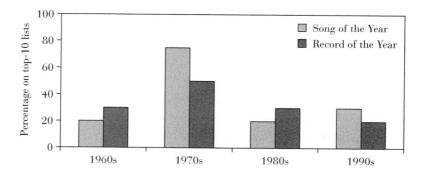

17. Music awards versus bestsellerdom: percentage of Grammy winners that
 have appeared on annual top-ten bestseller lists, 1960s–1990s. Even the
 Grammys, widely disdained for their commercialism, have in fact become
 more independent of the record charts since the early 1970s.

than thirty winners has come from this most commercially success-
ful sector of published fiction. The picture is not much different for
the National Book Awards, founded in 1950. The NBA in fiction
never correlated as well with the market as the pre-1970s Pulitzer,
and in the last three decades of the twentieth century only two win-
ners (*Sophie's Choice*, by William Styron, and *Cold Mountain*, by
Charles Frazier) were among their year's top-ten sellers.

The overall trend is even more dramatic than this quick sketch
indicates. Between 1925 and 1940, more than a third of the annual
number-one bestsellers ended up winning the Pulitzer Prize. Since
1980, when the National Book Critics Circle Award joined the Pu-
litzer and the NBA as a premier American fiction prize, not a sin-
gle number-one bestseller has ever won any of these major awards.
The "blockbusters" have come to dominate the top-ten lists, while
prizes have supported a more and more distinct hierarchy of sym-
bolic value, with less and less of the mixing or confusion of catego-
ries that Bourdieu and many others have decried. This distinct hier-
archy of consecrated authors and works is, as I hope to have
shown, by no means independent of commerce; for one thing,
strenuous efforts have been made to leverage prizes, via journalistic
attention, in the marketplace—and even to position the prize as a
sort of brand deserving of consumer loyalty. But the fact remains
that, in advancing its own (mixed, complex, "impure") interests,
during precisely the period of its most explosive growth and widest
impact (the three decades since 1972), the awards industry has
helped to shape a scale of value ever further removed from the scale
of bestsellerdom.

At the other end of the art–entertainment spectrum from liter-
ary fiction, we can consider the top Grammy awards for popular
music. The Grammys are widely reputed to be among the most per-

fectly (and embarrassingly) commercial of all cultural honors, operating in a field—popular music—where distinctions between specific legitimacy (credibility among "serious" listeners and critics) and mere popularity seem almost laughably difficult to maintain. Especially so in recent decades, when "alternative" or independent artists have realized phenomenal commercial success. (One thinks of Nirvana in the United States, Blur and Oasis in Britain, as marking a turning point in this respect; Alanis Morissette's chart-dominating *Jagged Little Pill* solidified the trend in 1995.) Standard wisdom would suggest an ever more perfect correlation between the annual top Grammy winners and the annual top-ten lists of bestselling records. Yet we find that, except for a brief period in the early to mid-1970s, the likelihood of a Grammy Record or Album of the Year finishing among the top-ten bestsellers is only about 20 or 30 percent. There has been no trend over the past half-century toward closer alignment of prestige (as produced and indexed by the Grammys) and marketability or commercial success. Moreover, we may assume that some of the commercial success these Grammy winners *have* enjoyed is owing to the boost the award gives them in the marketplace. As in the case of book prizes, the size of that boost is notoriously difficult to judge; but the data presented here give no reason to suppose that, even in the field of popular music, prizes are tending more to facilitate an advancement of commercial interests at the expense of symbolic ones than to secure greater commercial support for work that has acquired extracommercial, symbolic value. Indeed, I have not found in any of my research evidence of a general complicity of prizes in a trend toward increasing consecration of the most saleable work.

Sources: Alice Payne Hackett, *70 Years of Best Sellers, 1895–1965* (New York: Bowker, 1967); Michael Korda, *Making the List:*

A Cultural History of the American Bestseller, 1900–1999 (New York: Barnes and Noble Books, 2001); National Book Foundation website (www.nationalbook.org/nba.html); *Publishers Weekly;* Pulitzer Prizes online archive (www.pulitzer.org/Archive/archive.html); Grammy website (www.grammy.com); Thomas O'Neil, *The Grammys: The Ultimate Unofficial Guide to Music's Highest Honor, a Variety Book* (New York: Perigee, 1999); Joel Whitburn, *The Billboard Book of Top 40 Albums,* revised and enlarged 3rd ed. (New York: Billboard Books, 1995); Joel Whitburn, *The Billboard Book of Top 40 Hits,* revised and expanded 7th ed. (New York: Billboard Books, 2000); Joel Whitburn, *The Billboard Top Ten Singles Charts, 1955–2000* (Menomonee Falls, Wisc.: Record Research, 2001).

Winner Take All: Six Lists

> *In broad terms, . . . the situation we have been seeing in other winner-take-all markets largely resembles the one we've been seeing in professional sports.*
> —Robert H. Frank and Philip J. Cook, *The Winner-Take-All Society* (1966)

The common competitive paradigm under which the modern cultural awards industry emerges along with international sporting events in the later nineteenth century (see Chapter 11), the dependency of many prizes on journalistic visibility and hence on the logic of celebrity (Chapters 4 and 9), the tendency of prizes over time to drift toward the center of their respective fields (Chapter 3), and the fact that prizes often function as a credential or mark of eligibility for other prizes (Chapter 6) all contribute to the intensification of the winner-take-all character of the symbolic economy in arts and entertainment. The proliferation of prizes has meant that relatively more artists and authors, and relatively more works, can today claim the distinction of a prize. But offsetting this apparent democratic dispersal of symbolic cultural wealth—often lamented as a "leveling" of aesthetic standards or a "Miss Congeniality syndrome"—has been the even more pronounced tendency for huge numbers of prizes to accrue to a handful of big winners. Here are a few examples.

1. Music: *Prizes and Awards Won by Michael Jackson, 1970–2003*

1 American Cinema Award

23 American Music Awards (including Artist of the Century)

2 American Presidential Awards (Reagan and Bush I)

2 Australia Music Industry Awards

1 Bambi "Pop Artist of the Millennium" Award

28 Billboard Awards

8 Billboard Video Awards

2 Black Entertainment Television Award

4 Black Gold Awards

2 BMI Awards

1 BMI Urban Award

1 Bob Fosse Award

1 Bollywood Award

17 Bravo Awards

3 BRIT Awards (including Artist of a Generation)

1 British Academy of Music Award

2 British Phonographic Industry Awards

1 British Television Industry Award

2 Cable Ace Awards

4 Canadian Black Music Awards

13 Cashbox Awards

3 Children's Choice Awards

1 Congressional Commendation

1 Crystal Globe Award

3 Dutch Grammy Awards

2 Dutch Music Factory Awards

1 Ebony Award

2 Emmy Awards

1 Entertainment Tonight Award (Most Important Entertainer of the Decade)

1 European MTV Music Award

2 *Forbes* magazine Entertainer of the Year Awards

1 French Film Award

2 Friday Night Video Awards

1 Genesis Award (the Doris Day Award for an Animal-Sensitive Work)

1 Golden Globe Award

18 Grammy Awards (including Living Legend)

1 Greek Record of the Year Award

1 *Guinness Book of World Records* Lifetime Achievement Award

2 Hong Kong Hit Radio Awards

1 Irish Music Award

1 Italy Artist of the Year Award

3 Japan Music Awards

2 *Live!* magazine Awards

1 Magical Life Award

1 MTV Movie Award

9 MTV Video Awards (and one MTV Award renamed the Michael Jackson Award)

8 NAACP Image Awards

1 NABOB Lifetime Achievement Award

1 National Association of Recording Merchandisers Award

1 National Urban Coalition Award

1 NRJ Music Award (France)

5 People's Choice Awards

1 *Pop Rock* magazine Award

2 Rock and Roll Hall of Fame inductions

1 Rockbjörnen Award

9 *Rolling Stone* magazine Awards

2 Smash Hits Awards

8 Soul Train Awards (and one Soul Train Award renamed the Michael Jackson Award)

1 Spanish Music Award

2 TVZ Video Awards (Brazil)

1 United Negro College Fund Award

1 *Vanity Fair* "Artist of the Decade" Award

1 Video Software Dealers Association Award

1 World Arts Award

12 World Music Awards

Total awards: 240. This is only a partial list, omitting many foreign prizes.

2. Cinema (Director): *Prizes and Awards Won by Steven Spielberg, 1970–2004*

1 Academy Award for Best Picture

2 Academy Awards for Best Director

5 Academy of Science Fiction, Fantasy, and Horror Films Awards

1 Amanda Award (Norway)

1 American Cinema Editors Golden Eddie Award

1 American Cinematheque Award

1 American Film Institute Lifetime Achievement Award

1 American Movie Award, Best Director

1 American Society of Cinematographers Board of Governors Award

1 Avioraz Fantastic Film Festival Grand Prize

2 BAFTA Awards

1 BAFTA/Britannia Award

3 Blue Ribbon Awards (Japan)

3 Boston Society of Film Critics Awards

2 Broadcast Film Critics Association Awards

1 Cannes Film Festival Award, Best Screenplay

1 Chicago Film Critics Associate Award

2 Czech Lion Awards

1 Dallas–Fort Worth Film Critics Award

3 David di Donatello Awards (Italy)

5 Daytime Emmy Awards

3 Directors Guild of America Awards

1 Directors Guild of America Lifetime Achievement Award

3 Emmy Awards

2 Empire Awards (U.K.)

1 Fotogramas de Plata Award (Spain)

1 Giffoni Film Festival Award (Italy)

2 Golden Globe Awards

1 Hasty Pudding Man of the Year Award

1 Hochi Film Award (Japan)

1 Honorary César Award (France)

1 Italian National Syndicate of Film Journalists Award

3 Kinema Junpo Awards (Japan)

1 Las Vegas Film Critics Society Award

1 London Critics Circle Film Award

2 Los Angeles Film Critics Association Awards

3 Mainichi Readers Choice Awards (Japan)

1 NAACP Image Award

1 National Board of Review Best Director Award

1 National Board of Review Billy Wilder Award

2 National Society of Film Critics Awards

1 Online Film Critics Society Award

6 Producers Guild of America Golden Laurel Awards

1 Rembrandt Award

1 Retirement Research Foundation Award

3 ShoWest Awards

1 Southeastern Film Critics Association Award

1 Thalberg Memorial Award

1 Toronto Film Critics Association Award

2 Venice Film Festival Awards

1 Walk of Fame Star

1 Young Artist Jackie Coogan Award

Total awards: 90, with more than 150 nominations. This compares to 27 awards won by John Ford, 21 awards won by Alfred Hitchcock, and 16 awards won by Charlie Chaplin.

3. **Cinema (Single Film):** *Prizes and Awards Won by* **Lord of the Rings: Return of the King** *(2003)*

11 Academy Awards

1 American Boy Scouts Good Scout Humanitarian Award

1 American Cinema Editors nomination

1 American Society of Composers, Authors, and Publishers Award

1 Art Directors Guild

5 BAFTA Awards

4 BFCA Awards

3 Chicago Film Critics Association Awards

1 Costume Designers Guild Award

3 Dallas–Forth Worth Film Critics Association Awards

1 Directors Guild of America Award

3 Empire Awards

3 Florida Film Critics Circle Awards

1 Gabon National Honor of Merit Award

4 Golden Globe Awards

1 Golden Satellite Award

1 Hollywood Makeup Artist and Hair Stylist Guild Award

2 Kansas City Film Critics Circle Award

8 Las Vegas Film Critics Society Sierra Awards

2 Los Angeles Film Critics Association Awards

1 National Board of Review Award

1 New York Film Critics Circle Award

9 Online Film Critics Society Awards

1 Producers Guild of America Golden Laurel Award

1 San Diego Film Critics Society Award

1 San Francisco Film Critics Circle Award

8 Saturn Awards

1 Screen Actors Guild Award

2 Seattle Film Critics Awards

2 Southwestern Film Critics Association Awards

1 Toronto Film Critics Association Award

1 USC Scriptor Award

1 Vancouver Film Critics Circle Award

4 Visual Effects Society Awards

Total awards: 79, with 117 nominations. The film will undoubtedly add to this total, but it has already surpassed the record 78 awards won by *Titanic* (1987). These numbers compare with the 10 awards won by *Gone with the Wind* (1939) and 3 by *Casablanca* (1942).

4. Architecture: *Awards Won by Frank Gehry, 1965–2004*

American Academy of Arts and Letters Gold Medal
American Institute of Architects Gold Medal
Americans for the Arts Lifetime Achievement Award
Arnold W. Brunner Memorial Prize
Companion, Order of Canada
Dorothy and Lillian Gish Award
Friedrich Kiesler Prize
Lotos Medal of Merit
National Academy of Design Award
Praemium Imperiale Prize
Pritzker Architecture Prize
Progressive Architecture Design Award
Royal Academy of the Arts, Honorary Academician
Royal Institute of British Architects Gold Medal
Wolf Prize
100 national or regional American Institute of Architects
 Awards for specific buildings
15 honorary doctoral degrees

Total awards: 130, plus many additional honors such as elections to royal and national academies.

5. Literature (poetry): *Awards Won by John Ashbery, 1960–2004*

Academia Nazionale dei Lincei, Antonio Feltrinelli International
 Prize for Poetry (Italy)
Academy of American Poets chancellorship (elected)
Academy of American Poets Fellowship

Academy of American Poets Wallace Stevens Award

American Academy and Institute of Arts and Letters member-
ship (elected)

American Academy of Achievement Golden Plate Award

American Academy of Arts and Letters Gold Medal for Poetry

American Academy of Arts and Sciences membership (elected)

2 *American Poetry Review* Jerome J. Shestack Poetry Awards

Bard College Charles Flint Kellogg Award in Art and Letters

Bavarian Academy of Fine Arts Horst Bienek Prize for Poetry

Bingham Poetry Prize

Bollingen Prize

Brandeis University's Creative Arts Medal for Poetry

Chevalier de l'Ordre des Arts et Lettres, French Ministry of Edu-
cation and Culture

Columbia County (New York) Council on the Arts Special Cita-
tion for Literature

Common Wealth Award for Literature

English Speaking Union Award

Fulbright Fellowship

Grand Prix des Biennales Internationales de Poésie (Belgium)

2 Guggenheim fellowships

Harvard University Signet Society Medal for Achievement in the
Arts

2 Ingram Merrill Foundation grants

MacArthur Foundation Award

Modern Poetry Association Frank O'Hara Prize

National Book Award

National Book Critics Circle Award

2 National Endowment for the Arts publication awards

National Endowment for the Arts Composer/Librettist grant

Nation magazine's Lenore Marshall Award

New York City Mayor's Award of Honour for Arts and Culture

New York State Poet Laureateship

New York State Writers Institute Walt Whitman Citation of
Merit

Officier, Légion d'Honneur of the Republic of France

Poetry magazine Harriet Monroe Poetry Award

Poetry magazine Levinson Prize

Poetry magazine Ruth Lilly Poetry Prize

Poetry Society of America Robert Frost Medal

Poetry Society of America Shelley Memorial Award

Pulitzer Prize for Poetry

Rockefeller Foundation grant for playwriting

Silver Medal of the City of Paris

Union League Civic and Arts Foundation Prize

Yale University Wallace Stevens Fellowship

Yale Younger Poets Series winner

Total awards: 45. There may be other poets who have won more awards than this, but I have been able to tabulate only about 30 awards for Seamus Heaney (who has, however, won the Nobel) and 25 for Adrienne Rich (who has won both the Tanning Prize and the Lannan Lifetime Achievement Award, neither of which has gone to Ashbery). The Ashbery list is described by its compilers as "partial."

6. Literature (prose fiction): *Awards won by John Updike, 1950–2004*

Academy of Arts and Letters Howells Medal

Academy of Arts and Letters membership (elected)

Ambassador Award of the English Speaking Union

American Book Award

Brandeis University Lifetime Achievement Award

Caldecott Award

Campion Award for contributions as a Christian Writer

Commandeur de l'Ordre des Arts et des Lettres (France)

Common Wealth Award

Conch Republic Prize for Literature

Edward MacDowell Medal for Literature

Elmer Holmes Bobst Award for Fiction

Enoch Pratt Society Award for Lifetime Literary Achievement

F. Scott Fitzgerald Award

Fulbright Foundation, Lincoln Lectureship

Guggenheim Fellowship

Harvard University Arts First Medal

Kutztown University Foundation Director's Award

Library of Congress, Honorary Consultant in American Letters

Lincoln Literary Award

Lotus Club Award of Merit

National Arts Club Medal of Honor

National Book Award

3 National Book Critics Circle Awards (2 for fiction, 1 for criticism)

National Book Foundation Medal for Distinguished Contribution

National Institute of Arts and Letters membership (youngest writer ever elected)

National Institute of Arts and Letters Rosenthal Award

National Medal of Arts

National Medal for the Humanities

New England Pell Award

Penn/Faulkner Award
Pennsylvania Distinguished Artist Award
Premio Scanno Prize (Italy)
2 Pulitzer Prizes for Fiction
Signet Society Medal for Achievement in the Arts
Thomas Cooper Library Medal

Total awards: 39, plus many other honors such as six honorary doctoral degrees and two appearances on the cover of *Time* magazine. Lists of prizes won by other contemporary novelists show 31 awards for Philip Roth (according to the Philip Roth Society), 26 for Peter Carey and 21 for Salman Rushdie (as tabulated by the British Council), and 23 for Toni Morrison (combined data from fansites and published sources). All these lists exclude honorary degrees and minor honors, and could no doubt be expanded.

Sources: Internet Movie Database (imdb.com); the Michael Jackson Fan Club (www.mjfanclub.net); "A Note on John Ashbery," *John Ashbery in Conversations with Mark Ford* (London: Between the Lines, 2003); the British Council's Contemporary Writers website (www.contemporarywriters.com); Centaurian website (userpages .prexar.com/joyerkes); Toni Morrison chronology (enotes.com/ Morrison); Philip Roth Society (orgs.tamu-commerce.edu/rothsoc/ bio.htm).

Notes

Introduction

1. Both art and sport are manifestations of the "play element" from which, according to Huizinga, all cultural activity derives. Johan Huizinga, *Homo Ludens: A Study of the Play Element in Culture* (Boston: Beacon Press, 1955; orig. pub. 1944).

2. From John Berger, speech on accepting the Booker Prize for Fiction, delivered at the Café Royal in London, November 1972. Reprinted in Berger, *Selected Essays of John Berger*, ed. Geoff Dyer (New York: Vintage, 2003), 253–257.

3. J. W. Von Goethe, letter to Carlyle, 1827, cited in Pascale Casanova, *La République Mondiale des Lettres* (Paris: Seuil, 1999), 27.

4. Pierre Bourdieu, *Outline of a Theory of Practice,* trans. Richard Nice (Cambridge: Cambridge University Press, 1977), 178.

5. Jacques Derrida, *Given Time, I: Counterfeit Money,* trans. Peggy Kamuf (Chicago: University of Chicago Press, 1992), 76.

6. The discourse of "nonproductive expenditure" or "absolute loss" is given its clearest statement in Bataille's 1933 essay "The Notion of Expenditure," in Bataille, *Visions of Excess: Selected Writings, 1927–1939,* trans. Allan Stoekl, with Carl R. Lovitt and Donald M. Leslie Jr. (Minneapolis: University of Minnesota Press, 1981). As Barbara Herrnstein Smith has argued, Bataille in fact is not so much refuting or even refusing economic thought as he is privileging certain symbolic values (in particular, the "glory" that attaches to extreme acts of "nonproductive expenditure") over the narrowly utilitarian and ultimately monetary values of "bourgeois" society. He is as concerned to "balance the accounts" as the bourgeois rationalists he despises, but he does so with reference to a precisely inverted or antibourgeois scale of values. In this respect, his theory of expenditure is far more politically as well as conceptually consonant with Bourdieu's sociology of art than is generally recognized. See Barbara

Herrnstein Smith, *Contingencies of Value: Alternative Perspectives for Critical Theory* (Cambridge, Mass.: Harvard University Press, 1988), 134–144.

7. Huizinga, *Homo Ludens,* 51.

8. I do not attempt here or elsewhere to provide a thorough overview of Bourdieu's system of thought. Good introductions include Loïc Wacquant, "The Structure and Logic of Bourdieu's Sociology," in Bourdieu and Wacquant, eds., *An Invitation to Reflexive Sociology* (Chicago: University of Chicago Press, 1992), 1–59; Rogers Brubaker, "Rethinking Classical Theory: The Sociological Vision of Pierre Bourdieu," *Theory and Society,* 14 (1985): 745–775; John B. Thompson, "Editor's Introduction," in Bourdieu, *Language and Symbolic Power* (Cambridge, Mass.: Harvard University Press, 1991), 1–34; and Paul DiMaggio, "Review Essay on Pierre Bourdieu," *American Journal of Sociology,* 84 (May 1979): 1460–74.

9. Bourdieu himself acknowledges what he calls a "deliberate and provisional reductionism" in his method, which he defends on the basis that it enables the sociologist to "import the materialist mode of questioning into the cultural sphere from which it was expelled, historically, when the modern view of art was invented" (*Invitation to Reflexive Sociology,* 116).

10. In addition to all the new scholarship in the history of the economics of culture, I refer here to the work that emerged in the late 1980s and early 1990s and that has been labeled the "New Economic Sociology." While it focused on the sociological dimensions or "social embeddedness" of the money economy, rather than on the economic dimensions of the cultural field, this work has nevertheless been useful to me as a set of sociological challenges to neoclassical economics and a source of insights into the mutual convertibility of different forms of capital. Good overviews of the issues involved in the New Economic Sociology are Sharon Zukin and Paul DiMaggio, eds., *Structures of Capital: The Social Organization of the Economy* (Cambridge: Cambridge University Press, 1990); Richard Swedberg, ed., *Economics and Sociology: Redefining Their Boundaries* (Princeton: Princeton University Press, 1990); and Roger Friedland and A. F. Robertson, eds., *Beyond the Marketplace: Rethinking Economy and Society* (New York: Aldine de Gruyter, 1990). In this last volume, see especially the essays by Paul DiMaggio ("Cultural Aspects of Economic Action and Organization," 113–136) and Mark

Granovetter ("Economic Action and Social Structure: The Problem of Embeddedness," 89–112).

11. Jeremiads against the commercialization of culture are as old as the capitalist markets themselves; they emerged at the moment when works of art began to depend less on the ancient system of patronage than on their successful circulation as commodities. But the sort of critique whose object is the specifically American apparatus of cultural production and marketing that began to take shape in the later nineteenth century, and that today is seen as defining the terms of a global economy of cultural goods, was not given its classic formulations until 1944, when Max Horkheimer and Theodor W. Adorno published their essay "The Culture Industry: Enlightenment as Mass Deception" (in *Dialectic of Enlightenment,* trans. John Cumming [New York: Continuum, 1989], 120–167), and the late 1950s and early 1960s, when Dwight Macdonald and his fellow New York intellectuals launched their attacks on "middlebrow" culture (or "midcult"). (Macdonald's essay "Masscult and Midcult" appeared in *Partisan Review* in 1960 and is reprinted in his collection *Against the American Grain* [New York: Random House, 1962].) Since the late 1970s, the field of cultural studies has offered far too many rejections, reformulations, and refinements of this commodification narrative to summarize here. A sense of the current range of positions can be drawn from the work of Tyler Cowen and David Harvey. In Cowen we find the unqualified defense of free-market capitalism as the means of democratizing culture. In Harvey we see the persistence of Frankfurt-style suspicions regarding capitalism's need to maximize the efficiency and profitability of cultural production, though it is also now acknowledged that global expansion of certain markets is opening some new opportunities for democratization through cultural practice. See Tyler Cowen, *In Praise of Commercial Culture* (Cambridge, Mass.: Harvard University Press, 1998); and David Harvey, "The Art of Rent: Globalisation, Monopoly, and the Commodification of Culture," in Harvey, *Spaces of Capital: Towards a Critical Geography* (New York: Routledge, 2001), 394–411.

1. Prize Frenzy

1. Gore Vidal and Peter Porter quoted in Karen MacGregor, "Traumas, Triumphs," *Times Higher Educational Supplement,* 3 November 1989, 14. "One of only two fiction writers present": Anonymous, "Success and the Other Author," *Times* (London), 14 July 1986, 12.

2. Lewis Carroll, *Alice's Adventures in Wonderland*, 30th ed. (Pittsburgh: Project Gutenberg, 1994), ch. 3; quoted in this context, for example, in Christopher Hitchens, "These Glittering Prizes," *Vanity Fair*, 56 (January 1993): 20.

3. David Segal, "Heavy Medals: Journalism Awards," *Washington Monthly*, 25, no. 3 (March 1993): 12.

4. Greg Dawson, "Last Thing TV Needs Is Another Award Show," *Orlando Sentinel Tribune*, 11 June 1992, E1.

5. Domestic statistics are drawn from the print edition of U.S. Census Bureau, *Statistical Abstract of the United States* (1998), and from the historical statistical abstracts available from the Census Bureau website at www.census.gov; figures concerning book expenditures are found in the "Communications and Information Technology" tables. Global data are from Angus Maddison, *The World Economy: A Millennial Perspective* (Paris: Organization for Economic Cooperation and Development, 2000).

6. Valerie J. Webster, ed., *Awards, Honors, and Prizes*, 22nd ed. (Farmington Hills, Mich.: Gale Group, 2004).

7. Specifics are available at www.icda.org. Larry Tise, the ICDA's founder and chairman, has acknowledged in conversation that the actual number of prizes in the world is "many times larger" than the 26,400 that the ICDA was able to take into consideration.

8. Mary B. W. Tabor, "A Poet Takes the Long View, Ninety Years Long," *New York Times*, 30 November 1995, C13.

9. Anonymous column in the Business pages (C7), titled "Business People," *Buffalo News*, 31 May 1995.

10. The ESPYs ceremony, founded in 1993, and usually hosted by one of the regular entertainment-award hosts such as Dennis Miller or Samuel L. Jackson, marks the increasingly blurred boundary between art and sports in other ways as well. In some years, for example, the ESPYs have included an award for Outstanding Performance by an Athlete in Entertainment. The red-carpet pre-ESPYs show is closely modeled on the pre-Oscars shows, and the celebrities in attendance include major film and television stars.

2. Precursors of the Modern Cultural Prize

1. Early press coverage of the awards is discussed in Susan Quinn, *Madame Curie: A Life* (New York: Simon and Schuster, 1995), 197–199.

2. The first Pulitzers were not awarded until 1917, but a rough scheme

for the prizes is sketched into Pulitzer's planned benefaction for a journalism school at Columbia University, which he described in a memo of August 1902. John Hohenberg, *The Pulitzer Prizes: A History of the Awards in Books, Drama, Music, and Journalism, Based on the Private Files over Six Decades* (New York: Columbia University Press, 1974), 10–11.

3. By the nineteenth century, and particularly in England, the field of architecture was quite dependent on competitions, which constituted the very system of its organization as a *professional* field. But these must be distinguished from actual prizes, which remained quite rare until the mid-twentieth century. The architecture competition is a contract rather than a gift, more like an audition than an award. It is essentially a way of regulating employment practices. See Joan Bassin, "The Development of the Competition System," in Bassin, *Architectural Competitions in Nineteenth-Century England* (Ann Arbor: UMI Research Press, 1984), 1–17.

4. A. E. Haigh, *The Attic Theatre: A Description of the Stage and Theatre of the Athenians, and of the Dramatic Performances at Athens,* 3rd ed. (Oxford: Clarendon Press, 1907), 2. A somewhat more recent scholarly study of the early Athenian festivals, which traces the rise of the so-called City Dionysia to its dominant position among the Attic festivals, is H. W. Parke, *Festivals of the Athenians* (Ithaca: Cornell University Press, 1977), esp. 125–136.

5. Haigh, *Attic Theatre*, 4. On the relationship of festivals to ancient practices of urban place-promotion, see Noel Robertson, *Festivals and Legends: The Formation of Greek Cities in the Light of Public Ritual* (Toronto: University of Toronto Press, 1993).

6. I rely on an account of the Cannes pressroom provided by John Katz, in conversation, June 1999.

7. Though its first occurrence may be traceable to the castle of Lord Rhys in the twelfth century, the Eisteddfod stands as evidence less of a continuous tradition of competitive arts festivals than of the distinctly modern practice of inventing or at least reinventing "traditional" practices to promote the cause of nationalism. For other relevant examples, in Scotland as well as Wales, see the essays collected in Eric Hobsbawm and Terrance Ranger, eds., *The Invention of Tradition* (Cambridge: Cambridge University Press, 1983).

8. D. T. Max, "The Oprah Effect," *New York Times Magazine,* 26 December 1999, 36.

9. In *Festivals of the Athenians,* Parke comments on the increasing po-

litical and bureaucratic control of this originally religious festival, noting that "the official responsible for all the organization of the City Dionysia was not the basileus, the old religious official of the community, but the archon, the political leader whose secular importance had tended to increase during the sixth century" (129).

10. Karlis Racevskis, *Voltaire and the French Academy* (Chapel Hill: University of North Carolina Press, 1975), 17.

11. The complexities of *l'affaire du Cid*, which was orchestrated by Richelieu but did not prevent Richelieu's continued patronage of Corneille or Corneille's eventual election to the French Academy (in 1647), have been the object of much commentary, most of it designed to illustrate the egregiously political, unliterary orientation of the academy under the great cardinal. A brief account that is less dismissive of the early academy than most is D. Maclaren Robertson, *A History of the French Academy* (New York: Dillingham, 1910), 29–39.

12. Linda Colley, *Britons: Forging the Nation, 1707–1837* (New Haven: Yale University Press, 1992), 168; Erik Simpson, "Minstrels and the Market: Prize Poems, Minstrel Contests, and Romantic Poetry," *ELH*, 71 (Fall 2004).

13. The original letter is in the collection of the Pierpont Morgan Library. It appears transcribed, apparently from a slightly imperfect Abbotsford copy, in H. J. C. Grierson, ed., *The Letters of Sir Walter Scott*, vol. 6, 1819–1821 (New York: AMS Press, 1971; orig. pub. 1934), 397–405. Much of it is also reprinted in David Gardner Williams, *The Royal Society of Literature and the Patronage of George IV* (New York: Garland, 1987; orig. pub. 1945). The note of apology, or spin-control, that Scott sent a few days later to the Lord Viscount Sidmouth appears in Grierson, pp. 417–419.

14. Grierson, *Letters of Sir Walter Scott*, 398–399.

15. The point is well supported by Colin Trodd, "The Authority of Art: Cultural Criticism and the Idea of the Royal Academy in Mid-Victorian Britain," *Art History,* 20 (March 1997): 3–22.

16. Grierson, *Letters of Sir Walter Scott*, 399.

17. MacArthur Foundation, "MacArthur Fellows Program: Overview," www.macfdn.org.

18. Grierson, *Letters of Sir Walter Scott*, 401, 400.

19. Ibid., 399. The passage is incorrectly copied in Grierson (and so also in Williams, *Royal Society of Literature*, p. 45), where "Royal benevolence" appears twice, in place of "bounty of the Sovereign."

20. Grierson, *Letters of Sir Walter Scott,* 401, 402 (where the last phrase is incorrectly rendered as "acquired any honors").

21. Ibid., 400, 404.

22. Ibid., 402, 405.

23. This disposition appears in England in 1660, with the founding of the Royal Society of London for Improving Natural Knowledge, and is shared by most of the canonical figures of the eighteenth century. To take the best-known example, Alexander Pope derides the Fellows of the Royal Society (F.R.S.) in the mock awards ceremony in his *New Dunciad* (1742), where the Goddess of Dullness confers her royal honors on the dunces (IV, 564–569):

> *Next, bidding all draw near on bended knees,*
> *The Queen confers her Titles and Degrees,*
> *Her Children first of more distinguish'd sort,*
> *Who study Shakespear at the Inns of Court,*
> *Impale a Glow-worm, or Vertu profess,*
> *Shine in the dignity of F.R.S.*

24. Williams, *Royal Society of Literature,* 37.

25. The statement was made by the archbishop of Noyon in 1699, as quoted by Paul Mesnard, *Histoire de l'Académie française depuis sa fondation jusqu'en 1830* (Paris: Charpentier, 1857), 30, cited in Racevskis, *Voltaire and the French Academy,* 18. Indeed, the academy's founding motto is "A l'immortalité" ("To immortality"), and even in the days when the official seal of the academy bore the face of Richelieu, the counter-seal bore this legend—from which is said to derive the sometimes ironic habit of referring to the academicians as "immortals."

3. The Logic of Proliferation

1. Pierre Bourdieu, *The Rules of Art: Genesis and Structure of the Literary Field,* trans. Susan Emanuel (Stanford: Stanford University Press, 1996), 258.

2. The Real Academia Española (Royal Spanish Academy of Language) was founded in Madrid in 1713 and approved by royal warrant of King Philip V the following year. As with the other royal academies, its original stated purpose was to guard the purity of the national language.

3. Leo Braudy, *The Frenzy of Renown: Fame and Its History,* 2nd ed. (New York: Vintage, 1997; orig. pub. 1986). For an example of the

process by which the fact of collaboration can be set aside in the interest of promoting one particular collaborator to the level of stardom (a process that is by no means socially innocent), see Denise Scott Brown's discussion of her working partnership with her husband, Robert Venturi (who has won the Pritzker and many other architecture prizes for *individual* achievement): Denise Scott Brown, "Room at the Top? Sexism and the Star System in Architecture," in Ellen Perry Berkeley, ed., *Architecture: A Place for Women* (Washington: Smithsonian Institute Press, 1989), 237–246.

4. Anders Österling, "The Literary Prize," in Henrik Schück et al., *Nobel: The Man and His Prizes,* 2nd ed. (Amsterdam: Elsevier, 1962), 82.

5. In fact, the two prizes were founded so close together that competing claims of historical priority (which in turn support a prize's claim to priority of position on France's fall prize calendar) continue to animate their public jockeying for attention and prestige. For some examples, see "Les Dames du Femina réprouvent les manières des messieurs du Goncourt," *Agence Presse,* 3 November 1999; and Marc Burleigh, "French Literary World in a Tizzy over Book Prizes," *Agence France-Presse,* 21 October 2003. On the Goncourt brothers, their literary salon, and the founding of the prize, see Pierre Sabatier, "Du grenier d'Auteuil au Prix Goncourt," *Nouvelle Revue des Deux Mondes,* 12 (1975): 593–611.

6. The quotations about gaps in the Nobel lineup are from former British prime minister Edward Heath, one of the Praemium Imperiale's six International Advisers, who sit, at least symbolically, atop the complex administrative structure of the awards. (As quoted in Patricia Reaney, "John Gielgud Wins Japanese Theatre Award," Reuters World Service, 27 September 1994.) For an example of news coverage that happily accepts the language of the Praemium Imperiale's own press releases (the phrase "equivalent of a Nobel Prize" appears twice in the lead paragraph), see Rob Scully, "Art World 'Nobel' for Lloyd Webber," Press Association Newsfile, 15 June 1995.

7. Hyatt Foundation, "A Brief History of the Pritzker Architecture Prize," Media Kit Booklet announcing the 1997 Pritzker Architecture Prize Laureate (Los Angeles: Jensen and Walker, 1997), 25; Anonymous, "The Purpose of the Pritzker Architecture Prize," www.pritzkerprize.com/main. These Hyatt Foundation sources make no mention of the fact that Pritzker did not himself come up with the idea for a "Nobel of architecture" but was approached, as a

second or third choice for patron, by a cultural entrepreneur named Carleton Smith. For a good, if typically condescending, journalistic account of the history of the Pritzker, see the essay by architecture critic Martin Filler, "Eyes on the Prize," *New Republic,* 26 March 1999, 86–88.

8. The Wolf Prizes to Promote Science and Art for the Benefit of Mankind were established in 1978 under the auspices of the Wolf Foundation in Israel. The foundation's wealth derives from the estate of Dr. Ricardo Wolf, a German-born diplomat. Six $100,000 awards are presented each year, four in the sciences, one in mathematics, and one in the arts. The arts prize revolves annually among architecture, music, painting, and sculpture. Frank Gehry won in 1992.

9. BBC 1, "Omnibus at the Tate, 1984." Video TAV-1278D, Tate Gallery Archive.

10. David Sexton, "Books That Win More Prizes Than Readers," *Sunday Telegraph,* 25 July 1993, 6. The cash award for this prize is surprisingly large: £5,000.

11. This association has reached the point where it is treated as major news if the Renaudot is awarded to a novel from another publishing house. See, for example, Herbert R. Lottman, "France's Goncourt and Renaudot Prizes Break with Tradition," *Publishers Weekly,* 237 (14 December 1990): 15.

12. Not surprisingly, however, while the Prix Novembre was announced at its founding as a prize that would enjoy "total independence" *(toute indépendance)* from the kind of social, political, and above all commercial interests that have shaped the Goncourt and other French book awards, its winners have tended, since the mid-1990s, to be drawn from the Goncourt and Renaudot shortlists.

13. On the Booker's relation to the Goncourt, see Anne Strachan, *Prizewinning Literature: UK Literary Award Winners* (London: Library Association, 1989), ix; also see Tom Maschler's recollections of the prize's genesis in "How It All Began," *Booker 30: A Celebration of 30 Years of the Booker Prize for Fiction* (London: Booker PLC, 1998), 15–16. Mark Longman of the Booker Management Committee also stressed the need to adhere closely to the model of the Goncourt, with its proven capacity to raise "excitement among the reading public"; the manuscript of Longman's speech, delivered on 15 January 1970, is in the Man Booker Prize archive, Oxford Brookes University, Oxford. For a more detailed treatment of the rise of literary prizes in the U.K., see James F. English, "The Prize Phe-

nomenon in Context," in Brian Schaffer, ed., *A Companion to the British and Irish Novel, 1945–2000* (Oxford: Blackwell, 2004), 160–176. On the Turner Prize's "conscious emulat[ion]" of the Booker, see Virginia Button, *The Turner Prize* (London: Tate Gallery Publishing, 1997), 19.

4. Prizes as Entertainment

1. For general background on the Academy Awards, the best of the many books on the subject is Emanuel Levy, *Oscar Fever: The History and Politics of the Academy Awards* (New York: Continuum, 2001).

2. The self-flattering character of these comparisons can be judged from an article that is included in the Peabody promotional packet and that descibes Steven Spielberg, upon hearing the news of his 1993 Peabody win for the Kids' TV show *Animaniacs,* "running through the halls shouting to his staff, 'This is the *Peabody!* It's better than the Oscar, better than the Emmy. This is the *Peabody!* Do you know what this *means?!*'"

3. Both NETPAC (the Network for Promotion of Asian Cinema) and SIGNIS (the World Catholic Association for Communication) are typical of the NGOs that over the past two decades have become increasingly active on the film festival circuit, founding and sponsoring prizes as part of their broader promotional mission. SIGNIS, for example, organizes "ecumenical juries" to select films of outstanding "spiritual value" at the festivals of Cannes, Berlin, Monte Carlo, and Ouagadougou, among others.

4. Joseph Horowitz, *The Ivory Trade: Music and the Business of Music at the Van Cliburn International Piano Competition* (New York: Summit, 1990), 14.

5. The most complete list I have found is that of Masa Mizuno, published on the web at www.afn.org/~afn39483 (accessed April 2005).

6. Horowitz, *Ivory Trade,* 15. We should add a couple of provisos here, however. First, because the competitions tend to value young performers' technique over such qualities as the range of their repertoire or their capacity to endure the grueling demands of touring, competition prizes are often misleading predictors of long-term success. Second, we need to recognize that prize judging is not performed in a vacuum, but is influenced by both published reviews and off-the-record chatter among experts. These ways of establishing a hierarchy of value or talent have neither atrophied nor lost their efficacy.

What's new is the degree to which prizes mediate these traditional practices of reputation making and impose themselves between reputation makers and the marketplace.

7. Horowitz, *Ivory Trade*, 72–76. The Leventritt, which never did quite make the transition to high visibility, has since been discontinued.

8. Daniel Bell, *The Coming of Post-Industrial Society: A Venture in Social Forecasting* (New York: Basic Books, 1973).

9. For an overview of this literature, see Pat Walker, ed., *Between Labor and Capital: The Professional Managerial Class* (Boston: South End, 1979), in particular the contribution of Barbara Ehrenreich and John Ehrenreich, "The Professional-Managerial Class."

10. Alvin W. Gouldner, *The Future of Intellectuals and the Rise of the New Class: A Frame of Reference, Theses, Conjectures, Arguments, and an Historical Perspective on the Role of Intellectuals and Intelligentsia in the International Class Contest of the Modern Era* (New York: Seabury/Continuum, 1979), 5. Randall Collins, *The Credential Society: An Historical Sociology of Education and Stratification* (New York: Academic Press, 1979), 71.

11. Though historians have long since abandoned the late-1970s tendency to treat the expanding sphere of cultural workers and cultural credentials as an eclipse or substantial erosion of the power associated with corporate money (a power whose continuing hold over social arrangements is today clearer than ever), many aspects of the New Class narrative persist. Books telling versions of the story of the rising importance of cultural capital and cultural markets have appeared in abundance since the early 1990s, not only with the explosion of academic studies of "globalization," but with the rapid spread of this narrative outward from academic genres to the now enormously popular genres of business journalism and management theory. "The capital assets that are needed to create wealth today," writes Thomas Stewart, "are not land, not physical labor, not machine tools and factories. They are, instead, knowledge assets." (Stewart, *Intellectual Capital: The New Wealth of Organizations* [New York: Doubleday, 1997], x.) A pop urban-studies version of the narrative (connecting the fates of various American cities to the proportion of specifically "creative" workers—professors, musicians, artists, software writers, web designers, etc.—in their populations) is Richard Florida, *The Rise of the Creative Class, and How It's Transforming Work, Leisure, Community and Everyday Life* (New York: Basic Books, 2002).

12. I hasten to acknowledge that Collins—like many scholars of the left who helped to craft a critical narrative of New Class ascendancy, from the economist Samuel Bowles to the linguist Noam Chomsky—doubts whether the shift toward cultural capital represents any real rearrangement of social relations at all. The dramatic expansion of the apparatus of cultural and educational credentialing, he points out, has not in any way lessened the rigidity of social stratification in America. It "has had no effects at all for increasing opportunities for social mobility" (*The Credential Society,* 182). One might even conclude that the ascendancy of the cultural sector has assured the foreclosing of such opportunities, since it appears that, contrary to what Bell and other politically orthodox thinkers had assumed, cultural assets may be "even more readily passed on from parents to children than are economic and political resources" (182–183). Nor is this pessimistic view limited to the American case. Collins cites a study from central Africa that "shows the basic pattern even more sharply" (183); and sociologists of education in Britain, as well as Bourdieu and his associates in France, have arrived at this same conclusion. See, for examples, Roy Lowe, *Education in the Post-War Years: A Social History* (London: Routledge, 1988); Pierre Bourdieu, *Homo Academicus,* trans. Peter Collier (Stanford: Stanford University Press, 1988); as well as Bourdieu with Jean-Claude Passeron, *The Inheritors: French Students and Their Relation to Culture* (Chicago: University of Chicago Press, 1979); or for a very short version of the argument, Bourdieu, "The Racism of 'Intelligence'" (1978), in Bourdieu, *Sociology in Question,* trans. Richard Nice (London: Sage, 1993), 177–180. In the American context, an important study that precedes Collins' is Samuel Bowles and Herbert Gintis, *Schooling in Capitalist America* (New York: Basic Books, 1976). Recent studies by the National Opinion Research Center and the Higher Education Research Institute show a continuing and indeed rising correlation between money and educational capital in the United States. See Anonymous, "Report Finds that Income Best Predicts Education," *New York Times,* 17 June 1996, A12; and David Leonhardt, "As Wealthy Fill Top Colleges, Concern Grows over Fairness," *New York Times,* 22 April 2004.

13. Danny Quah, "The Weightless Economy in Growth," *Business Economist,* 30 (March 1999): 40–53. This piece is representative of Quah's many papers and articles on the topic.

14. David Harvey, *The Condition of Postmodernity: An Enquiry into the*

Origins of Cultural Change (Oxford: Blackwell, 1989), vii. In its basic contours, Harvey's analysis is consistent with those of Giovanni Arrighi and Eric Hobsbawm, both of whom likewise periodize the "long twentieth century" with a key break around 1970–1973. For Hobsbawm, this break marks the start of an extended period of "crisis" for the left, but also for capitalism itself, which has seen the end of its "Golden Age" and is now careening out of control toward its inevitable catastrophe. Arrighi, too, speaks in terms of a growing "crisis" since 1972, but he emphasizes the resiliency of capitalism—its capacity to defer catastrophe, emerging from each crisis of overproduction in a new, vastly expanded form. Arrighi, *The Long Twentieth Century* (London: Verso, 1994); Hobsbawm, *The Age of Extremes: A History of the World, 1914–1991* (New York: Vintage, 1994), 403; Hobsbawm, *On the Edge of the New Century*, ed. Allan Cameron (New York: New Press, 2000), 102.

15. On celebrity, see Leo Braudy, *The Frenzy of Renown: Fame and Its History*, 2nd ed. (New York: Vintage, 1997; orig. pub. 1986); Richard Dyer, *Stars*, expanded ed. (Berkeley: University of California Press and British Film Institute, 1998; orig. pub. 1979); Dyer, *Heavenly Bodies: Film Stars and Society* (New York: St. Martins, 1986). On Hemingway and Picasso, see Leonard J. Leff, *Hemingway and His Conspirators: Hollywood, Scribners, and the Making of American Celebrity Culture* (Lanham, Md.: Rowman and Littlefield, 1997); and Michael C. Fitzgerald, *Making Modernism: Picasso and the Creation of the Market for Twentieth-Century Art* (Berkeley: University of California Press, 1996).

16. P. David Marshall, for example, sees the celebrity system in these decades as effecting a collapse of the distances or differences between various spheres of public life, to the point where the political system itself is now (in the United States, at any rate) subsumed under the logic of celebrity. See Marshall, *Celebrity and Power: Fame in Contemporary Culture* (Minneapolis: University of Minnesota Press, 1997), esp. 248–250.

17. Mason Wiley and Damien Bona, *Inside Oscar: The Unofficial History of the Academy Awards*, 4th ed. (New York: Ballantine, 1993), 438, 440.

18. These ratings are based on the All-Time Top Television Programs (1961–2000), as reported in *The World Almanac and Book of Facts 2002* (New York: World Almanac Books, 2002), 282. The 1970 Academy Awards show is thirty-eighth on the All-Time list. These

statistics were compiled by Nielsen Media Research from data concerning the viewing habits of sample households.

19. Michael Jordan, CEO of CBS, quoted in Mark Gunther, "What's Wrong with This Picture? Plenty," *Fortune,* 12 January 1998, 106.

20. The freak success of the game show *Who Wants To Be a Millionaire?* began in the third quarter of 1999 to change this profit picture at ABC dramatically, if temporarily. By mid-2000, that one show was estimated to be worth $500 million per season in profits to the network. Bill Carter, "Good Times Add Ring of Truth to TV Networks' Spring Celebration," *New York Times,* 15 May 2000, C.

21. On advertising revenues, see Stuart Elliot, "Despite Up-and-Down Ratings, Marketers Still Flock to the Academy Awards Broadcast" ("Advertising" column), *New York Times,* 20 March 2000, C. On profits, see Bill Higgins, "Kudos Gold Mine: Nets, Orgs, Vary Widely in Award Rewards," *Daily Variety,* 3 September 1999, 1.

22. Thomas O'Neil, *The Grammys for the Record* (New York: Penguin, 1993), 193.

23. Tom Shales, "Hey Audience! You're Beautiful! Mmmm-Wahh! The Awards Awards," *Washington Post,* 11 December 1977, F1.

24. The numbers continue to climb. According to Nielson Media Research, there were 100 televised awards shows in the United States in 2002, not counting repeats such as the multiple airings of the MTV Movie Awards. See Caryn James, "Awards Shows: The More Obscure, the Juicier?" *New York Times,* 23 March 2003, sect. 2, p. 1.

25. Robert W. Welkos, "Oscars 99: Cinema's Super Sunday," *Los Angeles Times,* 13 March 1999, F1; Robert Dominguez, "Now There's a Battle for Pre-Show Preeminence," *New York Daily News,* 18 March 1999.

26. There has been speculation that the academy may also have been motivated by a desire to limit the time available to the now-ubiquitous "awards consultants," studio lobbyists, and other PR personnel involved in steering votes toward particular nominees, since in recent years the ostensibly sordid drama of these twelve-week insider campaigns had been garnering almost more press coverage than the nominated films and artists themselves. It remains to be seen, however, whether the date change will have much effect on the campaigns other than to ratchet up their tempo. See Robert Abele, "Caught in a Maddening Crowd," *Los Angeles Times,* 11 February 2004, E1.

27. The promotional phrases quoted in this paragraph are all drawn

from a press release distributed with the 1996 Independent Spirit Awards press packet: "Bravo and the Independent Film Channel Invite You to 'Zap the Oscars' on March 25 from 8:00PM/ET to 1:00AM/ET" (March 23, 1996).

28. The supposed scandal of Miramax's tactics follows the parodic form I discuss in Part III. See Vincent Canby, "Hollywood's Shocked and Appalled by Miramax? Oh, Please!" *New York Times,* 25 March 1999, E1.

29. The first and most substantial set of changes is described in Dominic Pride, "BRIT Awards Get Expanded Voting: Organizers Hoping to Boost Credibility," *Billboard,* 9 October 1993.

30. This temporal logic is represented graphically in Pierre Bourdieu, *The Rules of Art: Genesis and Structure of the Literary Field,* trans. Susan Emanuel (Stanford: Stanford University Press, 1996), 159, figure labeled "The temporality of the field of artistic production."

31. Nielsen ratings for the show climbed as much as 60–70 percent a year through the 1990s, and by 1999 it was reaching nearly 11 million viewers, making the program a close second to MTV's top-rated show of the year, the Music Video Awards, and one of the few cable shows to exceed $1 million in ad revenue for its affiliates. Most of these viewers fall into MTV's core demographic group of 12–34-year-olds, which is what makes the show, in industry parlance, "bigger than its ratings."

32. Joe Bob Briggs, "Joe Bob Goes to the Drive-in," *San Francisco Chronicle,* Sunday Datebook, 6 March 1994.

33. I should note here that the Academy of Motion Picture Arts and Sciences strictly forbids, as an infringement on their registered trademark, use of the terms "Oscars" or "Academy Awards" by any other awards program. Thus, for example, to quote from the academy's own legal regulations, an award may be publicized as "the Uruguayan equivalent of the Oscar Award," but not as "the Uruguayan Oscar" or "the Oscar of Uruguay." The ten pages of legal regulations pertaining to AMPAS' intellectual property, some implications of which I will discuss later on, are available on the Oscars website at www.oscars.org/legal/regulations.html.

34. William Margol, interview with the author, March 1998.

35. It is said that winning a Newbery Prize for Children's Literature "guarantees 100,000 in hardcover sales in the first year." More significant is the high likelihood of a Newbery book maintaining

strong sales for years or decades afterward, as parents of each rapidly emerging reader-generation purchase the book for their children. Many bookstores now even feature a Newbery (or Newbery and Caldecott) shelf, where these instant classics may be perused as a set—more or less as though they were titles bearing a common authorial signature or products manufactured under the same brand name. On the Newbery sales boost, see Judith Miller, "Value of Multiplying Awards May Be Eroding," *Austin American-Statesman,* 14 December 1996, C13. On the convergence of the authorial signature with the commercial brand name, see John Frow, "Signature and Brand," in Jim Collins, ed., *High-Pop: Making Culture into Popular Entertainment* (Oxford: Blackwell, 2002), 56–74.

As regards the effect of prizes on porn video sales, reliable statistics are impossible to obtain—in part because there is little continuity in an industry where both production companies and prizes typically last less than a decade, and where so many of the producers and retailers (now mostly online) keep actual sales figures to themselves. But among industry people there is a strong consensus that buyers of porn, even more than buyers of other entertainment products, take their cues from the awards. Certainly the correlation between prize-winners and bestsellers appears to be very close, with the videos that have garnered the most trophies, such as *Justine* (1992), *Bad Wives* (1997), *Seven Deadly Sins* (1999), *The Fashionistas* (2002), and *The Masseuse* (2004), also appearing on the lists of most requested or most popular titles.

36. Tim Walker, "The Love Stories behind Cartland's Crown Jewels," *Daily Mail,* 4 April 1995.

37. Lyric sheet included in press packet and program for the (Not So) Sweet Sixteenth Annual Razzies, Hollywood Roosevelt Hotel, 24 March 1996. The Golden Raspberry Award Foundation's self-descriptive promotional phrases quoted in this paragraph and the next are taken from the materials in this press packet or from the Razzies website at www.razzies.com (accessed April 2005).

5. The Making of a Prize

1. David W. Kleeman (executive director, American Center for Children's Television, Des Plaines, Illinois), personal communication, 1 April 1998. The organization has since changed its name to the American Center for Children and Media.

2. American Center for Children's Television, "Ollie Awards: Rules and

Frequently Asked Questions," 1998 (sheet mailed by the ACCT on request).

3. The defenders of the short documentary prevailed, as they had done before when the academy moved to discontinue the category in 1993. See "Shorts Makers Blitz Academy," *Hollywood Reporter,* 21 April 1999, 5; Terry Pristin, "Oscar Board Rethinks Fate of the Short Documentary," *New York Times,* 26 April 1999, E1; Debra Kaufman, "Rescuing the Documentary Oscar," *Hollywood Reporter,* 15 May 2000, 8.

4. Such claims against Nobel's will represented a formidable obstacle. As Elisabeth Crawford points out, an earlier attempt, by the Italian merchant Jerome Ponti, to leave the whole of his (considerable but much smaller) fortune to support prizes in science and literature was successfully challenged by Ponti family members. Crawford, *The Beginnings of the Nobel Institute: The Science Prizes, 1901–1915* (New York: Cambridge University Press, 1984), 24, 26.

5. S. Ragnar Sohlman, "Alfred Nobel and the Nobel Foundation," in Henrik Schück et al., *Nobel: The Man and His Prizes,* 2nd revised and enlarged edition (Amsterdam: Elsevier, 1962; orig. pub. 1950), 42. See also Ragnar Sohlman's hugely informative *Legacy of Alfred Nobel: The Story Behind the Nobel Prizes,* trans. Elspeth Harley Schubert (London: Bodley Head, 1983).

6. So far as I can determine, the only published novelist or poet among the academy's membership in 1896 was Carl Snoilsky, head of the Royal Library and author of a half-dozen volumes of poems. Carl David af Wirsén, the academy's Permanent Secretary, was not himself a writer of fiction or poetry, but his background was literary and his publications included a critical study, published in 1870, of the work of Clas Livijn, Sweden's major gothic novelist and author of the E. T. A. Hoffmann–inspired *Spader Dame* (Stockholm: Swedish Academy, 1997; orig. pub. 1824).

7. Anders Österling, "The Literary Prize," in Schück et al., *Nobel,* 80.

8. Crawford, *Beginnings of the Nobel Institute,* 69. Crawford, one of the major historians of the Nobel Prizes, gives detailed estimates of purchasing power and salary comparison. Her conversions into present-day dollars, which need in any case to be inflated from 1984, strike me as somewhat too low—but of course such conversions are notoriously inexact. See also Burton Feldman, *The Nobel Prize: A History of Genius, Controversy, and Prestige* (New York: Arcade, 2000), 42–45.

9. The relevant statutes, reprinted in Schück et al., *Nobel,* are "Statutes of the Nobel Foundation," sect. 13 (650), "Provisional Statutes," sect. 4 (653), and "Statutes . . . for the Award by the Swedish Academy," sect. 3 (663). Ten percent of the annual income generated by the foundation's main fund is reinvested, so the available income shared out among the five prize sections amounts to 90 percent of the total. The Economics Prize, a curious and controversial hybrid—not, strictly speaking, a true Nobel Prize—was added in 1969, and is funded by the Swedish Riksbank rather than the Nobel Foundation.

10. The official adjusted figure, from Annika Ekdahl in the Communications and External Relations office of the Nobel Foundation, is "U.S. $155 million in 2000 year-end currency." My own conversion into real 2000 dollars would be about double that amount. (The five commonly used conversion formulas given on the Economic History Services website—at www.ehs.net—produce numbers ranging between $190 million and $7.2 billion, the latter being calculated according to relative share of gross domestic product.)

11. In an October 1999 interview at the offices of Orange, Raymond confirmed that the prize was then costing the company "more than £200,000" but not as much as £300,000 per annum. Figures for the Booker Prize are roughly comparable. According to news reports about the withdrawal of Booker's 2001 sponsor, the Big Food Group (the conglomerate into which the old Booker company had been absorbed), the cost of running the £21,000 prize was £350,000. And when a new sponsor, the Man Group, was eventually secured, the prize money was increased to £50,000 while the operating budget was pegged at "a minimum of £2.5 million over five years" (Tony Thorncroft, "New Sponsor for the Booker Prize," *Financial Times,* 26 April 2002).

12. Martin Filler, "Eyes on the Prize," *New Republic,* 26 March 1999, 90.

13. Alvin H. Reiss, "Famed Music Competition Woos and Wins Sponsors," *Fund Raising Management,* 24 (June 1993): 47–49.

14. Oliver Burkeman, "'Put It Down? I Couldn't Even Pick It Up,' Admits U.S. Book Award Judge," *Guardian,* 30 November 2002. The judge in question was Michael Kinsley, who cheerfully acknowledged his failure to read most of the books nominated for the National Book Award in nonfiction. Book prize judges, said Kinsley, "must put aside any fuddy-duddy notion of not judging a book by its cover."

6. Taste Management

1. Pierre Bourdieu's useful but often vexingly circular concept of *habitus* means the set of internalized (and hence bodily, as well as intellectual) attitudes, inclinations, strategies, and dispositions that form the basis of one's feel for the game one is playing, one's *sens pratique* ("practical sense") of how to do things on a particular field—along with one's sense of where one belongs (as in "knowing one's place"), and where everyone else belongs, on that field. See Pierre Bourdieu, "Structures, *Habitus*, Practices" and "Belief and the Body" in Bourdieu, *The Logic of Practice*, trans. Richard Nice (Stanford: Stanford University Press, 1990), 52–79.

2. A typical example is the biographical paragraph about a particular a juror for the 2000 International IMPAC Dublin literary award. The passage states that she "served on the judging panel in the novel category for the prestigious Whitbread Literary Prize for Literature." See www.impacdublinaward.ie/judges2000.htm (accessed April 2005).

3. Jocelyn McClurg, "Litchfield Man's Firm Offers $162,000 Prize," *Hartford Courant*, 18 May 1995, A1.

4. Edwin McDowell, "Fiction with Solutions," *New York Times*, 12 December 1990, C22.

5. Jack Mathews, "Film Directors See Red over Ted Turner's Movie Tinting," *Los Angeles Times*, 12 September 1986.

6. This was the view of the winner himself, Daniel Quinn, who, though Turner never exercised the option, believed that the award "was created so that Turner would have a book that could be made into a movie." Jeff Favre, "Call Him Surprised," *Chicago Tribune*, 2 January 1996, C.

7. McDowell, "Fiction with Solutions."

8. The Arts for the Parks promotional literature notes only in small print that the sponsoring academy is a private, for-profit organization, while repeatedly highlighting in its main text the claim that the competition was created "in cooperation with the National Park Foundation" (the official national nonprofit partner of the government's National Parks Service). It appears that the NPF contributed seed money to the initiative when it was launched in 1986, but has not been involved in the program since then. My discussion is guided by the official competition literature for 1997; a personal letter from Jamie Chapman, competition coordinator, dated May 8, 1998; and information available at www.artsfortheparks.com as of May 2005.

9. Jonathan Yardley, "Literary Lions and the Tame Turner Award,"

Washington Post, 17 June 1991, C2. An angry reply from William Styron appeared two weeks later: "We Weren't in It for the Money," *Washington Post,* 16 July 1991, A19.

10. Styron, "We Weren't in It for the Money."

11. Paul Gray, "The $500,000 Firefly," *Time,* 17 June 1991, 79. One of the more delightful ironies of this whole episode, however, is the fact that Quinn's eccentric book, so evidently hopeless for commercial (not to mention cinematic) purposes that Turner decided to cut its losses and scale back the planned big promotional launch, actually went on to become a valuable property for Bantam/Turner, acquiring a word-of-mouth reputation as a terrific book for getting young readers talking about ethics, and establishing itself, by the late 1990s, as a staple of the secondary-school curriculum.

12. Yardley, "Literary Lions."

13. Anonymous, "Turner 'Tomorrow' Award Sparks Row," *Facts on File World News Digest,* 27 June 1991.

14. Yet this was not a unique case. For a nearly identical act of jury rebellion, with essentially the same outcome, see PHS, "The Times Diary: Booby Prize," *The Times* (London), 11 July 1985.

15. Styron, "We Weren't in It for the Money."

16. Stephen Pile, "Outrage at the Tate," *Daily Telegraph,* 23 July 1994.

17. Most major advertising prizes, including the bulk of the Mercurys and CINDYs, are awarded according to product type. This is one indication that, when it comes to defining "creativity" and "artistic achievement," the imperatives of commerce are asserted with relatively greater force for advertisers than for other cultural producers. At the same time, most advertising awards, including the Clios, employ numerous technical categories (computer animation, cinematography, original music, etc.), as well as broad divisions according to medium (billboard, magazine, television/cinema), which are not pegged to particular product types.

18. Andrew Jaffe, interview with the author, July 1999.

19. Wendy Rosenfield, "Changes Afoot for the Barrymores," *Philadelphia Weekly,* 19 May 1999, 44.

20. Marcella Meharg, personal communication, March 1998 and July 1999. Janet Salter (president of the Beverly Hills Theatre Guild), phone conversation, 10 July 1999.

21. Erik Simpson, "Minstrels and the Market: Prize Poems, Minstrel Contests, and Romantic Poetry," *ELH,* 71 (Fall 2004).

22. It is noteworthy that the winner of Barnum's contest, the well-re-

spected poet Bayard Taylor, had earlier that year delivered the Phi Beta Kappa poem at Harvard—at that time probably the highest honor based at the universities and available to nonstudent poets. This suggests less distance between the academic and nonacademic forms of poetry prize than we might imagine, but the early history of America's prize-poem tradition has been too little excavated by scholars to support much speculation on this score. I am grateful to Max Cavitch for alerting me to Taylor's suggestive double victory of 1850.

23. Charles Sprague et al., *Boston Prize Poems, and Other Specimens of Dramatic Poetry* (Boston: Joseph T. Buckingham, 1824).

24. Lawrence Thompson, "An Inquiry into the Importance of Boston Prize Poems," *The Colophon,* New Graphic Series, 1, no. 4 (1940): 55–62.

25. George Bradley, "Introduction," *The Yale Younger Poets Anthology* (New Haven: Yale University Press, 1998), lxxxvi.

26. James Waller, "The Culture of Competition," *Poets and Writers,* 27 (July–August 1999): 43.

27. Ibid., 42.

28. My information about the Yale prize is largely drawn from Bradley's excellent introduction to *The Yale Younger Poets Anthology,* xxi–ci. The years of Auden's service as judge are discussed on pages lviii–lxxii.

29. Waller, "The Culture of Competition," 45.

30. Ibid., 44.

31. Ibid. For an example of how the lack of a winner attracted more publicity than a winner would have, see David Streitfeld, "And the Winner Isn't . . . ," *Washington Post,* 3 October 1997, B1.

32. Edwin McDowell, "Paco's Story Wins Top U.S. Award," *Globe and Mail* (Toronto), 11 November 1987.

33. Richard Eder, "*Paco's Story,* by Larry Heinemann," *Los Angeles Times,* Sunday Book Review, 7 December 1986; John Leonard, "*Beloved,* by Toni Morrison," *New York Times,* Sunday Book Review, 30 August 1987. Leonard said the novel "belongs on the highest shelf of American literature, even if half a dozen canonized white boys have to be elbowed off." "Without *Beloved,*" he wrote, "our imagination of the nation's self has a hole in it big enough to die from."

34. See Richard Eder's postscript on the affair, "Endpapers: Black Prizes,

Black Prospects," *Los Angeles Times,* Sunday Book Review, 14 February 1988, 15.

35. "NBA Names Judges for 1988, Increases Fiction Jury to Five," *Publishers Weekly,* 234 (12 August 1988): 320.

36. With respect to the Booker Prize, this is well documented in Richard Todd, *Consuming Fictions: The Booker Prize and Fiction in Britain Today* (London: Bloomsbury, 1996). Tom Holman shows that in more recent years other literary prizes besides the Booker have begun to exercise a significant effect, as well. See Holman, "The Race for the Prize," *The Bookseller,* 5 December 2003, S10.

37. John McGowan, *Democracy's Children: Intellectuals and the Rise of Cultural Politics* (Ithaca: Cornell University Press, 2002), makes a compelling call for cultural studies to develop "an ethnography of business to match its sophisticated ethnographies of consumers." This would indeed help us to overcome certain "fatuous opinions of commerce that now pass unchallenged." What I would add, though, is that we need to recognize the spaces that are neither "commerce" nor "culture," and begin to develop an ethnography of those who dominate this expanding neither/nor region of intermediary or conversional practices.

7. Trophies as Objects of Production and Trade

1. Whereas the science and literature medals are "Swedish," the medal for the Peace Prize is "Norwegian"; it was designed by Norwegian sculptor Gustav Vigeland and is minted by Norway's Royal Mint in Kongsberg. Its gold content is, however, comparable to that of the Swedish medals. Jeffrey Schramek, a dealer in awards and medals who boasts a Nobel medal as the centerpiece of his own collection (James Chadwick's 1935 Nobel Prize in Physics, acquired by Schramek in 1995), has told me that Sotheby's did an extremely poor job of cataloging and publicizing the Angell medal, and that it could have pulled a higher price if the auction had been handled more expertly. But this casual treatment of the medal by Sotheby's is merely another indication that the collector's market for (nonmilitary) awards had not yet taken off in 1983.

2. Hollywood memorabilia dealer Malcolm Willits, quoted in Daniel Cerone, "Orphan Oscars," *Los Angeles Times,* 8 February 1989, part 6.

3. David Gardner Williams, *The Royal Society of Literature and the Pa-*

tronage of George IV (New York: Garland, 1987; orig. pub. 1945), 296.

4. Ibid.

5. Ibid., 281.

6. Indeed, in this industry the names of the prizes a company is associated with count for much more than its own corporate name. For most of the twentieth century, the leading American awards-medal manufacturer was Medallic Art Company (MACO), headquartered in Danbury, Connecticut. This company was dissolved in 1989, with some of its management launching a new company called Recognition Products International (now RPI—the Protocol Group) in Easton, Maryland. Most assets of the Medallic Art Company, including all rights to the name, the historical dies, the product packaging and configuration ("trade dress"), and so on, were sold to Robert Hoff of what was then the Tri-State Mint Company (and is now the new Medallic Art Company) in Nevada. All of this the original MACO management was willing to give up. But what they took with them to RPI were the prestige clients—Pulitzer, Peabody, and so forth. This is where the real value of MACO resided, in the association with high-status prizes, which RPI has very successfully exploited. For information about the relationship of the two companies, I am indebted to Chuck Bresloff of RPI and to Mark Frost, art director at MACO.

7. Today Mitzi Cunliffe is chiefly remembered as the designer of the BAFTA mask. A typically circular proliferation occurred in July 2000, when, at the behest of Cunliffe's first husband, Joseph Solomon, the Cunliffe Sculpture Prize was established for undergraduates at Oxford. The artist best known for designing a prize trophy was thus herself in due course memorialized with a prize for other artists.

8. Correspondence between M. Edwards and Jan Pienkowski, January 1973. Committee financial records show that Booker paid £310 for the five new statuettes in October 1973. Man Booker Prize archive, folder 1973, Oxford Brookes University, Oxford.

9. RPI, for example, bills its medallions as "High Bas Relief Sculpture by widely acclaimed Award Winning Sculptors." Promotional brochure, 1995.

10. These prints are not worth as much as one might think, however. According to Artprice.com, another 1974 de Kooning lithograph of comparable dimensions but smaller edition size (150), *Spoleto,* was auctioned at William Doyle in 1996 for only $500. A 1973 litho-

graph, *Two Women,* from an edition of 100, sold at Sotheby's the following year for just $1,100.

11. Jeffrey Schramek and Associates, "Awards of Outstanding International Importance to Statesmen and Heroines: Concepts," www.collectnobel.com. Accessed May 2005.

12. Almar Latour, "Even at the Dinner for the Nobel Prize, They Steal the Spoons," *Wall Street Journal,* 7 December 2000, A1.

13. Susan Stewart, *On Longing: Narratives of the Miniature, the Gigantic, the Souvenir, the Collection* (Durham: Duke University Press, 1994), 154, emphasis added.

14. Charles Thomas, conversation with the author, 17 June 2004.

15. Todd S. Purdham, "His Best Years Past, Veteran in Debt Sells Oscar He Won," *New York Times,* 7 August 1992, A10.

16. Remarkably, however, the academy has mounted a new legal challenge, centered on Christie's attempt to auction Orson Welles's 1942 co-screenwriting Oscar for *Citizen Kane,* and aiming to extend the 1950 first-refusal clause to cover the sale of earlier statuettes, as well. See Dave Kehr, "Objection Quashes Sale of Welles's 'Kane' Oscar," *New York Times,* 22 July 2003, E1 (source of the epigraph to this chapter).

17. Anonymous, "Spacey Mystery Buyer," *Dominion* (Wellington), 15 September 2001, 22; Anonymous, "Actor Returns Oscar Home," *Gazette* (Montreal), 18 September 2001, B7.

18. Daniel Cerone, "Orphan Oscars," *Los Angeles Times,* 8 February 1989.

19. The early history of these legal battles, including the arguments used by the academy's attorneys, is reviewed in the decision of the 1955 trial. *Schnur and Cohan, Inc., vs. Academy of Motion Picture Arts and Sciences,* no. 6128, 15 June 1955, United States Court of Customs and Patent Appeals 42 C.C.P.A. 963; 223 F.2d 478; 1955 CCPA LEXIS 173; 106 U.S.P.Q. (BNA) 181. Oral argument 2 May 1955.

20. As listed in the catalog of the Hollywood memorabilia dealer Stairway to the Stars. One such watch did sell for this price at an AMC auction in 2001.

21. Cerone, "Orphan Oscars," Section 6, p. 1.

8. Scandalous Currency

1. The three epigraphs are taken from: Philip Howard, "Curling Up with All the Bookers," *The Times* (London), 19 October 1982, 12;

David Lehman, "May the Best Author Win: Fat Chance—A Flap over Book Prizes," *Newsweek*, 107 (21 April 1986): 86; and Anonymous, "A Turner for the Worse," *Daily Telegraph*, 29 November 1995, 20.

2. Dustin Hoffman, OBIE Awards, 27 May 1985, New York; Bill Murray, New York Film Critics Circle Awards, 10 January 1999, Windows on the World, New York; Sally Field, Academy Awards, 14 April 1980, Dorothy Chandler Pavilion, Los Angeles.

3. Mick Lasalle, "MTV Movie Awards Goof-Off," *San Francisco Chronicle*, 12 June 1992, D1.

4. Pierre Bourdieu, *Photography: A Middle-Brow Art*, trans. Shaun Whiteside (Stanford: Stanford University Press, 1990), 96.

5. Pierre Bourdieu and Hans Haacke, *Free Exchange* (Stanford: Stanford University Press, 1994), 84.

6. It might seem scandalous, as well, that the other towering figure of European letters, Emile Zola, was passed over. But here the academy was given some latitude owing to the fact that Alfred Nobel was known to have loathed Zola's work.

7. It is likely, as well, that Tolstoy would have declined the prize had they offered it to him in a subsequent year. Not only might he have felt some bitterness toward the academicians after they gave their inaugural prize to Prudhomme, but, as Carl David af Wirsén noted in his 1902 committee report on Tolstoy, the Russian had recently spoken out more generally about "the lack of worth, nay, the harm in money prizes." Anders Österling, "The Literary Prize," in Henrik Schück et al., *Nobel: The Man and His Prizes*, 2nd revised and enlarged edition (Amsterdam: Elsevier, 1962; orig. pub. 1950), 92.

8. In accordance with the logic that we will examine in the next section, however, the Bollingen soon began to reap a symbolic profit from its scandalous visibility, eclipsing the Pulitzer as (to quote the *New York Times*) "America's most prestigious poetry award." See James F. English, "Prizes," in Eric Haralson, ed., *Encyclopedia of American Poetry: The Twentieth Century* (Chicago: Fitzroy Dearborn, 2001), 580.

9. Anonymous, "Never Mind the Plot, Enjoy the Argument," *Independent*, 6 September 1994, 12.

10. Richard Brooks, "Judges Trade Insults as Book Award Turns into Prizefight," *Observer*, 7 May 1995, 3.

11. Anonymous, "The Booker Prize," *Economist*, 15 October 1994, 118; Annalena McAfee, "Judges Split as Kelman Wins Booker," *Financial Times*, 12 October 1994, 12. The tally of "fucks" is reported

in Robert Winder, "Highly Literary and Deeply Vulgar," *Independent*, 13 October 1994, 18.

9. *The New Rhetoric of Prize Commentary*

1. John Sutherland, "The Bumpy Ride to the Booker, 1981," *Times Higher Education Supplement*, 30 October 1981, 11; Richard Todd, *Consuming Fictions: The Booker Prize and Fiction in Britain Today* (London: Bloomsbury, 1996), 62–64.

2. In fairness to Maschler, it should be pointed out that during the same period, Cape novels won an even greater share of James Tait Black memorial prizes.

3. The NCR Book Award struggled through the mid-1990s, when AT&T acquired NCR and changed the subsidiary's name to AT&T Global Information Solutions. The prize finally collapsed in 1998, leaving a vacuum at the top of the nonfiction category, which was quickly filled by the Samuel Johnson Prize, currently sponsored by BBC4.

4. Documents pertaining to the administration of the prize in those years are housed in the uncatalogued Booker archive of the Book Trust, Oxford Brookes University, Oxford. I am grateful to Sandra Vince and Russell Pritchard of the Book Trust, as well as to Martyn Goff, for granting me access to this archive and assisting me in my research.

5. The full text of Berger's speech was printed in the *Guardian*, 24 November 1972, 12. It has since been reprinted as "Speech on Accepting the Booker Prize for Fiction," in Berger, *Selected Essays of John Berger*, ed. Geoff Dyer (New York: Vintage, 2003), 253–257.

6. The prize's role in this process from the early 1980s to the mid-1990s has been traced by Graham Huggan in "Prizing Otherness: A Short History of the Booker," *Studies in the Novel*, 24 (Fall 1997): 412–433. Huggan's broader argument about the continuance of imperial patterns of domination through the marketing of the "postcolonial exotic" can be found in Huggan, *The Postcolonial Exotic: Marketing the Margins* (London: Routledge, 2001), where the above article is reprinted (105–123).

7. According to a 1987 profile on Berger in the *New York Times* (Gerald Marzorati, "Living and Writing the Peasant Life," 29 November 1987), *Ways of Seeing* had by that date sold more than a quarter-million copies in the United States alone.

8. Even *Punch* chimed in on the impropriety of Berger's refusenik stance with a bit of doggerel: "How very right to wield the lash / On

those who give you tainted cash! / Our admiration knows no bounds. / We're sending you TEN THOUSAND POUNDS. / On second thought we think it best / To keep it in the old oak chest" (*Punch*, 6 December 1972, 834). These sorts of deprecations smuggle in a defense of aesthetic purity (artistic practice untainted by politics) under the guise of a common-man distaste for the ostensibly purist stance of the artist.

9. J. G. Farrell, quoted in *Morning Star* (London), 6 December 1973.

10. The sense of a scandal was augmented by Lord Butler, who, at the podium to present the winner's check to Farrell, began his presentation speech with two anti-Semitic jokes. The offense was particularly sharp given that Farrell's publisher, present at the ceremony, was the distinguished Arthur Weidenfeld—Baron Weidenfeld of Chelsea, author of *The Goebbels Experiment,* and one-time Israeli chief of cabinet.

11. Minutes of Booker Management Committee meeting, 8 January 1974. Man Booker Prize archive, folder 1974, Oxford Brookes University, Oxford.

12. These counts are based on the clippings in the Man Booker archive.

13. Bryan Appleyard, "Glittering Prizes and a Game Called Celebrity Sadism," *Sunday Times* (London), 21 October 1990. Christopher Hope, a South African writer shortlisted in 1992, vividly described the ethos of the award banquet from the vantage point of the also-ran: "The TV cameras get into your earhole and watch you push food around your plate while you get slagged off." Quoted by Geraldine Brooks, "No Civility, Please, We're English," *GQ,* 63 (February 1993): 59 ("Letter from London").

14. As with artists, however, journalists who display bad behavior or make ill-considered remarks at the Booker dinner may gain a certain cachet as a result. Malcolm Bradbury's 1992 novel *Doctor Criminale* (New York: Viking), the ultimate insider's satire of the Booker, appropriately begins with the journalist-protagonist, Francis Jay, becoming an overnight celebrity by making a few highly unprofessional remarks at a Booker dinner.

15. Ion Trewin, quoted in Patricia Miller, "Booker Triumph 'Like Avalanche Smothering You,'" *Sunday Times* (London), 24 October 1982. On the sales boost for Keneally's novel see Gay Firth, "The Financial Facts of Fiction: The Booker Prize," *Financial Times,* 6 October 1984.

16. The classic denunciation of these tendencies is Daniel J. Boorstin,

The Image: A Guide to Pseudo-Events in America (New York: Harper and Row, 1964; orig. pub. 1962), esp. 45–76, 118–180. A more ambitious and less tendentious study of contemporary celebrity culture and its place in the long history of fame is Leo Braudy, *The Frenzy of Renown: Fame and Its History,* 2nd ed. (New York: Vintage, 1997; orig. pub. 1986). The most important book on cinematic celebrity and the Hollywood star system is still Richard Dyer's superb *Stars* (Berkeley: University of California Press and British Film Institute, 1998; orig. pub. 1979). A useful study of the specifically literary dimension of celebrity culture is Joe Moran, *Star Authors: Literary Celebrity in America* (London: Pluto, 1999).

17. Goff continues to this day to leak great quantities of "scandalous" gossip to the press. See, for example, the many incidents of "dumbing down, feuding, swearing, and farce" Goff recounted for the *Observer*'s David Smith. Smith, "A Prize Bunch of Literary Egos," *Sunday Observer,* 31 August 2003.

18. Philip Howard, "Curling Up with All the Bookers," *Times* (London), 19 October 1982, 12.

19. E. J. Craddock, "Why the Booker Prize is Bad News for Books," *Times* (London), 7 October 1985, 15.

20. Susannah Herbert, "The Night Booker Became a Dirty Word," *Daily Telegraph,* 13 October 1994. Herbert is here quoting Bing Taylor, general marketing manager of W. H. Smith's book department—but as the headline suggests, she takes essentially the same view that Taylor does.

21. "Who Needs the Booker? The Sorry State of a Literary Prize," *Economist* (21 October 1989).

22. "For Love of Literature and Loadsamoney," *Sunday Times* (London), 2 October 1988, G8 (emphasis added).

23. Anthony Thwaite, "Booker 1986," *Encounter,* 68 (February 1987): 37, 38 (emphasis added).

24. Margaret Forster, "Secrets of a Glittering Prize," *Sunday Times* (London), 26 October 1980, 13.

25. Bill Buford, "Send in the Scones," *Vogue* (USA), 175 (December 1985): 196 (emphasis added).

26. For example, Hermione Lee, a judge in 1981, wrote a defensive piece for *TLS* about the predominance in the press of "the 'idiotic Booker prize' school of thought" (30 October 1981, 1268). But by 1984 she was moderating the irreverent studio team debate for British TV Channel 4's first broadcast of the award dinner, and her own com-

mentaries on the prize have subsequently grown more biting and satiric.

27. John Gross, "The Booker's Baneful Influence," *Times* (London), 13 September 1990. Gross was chair of a particularly distinguished panel of judges in 1971, comprising Saul Bellow, John Fowles, Lady Antonia Fraser, and Philip Toynbee.

28. William Gass, "Prizes, Surprises, and Consolation Prizes," *New York Times Book Review*, 5 May 1985.

29. Quotations from the *Nation* and the *Tribune* appear in William Joseph Stuckey, *The Pulitzer Prize Novels: A Critical Backward Look* (Norman: University of Oklahoma Press, 1966), 249. Stuckey observes that, at the time of his writing, "it is difficult to locate even one critic today who holds the Pulitzer Prize in very high esteem" (249).

30. Joseph Epstein, "The All-American Honors List," *TLS*, 13 June 1975, 650–651.

31. Carlos Baker, "Forty Years of Pulitzer Prizes," *Princeton University Library Chronicle*, 18 (Winter 1957): 55–70.

32. Roland Barthes, "The Writer on Holiday," *Mythologies*, trans. Annette Lavers (New York: Noonday, 1973), 30.

33. Mark Lawson, "Never Mind the Plot, Enjoy the Argument," *Independent*, 6 September 1994.

34. Todd, *Consuming Fictions*, 64.

35. Elaine Showalter, "Coming to Blows over the Booker Prize," *Chronicle of Higher Education*, 28 June 2002, B11. McCrum's remark in the *Observer* is quoted by Showalter.

36. This was the Tory minister Alan Clark, who chaired the (scandalously) fractious jury for the 1995 NCR Prize. "They didn't put me in for my taste and discernment in this field," Clark observed in a post-ceremony interview. "I was put on the committee in the hope that there might be a row, in inverted commas, and that I might be controversial and this would attract publicity to the whole affair." See Julia Llewellyn Smith, "They Invited Me Hoping for Controversy," *Times* (London), 6 May 1995, Features section.

37. Brooks, "No Civility, Please," 62. For further gossip on the affair, see "Times Diary," *Times* (London), 15 October 1992.

38. Pierre Bourdieu, "Price Formation and the Anticipation of Profits," in Bourdieu, *Language and Symbolic Power*, ed. John B. Thompson, trans. Gino Raymond and Matthew Adamson (Cambridge, Mass.: Harvard University Press, 1991), 67–72.

39. Appeals to Time as an objective arbiter disconnected from history and society are everywhere in the commentary on literature and arts prizes. A typical example is Phillip Howard, "And Thundering in to the Final Page . . . ," *Times* (London), 19 October 1982, 12: "The only objective judge of literature is Time. . . . Let us not pretend that [winning a prize] means anything about [a book's] literary value in the long eye of history."

40. Pierre Bourdieu, *The Rules of Art: Genesis and Structure of the Literary Field,* trans. Susan Emanuel (Stanford: Stanford University Press, 1996), 274. For Bourdieu, such a suspension between belief and disbelief is scarcely imaginable, appearing only as a special complication or nuance in the habitus of the most refined and reflexive authors; his example is Mallarmé. I see it as an increasingly general circumstance of the *illusio,* which designates, after all, a form of collective rather than individual belief.

10. Strategies of Condescension, Styles of Play

1. Even in America the charge of Bookerization is a familiar one. See, for example, David Lehman's account of the Bookerization of the National Book Awards, "May the Best Author Win: Fat Chance—A Flap over Book Prizes," *Newsweek,* 107 (21 April 1986). According to Lehman, Barbara Prete, who was in charge of these prizes back in the mid-1980s when they were struggling along under the name "American Book Awards," made a number of trips to London to study the way Martyn Goff and the Book Trust administered the Booker Prize. One result of these visits was Prete's decision to begin announcing a shortlist of nominees some weeks prior to the announcement of a winner, a change which succeeded in producing a Booker-style sore-loser scandal the very first year of its implementation. The next year saw the even larger sore-loser scandal (discussed below) involving Toni Morrison's *Beloved.*

2. Pierre Bourdieu and Hans Haacke, *Free Exchange* (Stanford: Stanford University Press, 1994), 52.

3. Pierre Bourdieu, "The Invention of the Intellectual," in Bourdieu, *The Rules of Art: Genesis and Structure of the Literary Field,* trans. Susan Emanuel (Stanford: Stanford University Press, 1996), 129–131.

4. A good, brief account of the affair can be found in Annie Cohen-Solal, *Sartre: A Life* (New York: Pantheon, 1985), 444–449.

5. Pierre Bourdieu, "The Market of Symbolic Goods," trans. R. Saw-

yer, in Bourdieu, *The Field of Cultural Production: Essays on Art and Literature* (New York: Columbia University Press, 1993), 130. Since this essay's original appearance in 1971, Bourdieu's analysis of the logic of relation between the field of restricted production and the field of general production has undergone some refinements, particularly as regards the differing temporalities ("modes of aging") of the two fields. For the most recent version, see Bourdieu, "The Market for Symbolic Goods," *Rules of Art,* 141–173.

6. Mason Wiley and Damien Bona, *Inside Oscar: The Unofficial History of the Academy Awards,* 4th ed. (New York: Ballantine, 1993), 447.

7. Thomas Bernhard, *Wittgenstein's Nephew: A Friendship,* trans. Ewald Osers (London: Quartet Books, 1986), 78.

8. Peter Marks, "Adding Drama to Musical, Andrews Spurns a Tony," *New York Times,* 9 May 1996, A1, B6.

9. A section of the letter appears on Pomona College's "San Narciso Community College" Thomas Pynchon Homepage at www.pynchon .pomona.edu/bio/facts.html (accessed April 2005).

10. See Joe Moran, *Star Authors: Literary Celebrity in America* (London: Pluto, 1999), 54, 64–66. Moran also mentions the fate of John Updike's recurring protagonist Henry Bech, a once-prolific author whose protracted midlife writer's block has the effect of increasing his stature and renown, even garnering him at one point the "Melville Medal" for the "most meaningful silence" in American letters.

11. Anonymous, "Pulitzer Jurors Dismayed on Pynchon," *New York Times,* 8 May 1974.

12. The whole sequence of events is somewhat eccentrically and unreliably documented in Chris Brook, ed., *K Foundation Burn a Million Quid* (London: Ellipsis, 1998), 5–30. See also Lynn Cochrane, "Fans to Watch £1m Go Up in Smoke for Glaswegian Football Fans," *Scotsman,* 4 November 1995; Robert Sandall, "Money to Burn," *Sunday Times* (London), 5 November 1995.

13. See Lawrence Weschler, *Boggs: A Comedy of Values* (Chicago: University of Chicago Press, 1999).

14. The statuette-snatcher was Alan "Gimpo" Goodrick, a KLF roadie and K Foundation collaborator who shot the documentary film *Watch the K Foundation Burn a Million Quid.* A wealth of archival material related to Drummond and Cauty in their various incarnations is available for free download at ftp://ftp.xmission.com/pub/users/l/ lazlo/music/klf/. Accessed April 2005.

15. For assistance in gaining access to the Tate Gallery Archive, where I viewed the videotapes of Turner broadcasts, and for granting me a helpful interview in October 1999, I am grateful to Virginia Button. Button's authorized and uncritical history of the Turner is entitled *The Turner Prize* (London: Tate Gallery Publishing, 1997).

16. The mere announcement that K Foundation would be sponsoring this award was page 3 news in the *Daily Telegraph,* 31 August 1993.

17. Estimates vary as to how much Drummond and Cauty spent on their publicity campaign, which included full-page ads in the *Guardian,* the *Sun,* the *Observer,* the *Sunday Times,* and NME (*New Musical Express*) magazine; limousine service for journalists participating in the pre-awards money-nailing event; and purchase of the entire commercial break in British TV Channel 4's coverage of the Turner Prize.

18. With regard to the long-term value of their first work, *Nailed to the Wall,* with its £500,000 price tag as a work of art and its face value of £1 million, Cauty and Drummond had this to say: "Over the years the face value will be eroded by inflation, while the artistic value will rise and rise. The precise point at which the artistic value will overtake the face value is unknown. Deconstruct the work now and you double your money. Hang it on a wall and watch the face value erode, the market value fluctuate, and the artistic value soar. The choice is yours." Jim Reid, *K Foundation—Money: A Major Body of Cash,* self-published exhibition catalogue, 1993, quoted in "K Foundation Art Award," *Wikipedia* encyclopedia entry (en.wikipedia.org/wiki/K_Foundation_art_award), accessed April 2005.

19. Alison Roberts, "Turner's Best Equals the Worst," *Times* (London), 24 November 1993.

20. Susannah Herbert and Victoria Combe, "Pop Group 'Prize' Rocks the Tate," *Daily Telegraph,* 31 August 1993.

21. Roberta Smith, "The Best of Sculptors, the Worst of Sculptors," *New York Times,* 30 November 1993.

22. Damien Hirst, quoted in Anonymous, "Damien Hirst Is Unanimous Winner of the Turner Prize," *Daily Telegraph,* 29 November 1995.

23. Anonymous, "Prize Idiots: The Turner Prize Award," *Daily Mirror,* 30 November 1995.

24. Julian Stallabrass, *High Art Lite: British Art in the 1990s* (London: Verso, 1999).

25. Anonymous, "A Turner for the Worse," *Daily Telegraph,* 29 November 1995.

26. David Mills, "A Conspiracy of Theorists," *Sunday Times* (London), 28 November 1993.

27. This is not to say that the cultural left cannot mount an occasional direct attack on the commodification of art. Stallabrass does just this in arguing that high art lite was in large measure a product of Thatcherism, sponsored and engineered by Thatcher's masterful image-maker, Charles Saatchi (creator of the "Labour Isn't Working" campaign). As Stallabrass remarks, "It is no coincidence that the dominant buyer of British contemporary art made his fortune in ads" and put his advertising expertise at the service of hard-right hegemony (*High Art Lite*, 259). My point, though, is that Stallabrass' rejection of all playfulness and duplicity, his posture of high seriousness and critical purity, which he acknowledges to be a kind of throwback to the tradition of Roger Fry, tends to slide his rhetoric into alignment with the cultural mouthpieces of the corporate right he decries.

28. Anonymous, "Morrison, duCille, Baquet, Pulitzer Prizewinners," *Jet*, 74 (18 April 1988): 14.

29. Anonymous, "Black Writers in Praise of Toni Morrison," *New York Times Book Review*, January 24, 1988, 36.

30. Anonymous, "NBA Names Judges for 1988, Increases Fiction Jury to Five," *Publishers Weekly*, 234 (12 August 1988): 320.

31. Carol Iannone, "Toni Morrison's Career," *Commentary*, 84 (December 1987): 59–63; and idem, "Literature by Quota," *Commentary*, 91 (March 1991): 50–53. As part of the anti-Morrison campaign during the 1987–1988 awards season, the *New Criterion* (edited by Hilton Kramer) also ran a piece timed to coincide with the Pulitzer jury's deliberations: Martha Bayles, "Special Effects, Special Pleading," *New Criterion*, 6 (January 1988): 34–40.

32. A key document in this connection is Roger Cohen, "Ideology Said to Split Book-Award Jurors," *New York Times*, 27 November 1990. In that piece, Cohen reports the complaints of Paul West regarding the 1990 National Book Award jury's domination by "ethnic concerns" and "ideology" in their selection of Charles Johnson's *Middle Passage*. Iannone and other conservative culture warriors seized on these complaints, and West himself wrote of the affair at length in "Felipe Alfau and the NBA," *Review of Contemporary Fiction*, 13 (Spring 1993).

33. Unlike Morrison, however, Roth had already won the National Book Award, for *Goodbye, Columbus* in 1960.

34. Christopher Hitchens, "These Glittering Prizes," *Vanity Fair*, 56 (January 1993): 22.

35. Ibid.

36. John Gross, "The Booker's Baneful Influence," *Times* (London), 13 September 1990.

37. Such discontinuities are frequently rehearsed by the founders of competing prizes. When the National Book Awards were founded in 1950, the founders could point to the following omissions on the Pulitzer fiction list: Sherwood Anderson, John Dos Passos, Theodore Dreiser, William Faulkner, F. Scott Fitzgerald, and Ernest Hemingway. They quickly presented their new prize to Faulkner for his *Collected Stories* (1951).

38. A good treatment of the Pulitzer's long record of corruption and cronyism—focused on the awards in journalism rather than those in literature—is David Shaw, *Press Watch: A Provocative Look at How Newspapers Report the News* (New York: Macmillan, 1984), 181–214.

11. *The Arts as International Sport*

1. The fact that individual states lose autonomy in the areas of finance and trade as an inevitable result of the capitalist mode of production—and not, for example, as a result of any particular national hegemony (such as America's today, or England's in the nineteenth century)—was stated very clearly by Marx and Engels. In *The German Ideology* (1846) they contrast the strictly "limited . . . and local form of exchange" that characterized feudal economies with the global reach of industrial capital, which by the end of the eighteenth century had "made all civilized nations and every individual member of them dependent for the satisfaction of their wants on the whole world, thus destroying the former natural exclusiveness of separate nations." Capitalism had thereby "produced world history for the first time." Karl Marx and Friedrich Engels, *The German Ideology* (Marx-Engels Internet Archive: www.ex.ac.uk/Projects/meia/Archive/1845-GI), ch. 3.

2. Monty Python, "Novel Writing (Live from Wessex)," *Monty Python's "The Final Rip-Off"* (Virgin Records, 1992). The skit exists in various forms and in various media; the version cited here can be downloaded from the Hardy Sound Library at pages.ripco.net/~mws/sounds.html (accessed April 2005). At the start of the skit, Hardy is said to be writing *Return of the Native*—and it is the first

sentence of that 1878 novel that he in fact begins to compose. But many contextual references—to the author's "eleven novels to date" (*Jude* was his twelfth), to his difficulties writing *Tess of the d'Urbervilles* (his most recent novel before *Jude,* published in 1891), and so on—clearly situate us at the time of the composition of *Jude the Obscure.*

3. Enzo di Martino, *La Biennale di Venezia, 1895–1995* (Milan: Giorgio Mondadori, 1995).

4. Shearer West, "National Desires and Regional Realities in the Venice Biennale, 1895–1914," *Art History,* 18 (September 1995): 410.

5. Ibid., 404–434, esp. 407–413. West argues convincingly that, for all its avowed internationalism, the Biennale continued to serve primarily nationalistic purposes for Italian participants. As he puts it, "The exhibition itself carried contradictory messages, trying to convince 'insiders' of Italian cultural unity while impressing 'outsiders' with Italy's modernity and internationalism" (422).

6. John J. MacAloon, *This Great Symbol: Pierre de Coubertin and the Origins of the Modern Olympic Games* (Chicago: University of Chicago Press, 1981), 187.

7. Ibid., 252.

8. *New York Times,* 28 April 2003, Obituaries page.

9. For one recent expression of this skepticism regarding the "red-in-tooth-and-claw competitive model," see Christopher Prendergast, "Negotiating World Literature," *New Left Review,* 8 (March–April 2001).

10. See Elisabeth Crawford's discussion of the "new patrons of science in the late nineteenth century" in Crawford, *The Beginnings of the Nobel Institute: The Science Prizes, 1901–1915* (New York: Cambridge University Press, 1984), 16–22.

11. Crawford offers the most thorough survey of the early press response to the Nobels (ibid., 188–210).

12. So strong is the association between the Nobels and the Olympics that in the mid-1980s there was a movement to secure the Nobel Peace Prize for the International Olympic Committee. But though the IOC was nominated three years running, it never received the prize. Robert Sullivan, "Nobel Gesture: International Olympic Committee nominated for Nobel Peace Prize," *Sports Illustrated,* 9 June 1986, 12.

13. Anthony Giddens, *Consequences of Modernity* (Cambridge: Polity Press, 1990).

14. Thus for example the Neustadt, in its promotional materials, boasts that Gabriel García Márquez, Czeslaw Milosz, and Octavio Paz all received that prize years before winning their Nobels.

15. "Ivar Ivask, Author, Critic, Founder of Neustadt Prize" (obituary), *Los Angeles Times,* 27 September 1992, A34.

16. Martin Filler, "Eyes on the Prize," *New Republic,* 26 April–3 May 1999, 88.

17. For a good overview of Wallerstein's world-systems analysis, see the essays collected in Immanuel Wallerstein, *The Essential Wallerstein* (New York: New Press, 2000).

18. As regards economics and trade, it remains a disputed question whether we have really been witnessing a sudden collapse of the nation-state model of exchange and the first dawn of "truly global-ized" markets. Certainly there is call for some skepticism toward the grander claims and prophecies emanating from the London School of Economics and other centers of Third-Wayism and kindred doc-trines of the New, especially given the recent restoration of national-ist trade barriers and the tendency, evident in such initiatives as the World Social Forum, for economically peripheral nations—in partic-ular those of the so-called Global South, led by Brazil and India—to begin withdrawing en masse from 1980s- and 1990s-style global trade agreements.

19. The transformation I am trying to describe is in effect the beginning of the end of the modern world-cultural system itself, a system, dat-ing from the sixteenth century, in which, as Pascale Casanova puts it, "international struggles take place and have their effects princi-pally within national spaces." Casanova has provided the most pow-erful description of this system, at least in its literary aspect, in *La République mondiale des lettres* (Paris: Seuil, 1999); quotation above is taken from Casanova, "Literature as a World," *New Left Review,* 31 (January–February 2005): 81. Casanova recognizes that there has been a major upheaval in this system since the 1970s, though, in my view, her brief account of the shifts that have taken place, an account focused on media conglomeration and the rise of the blockbuster model, conforms too readily to the familiar narrative of cultural commodification.

12. The New Geography of Prestige

1. On Goethe, Valéry, and other early theorists of the *Weltmarkt* or global system of cultural (and especially literary) exchange, see

Pascale Casanova, *République mondiale des lettres* (Paris: Seuil, 1999), 26–28 (Goethe quote on 27).

2. Jeanne Adams, "Polémiques autour du premier Grand Prix Littéraire de l'Algérie: La Situation des lettres algériennes en 1921," *Revue de L'Occident Musulman et de la Méditerranée*, 37 (1984): 15–30.

3. For these quotations from the various participants in the debate, see ibid.

4. The quarrel escalated all the way to the Conseil d'Etat, which ultimately affirmed the prize commission's decision in 1922. But the partisans of Randau succeeded in purging the commission of most of its offending members and eventually in securing him the prize (for 1929). Quotations are taken from Adams, "Polémiques autour du premier Grand Prix"; background on the prize and prizewinners is found in Jean Déjeux, "Le Grand Prix Littéraire de l'Algérie, 1921–1961," *Revue d'Histoire Littéraire de la France*, 85, no. 1 (1985): 60–71.

5. On the complex connotations of the subtitle, see the detailed and fascinating consideration of the Maran affair in Brent Edwards, *The Practice of Diaspora: Literature, Translation, and the Rise of Black Internationalism* (Cambridge, Mass.: Harvard University Press, 2003), 81–87.

6. This activity in the literary sphere—boosted also by publication of Blaise Cendrars' *Anthologie nègre* in 1921—was part of the wider effort in post–World War I France to consecrate African art and culture. Henri Clouzot and André Level published *L'Art nègre et l'art océanien* in 1919. This was followed by works such as Stéphen Chauvet, *Arts indigènes des colonies françaises* (Paris: Maloine, 1924); and Georges Hardy, *L'Art nègre* (Paris: Laurens, 1927).

7. Here again, I am indebted to Edwards' discussion in *The Practice of Diaspora*.

8. William Fagg, "African Art and the Modern World," *Premier Festival mondiale des arts nègres: Dakar, 1–24 avril 1966* (Dakar: André Rousseau, 1966), 44–47.

9. On isicathamiya, see Veit Erlmann, *Nightsong: Performance, Power, and Practice in South Africa* (Chicago: University of Chicago Press, 1996), esp. chs. 10 and 11. On dzokpikpli, see Daniel Avorgbedor, "Competition and Conflict as a Framework for Understanding Performance Culture among the Urban Anlo-Ewe," *Ethnomusicology*, 45, no. 2 (2001): 260–282.

10. It may be that music plays a smaller role in the domestic culture than

it does in the international marketplace. While music has been the most rapidly growing cultural export in post-Apartheid South Africa (as also in Zimbabwe), a Johannesburg reporter points out that in order to publicize the country's first official Music Day in 1999, sponsors felt compelled to enlist "sporting stars, models, and comic-strip characters" for their advertising campaign, since these figures enjoyed far wider recognition than the top musical artists. Anonymous, "SA Musicians Striking the Right Note on Music Day," *Mail and Guardian* (Johannesburg), 26 March 1999. On the place of the South African music industry in the international music market, see *The South African Music Industry 2001: Facts, Trends, Future* (Johannesburg: KPMG Media and Entertainment, 2001).

11. Erlmann, *Nightsong*, 224–242.

12. Ibid., 291. As Erlmann discusses, Shabalala's autobiographical account of these early successes involves a large measure of self-mythologizing. But Ladysmith Black Mambazo's domination of the prize contests is not in doubt.

13. Chris Stapleton and Chris May, *African All-Stars: The Pop Music of a Continent* (London: Quartet, 1987).

14. Muff Andersson, *Music in the Mix: The Story of South African Popular Music* (Johannesburg: Raven Press, 1981), 93. A bestseller list based on K-Mart's internal sales figures appears on page 57.

15. "A Word from the Editor," *African Music: Journal of the International Library of African Music*, 6, no. 4 (1987): 3.

16. Andersson, *Music in the Mix*, 91–92.

17. The terms "world beat" and "world music" date well back into the 1970s, and a number of Afropop artists, from Osibisa (Ghana) to Tabu Ley (Zaïre), had enjoyed success in London and, especially, in Paris at the very start of that decade. But it was not until a sufficient network of prizes and competitions had emerged to relay African artists from local into international forums that the Afro-fusion club scene in Europe began to attract serious attention from record companies and music magazines.

18. A thoughtful analysis of the whole *Graceland* affair is Louise Meintjes, "Paul Simon's *Graceland*, South Africa, and the Mediation of Musical Meaning," *Ethnomusicology,* 34 (Winter 1990): 37–74. An excellent overview of the debates about the politics of world music more generally is Neil Lazarus, "Afropop and the Paradoxes of Imperialism," in Lazarus, *Nationalism and Cultural Practice in the Postcolonial World* (Cambridge: Cambridge University Press, 1999).

19. By this time, too, the group had finally started to win national awards, with multiple prizes at the post-Apartheid South African Music Awards (SAMAs), founded in 1994. Shabalala was honored with the SAMA Lifetime Achievement Award in 1996, and Mambazo won the prize for Best Duo or Group in 1996 and 2000. That the group was being celebrated, at the national level, precisely for having achieved such stunning (economic and symbolic) success in global markets is suggested by their 2000 SAMA award for Best Achievement by a South African Artist in International Markets.

20. In a further affirmation and augmentation of the group's global status, Mambazo was invited three years later to perform at the Olympic Games in Atlanta.

21. Meintjes, "Paul Simon's *Graceland*," 63.

22. A useful overview of place-promotion studies, focusing on the British context, is John R. Gold and Stephen V. Ward, eds., *Place Promotion: The Use of Publicity and Marketing to Sell Towns and Regions* (Chichester: Wiley, 1994).

23. The notion of a "Third Cinema," distinct in its aesthetics, production values, and politics both from the dominant, industrial "first" cinema (associated with Hollywood and the United States) and from the independent, auteurist "second" cinema (associated with the New Wave directors of Europe), emerged in Latin America in the 1960s, but was quickly generalized to other national and regional contexts, especially postcolonial ones. Since the 1970s, it has become a staple category of the international film festivals. The original manifestos and theorizations of Third Cinema are collected in Michael Martin, ed., *New Latin American Cinema, Volume I: Theories, Practices, and Transcontinental Articulations* (Detroit: Wayne State University Press, 1997).

24. Many of the traditionally noncompetitive festivals, which include such major events as London, Vienna, Toronto, and Sundance, have over the years introduced and then gradually expanded an array of prizes, or offered themselves as a forum for presentation of prizes decided elsewhere and independently. Moreover, the sheer competitiveness of the selection process (the Sundance Institute receives more than 1,700 feature submissions and 2,000 shorts each year, from which only 100 features and 60 shorts are selected for screening) clearly places all festivals, regardless of their use of FIAPF-approved jury prizes, firmly within the circuitry of international cultural competition.

25. In its rising dependency on the festivals, the avant-garde or art cinema has followed the historical course described by David Chaney with respect to the visual arts, drawing primary sustenance not from the universities but from the tourism and place-promotion industries. See Chaney, "Cosmopolitan Art and Cultural Citizenship," *Theory, Culture and Society,* 19, no. 1 (2002): 157–174.

26. Hamid Naficy, *An Accented Cinema: Exilic and Diasporic Film-making* (Princeton: Princeton University Press, 2001), 10.

27. Ibid., 46–56. Homi Bhabha, "Preface: Arrivals and Departures," in Hamid Naficy, ed., *Home, Exile, Homeland: Film, Media, and the Politics of Place* (New York: Routledge, 1999), vii–xii.

28. Bhabha reminds us that "to be unhomed is not to be homeless." It is, rather, to experience "the relocation of the home and the world—the unhomeliness—that is the condition of extra-territorial and cross-cultural initiations." Homi Bhabha, *The Location of Culture* (New York: Routledge, 1994), 9.

13. Prizes and the Politics of World Culture

1. Sundance was originally set up to promote and celebrate U.S. independent film, but it has been steadily expanding its World Cinema section since the early 1990s, and especially since the turn of the century. As this section has expanded, it has become increasingly clear that World Cinema is not simply a catch-all category for films from outside North America. In 2004, for example, there were dozens of films from Latin America, Asia, and Africa, but the major European auteurs were notably absent. The "world" in this context means in effect "developing world," "Global South," "minor," or "third."

2. On Soyinka's arrival in Lagos, see for example the Reuters wire report "Nigeria Honors Nobel Prize Winner," *New York Times,* 18 October 1986.

3. Chinweizu repeated this quip many times.

4. The attack on Soyinka and the Nobel Prize was spearheaded by the Igbo literary critics Chinweizu, Onwuchekwa Jemie, and Ihechukwu Madubuike, who had for years, in the pages of *Transition* and other journals, been denouncing Soyinka as a "Euromodernist" who "assiduously aped the practices of twentieth-century European modernist poetry." See the collection of their coauthored essays *Toward the Decolonization of African Literature,* vol. 1 (Washington: Howard University Press, 1983), above quotation from page 163. After Soyinka won the prize, Chinweizu escalated this *bolekaja* ("come

down and fight") rhetoric in *Decolonising the African Mind* (Lagos: Pero Press, 1987) and *Voices from Twentieth-Century Africa: Griots and Towncriers* (London: Faber, 1988). In his introduction to the latter (an anthology), he says that one can imagine "Vorster, Botha, and Hitler" embracing Soyinka "as an auxiliary Bantu spokesman for white supremacy."

5. This sense of the Swedish Academy's strategy was aired in such periodicals of the African diaspora as *West Africa* and *African Concord*. For a discussion of this and other press coverage of the award, see James Gibbs, "Prize and Prejudice: Reactions to the Award of the 1986 Nobel Prize for Literature to Wole Soyinka, Particularly in the British Press," *Black American Literature Forum*, 22 (Autumn 1988): 449–465. Gibbs mentions one writer in *West Africa* who speculates that the decision to pass over Senghor was a way of punishing the French for Sartre's notorious refusal of the Nobel (459). In general, this account of events conforms with Pascale Casanova's description of the "world republic of letters" as a system whose great centers of power are Paris (promoting Senghor) and London (promoting Soyinka), which between them hash out the stakes of world consecration.

6. Wole Soyinka, "Neo-Tarzanism: The Poetics of Pseudo-Tradition," *Transition*, 48 (1975): 38–44; reprinted in Soyinka, *Art, Dialogue and Outrage: Essays on Literature and Culture* (New York: Pantheon, 1993).

7. Gibbs, "Prize and Prejudice," 453.

8. Chinweizu et al., *Toward Decolonization*, 208. I should add here that Soyinka's long record of highly principled and courageous political dissidence has by now lifted him beyond the reach of such attacks and established him beyond question as the most revered author and the leading secular intellectual of Nigeria. But we must not project this figure back onto the more controversial Soyinka of the mid-1980s.

9. Not surprisingly, Chinweizu became a leading voice of anti-globalization in the 1990s.

10. Quoted in Bernth Lindfors, "Beating the White Man at His Own Game: Nigerian Reactions to the 1986 Nobel Prize in Literature," *Black American Literature Forum*, 22 (Autumn 1988): 475–488.

11. Gibbs, "Prize and Prejudice," 454.

12. Paul Hirst and Grahame Thompson, *Globalization in Question*, 2nd ed. (Cambridge: Polity, 1999), 23. Hirst and Thompson, two of the

most outspoken globalization skeptics, make the distinction between an inter-national and a properly global economy in order to argue that the latter is in fact a myth.

13. International trade in "cultural goods" is likely to continue rising, however, even if trade in agricultural and industrial goods declines. As UNESCO has documented, the global trade in cultural goods has been outstripping other sectors, rising from 2.5 percent of all world imports in 1980 to 2.8 percent in 1998. This represents a rise from $12 per capita to $45 per capita. See Phillip Ramsdale, "International Flows of Selected Cultural Goods, 1980–1998" (Paris: UNESCO Institute for Statistics, 2000). Www.uis.unesco.org (in Publications: Documents, accessed May 2005). Capsule statistics from this study are given in "Did You Know? International Trade in Cultural Goods," in the "Fast Facts" section of the website.

14. In his scintillating manifesto "Conjectures on World Literature," *New Left Review,* 1 (January–February 2000): 54–68, Franco Moretti makes the important methodological point that "world literature is not an object, it's a *problem*"—that is, it presents us with the task not of reading "it" (the body of world literature) more completely or assiduously, but of developing a "new critical method" (essentially a literary sociology) by means of which we might secure a more comprehensive and commanding, if necessarily also more "distant," critical perspective. I am in broad sympathy with this view, though I focus my attention not on the kinds of geographic patterns that may be discerned in the production and dispersion of what are now world literary forms (this has been Moretti's project), but on the way that world literature has been refashioned as a category—as a putative object—during the most recent phase of that global dispersion. Its production depends in part on certain kinds of Western literary institutions, themselves undergoing a process (rather later than that of Western literature itself) of global replication, adaptation, and appropriation. The functioning of these increasingly "glocalized" and/ or deterritorialized institutions is fundamental to the "problem" of world literature as it presents itself today. See also Moretti's rejoinder to critics in "More Conjectures," *New Left Review,* 20 (March–April 2003): 73–81, and his *Atlas of the European Novel, 1800–1900* (London: Verso, 1998).

15. See Waïl S. Hassan, "World Literature in the Age of Globalization: Reflections on an Anthology," *College English,* 63, no. 1 (2000): 38–47. I am indebted also to Jessica Lowenthal for her unpublished pa-

per "What Is World Literature and Where Can I Buy It? The World Literature Anthology in the Twentieth Century," University of Pennsylvania, December 2002.

16. Even Pascale Casanova, who takes the long view on world literature, suggests toward the end of her book that recent globalization of the market in literary value, which is fracturing and dispersing the centers of literary power, represents the imposition of a more emphatic and remorseless commercial logic upon the selection of a world literature canon. See Casanova, *La République Mondiale des Lettres* (Paris: Seuil, 1999), 233–236.

17. Ian Anderson, "World Music History," *Folk Roots,* 21 (2000): 36–39.

18. Quoted in Lindfors, "Beating the White Man at His Own Game," 481.

19. Huggan, however, is (I think rightly) less interested in marshaling an aesthetic critique of the works that fall under this rubric than in crafting a political critique of the institutions that have produced and sustained their reception as representative works of "postcoloniality."

20. Francesca Orsini, "India in the Mirror of World Fiction," in Christopher Prendergast, ed., *Debating World Literature* (London: Verso, 2004), 333.

21. Maurice Delafosse, quoted in Brent Edwards, *The Practice of Diaspora: Literature, Translation, and the Rise of Black Internationalism* (Cambridge, Mass.: Harvard University Press, 2003), 82.

22. Bernice Rubens, quoted in John Mullin, "Prize Fighters," *Guardian,* 23 May 2002.

23. Raoul Granqvist, "Wole Soyinka, Nobel Prize Winner: Sweden Acknowledges Africa," *Black African Literature Forum,* 22 (Autumn 1988).

24. Dinitia Smith, "In Its Debut, a Big Prize for Freedom Helps Writer," *New York Times,* 21 April 1999, E1.

25. Graham Huggan is the only critic who has undertaken a sociological analysis of these "postcolonial patrons" (as he aptly refers to them). In "Prizing Otherness: A Short History of the Booker," *Studies in the Novel,* 24 (Fall 1997), Huggan explains the rise of such dubious financial sponsors in the later twentieth century as an effect of the growth of "huge transnational corporations." While that is clearly one aspect of the phenomenon (most pronounced in Europe and the United Kingdom), there has been a dramatic rise in noncorporate sponsorship, as well (most pronounced in the United States). What

does seem clear, and deserves far more attention than I have given it in this chapter, is that the public sponsorship of prizes has been declining relative to sponsorship by corporations and (private) foundations: a little-noticed effect of the neo-liberal pauperization of the state.

26. Benedict Anderson, "You Who Read Me, Friend or Enemy: The Choices of the Third World Novelist," Southeast Asia Lecture Series, Princeton University, 3 October 2002.

27. Keri Hulme, *the bone people* (London: Picador, 1985). I have followed Hulme in using all lowercase letters for the book's title, though later editions and critical discussions of the novel have not always done so. The lowercase title itself is something of a hallmark, or cliché, of world culture.

28. A review by A. McLeod appeared in the student magazine of Auckland University, *Craccum*, 17 April 1984, 18–19, followed by a review by D. S. Long in the April–May issue of *Tu Tangata*, the journal of the Ministry of Maori Development. The first really major review, by Joy Cowley and Arapera Blank, appeared in the 12 May issue of *The Listener*, then New Zealand's leading arts and literature weekly, with a circulation of over a million. Blank, a professor at Glenfield College, Auckland, was serving on the Pegasus jury at the time he published the review.

29. Philip Howard, "Poetic Kiwi Tale Takes Booker Prize," *Times* (London), 1 November 1985.

30. Anonymous, "Monster Novel at Large: Keri Hulme, Author of *The Bone People*," *Guardian*, 2 October 1985.

31. The two prizes merged in 1996 (after Wattie's was bought out by Montana Wines) to form the Montana New Zealand Book Awards, ending a twenty-year battle over which was the nation's "premier" prize—a battle that was, however, reanimated just five years later by the founding of the Schaeffer prize.

32. C. K. Stead, "Keri Hulme's *The Bone People* and the Pegasus Award for Maori Literature," *Ariel*, 16 (October 1985): 101–108. For a discussion and rebuttal, see Margerie Fee, "Why C. K. Stead Didn't Like *the bone people*: Who Can Write as Other People," *Australian and New Zealand Studies in Canada*, 1 (Spring 1989).

33. Edwin McDowell, "A Noted 'Hispanic' Novelist Proves to Be Someone Else," *New York Times*, 22 July 1984, A1.

34. The favorite that year was, understandably, Doris Lessing's *The Good Terrorist*, with Peter Carey's *Illywhacker* close behind. One

suspects, however, that if the oddsmakers had noticed Martyn Goff's glowing review of *the bone people* in the *Daily Telegraph,* they would have shortened the odds considerably. In a later interview with Ion Trewin, Goff acknowledged maneuvering hard behind the scenes to keep Hulme's novel in the running despite initial resistance from the judges. *Booker 30: A Celebration of 30 Years of the Booker Prize for Fiction, 1969–1998* (London: Booker PLC, 1998), 21.

35. Dea Birkett, "Maori Mafia versus Pakeha Redneck," *Guardian,* 25 February 1994, A26. Hulme is one of only two Maori authors (and there are no other New Zealanders) included in Victor J. Ramrash, ed., *Concert of Voices: An Anthology of World Writing in English* (Peterborough, Ontario: Broadview Press, 1994).

36. Chris Bongie, *Islands and Exiles: The Creole Identities of Post/Colonial Literature* (Stanford: Stanford University Press, 1998), 417.

37. Of the novels that won the New Zealand Book Award between 1977 and 1990, only Janet Frame's *Living in the Maniototo* (1980) and *The Carpathians* (1989) are still available in the United States and Britain. Among Maori writers, most of Patricia Grace's work of the 1980s, and all of Witi Ihimaera's (including the anthology of Maori literature he edited in 1983) had gone out of print by the mid-1990s. Ihimaera's *Whalerider,* however, a New Zealand bestseller and winner of the 1988 Wattie Book of the Year Award, returned dramatically to North American bookshops with the release of Niki Caro's film adaptation in 2003. With its mythical narrative and pronounced magical elements, *Whalerider* marked a sharp departure from Ihimaera's earlier novels, which had been works of closely observed autobiographical realism. It was, in fact, a work far more susceptible of recognition by the institutions of "world literature." And while those institutions have not yet conferred much honor on Ihimaera, it is notable that the film *Whalerider,* for which he received a co-producer credit, won the World Cinema award at Sundance 2003. It seems likely to me that *Whalerider* will now join *the bone people* as a second New Zealand novel in the world literature canon, and that it will be the one which, like Achebe's *Things Fall Apart* among world-canonized African novels, is most frequently assigned as a classroom text.

Index

Numbers in italics refer to pages with illustrations.